GREAT WOMEN SCULPTORS

GREAT WOMEN SCULPTORS

Φ

PREFACE
PAGE 8

INTRODUCTION
PAGE 9

A

PAGE 18
Magdalena Abakanowicz
Alice Adams
Kelly Akashi
Jane Alexander
Shaikha Al Mazrou
Olga de Amaral
Janine Antoni
Ruth Asawa
Tauba Auerbach
Ghazaleh Avarzamani
Alice Aycock
Margarita Azurdia

B

PAGE 30
Leilah Babirye
Nairy Baghramian
Natalie Ball
Rina Banerjee
Fiona Banner aka The Vanity Press
Rosa Barba
Phyllida Barlow
Yto Barrada
Mária Bartuszová
Rana Begum
Nina Beier
Patricia Belli
Lynda Benglis
Lauren Berkowitz
Sarah Bernhardt
Huma Bhabha
Alexandra Bircken
Cosima von Bonin
Monica Bonvicini
Chakaia Booker
Louise Bourgeois
Carol Bove
Beverly Buchanan
Heidi Bucher
Dora Budor
Angela Bulloch
Teresa Burga

C

PAGE 57
Seyni Awa Camara
Elaine Cameron-Weir
Nina Canell
Jodie Carey
Claudia Casarino
Rosemarie Castoro
Elizabeth Catlett
Helen Chadwick
Judy Chicago
Saloua Raouda Choucair
Chryssa
Lygia Clark
Camille Claudel
Marie-Anne Collot
Gisela Colón
Marta Colvin
Fiona Connor
Nicola Costantino
Petah Coyne

D

PAGE 76
Anne Seymour Damer
Vanessa da Silva
Paula Dawson
Berlinde De Bruyckere
Agnes Denes
Abigail DeVille
Karla Dickens
Tara Donovan
Sokari Douglas Camp
Mikala Dwyer

E

PAGE 86
Abastenia St. Leger Eberle
Nicole Eisenman
Vaska Emanuilova
Tracey Emin
Ayşe Erkmen
Helen Escobedo
Tamar Ettun

F

F

PAGE 93

Claire Falkenstein
Alia Farid
Monir Shahroudy Farmanfarmaian
Simone Fattal
Félicie de Fauveau
Lara Favaretto
Maria Faydherbe
Rachel Feinstein
Sonja Ferlov Mancoba
Teresita Fernández
Sylvie Fleury
Ceal Floyer
Laura Ford
María Freire
Nancy Fried
Elisabeth Frink
Katharina Fritsch
Meta Vaux Warrick Fuller
Sue Fuller

H

PAGE 126

Fiona Hall
Lauren Halsey
Anthea Hamilton
Han Sai Por
Siobhán Hapaska
Rachel Harrison
Emma Hart
Auriea Harvey
Maren Hassinger
Mona Hatoum
Holly Hendry
Camille Henrot
Barbara Hepworth
Gertrude Hermes
Eva Hesse
Sheila Hicks
Nancy Holt
Jenny Holzer
Rebecca Horn
Roni Horn
Harriet Hosmer
Klára Hosnedlová
Marguerite Humeau
Anna Hyatt Huntington

J

PAGE 152

Ann Veronica Janssens
Madeleine Jouvray
Katarzyna Józefowicz
Caterina de Julianis

G

PAGE 112

Anya Gallaccio
Lily Garafulic
Adebunmi Gbadebo
Gego
Isa Genzken
vanessa german
Sonia Gomes
Dora Gordine
Sheela Gowda
Laura Grisi
Nancy Grossman
Gu Erniang
Guan Xiao
Shilpa Gupta

I

PAGE 150

Cristina Iglesias
Iman Issa

K

PAGE 156

Nadia Kaabi-Linke
Reena Saini Kallat
Edith Karlson
Bronwyn Katz
Clementine Keith-Roach
Zsófia Keresztes
Rachel Khedoori
Bharti Kher
Kimsooja
Katarzyna Kobro
Käthe Kollwitz
Elza Kövesházi-Kalmár
Brigitte Kowanz
Kitty Kraus
Shigeko Kubota
Shio Kusaka
Yayoi Kusama
Alicja Kwade

L

PAGE 174

Nicola L.
Marcelle Renée Lancelot-Croce
Artis Lane
Greer Lankton
Liz Larner
Lee Bul
Marie-Louise Lefèvre-Deumier
Simone Leigh
Jac Leirner
Sherrie Levine
Hannah Levy
Edmonia Lewis
Tau Lewis
Liao Wen
Liliane Lijn
Kim Lim
Won Ju Lim
Laura Lima
Maya Lin
Lin Tianmiao
Tayeba Begum Lipi
Rita Longa
Liza Lou
Sarah Lucas

5

M

PAGE 198

Savia Mahajan
Anna Maria Maiolino
Anina Major
Tosia Malamud
Rebecca Manson
Teresa Margolles
Marisol
Maria Martins
Rebeca Matte
Rita McBride
Andrea de Mena
Lindsey Mendick
Marisa Merz
Annette Messager
Marta Minujín
Mary Miss
Kazuko Miyamoto
Nandipha Mntambo
Anna Morandi Manzolini
Delcy Morelos
Mariko Mori
Blanche-Adèle Moria
Annie Morris
Meera Mukherjee
Mrinalini Mukherjee
Vera Mukhina
Portia Munson
Wangechi Mutu
Ethel Myers

N

PAGE 227

Rei Naito
Ana Navas
Senga Nengudi
Rivane Neuenschwander
Louise Nevelson
Otobong Nkanga

R

PAGE 254

Germaine Richier
Clara Rilke-Westhoff
Luisa Roldán
Annabeth Rosen
Properzia de' Rossi
Eva Rothschild
Michal Rovner
Nancy Rubins
Kathleen Ryan
Veronica Ryan

P

PAGE 239

Katrina Palmer
Lygia Pape
Cornelia Parker
Helen Pashgian
Jennifer Pastor
Katie Paterson
Beverly Pepper
Judy Pfaff
Julia Phillips
Patricia Piccinini
Cathie Pilkington
Paola Pivi
Liliana Porter
Marjetica Potrč
Jane Poupelet

O

PAGE 233

Tomie Ohtake
Precious Okoyomon
Füsun Onur
Meret Oppenheim
Chana Orloff
Virginia Overton

S

PAGE 264
Alison Saar
Betye Saar
Niki de Saint Phalle
Takako Saitō
Doris Salcedo
Augusta Savage
Mira Schendel
Lara Schnitger
Claudette Schreuders
Dana Schutz
Irena Sedlecká
Usha Seejarim
Tschabalala Self
Beverly Semmes
Arlene Shechet
Shen Yuan
Alyson Shotz
Mary Sibande
Ayesha Singh
Lucy Skaer
Kiki Smith
Renee So
Valeska Soares
Monika Sosnowska
Diamond Stingily
Jessica Stockholder
Michelle Stuart
Alina Szapocznikow
Sarah Sze

T

PAGE 293
Sophie Taeuber-Arp
Dorothea Tanning
Lenore Tawney
Alina Tenser
Tatiana Trouvé
Anne Truitt
Shirley Tse

Y

PAGE 316
Yamazaki Tsuruko
Haegue Yang
Kennedy Yanko
Lena Yarinkura
Anicka Yi
Yin Xiuzhen
Daisy Youngblood

W

PAGE 306
Kara Walker
Meg Webster
Nicole Wermers
Pae White
Rachel Whiteread
Gertrude Vanderbilt Whitney
Alison Wilding
Hannah Wilke
Jackie Winsor
Betty Woodman

Z

PAGE 323
Andrea Zittel

V

PAGE 300
Sara VanDerBeek
Paloma Varga Weisz
Joana Vasconcelos
Cecilia Vicuña
Claude Vignon
Ursula von Rydingsvard

GLOSSARY
PAGE 324

INDEX
PAGE 333

WRITERS
PAGE 342

PREFACE

*Maia Murphy, Olivia Clark,
and Charlotte Flint*
Editors

Sculpture assertively resists definition, either by substance or texture, size or shape, permanence or presentation—really by any category. *Great* ~~Women~~ *Sculptors* is a celebration of this endless mutability, and a testament to the artists who have embraced it to create new forms in different ways.

The more than three hundred artists in this book likewise defy categorization. Born in sixty-four countries over the past five hundred years, these artists make sculptural work that demonstrates striking creativity across myriad approaches to media, shape, technique, and subject. This is in spite of historical and contemporary challenges to accessing training, materials, and platforms that intersect with gender, race, identity, and biography, all of which can accompany being a woman who sculpts.

What does unite the works in this volume is how they initiate an encounter *in space*. Whether on a plinth or suspended from the ceiling, three-dimensional or flat, made of stone or yarn, the sculptures in these pages allow viewers and artists to interact with a presence in, build a connection to, or exist among a particular time and place. In her introduction to this book, Lisa Le Feuvre writes about sculpture as "both a material object and an invitation to perceive." It infers the existence of the viewer, of our sharing space with its physicality. Sculpture's emphasis on the relationship of the artwork to its ground or support, to how it is situated in its environment, makes it inherently relational.

That such a book as this is even possible speaks to the global and generations-long network of researchers, scholars, and advocates who have ensured that the extraordinary contributions of these artists are remembered. Organized alphabetically by each artist's surname, *Great* ~~Women~~ *Sculptors* follows the precedent set by Phaidon's *The Art Book* series, prompting new connections and surprising juxtapositions to be made between artists and artworks that are beyond chronological or geographical frameworks.

It continues the project initiated by Rebecca Morrill as commissioning editor for Phaidon's *Great* ~~Women~~ *Artists* (2019) and *Great* ~~Women~~ *Painters* (2022), who conceived of this publication as the next in the series. While there is some overlap of names among these books, a new artwork illustration is presented for each. This volume does not claim to present a definitive list of the greatest artists, as such an endeavor would require many hundreds more pages and its compilation would inevitably entail an element of subjectivity. Instead, it is a declaration of the long and rich history of women artists that honors sculpture's invitation to imagine new possibilities of creating and experiencing the world.

INTRODUCTION
Lisa Le Feuvre

Sculpture, three-dimensional forms of solid material.
Never what I do! [1]
 Gego

Great ~~Women~~ Sculptors charts a set of coordinates for sculptural thinking through a network of artistic investigations spanning the fifteenth century through to the present. This transhistorical and transnational volume takes a journey through, with, and around sculpture. It demonstrates sculpture can be a solid three-dimensional form made of solid material, but it does not need to be. The epigraph is by Gego (p.115), an artist whose understanding of sculpture as a heavy, immovable, firmly situated, and static object made her reject the very term "sculpture" for her own work. Yet here she is, in a book dedicated to sculpture. How can that be? A trained architect and engineer, Gego extended the point into a line, creating planes, volumes, and three-dimensional projections into space. She worked with structure, scale, and gravity—primary sculptural concerns—to make gatherings of lines vibrating in space. Some are spiders' webs filling rooms, others are cascading lines and stretching geometrical forms. In all cases her sculptures—as they surely are—encourage those who perceive them to look harder, think deeper, and engage all the senses in the experience of the world.

In her essential text "Sculpture in the Expanded Field," written in 1979, the art historian Rosalind Krauss described the shifting edges of the discipline of sculpture:

> Over the last ten years rather surprising things have come to be called sculpture: narrow corridors with TV monitors at the ends; large photographs documenting country hikes; mirrors placed at strange angles in ordinary rooms; temporary lines cut into the floor of the desert. Nothing, it would seem, could possibly give to such a motley of effort the right to lay claim to whatever one might mean by the category of sculpture. Unless, that is, the category can be made to become almost infinitely malleable. [2]

Sculpture can be made of flickering television monitors. Shigeko Kubota (p.170), a core member of the Fluxus movement, created video sculptures using the object nature of moving-image display units to undo the assumptions that timebound experiences are fleeting and fragile. Sculpture can be located in the landscape, far from the museum or the urban realm. Beverly Buchanan (p.52), central to Land art, chose sculptural sites that are historically charged, yet her works are unmarked and far from the nodes of the international art market. Sculpture too can be made from mirrors. Alicja Kwade (p.173) builds mathematically precise

sculptures that combine spheres of different materials with mirrors, each embodying, reflecting, and revealing systems of material values. Sculpture can be made from the surface of the planet: Delcy Morelos's (p.217) material is clay, soil, water, ground cloves, and cocoa powder. She creates environments, brings the landscape indoors, and, in her sculptures, matches the volume of earth with the volume of smell that reaches through the nostrils into the body. Seeing is just the beginning.

Sculpture is both a material object and an invitation to perceive. It is concerned with objects, with relationships; with the inescapable force of gravity, the light that illuminates it, and the space that holds it; with memory, the body; and with the many complications of being human. The complexity of sculpture lies in its dual existence as an object and an initiator of experience. The former is empirical, the latter contingent on time and context. Objects are all around us; experiences are constant. We human beings make objects to try to make sense of the world and then, just when we think we have reached a semblance of understanding, we step back, and fall over an unexpected thing. Sculpture is wonderfully in and of the world—we all are experts in the tricky relationships with objects. Sculpture demands an encounter, insisting that it takes place in time and space. It involves mobility—whether material or immaterial, sculpture needs to be perceived from all angles and felt as much as seen. Sculpture can be scaled to the body in many ways. Lygia Clark's (p.68) architectural *Matchbox Structures*, for example, fit in the hand. Matchboxes, now an almost obsolete object, are designed to fit the pocket and be easily opened by a push of the fingers. They are emblematic of tactility, temporary structures that secure the potential of fire, with no use once their contents are spent—and they can be material for sculpture. And sculpture can be monumental in size. Phyllida Barlow (p.36) made sculptures that push to the absolute edges of spaces and vision, touching ceilings and slipping behind structural architecture. Barlow understood sculpture as a sentient language that collides form with content and subject, and it does so in order to possess everything that surrounds it. Be it the weather, uninvited noise, lapses in concentration, or the surrounding architecture, for her sculpture was in a constant reciprocal dialogue with the air around it.

The ubiquity of objects and experiences makes sculpture profoundly human, and acutely powerful as an art form. Sculpture is concerned with bodies, with pushing against and pulling with the space that holds it. It is a situated object—contingent on circumstances of production, reception, and distribution. The following pages underline sculpture as a productive and fertile realm of artistic production, study, and engagement that resonates with the ways in which we attempt to order and understand the world that surrounds us. Sculpture is everywhere, but everything is not sculpture. Sculpture can be fleeting, time bound, contingent, fluid, and temporal. It is material and thought, additive

and subtractive, autonomous and contingent, permanent and impermanent, temporal and timeless. What makes the gestures described by Krauss as this thing called "sculpture" is attention to the body in space.

*

Processes of carving, molding, modeling, and cutting are at the root of the slippery definition of sculpture. Sculpture is a verb involved with fabrication, no matter what story might be being told. Relationships between making and unmaking, producing an object from nothing, and reducing a block of something into an object is the place where sculpture begins. These material processes traditionally are activated in places like foundries, kilns, and quarries, using tools on materials. Plaster, marble, concrete, bronze, and wood are some of the substances associated with sculpture, but it can just as well be made from air, water, film, paper, photography, dust, fragrance, the voice, or pigment. The possibilities are expansive; there are no limits to the material matter of sculpture. Nicole Eisenman's (p.87) *Maker's Muck* (2022) shows the sculptor at work—a plaster figure sits at a constantly turning potter's wheel, big hands spreading clay, the action surrounded by a parade of maquettes for Eisenman's own sculptures. The scene is staged on a wooden platform—a slice of matter reclaimed from the Coney Island boardwalk. Artists who worked with marble during the nineteenth century would show their skill of making in the flowing drapery, surface of the skin, and hair of their subjects, with the translucence of their chosen material enabling skin to seem supple and alive. Often working to commission, and in the studios of the generations that preceded them, sculptors would turn their attention to the classicism of Rome and Greece revered in museums, retelling stories, and charting the changing present. Edmonia Lewis (p.185) made *Forever Free* in Rome in 1867, two years after the abolition of slavery in the United States. Wrought from marble, Lewis persuades the solid material into flowing form. Unlike most sculptures marking the Thirteenth Amendment to the United States Constitution, which abolished slavery and involuntary servitude, her figures have agency. She depicts a man standing tall, his left arm raised and with his hand holding a shackle that had once chained him to a ball, which now sits beneath his foot. His right arm rests on the shoulder of a kneeling, but not submissive, woman—her own ankle wrapped with a broken shackle.

Figurative sculpture can portray a generic or a specific body. Who sculpts, who is being sculpted, why a person is sculpted, and how they are depicted loudly speaks to the values of the time of making. A training in the skills of sculpture was not an option for all sculptors. Unlike her white male contemporaries, Lewis did not have a training in anatomy—it was not deemed appropriate study for a woman. Harriet Hosmer (p.146), like Lewis an expatriate American who moved to Rome, is a rare example

of a woman Neoclassical sculptor who did manage to study anatomy, but it was not learned through sculptural training. Rather, despite being committed to working as a sculptor, she attended medical school in Missouri—enabled by the encouragement of her father. As a white artist, Hosmer had more privileges than Lewis and both artists' economic mobility enabled them to travel and work. For Lewis and Hosmer, working with a live model as they developed their sculptural practice was impossible. At this time, the model would be nude and female: acceptable for male sculptors to see, but not female ones. Hosmer's marble *Beatrice Cenci* of 1857, like Lewis's figures, was made in Rome. She too shows her skill in the folds of drapery, the hair, and the surface of the skin of her subject. Her named subject, a sixteenth-century noblewoman beheaded for killing her abusive father, was a typical subject for Hosmer. She chose women who fought back and, in working from a live model outside the walls of the academy, was intent on showing the sensuality of women.

Lack of access to sculptural training and resources persisted long into the next century for women. Mária Bartuszová (p.38) created sculptures that are studies in the pleasure of tactile making and looking. She chose plaster, directly casting perfect shapes of rubber balloons, taking the idea of a hand-scaled expandable object filled with air, almost weightless and designed to be thrown and caught, as a sculptural possibility. Bartuszová initially studied ceramics, but this was not her first choice. She applied to study sculpture at the University of Applied Arts in Prague, passed the entrance exams but was not admitted, with her place offered to a male student. Instead, she turned to study ceramics and porcelain—materials seen as being more suited, one can assume, to the fact of her being a woman. On graduating, with no access to a ceramic studio, she made work at home—a space where so much sculpture by women is made. Biography most certainly impacts the access to sculptural training and resources.

Sculptural processes form the sculptural object. Legacies of statuary, solidity, material, and memorial inform both its making and its reverberation in the world. It is called upon for tableware, memorial, and decoration; and is used in the service of propaganda, distraction, traffic calming, and fountains. It represents power, political nuance, populism. The desire for permanence has often been cited as one of sculpture's long-standing and well-known characteristics, seen as part of its capacity to give durable form to ideas and extend them publicly into the future. Yet, even when made of the most enduring materials, sculptures can become obsolete. Sometimes they lose their charge when their subjects become forgotten, other times what they were made to celebrate becomes irrelevant, or even unethical. And they also can simply fall apart. Nina Beier (p.40) wryly shows forgotten sculptures in her *Women & Children*, a 2022 work that gathered historic bronze sculptures of women and children into

a fountain. Clustered together, water streams from each figure's eyes as they lie, lounge, and linger. Public statues made of bronze tend to present named men, dressed in a manner to communicate their social status. Those of women and children, on the other hand, are most likely to be nameless and nude and, if they are not passive, their actions dedicated to care or to sadness. This convention makes counter-representations especially charged.

Figurative sculpture takes many forms in all its allusions to the body. Sarah Lucas (p.197) makes sculpture from ordinary things—items, objects, and language that constitute the world in which we live. It could be fruit, vegetables, tights, concrete blocks, battered office chairs, fluorescent tubes, flints, or mattresses. Or her ready-at-hand things could be the slang that carries assumptions and histories silently on its back in casual conversation—the shorthand, for example, used for men and women and their differences. She always pays attention to the body, that decaying and sensible object we all know so well, with its irritating requirements of maintenance and care. Lucas's bodies do not show the idealism of Lewis or Hosmer. *Suffolk Bunny* (1997–2004), for example, is made from tan tights, blue stockings, a chair, a clamp, wire, and kapok, the stuffing that fills soft toys. Tights are designed to make naked flesh acceptable, to take away the scars and discolorations that evidence experience and pumping blood. This smoothed-out skin is regarded as a particularly feminine body surface; these quotidian skin coverings also act as a physical precedent to the way skin can be smoothed through digital post-production. Lucas's lumpy and imperfect figure is brutally human—this is really what bodies are like. Made of polychromed wood in 1675, Andrea de Mena's (p.208) *Mater Dolorosa* has a different kind of realism. It depicts the Virgin Mary with glass tears falling from her eyes and an emotive blush to her cheeks. She is beautiful. De Mena's use of shadow as she carved into solid form brings an intense sense of a living, breathing being to inspire and sustain religious ardor. Her sculpture sits on a pedestal that bears its maker's name: in 1675 women did not have the legitimacy to sign any legal documents. To make, and then to assert authorship, was a radical move for a woman sculptor.

How sculpture touches the ground is crucial. Just like humans, objects are subject to the relentless pull of gravity. Lucas chooses a chair; Eisenman a salvaged platform; Lewis an integral marble oval base on which the title, date, and her name are inscribed. Sculpture sits in space, pulling and pushing all that visually surrounds it for its own ends. Even when not figurative, sculpture is always concerned with the body: to be perceived, sculpture must be walked around, interrupted by light and shadow, and it asks that time is spent with it. It is a gravity-defying object that structures the space between itself and its perceiver. Ann Veronica Janssens (p.152) has no need for support for her *Untitled (blue glitter), open sculpture #3* (2015–): its material is blue glitter that directly resides

on the floor. First it is piled into a small heap, and then kicked into a form that holds its space simply through gravity, shining with the same magic of incandescent marble. Each time it is shown, it takes a different form, refusing assumptions of sculptural stasis. Nancy Holt (p.142) literally integrated the ground into her 1974 earthwork *Hydra's Head*— set beside a river, it comprises six circular pools of water, marking the constellation Hydra and reflecting the skies above.

*

The artists represented in this volume assert the power of sculpture, and the qualities of solidity and three-dimensionality are the mere baseline of sculpture. Sculpture has been around for a very long time. Perhaps—"perhaps" because there is so much yet to be known—one of the earliest-known artworks was made around 32,000 years ago, and it was a sculpture. In 1939 archaeologists uncovered a series of objects made from mammoth ivory in a Paleolithic site known as the *Stadelhole* (stable cave) in Hohlenstein, southern Germany. One was a part-animal part-human figure, known today as the *Löwenmensch* (lion-human) figurine and, after much research, this statuette has come to be recognized as one of the first works of art. It brings into being something that has not existed before in the material world. Who made it is unknown.

This publication's inventory starts with a carved cherry pit surrounded by precious stones. Scaled to sit in the hand, this is a sculpture made by Properzia de' Rossi (p.258) in the early sixteenth century, a time when it was assumed that only male artists were capable of making sculpture. From these Renaissance beginnings, sculpture mutates in every direction. The statue and monument give way to the anti-statue and "un-monument." Everyday objects are wrestled to the ground by their contexts. Volume shifts its register from physical occupation of space to levels of sound, smell, and light. Solidity is replaced with event, form by ideas. Matter and material are subsumed by process as sculpture infects, extends, appropriates, uses, and abuses painting, drawing, film, and photography. Terms that include "Installation art," "socially engaged practice," and "Land art" step on the toes of sculpture. And then, even after all this unexhausted list of expansions on sculpture and the sculptural imaginary have been effectuated, the object continues to return again and again in new ways. It is often disagreeable and contentious and, no matter what its scale, it can become invisible. This collection shows the conditions that create the very definition of sculpture.

Traditionally, the physical object has been regarded as the stuff of sculpture, the means to address scale, volume, and weight. But a sculpture's history hinges as much on the ways that it is distributed as it does on its material form. Sculpture, an often-cumbersome art form, is made mobile through publications, images, digital resources, recommendations, and rumors. It breathes into the world via these

flawed, biased, and partial distribution networks that create visibility, critical discourse, and the canon of sculpture. This book is about sculpture—and is also about the production of sculpture by women. It offers a set of coordinates and shows that there are—and there always have been—women sculptors everywhere. The standard narrative of sculpture, however, tells a different story.

In December 1971 Nancy Holt wrote a letter to the artist Carl Andre (1935–2024) following an invitation to present examples of her sculpture in an exhibition dedicated to the work of female artists at the John Weber Gallery in New York.[3] She curtly reminds him this had already been done in Lucy Lippard's *Twenty-Six Contemporary Women Artists* earlier that year at The Aldrich Contemporary Art Museum in Ridgefield, Connecticut. When Lippard described the exhibition, she was direct:

> I took on this show because I knew there were many women artists whose work was as good or better than that currently being shown, but who, because of the prevailingly discriminatory policies of most galleries and museums, can rarely get anyone to visit their studios or take them as seriously as their male counterparts. The show itself, of course, is about art. The restriction to women's art has its obviously polemic source, but as a framework within which to exhibit good art it is no more restrictive than, say, exhibitions of German, Cubist, black and white, soft, young, or new art . . . Within the next few years, I expect a body of art history and criticism will emerge that is more suited to women's sensibilities. In the meantime, I have no clear picture of what, if anything, constitutes "women's art," although I am convinced that there is a latent difference in sensibility; and vive la difference.[4]

Holt notes in her letter to Andre: "The end result of that show was not meant to proliferate copy shows, but to put women in a better position to advance professionally with other artists (male and female) in shows chosen for aesthetic reasons." She retorts that for a male artist to curate an exhibition of only women at a gallery that had never shown a single artwork by a female artist was driven by guilt rather than knowledge, admonishing it is "too easy a way of dealing with the real problem of including good art by women in art shows, not women's shows."

*

More than half a century later, is there a clear sense of what "women's art" might be? Is there a woman's sensibility that can be identified in this index of more than three hundred sculptors? An art that matters, one that recalibrates how the world is understood, is not generated from personal self-expression. Rather, it grows from the circumstances of its time and making, and resonates with the specifics of the history of sculpture

in the past and future, as well as the world that holds it. One of these conditions is structural misogyny. This is a quality that in these times—the 2020s—can be named and recognized as fact in all circles. A decade ago, that was not so—as a caveat, one must remember that if something can be named it has an existence. The body is the primary site where such attitudes have long been projected, and instances of the female body being fragmented through contempt abound. These acts of disrespect are claimed by Kiki Smith (p.284) piece by piece, and she describes that much of her work "is about living with the shame of being female in public . . . It seems important for me to hang out there with my experience to be a girl-child, to see if I could live through that in public."[5]

Smith's method is to deploy materials that are tactile, familiar, loaded with histories of art and labor. There is bronze, there is horsehair, porcelain, glass, tapestry, wax, terracotta. She sculpts the bodies of humans and of other animals as a reminder to us that we must be feeling subjects, that we must bring fragments into powerful wholes to find agency—that power that so often women have to fight to possess. This is a lesson on why bodies matter, why art matters, and why art by women matters. Any person who has experienced what it is to be a woman knows there are erroneous expectations concerning all aspects of their being—assumptions of presence, of conduct, of power, of rightful place in the world. Sculpture takes up space, be that in studios, collection storerooms, museum galleries, or on trucks as it moves from place to place. It takes time and money too to make sculpture—resources women artists persistently have less of. Women are rarely encouraged to take up space. To dedicate a book—a weighty tome, at that—to the sculptural production of women is rare.

Rebecca Morrill states in the introduction to the first volume in this series, *Great ~~Women~~ Artists*: "Any book of women artists is likely to be seen as a descendant of feminist art history."[6] That is certainly true, yet surely any book of artists should be seen as a descendant of feminist art history. Sculpture is particular: its history persists in not seeing women. Rather than expanding the canon, this book is an index that ruptures the received account of sculpture. It rethinks the linguistic structures of what sculpture might be and, in doing so, rethinks the structures that formulate assumptions of sculpture, and of women. Assumptions are nets that catch and filter; they release through the holes what does not fit the desired structure. In 1971, the same year Holt's letter was written, the art historian Linda Nochlin published an article titled "Why Have There Been No Great Women Artists?"[7] She asked the question, with a caustic tone, now more than half a century ago, her exacting language repeating a phrase that continues to echo today.

1. Gego, "Sabidura 13," in Maria Elena Huizi and Josefina Manrique, eds. *Sabiduras and Other Texts by Gego* (New Haven, Connecticut: Yale University Press, 2005), 131.
2. Rosalind Krauss, "Sculpture in the Expanded Field," in *Passages in Modern Sculpture* (Cambridge, Massachusetts: MIT Press, 1981), 30.
3. Unpublished letter from Nancy Holt to Carl Andre, December 2, 1971; Nancy Holt Estate Records, Archives of American Art, Smithsonian Institution, Washington, D.C.
4. Lucy R. Lippard, "Introduction," in *Twenty-Six Contemporary Women Artists* (Ridgefield, Connecticut: The Aldrich Museum of Contemporary Art, 1971), n.p.
5. David Frankel and Kiki Smith, "In her own words: Interview by David Frankel," in Helaine Posner, ed. *Kiki Smith* (Boston, Massachusetts: Bulfinch Press, 1998), 41.
6. Rebecca Morrill, "Introduction," in *Great Women Artists* (London: Phaidon Press, 2019), 9.
7. Linda Nochlin, "Why Have There Been No Great Women Artists?," *ARTNews*, January 1971, 23–39, 67–9.

Nochlin observes:

> the unstated domination of white male subjectivity is one in a series of intellectual distortions which must be corrected in order to achieve a more adequate and accurate view of historical situations . . . The arts, as in a hundred other areas, are stultifying, oppressive and discouraging to all those, women among them, who did not have the good fortune to be born white, preferably middle class and, above all, male.

To be great is to be exceptional, to be valued above others. Nochlin pricks the bubble of artistic genius, and points to the structures that formulate the notion of art history. She identifies the "very nature of our institutional structures themselves and the view of reality which they impose on the human beings who are part of them" as being at the root of the invisibility of women artists. Institutions form the conditions of production enabling some, not all, to produce sculpture. "Why have there been no great women artists" cannot be uttered in the same way that it was before. Today it is clear why, and it is clear the question is built from conscious bias.

Does one need to call out the condition of womanhood at this moment in sculpture studies? Women sculptors have always been there. If one looks over one's shoulder, not too far back, just a little way, it is clear so much has changed. Art academies are full of women artists; sculpture professors and technicians are no longer solely men. Women sculptors are everywhere. What speaks loudly in the following pages is the strength, relevance, urgency, and variance of the work of these artists and it shows voices that can be amplified within structural invisibility. Sculpture, like any specific subject, builds on discourses that have gone before. This book is an assertion of what is already there: it is a springboard for research, a pointing to the gaps, the fissures, and the possibilities. It is not comprehensive, wonderfully so, as it sets out to answer a different question from the one Nochlin asks, that being "who are the women sculptors?" And it shows very clearly to any person who might claim there *are* no women sculptors, the answer is simple: open your eyes.

MAGDALENA ABAKANOWICZ

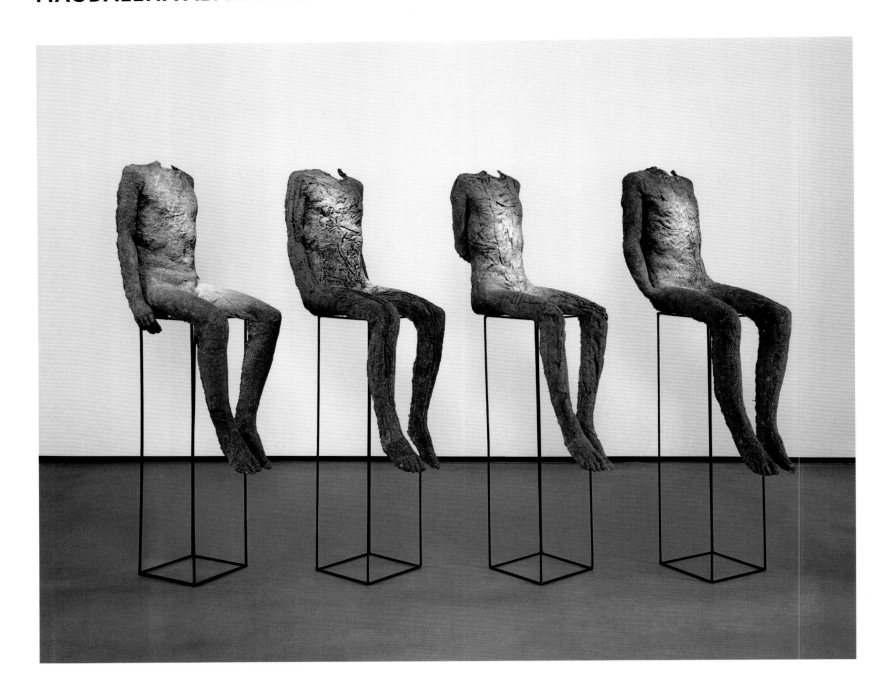

FOUR SEATED from the series **RAGAZZI**
1989–90, burlap and resin on iron frame,
4 figures, each 62 ½ × 15 × 20 ½ in.
(158.8 × 38.1 × 52.1 cm)

Magdalena Abakanowicz, born 1930,
Falenty, Masovian, Poland. Died 2017,
Warsaw, Masovian, Poland.

Aged thirteen, Magdalena Abakanowicz witnessed a Nazi soldier shooting her mother in the arm. The following year, as the Germans advanced into eastern Poland, the family fled their rural home for Warsaw, where Abakanowicz worked in a makeshift hospital for the wounded. Following the end of World War II, she earned a painting degree at Warsaw's Academy of Plastic Arts, where she rejected departmental demarcation to incorporate textiles. In the early 1960s she began weaving monumental, free-hanging sculptures from horsehair, sisal, and flax. Despite international recognition, and developments in the international Fiber Art Movement by artists such as Sheila Hicks (p.141) and Mrinalini Mukherjee (p.222), Abakanowicz resented the persistent association of textiles with domestic craft. She abandoned weaving in the mid-1970s for burlap and cotton, and eventually, bronze, wood, and stone. Unmediated contact with her materials was essential: she crafted the figures in *Four Seated* individually using plaster molds she had made in the 1970s. Evoking her early experiences of decimated bodies, as well as the capacity of crowds to act like a "brainless organism"—as she wrote in the 2002 monograph *Working Process e non solo*—headless or hollow figures occupied Abakanowicz for over twenty years. Using cotton knotted to recall organs and sinews, Abakanowicz wished to confront viewers with her figures' "solitude in multitude."—AC

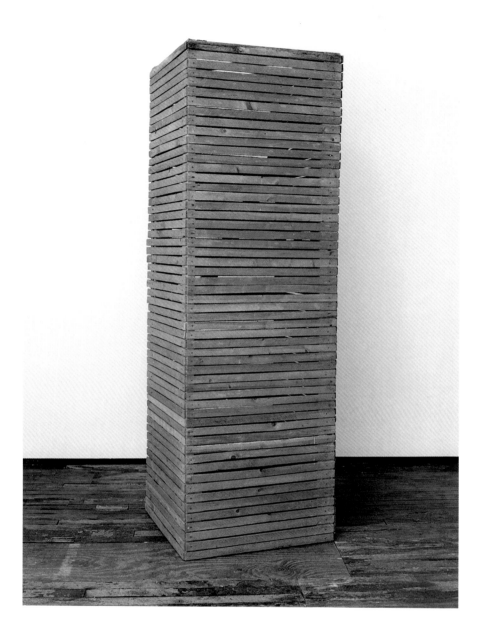

VOLUME
1974, 2×4's framing and wood lath sheathing,
95 × 30 × 30 in. (241.3 × 76.2 × 76.2 cm)

Alice Adams, born 1930, Brooklyn, New York, USA.

While Alice Adams is widely recognized for her site-specific public installations made from the 1980s onward, her preceding studio practice and contributions to "anti-form" abstraction have, until more recently, been largely unaccounted for. Trained as a weaver, Adams first pursued a means of integrating the decorative arts with architecture and, in the mid-1960s, expanded her repertoire of fibers to include industrial products such as metal wire, telephone cabling, and tarred rope, lending her tapestries a sculptural form. Three of these woven works were included in curator Lucy Lippard's *Eccentric Abstraction* (1966), a seminal group exhibition in New York that countered Minimalism's machined-polished abstraction with a tactile sensuality. Exchanging her weaver's warp for chain-link fencing and wooden lath, Adams began producing vertical, wall-like works. Walls, as structures and substrates, proved a lasting preoccupation in her ongoing engagement with the built environment. Her materials, more often salvaged, or sourced from hardware stores and lumberyards, were used for their intended purpose—to build rather than sculpt or shape. The resulting constructions, appearing as architectural artifacts, recall the demolitions and rapid redevelopment that characterized New York's mid-century "urban renewal" ambitions. In *Volume*, the exposed wooden frame and lath suggest unfinished or derelict buildings—unplastered, the interior structure is revealed.—LB

KELLY AKASHI

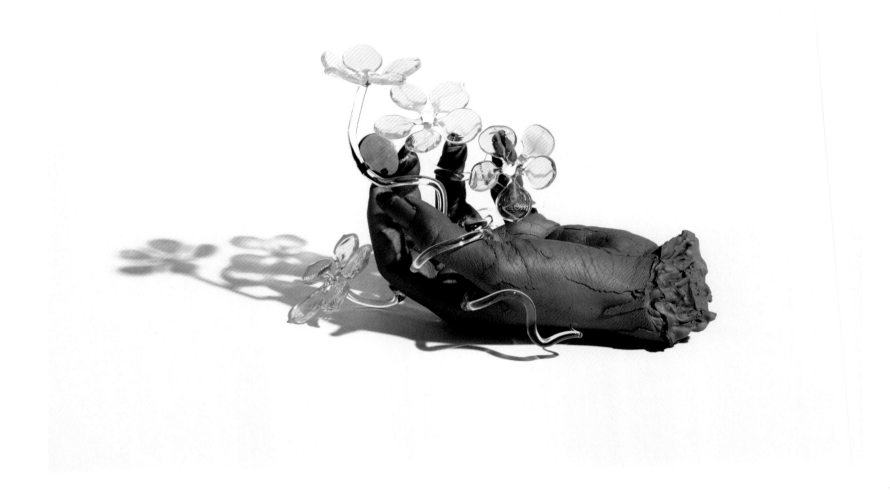

CULTIVATOR (HANAMI)
2021, flame-worked borosilicate glass and lost-wax cast bronze, 9 × 10 × 4 in. (23 × 25.5 × 10.2 cm), Sonya Yu collection

Kelly Akashi, born 1983, Los Angeles, California, USA.

Although working across various disciplines and focusing mostly on sculpture, Kelly Akashi was originally trained in analog photography. Turning away from the medium after graduating in 2006, she discovered similar tactile qualities in the processes of molding and casting. Since then, Akashi has gone on to investigate fossils and geological timelines as part of her artistic explorations. Perhaps this is why themes of permanence and transformation are central to her practice. Implementing glass-blowing, candle-making and metal-casting techniques, and deploying acrylic, mud, rope, and wax, the artist is continually experimenting with new materials. Often the medium's history, inherent materiality, and social context inform her creative output and thus become integral to the narrative of her work. As in many of Akashi's sculptures, the hand in *Cultivator (Hanami)* was cast from the artist's body. *Hanami*, the Japanese tradition of enjoying the ephemeral beauty of cherry blossoms, prompts deeper questions of transience. Akashi makes a point to render her anatomy naturalistically; this might include aging skin or long fingernails, which the artist considers to be a "material that the body produces that offers a measurement of time," as noted in a 2023 interview for Paris+ par Art Basel. Incorporating botanical formations permanently entangling the artist's cast fingers, *Cultivator (Hanami)* invokes an indexical relic of human life, blurring notions of past, present, and future.—JM

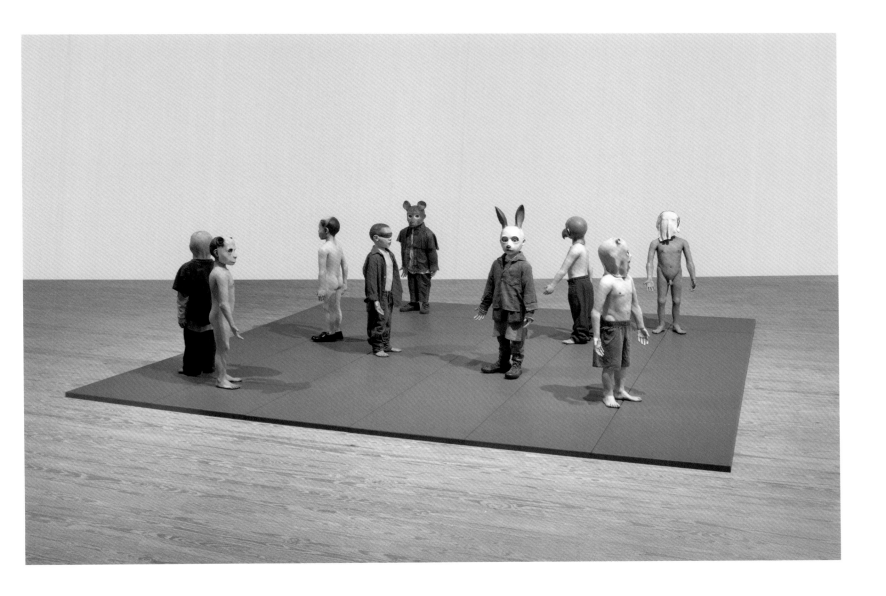

BOM BOYS
1998, fiberglass resin, found clothing, acrylic paint,
synthetic clay, and painted fiberboard squares,
41 ⅜ × 141 ¼ × 141 ¼ in. (105 × 360 × 360 cm)

Jane Alexander, born 1959, Johannesburg, Gauteng,
South Africa.

Jane Alexander's figural installations, tableaus, and photomontages bridged her home country's cultural isolation during the anti-Apartheid struggle with a new era: with the 1994 election of Nelson Mandela, cities like Johannesburg and Cape Town became cultural beacons and sites of migration for the entire African continent. This duality is expressed in her sculptural practice, which is intimate in tone but politically resonant, technically rigorous but socially attuned, outwardly bestial but insistently humane. *Bom Boys*, its separate figures cast in fiberglass resin from a single mold but topped with different masklike visages, is named after graffiti on Cape Town's Long Street. The eponymous "boys" refer to the roving groups of street youths all too common in a country then undergoing a profound transition. Then, as now, Long Street was a place of touristic consumerism and both petty and organized crime, a thoroughfare where this gilded city's contradictions are laid bare. As with so many of Alexander's projects, *Bom Boys* balances whimsy with danger—her delicate constructions embodying an ambivalence that occasionally gives way to melancholy.—IB

SHAIKHA AL MAZROU

RED STACK
2022, fiberglass and resin on polystyrene core over
steel armature, 157 ½ × 120 ⅛ × 90 ½ in.
(400 × 305 × 230 cm)

Shaikha Al Mazrou, born 1988, Dubai, United Arab
Emirates.

Drawing from color theory, geometric abstraction, and Minimalism, Shaikha Al Mazrou's works
are often deceptively simple from afar, but steeped in the study of the physical properties of tension,
space, and weight of her materials in a given environment. She folds, compresses, stretches, and
shapes mass-produced construction and electronic materials into abstract expressions that explore
the interplay between form and content. Confounding the softness and inflated quality of cushions
or helium balloons with the industrial hardness and density of steel and fiberglass, *Red Stack* is
exemplary of Al Mazrou's conceptual yet playful explorations of materials and their contradictory possi-
bilities. Describing her practice to *Gulf News* in 2021, she explained, "I don't like to identify myself
as a sculptor. I'm an artist that works with different mediums that is based on a specific show or concept.
So technically sometimes the concept drives the material." Here, the monochromatic saturated red
palette pops against the lush green settings of outdoor sculpture gardens, inviting the public to be active
participants in experiencing the work up close. In spite of her irreverent approach to traditional concep-
tions of sculpture, Al Mazrou speaks of listening to and obeying the nature of the rigid materials,
especially when at some point they refuse to be further molded and exhausted.—OZ

BRUMA G (THE MIST G), BRUMA D (THE MIST D), AND BRUMA F (THE MIST F)
2013, linen, gesso, and acrylic on wood, each 75 × 35 ½ in. (190 × 90 cm)

Olga de Amaral, born 1932, Bogotá, Colombia.

A preeminent figure of Latin American abstraction, Olga de Amaral studied architectural drafting at the Universidad Colegio Mayor de Cundinamarca in Bogotá, and moved to Michigan in her early twenties, where Finnish American textile designer Marianne Strengell (1909–98) introduced her to fiber art at the Cranbrook Academy of Art. To this day, thread is at the center of Amaral's ethereal creations. Over the course of a career that spans more than six decades, the Bogotá-based artist has crafted large-scale works with fiber covered in glistening gold and silver leaf, drawing on unexpected materials like horsehair and packing plastic, and carefully colored and assembled delicate threads to create hanging sculptures that explore time and space, movement, texture, and light, as seen in her extensive *Bruma* series. The series' environmental title speaks to the shimmering, amorphous quality of the works, produced by the gesso and acrylic paint Amaral has painstakingly added to the linen threads. "Thread is like a pencil," the artist said during an interview with *Vogue* in 2022. "I am amazed by the process of coloring thread. Painting thread is so elemental, and yet without being able to do this, I wouldn't be able to do anything."—SGU

JANINE ANTONI

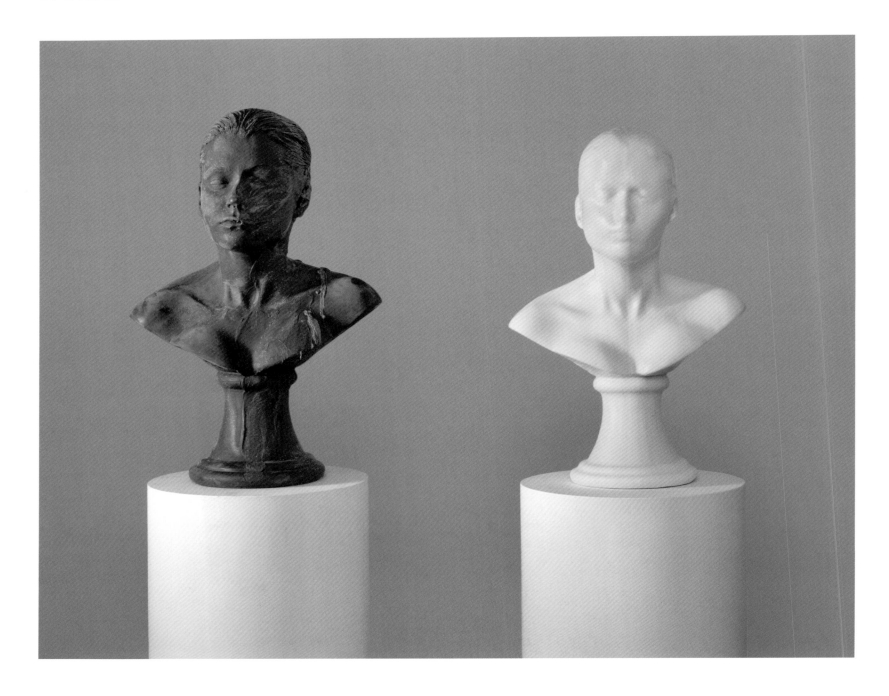

LICK AND LATHER
1993, 1 licked chocolate self-portrait bust and
1 washed soap self-portrait bust on pedestals,
each bust c. 24 × 16 × 13 in. (c. 61 × 40.6 × 33 cm),
each pedestal 45 × 13 in. (114.3 × 33 cm), edition of
7 + 2 AP, San Francisco Museum of Modern Art

Janine Antoni, born 1964, Freeport, Grand Bahama,
The Bahamas.

Janine Antoni has used her own body as a tool to destabilize established art historical narratives throughout her career. In 1993, looking to critique established ideals of beauty inherent in classical sculpture, she cast a series of portrait busts directly from her body in chocolate and soap. She continued to shape these by licking the chocolate and bathing with the soap form, further transforming them through the caring acts of eating and washing. Antoni later reflected on the self-aggrandizing role that figurative sculpture can play. In the San Francisco Museum of Modern Art's audio guide for this work, she mused: "what would [it] mean in this day and time to try and make a self-portrait? . . . I thought of this notion of immortalizing oneself in the sculpture . . . [and pushing] against the grain of that by working with these ephemeral materials." At first glance, the sculptures look to be made from gleaming marble and patinated bronze, belying the everyday materials. Antoni's artworks sit between sculpture and performance with a special emphasis on returning viewers' focus to the making of each piece. Treating the portrait bust as a more intimate, personal object that can be handled and reshaped, Antoni challenges the grandeur of classical sculpture.—CF

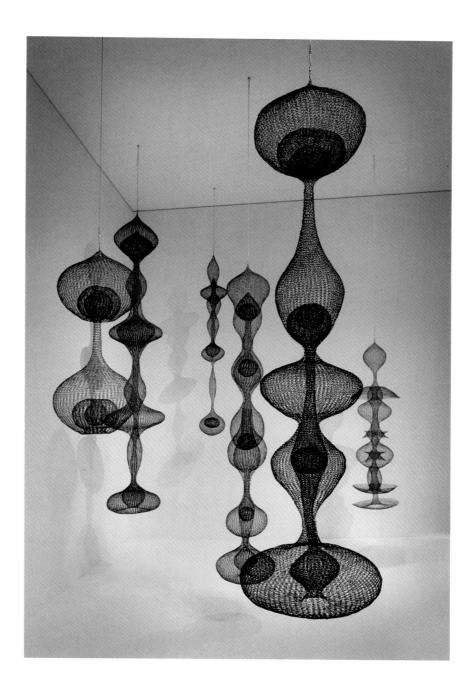

UNTITLED (S.157), **UNTITLED** (S.266),
UNTITLED (S.550), **UNTITLED** (S.065),
UNTITLED (S.283), and **UNTITLED** (S.573)
c. 1958, copper wire; 1961, brass and copper wire;
c. 1958, oxidized copper and brass wire; c. 1960–3,
oxidized copper and brass wire; c. 1953, iron and
brass wire; and 1954, enameled copper and iron wire;
dimensions variable, installation view, *Architecture of
Life*, Berkeley Art Museum and Pacific Film Archive,
California, 2016

Ruth Asawa, born 1926, Norwalk, California, USA.
Died 2013, San Francisco, California, USA.

Ruth Asawa was a formally innovative artist best known for her ethereal, biomorphic hanging sculptures made out of wire, such as the *Untitled* works seen here. Born in rural California, Asawa was the daughter of Japanese immigrant farmers and her early years working on the family farm informed a lifelong interest in nature and organic forms. After the Japanese attack on Pearl Harbor in 1941, Asawa and her family were incarcerated in internment camps in California and Arkansas for sixteen months. Upon her release she sought to become a teacher but, barred from receiving a teaching degree because of her race, she enrolled instead at the experimental Black Mountain College in North Carolina in 1946, where she developed her distinctive aesthetic style and vision. Her wire sculptures were initially inspired by Mexican basket-making practices, which she learned on a trip to Mexico in 1947. Using only the repeated loop of a spool of wire, she quickly moved beyond basket shapes toward work that was increasingly intricate, ultimately suspending her sculptures from the ceiling. Her inventive use of the simple line of wire—what she later called, in a 1981 interview with *Art Education*, "the economy of a line"—opened up radically new possibilities for her to simultaneously create and contain three-dimensional space, creating endlessly variable voluminous forms.—CD

TAUBA AUERBACH

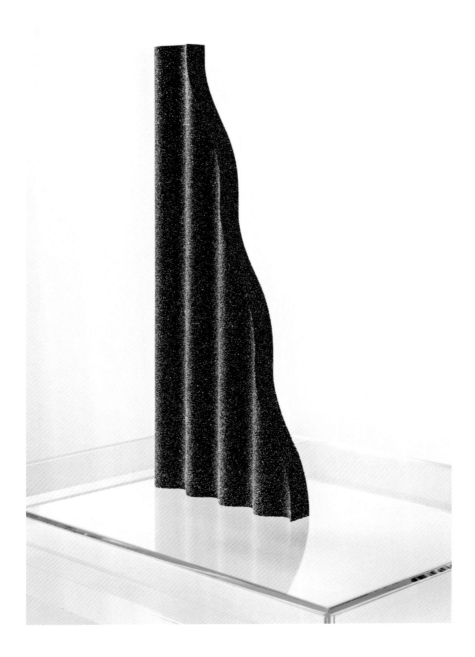

GNOMON/WAVE FULGURITE I.II
2013, sand, garnet, shell, glass, and resin, cast at
Factice, 26 × 11 × 2 in. (66 × 27.9 × 5.1 cm)

Tauba Auerbach, born 1981, San Francisco,
California, USA.

Tauba Auerbach explores ideas from physics, mathematics, and logic through practices that include
painting, drawing, sculpture, and weaving. Challenging the relationship between appearance and reality
is central to Auerbach's work, notably in earlier paintings that generated effects of flatness and three-
dimensionality, as in the series *Fold* (2009–12). The artist is often guided by what sparks their curiosity,
learning how to flamework glass in 2015 after new ideas that called for working with the medium
emerged. Interested in the patterns of connectivity between things and our capacity to perceive and
understand them, Auerbach's recent works include intricate networks of glass particles baked into frit
lace, repurposing the imagery accidentally created when grains of glass fuse to the layers during firing,
as well as woven beaded sculptures that simultaneously appear to be synthetic 3D-printed models
and organic matter. Through their manipulation of such a fragile material, they investigate ideas
about free will—both of the glass itself and of the artist-maker—telling *Flash Art* in 2023, "Glass
is very humbling. It's fussy and can hurt your body and break your heart." Another outcome of their
experimental approach is this wavelike sculpture, which conveys concepts of time and light by refer-
encing a gnomon, the vertical piece of a sundial whose shadow shows the time, and fulgurite, a natural
glass formed when sand is hit by lightning.—EDW

GHAZALEH AVARZAMANI

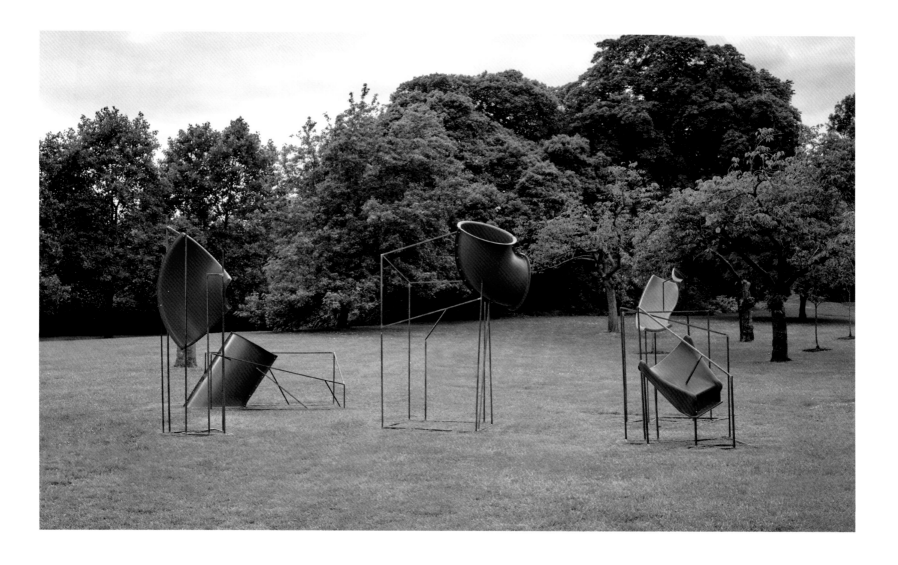

STRANGE TEMPORALITIES
2018, 5 segmented slides on metal armature, 57 ×
38 × 42.5 in. (144 × 96 × 107 cm), 78 × 77 × 41 ×
60 in. (198 × 195 × 104 × 152 cm), 44 × 86 × 25.5 in.
(111 × 218 × 64 cm), 96.5 × 27 × 25 in. (245 × 68 ×
63 cm), 100 × 69 × 41.5 in. (254 × 175 × 105 cm)

Ghazaleh Avarzamani, born 1980, Tehran, Iran.

Ghazaleh Avarzamani creates interactive public sculptures and installations that draw from everyday life to explore dominant power structures at work, analyzing how they are employed to achieve societal control and limit individual freedoms. Born and raised in Tehran until her twenties, Avarzamani lives and works between Toronto, Canada, and Margate, UK. Using play as a central tool, the artist deconstructs hierarchies of power in pieces that probe seemingly accessible, neutral spaces such as public parks and squares, museums, and civic buildings. In previous works, Avarzamani has repurposed rubber playground mulch—generally used as a protective material—to mimic vast, expansive pool-like spaces. She has also built chairlike structures mounted with traditional baskets, inspired by the ancient sport of cockfighting, putting humans in the role of a captive bird to rethink the role of passive spectator and comment on how certain types of conditioning lead to violent conflicts in contexts where peace once prevailed. *Strange Temporalities* is a large sculpture comprising fragmented sections of blue plastic playground slides reassembled and propped up by metal armatures. This sculpture is part of a series by the artist based on existing playgrounds as explorative sites for behavior and socialization. For Avarzamani, sculpture allows limitless possibilities to disrupt, question, transform, and propose new configurations for public space.—JD

ALICE AYCOCK

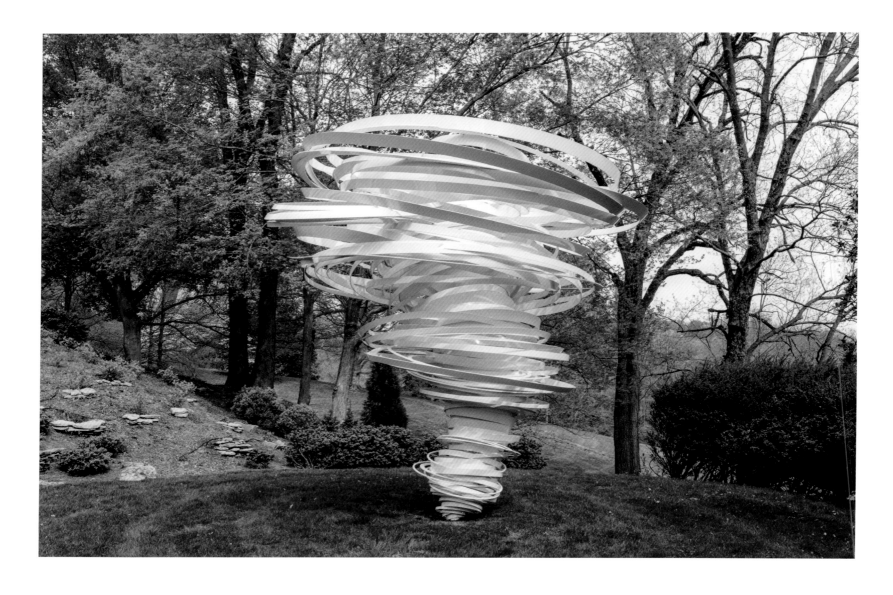

TWISTER AGAIN
2017, aluminum powder-coated white,
180 × 187 × 162 in. (457.2 × 475 × 411.5 cm),
private collection

Alice Aycock, born 1946, Harrisburg,
Pennsylvania, USA.

With a five-decade practice that reflects the larger transition from modernism to postmodernism, Alice Aycock creates architectural sculptures that, although environmentally attuned, deal in the metaphysical. The daughter of a construction engineer, Aycock initially started out making outdoor works, such as *Maze* (1972), but began to fashion speculative sculptures in the 1970s and 1980s. These sometimes sprawling works incorporated science and machine aesthetics, such as fan blades, as well as childhood memories and literary references. Since the 2000s Aycock has focused on translating this magical scientific approach into monumental public sculptures inspired by organic forms and dynamic movement. Recent works often incorporate industrial materials and high-tech fabrication processes: the public commission *Park Avenue Paper Chase* (2014) comprised seven gigantic aluminum and fiberglass structures that seemed to whirl down the Manhattan thoroughfare. Her vortex pieces, such as *Twister Again*, call upon violent forces of nature, harnessing centripetal power to capture "the notion of creativity and where things get stirred up," as Aycock declared in a 2020 video for the Artist Profile Archive. These works are not "the final idea," she continued, but "more like an idea under construction." Postmodern in their limitless approach, Aycock's sculptures have remained as open to interpretation as possible throughout her varied career, enduring as concepts under construction.—ESP

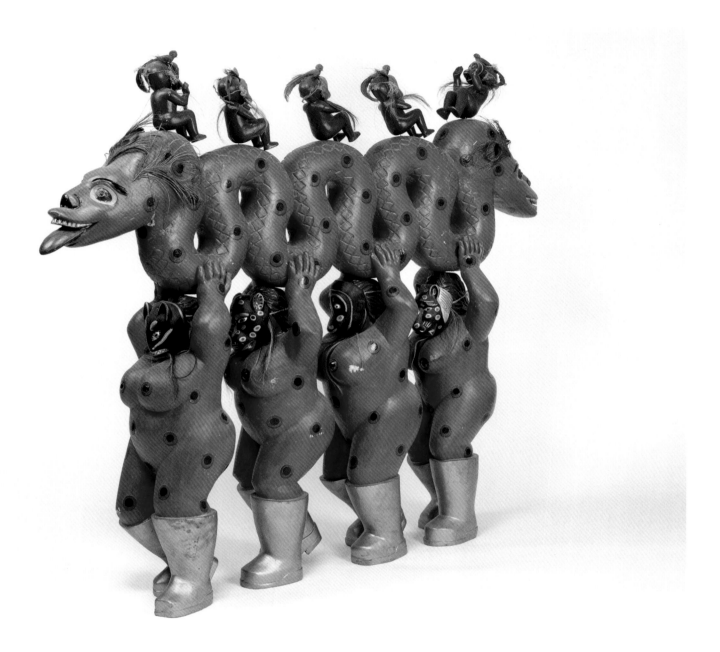

THE COMING OF THE GODDESS from the series
HOMENAJE A GUATEMALA (HOMAGE TO GUATEMALA)
1970–4, wood, feathers, twine, horsehair, and paint,
overall 49 ⅛ × 54 ¼ × 11 in. (124.5 × 137.7 ×
27.9 cm), Smith College Museum of Art,
Northampton, Massachusetts

Margarita Azurdia, born 1931, Antigua,
Sacatepéquez, Guatemala. Died 1998, Guatemala
City, Guatemala.

Margarita Azurdia started out working with painting in the 1960s. Her use of repetition, abstract patterns, and intense colors reflected her interest in the textiles of the Indigenous peoples of Guatemala. Progressively, the artist began experimenting with three-dimensional languages, and created sculptures and performances. Her sculptural production is notable for its figurative character and impactful use of color, as seen in her celebrated series *Homage to Guatemala* (1970–4), comprising fifty wood carvings created by local artists specializing in religious icons following Azurdia's drawings. *The Coming of the Goddess*, and the rest of the works from the series, embody Azurdia's anthropological, sociological, and formal studies of Indigenous art and interest in the cultural and religious diversity of Guatemala. Her use of stylized forms and natural elements like hair, feathers, and wood, as well as recurring themes of dancing and celebration, sit in parallel to many different ancient traditions of Indigenous Guatemala, but also to colonial Catholic sculpture in Latin America. As underscored by the work's title—goddess, not god—Azurdia's practice consistently centers the female body. It also anticipates her deepening interest, in the last decades of her life, in dance, ephemeral collective actions, feminism, and eco-activism.—RF

LEILAH BABIRYE

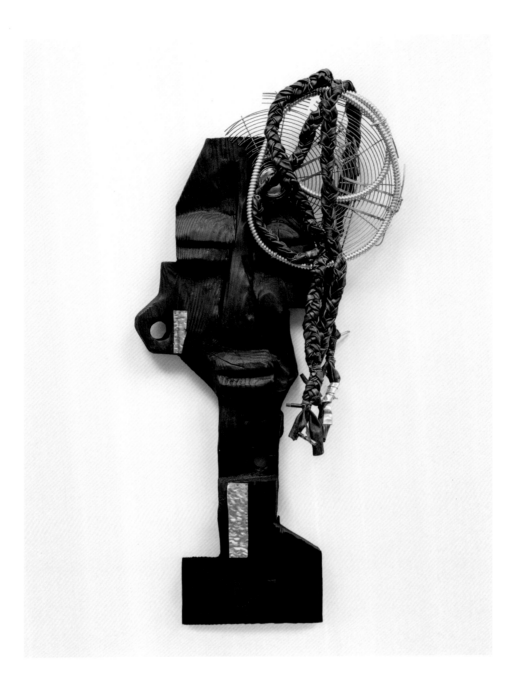

SENGA NANSEERA (KINDHEARTED KUCHU AUNTIE)
2020, wood, wax, aluminum, wire, nails, and found objects, 47 × 22 ⅞ × 3 ⅞ in. (119.4 × 58.4 × 10 cm)

Leilah Babirye, born 1985, Kampala, Uganda.

Intentionally using found and discarded materials in her work, Leilah Babirye reflects on the status of LGBTQ+ individuals in her culture and the Luganda language where Queer people are referred to as *abasiyazi* (sugarcane husk), which connotes garbage or that which is rejected. Babirye fled Uganda in 2015 after the government adopted legal measures commonly referred to as the "kill the gays" bill to oppress her community; she came to the United States initially on a visa, and gained asylum in 2018. By salvaging materials such as metal, aluminum, wood, and bicycle parts, Babirye reclaims pejorative associations to transform waste into monumental figures of grace, respect, and dignity. Using traditional techniques of carving and burnishing wood, she constructs multifaceted characters in a dynamic figurative style that incorporates her heritage while valorizing her community. *Kuchu* is a term of affection used by her Queer community to self-identify. In this sculptural mask, the familial is further emphasized with the title *Kuchu Auntie*, reflective of Babirye's lived experience within an extended code of allegiance and activist engagement, in which the Auntie is often a protective figure. Babirye inscribes meaning on Black subjectivity through figuration, embellishing them with elaborate hair and headdresses. Her powerful sculptures embody a liminal space, between Africa and the Diaspora, beauty and trash, pain and pride.—KM

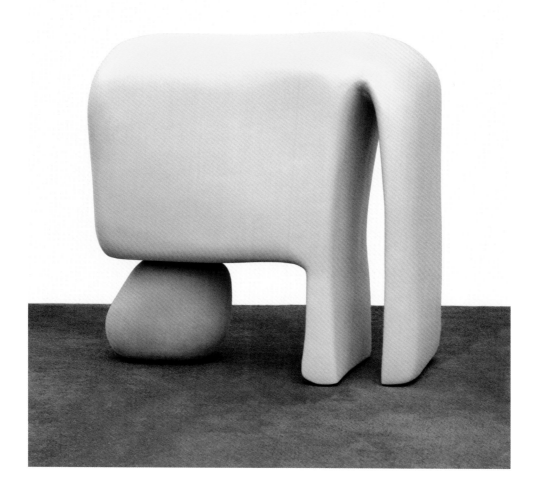

DÖSENDER (DROWSY) from the series
SITZENGEBLIEBENE (STAY DOWNERS)
2020, polyurethane and paint,
46 ⅞ × 43 ¾ × 24 ¼ in. (119 × 111 × 63 cm)

Nairy Baghramian, born 1971, Isfahan, Iran.

Engaging sculptural abstraction as a mode of research, the Iranian-born German artist Nairy Baghramian's inquiries into social, political, and art historical systems find a material form. "To understand something, I need to hold it," she told the *New York Times* in 2023. "Sculpture gave me that opportunity." Buildings and bodies—or rather their interiors—have proved a productive simile in her practice, which is populated by fleshy, bulbous shapes and prosthetic armatures that often sprawl across the architectures they inhabit. The works' confluence of anatomical allusions and industrial design, the organic and machined, cite functional things (an elbow, a doorstop, orthodontic braces) denied their intended purpose: objects rendered defiant and darkly funny in their failure. Organ or obstacle, Baghramian's sculptures propose critical reevaluations of structures—built and ideological—that include and exclude, and the thresholds and boundaries that define them. To this end, the artist's unruly, wayward objects become strategies of institutional critique, sculptural "misfits" on the margins of established convention. Her groupings of *Stay Downers*, to which this work belongs, borrow their title and dejected affect from the German word *Sitzengebliebene*, which describes those schoolchildren held back to repeat a grade. Here, two despondent pastel forms imperfectly meet, their compositional unease an allegory of social misalignment and assumed ineptitude.—LB

NATALIE BALL

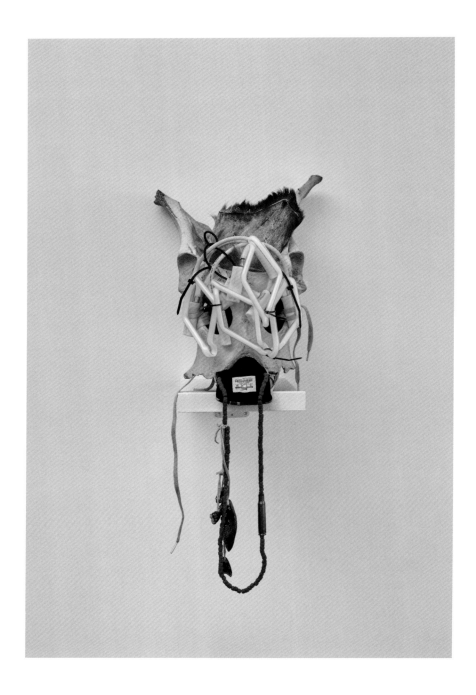

YOU USUALLY BURY THE HEAD IN THE
WOODS. TROPHY HEAD
2021, neon glass, extension cord, cow pelvic bone,
Nike Air Max, deer hooves, beads, bullet shells, and
elk hide, 28 × 12 ⅛ × 14 ⅝ in. (71 × 30.5 × 37 cm)

Natalie Ball, born 1980, Portland, Oregon, USA.

Rooted in her Black, Modoc, and Klamath heritage, Natalie Ball makes enigmatic power objects that challenge conventional notions of Indigeneity. Her formal education reflects her commitment to probing Indigenous narratives in art: after receiving a BA in both art and Indigenous, race, and ethnic studies from the University of Oregon, she continued her studies with an MA focusing on Indigenous contemporary art from Massey University in New Zealand and an MFA from Yale University in Connecticut. She then returned with her children to her ancestral homelands in Southern Oregon, where she now serves as an elected official on the Klamath Tribes Tribal Council. This was part of her ongoing effort to center herself, her family, and her artistic practice within their ancestral legacy, positioning herself as both an inheritor of the past and a future ancestor. Her work is deeply connected to these ideas. In her assemblage sculptures, such as *~~You usually bury the head in the woods~~. Trophy Head*, Ball uses both reference-laden manufactured objects—among them secondhand clothes and shoes, synthetic hair, and bullet casings—and natural materials, including at times hides from animals she has hunted herself. Like language—itself a source of influence, course of study, and material in Ball's practice—her works carry messages that fully reveal themselves only to those fluent in their vocabulary.—CD

32

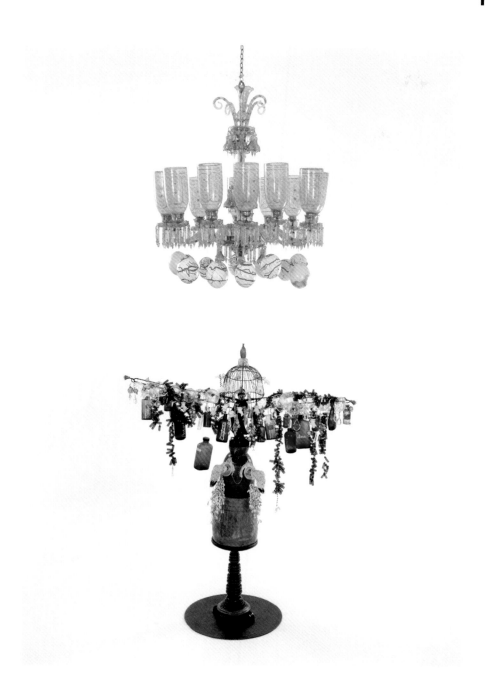

LADY OF COMMERCE
2012–23, hand-painted, leaded glass chandelier, wood figurine, vintage glass bottles, chandelier ornaments, birdcage, steel, wood pedestal, lace, cowry shells, taxidermy deer paws, Indian marriage jewelry, ostrich eggshells, porcelain doll hands, silver and gold leaf, wire, linen cord, and marble baby doll hands, 120 × 48 × 48 in. (304.8 × 121.9 × 121.9 cm)

Rina Banerjee, born 1963, Kolkata, West Bengal, India.

After living in Kolkata, London, Manchester, and, most recently, New York, Rina Banerjee uses her practice to explore her experiences of migration and cultural plurality. As part of the Indian Diaspora, her work often looks back on colonial history. In particular, she examines the political and economic exchanges that imperialism enabled, and how these relate to existing inequities both globally and locally. For her sculptures, Banerjee chooses items drawn from an array of cultures as both a celebration of human diversity and a reflection of the way commodity networks have proliferated to the extent that most goods are accessible in a globalized world. Natural and mass-produced objects from disparate places, including shells, dolls, painted ostrich eggs, and Indian marriage jewelry, form the sculpture *Lady of Commerce*. Glass trinket bottles labeled with the names of geographical locations—Portugal, Asia, America—are tangled around wire creating the figure's outstretched arms. Breasts are suggested by a pair of taxidermy deer hooves and the eclectic feminine form stands beneath a vivid yellow chandelier. The tchotchkes and natural materials aggregate into a form that imitates human body language. In this mutant figure of material abundance, where objects signifying different value systems converge, Banerjee highlights how consumption risks turning life into a mere commodity.—CRK

FIONA BANNER AKA THE VANITY PRESS

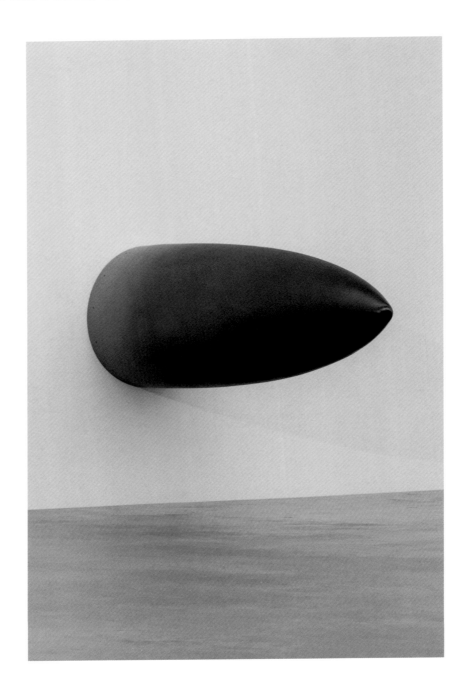

POKER FACE
2017, Jaguar drop tank nose cone and graphite,
67 × 26 ⅜ in. (170 × 67 cm)

Fiona Banner, born 1966, Merseyside, England, UK.

After graduating from Goldsmiths College, London in 1993, Fiona Banner came to prominence for her "wordscapes": publications and wall-based works in which visual sources including Vietnam war films are described in minute detail. She works under the moniker of her publishing company and, in 2009, registered herself as an ISBN (the unique code allocated to books when published). This speaks to her desire, detailed in an October 2011 interview with *Sculpture* magazine, to explore the limits and physicality of language because "words are extensions of our physical selves." Her first sculptural work was a series of *Full Stops*—enlarged punctuation marks carved initially out of polystyrene. Like these, the metal cone in *Poker Face* is divorced from its intended purpose. The drop tank served as an auxiliary fuel carrier for the Anglo-French Jaguar jet, which featured prominently in the 1990–1 Gulf War. There, its twin engines earned it the nickname of a comic book character—"Buster Gonad, unfeasibly large testicles." Banner's cone protrudes phallically from the wall, its exterior colored by an even layer of graphite. Airplanes recur in her two-dimensional, sculptural, and performance work as symbols of power structures and techniques of aggrandizement, often rendered absurd through playful recontextualization.—AC

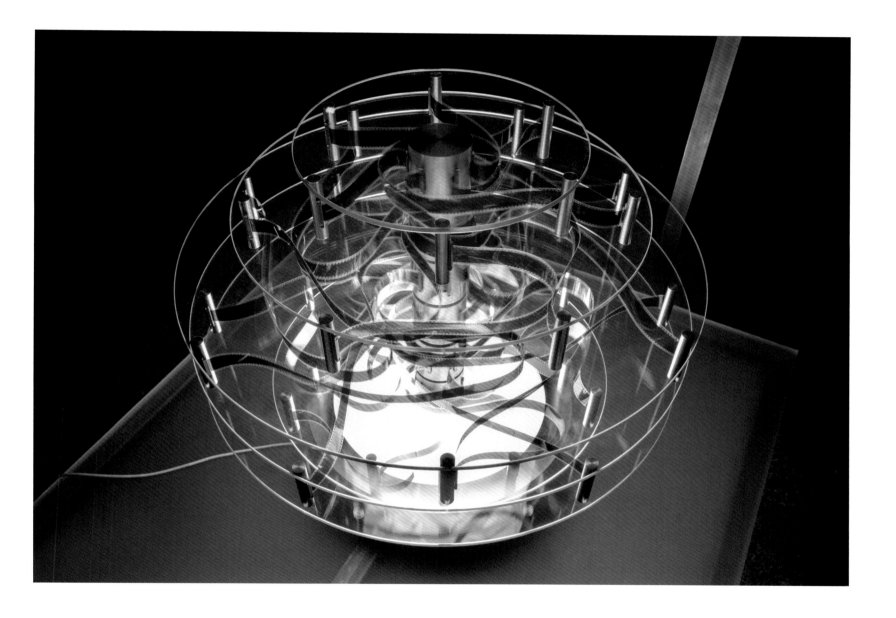

OFF SPLINTERED TIME
2021, glass, motors, 35mm film, and LED light,
27 ½ × 31 ½ × 31 ½ in. (70 × 80 × 80 cm),
installation view, *Rosa Barba: In a Perpetual Now*,
Neue Nationalgalerie, Berlin, 2021–2

Rosa Barba, born 1972, Agrigento, Sicily, Italy.

As a student in Cologne, Germany, in the late 1990s Rosa Barba worked for several years as a projectionist in a movie theater. The experience, on top of her earlier studies in film and theater, gave her a sense of the tactility of film reels as three-dimensional material, piquing her interest in sculpture. Over her career to date, Barba has developed a multifaceted body of work that deals with the performative and sculptural aspects of filmmaking, while investigating other elements including architecture, temporal experience, audience participation, and the limits and potentials of her chosen mediums. In a 2019 interview with *Border Crossings*, she explained, "I am interested in finding the boundaries and connections and intersections between things . . . I find where these forms come together and then I try to open up the in-between spaces." Presented as part of *Rosa Barba: In a Perpetual Now*, the inaugural exhibition celebrating the 2021 reopening of the Neue Nationalgalerie in Berlin, *Off Splintered Time* exemplifies this philosophy. Six glass disks are piled up in a diamond form and illuminated by a light source. Their constant rotating motion activates a strip of red 35mm celluloid film, which gets either tighter or looser depending on the direction of the spin, creating a dazzling kaleidoscope of light and color in the surrounding environment.—MR

PHYLLIDA BARLOW

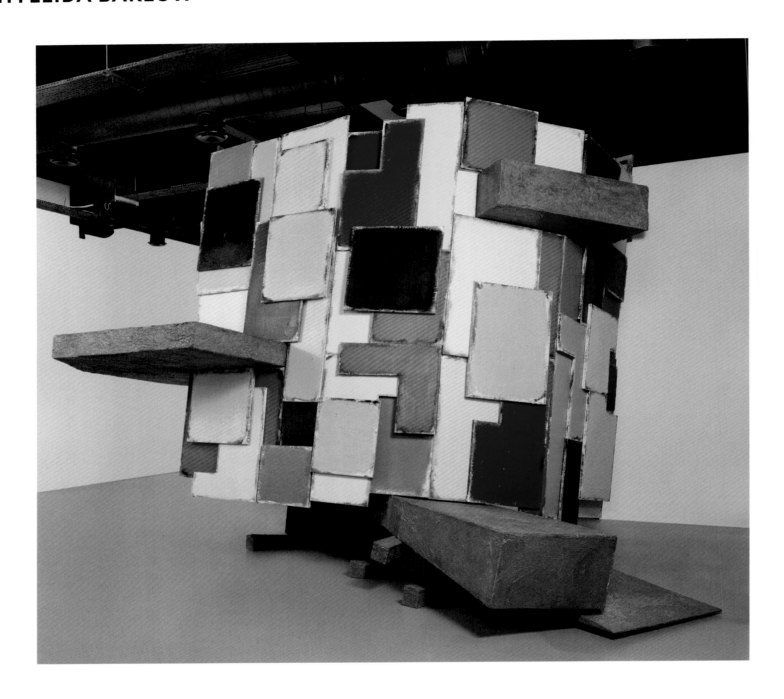

UNTITLED: UPTURNEDHOUSE2, 2012
2012, timber, plywood, cement, polyfoam board, polyurethane foam, Polyfilla, paint, varnish, steel, sand, and PVA, 196 ⅞ × 187 × 127 in. (500 × 475 × 322.5 cm), installation view, *Twin Town*, Korean Cultural Centre UK, London, 2012, collection Tate, London

Phyllida Barlow, born 1944, Newcastle upon Tyne, Tyne and Wear, UK. Died 2023, London, UK.

Phyllida Barlow left an enduring legacy that has redefined how sculpture is created and experienced, establishing a career as both a celebrated artist and respected teacher. In the 1960s she studied at both Chelsea College of Arts and Slade School of Fine Art in London under the mentorship of artists such as Elisabeth Frink (p.108). Barlow reinvented the Conceptual and Minimalist currents of the era by incorporating raw, ordinary, and often discarded materials such as plaster and cardboard. Her practice was rooted in a profound curiosity in her surroundings and how they are transformed by everyday life. The range of colors she used in her practice—from hot earth hues to bright greens—evokes street signs and the markings on construction sites. Rough edges and complex, sometimes disorienting assemblages reveal the processes of a sculpture's construction while also suggesting imminent collapse. *untitled: upturnedhouse2, 2012* is paradigmatic of Barlow's interest in creating both uneasy and playful relationships between viewer, sculpture, and space, and testing the limits of our perception of volume, scale, and mass. Disorienting to walk around, the work exemplifies what she described in a 2018 video for Hauser & Wirth as her "obsession with always trying to find an off-balance posture."—YN

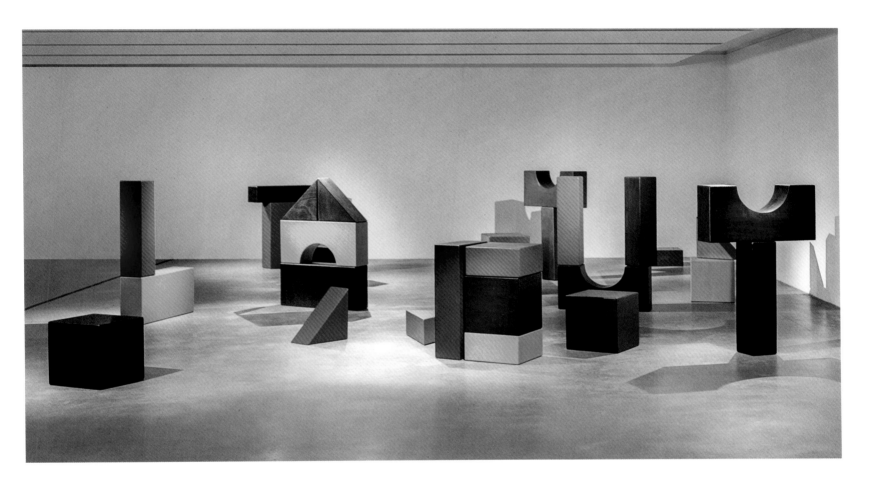

LYAUTEY UNIT BLOCKS (PLAY)
2010, wood and paint, dimensions variable,
Metropolitan Museum of Art, New York

Yto Barrada, born 1971, Paris, France.

In a 2018 interview with *Elephant* magazine, Yto Barrada noted, "I'm interested in building on the history of a place, a moment, a movement. The more I learn about something, the more meaning I find." Raised in Morocco, Barrada's practice complicates the myths and stereotypes French colonial rule helped to generate about the place and its citizens. Working across film, photography, sculpture, and installations, the artist's clean forms and sharp metaphors unearth subaltern stories. The 2017 work *Thérèse Unit Blocks* refers to the French ethnologist Thérèse Rivière, whose fieldwork in Algeria during the 1930s is an invaluable record of North African life under colonial power. Receiving no recognition during her lifetime, Rivière's achievements are memorialized in Barrada's geometric forms. *Lyautey Unit Blocks (Play)* spells out the last name of Louis-Hubert-Gonzalve Lyautey—who appears in Barrada's poster series *A Modest Proposal* (2010–13)—the Resident General of French-occupied Morocco from 1912 until 1925. During this period, Lyautey and the French architect Henri Prost redesigned Rabat, Casablanca, and Fez; however, despite sweeping surveys into local architectural practices, the new construction was reductive and oversimplified. Engaging with Barrada's interest in the histories of education and modern architecture—and formally similar to *Thérèse Unit Blocks*—her oversized playset cheekily critiques Lyautey's actions as naive and childlike while illuminating their darkly destructive edge.—MH

MÁRIA BARTUSZOVÁ

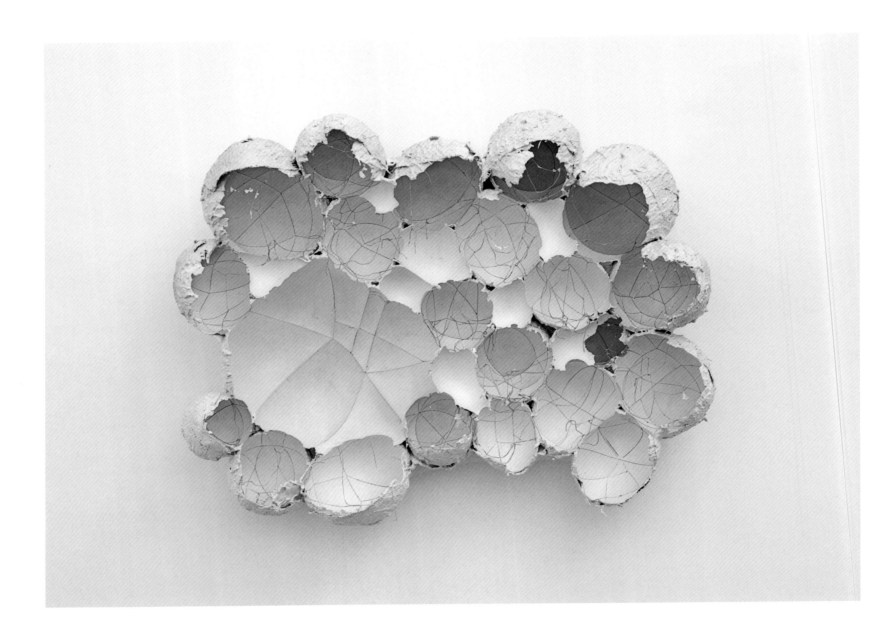

UNTITLED
1985, plaster and string, 41 ⅜ × 52 ¾ × 15 ⅜ in.
(105 × 134 × 39 cm), Tate, London

Mária Bartuszová, born 1936, Prague, Czech
Republic. Died 1996, Košice, Slovakia.

Working as a member of the Artists' Union in socialist Czechoslovakia, Mária Bartuszová began
experimenting with plaster in the early 1960s. Using the material's natural weight, she filled balloons
and condoms, submerging these objects in water before binding, knotting, and pushing at their shapes
to create her abstract, organic sculptures. The tactility of the process, and its resulting forms, led
Bartuszová to make "assembly kits" for blind and partially sighted children. Designed to be touched,
held, and manipulated, the objects emphasize the smooth, inviting surfaces typical of her sculpture.
Enchanted by the natural world, Bartuszová drew inspiration equally from Eastern religions and the
biomorphic works of Constantin Brancusi (1876–1957) and Isamu Noguchi (1904–88). Her practice
shifted in the 1980s when she began pouring plaster over the exterior of inflated balloons until the
pressure forced them to burst, a technique she termed "pneumatic shaping." These ovoid shapes
could be stacked one atop the other or arranged alongside each other to form a wall relief. Thin and
exceedingly fragile, the interlocking, hollow spheres laced with twine came to symbolize Bartuszová's
fascination with relationships and interpersonal connections, as well as her lifelong belief in human
beings' need for one another.—MH

NO. 1048 MESH
2020, powder-coated galvanized mesh,
153 ½ × 232 ¼ × 110 ¼ in.
(390 × 590 × 280 cm)

Rana Begum, born 1977, Sylhet, Bangladesh.

Working across sculpture, installation, and painting, Rana Begum has committed herself to experiments with light, color blocking, and form. She deploys a restrained, minimal aesthetic and numeric titles to maintain her focus on these elements, drawing on influences as diverse as Russian Constructivism, Islamic geometry, and the work of American Minimalist painter Agnes Martin (1912–2004). Begum's process is methodical: she keenly observes how light interacts with and shapes our environment, using her studies to inform sculptural installations, often using industrial materials like aluminum bars, designed to subtly morph with changes in illumination. In a 2021 interview with *Elle India*, Begum described the way light lends "a sense of transience and movement" to her pieces. *No. 1048 Mesh* is demonstrative of this effect. Sheets of metal mesh—a material long used by Begum—are transformed into clouds of color that, suspended in a cluster, appear ethereal as light filters through them. Designed to be walked around and looked through, the work appears both firm and airy, encouraging close inspection of its detail and depths where colors within colors emerge and seemingly vibrate.—CRK

NINA BEIER

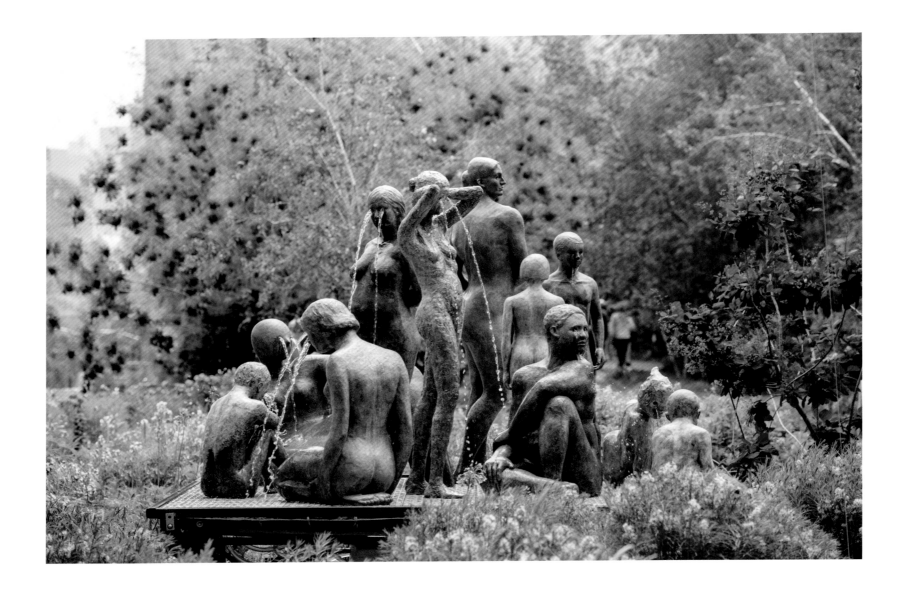

WOMEN & CHILDREN
2022, found bronze sculptures, dimensions variable,
installation view, The High Line, New York, 2022–3

Nina Beier, born 1975, Aarhus, East Jutland,
Denmark.

Theatrical tableaus and still lifes in Nina Beier's mixed-media sculptures investigate the power structures and hierarchies implicit within the fabric of society. Her works challenge long-accepted binaries such as masculine/feminine, interior/exterior, and authentic/artificial. Beier responds to a particular conflict, searching for objects that she has collected or behaviors that physically and historically convey her message or disrupt the narrative. *Women & Children* is a fountain with an unlikely ensemble of characters—bronze nude figures realized in a mélange of patinas and styles from antiquity to contemporary as if randomly plucked out of the annals of art history. A collection of found sculptures, they reference sources from the fourteenth-century Fountain of Vision at the Bom Jesus do Monte sanctuary in Portugal to pop-culture icons and present-day crying emojis. The title refers to the Victorian-era maritime code of conduct in which women and children were prioritized in rescue missions as they were presumed to be the weakest and the most helpless. The tears from their eyes that form the streams of water offer a caricature of the way women and children have been represented throughout history as dramatic, fragile, and vulnerable. Beier thus wryly offers a pointed critique of gendered tropes and preconceptions embedded in our social institutions.—OZ

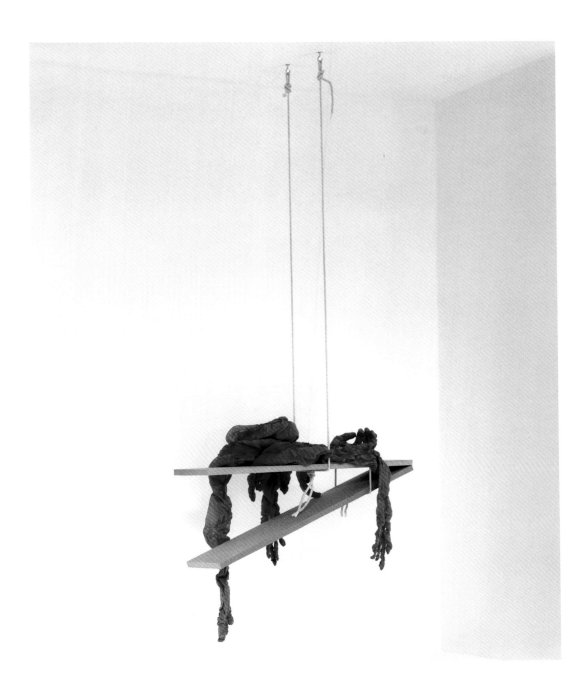

MUDA 2 (MOULT 2)
2019, ceramics, MDF, cotton rope, and fabric,
height variable × 31 ½ × 11 ⅞ in.
(height variable × 80 × 30 cm)

Patricia Belli, born 1964, Managua, Nicaragua.

Patricia Belli is renowned for her experimental use of craft and nontraditional materials, which, in her sculptures, are explored through different scales and presentations: hoisted up to the ceiling, spread out on the floor, or leaning against a wall or other architectural feature. For Belli, activating even the most banal places can create an atmosphere of mystery and tension. Having completed her artistic training between the United States and Nicaragua during the 1980s and 1990s, Belli's practice can be seen in relation to the different narratives of violence that hit Central America in the second half of the twentieth century. However, far from being configured as a mere illustration of violence, her works, many of them incorporating soft materials laid or stretched over hard surfaces, draw attention to the economy of their visual elements and their apparent fragility; it is as if, at any sudden movement from the audience, they could disassemble and transform into something else. *Moult 2*, for instance, is suspended from the ceiling and appears as a limp sack of skin, emptied of presence with shriveled fingers dangling, perhaps reaching or waiting for another state of existence. As indicated in the work's title, Belli's research seems to embrace a transitional state of being in "molt"—shedding parts on one side to then leave space for others.—RF

LYNDA BENGLIS

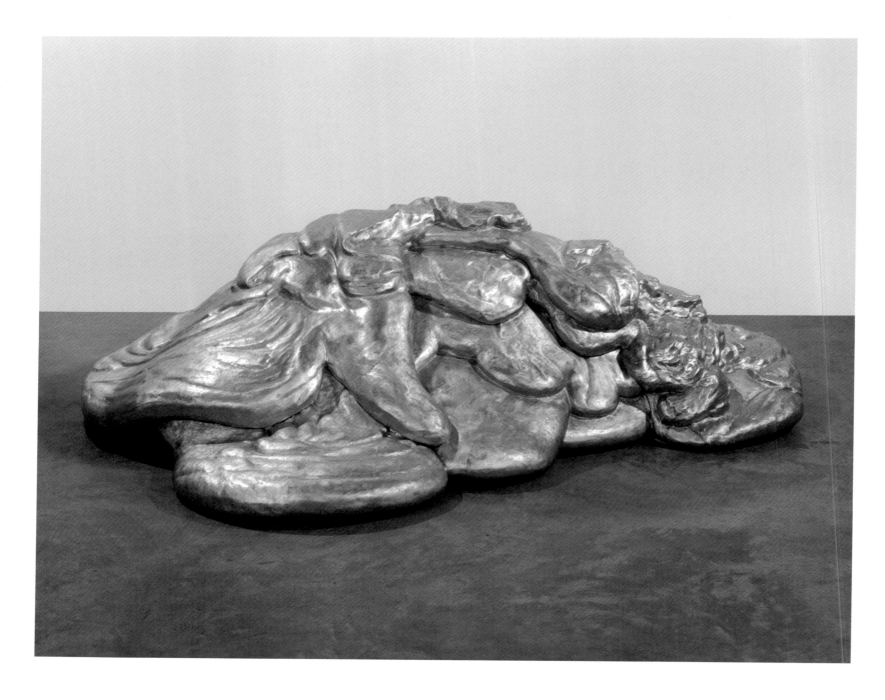

EAT MEAT
1969/75, aluminum, 24 × 80 × 54 in. (61 × 203.2 × 137.2 cm)

Lynda Benglis, born 1941, Lake Charles, Louisiana, USA.

A chameleonic artist whose sculptures transcend movements and media—from Minimalism to Process art, rubber to textiles—Lynda Benglis creates works that can be connected across her sixty-year career through their attention to matter and active making. She pours, molds, knots, or otherwise transforms an arsenal of often industrial materials to arrest them in fluid motion, what she calls a "frozen gesture." In the late 1960s her works of colorfully pigmented latex poured directly onto the floor blurred the distinction between painting and sculpture as well as process and form. She also experimented with polyurethane foam, building up sludgelike bulges that were then shaped by gravity and cast in bronze or metal, as in *Eat Meat*. Through her innovative use of both commercial materials as well as those tied to classical sculpture, and by bringing her works to the ground, Benglis played with the traditional tropes of the sculptural object. Although her practice is not only sculptural—spanning video, fabric knots, and fountains—Benglis's early poured forms demonstrate her consistent interrogation of the materiality of what she manipulates. As she told the art historian Judith Tannenbaum in 2009, "I've been interested in the contradiction of the real of metal or the real of plastic, and . . . what is synthesized, what is veneer, and what is not."—OC

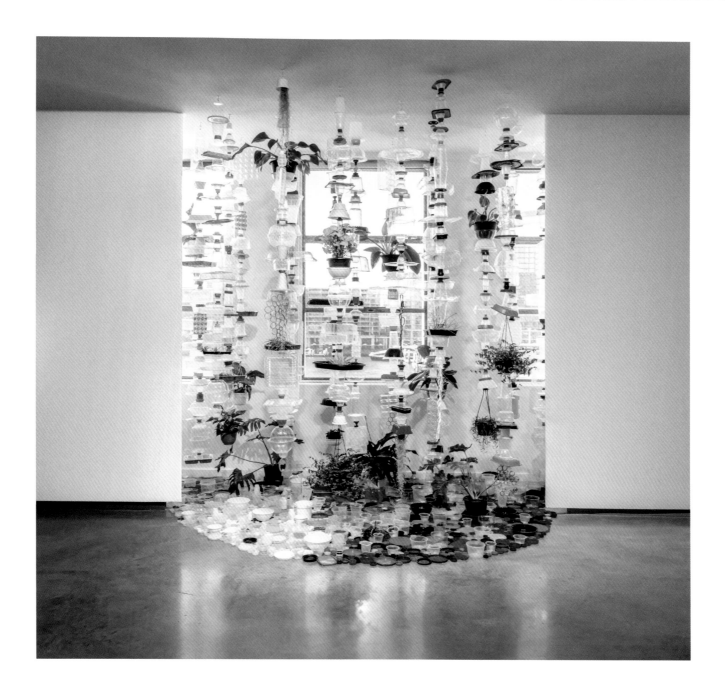

PLASTIC TOPOGRAPHIES
2020–1, plastic bottle tops, lids, containers, and plants, 157 ½ × 122 × 94 ½ in. (400 × 310 × 240 cm), installation view, *The National 2021: New Australian Art*, Museum of Contemporary Art Australia, Sydney

Lauren Berkowitz, born 1965, Melbourne, Victoria, Australia.

Over her thirty-year career, Installation artist Lauren Berkowitz has sourced and transformed refuse that, in this age of overproduction, increasingly defines our lives. Like Mikala Dwyer (p.85), Sarah Sze (p.292), and other artists who repurpose found objects, Berkowitz discerns value in the discarded and creates sculptures that realize the evocative potential of junk. Other references to Minimalism and Color Field painting are underscored by Berkowitz's assertion in a 2021 video interview for the Museum of Contemporary Art Australia that "the work is quite painterly." In recent years, Berkowitz has expanded her visual idiom to incorporate living plants, drawing together natural and artificial worlds in artworks that foreground inherent tensions. Against the backdrop of growing climate crises, sculptures like this suggest the fragile balance we must strike if we are to sustain our ecosystems. Berkowitz made *Plastic Topographies*, seen here in its third iteration at the Museum of Contemporary Art Australia, with materials collected by staff at the MCA along with her family and friends. Installed to catch sunlight, plants take root in salvaged plastic vessels, illuminating what Berkowitz described in the same interview as "the Jewish concept of Tikkun Olam, which is about small gestures, actions, and deeds which people can do to repair and rehabilitate the damage to our world."—SL

SARAH BERNHARDT

SELF-PORTRAIT AS A CHIMERA
c. 1880, bronze, 12 ½ × 13 ¾ × 12 ½ in.
(31.8 × 34.9 × 31.8 cm), Art Institute of Chicago

Sarah Bernhardt, born 1844, Paris, France. Died
1923, Paris.

Described as the first international superstar, Sarah Bernhardt became a mainstay in the avant-garde world of nineteenth-century Parisian art and theater. An actress, fashion icon, and artist's model, Bernhardt began training as a sculptor in 1869, exhibiting her work for the first time at the Paris Salon of 1874. She likely sculpted this inkwell self-portrait around 1880 when rehearsing to play the part of Blanche de Chelles in Octave Feuillet's play *Le Sphinx* (1874). The mythological part-woman, part-beast chimera and sphinx were symbols of the seductive femme fatale who lured men to their downfall. Using the sensuous, curvilinear forms of Art Nouveau, Bernhardt's piece challenges this male fascination with the threatening, animalistic female figure: her chimera does not depict a hypersexualized woman, but rather reveals the artist's interests and versatility. The bat wings and devil's head suggest her artistic response to fin-de-siècle Symbolism and her own preoccupation with the occult. The masks of tragedy and comedy on her epaulets indicate her profession as a stage performer. Aware of the aura of celebrity and enigma around her, Bernhardt reclaimed the image of the chimera as a form of self-promotion, presenting to the world a portrait of how she sought to be perceived.—OZ

RECEIVER
2019, bronze, 98 ¾ × 18 × 25 in.
(250.8 × 45.7 × 63.5 cm)

Huma Bhabha, born 1962, Karachi, Sindh, Pakistan.

The makeshift buildings and construction sites of Karachi's desert landscape remain an enduring influence on Huma Bhabha's work. Bhabha's mother was a painter who encouraged her daughter's interest in art. Aged nine, Bhabha visited Athens, where she was struck by the city's archaeological ruins and monumental sculpture. With its upright body, one monstrous foot striding just ahead of the other, *Receiver* recalls archaic Greek *kouroi*, as well as Gandhāran Buddhist sculpture from present-day northern Pakistan and Afghanistan. *Receiver*'s cast bronze replicates the roughly hewn textures of the inexpensive materials—cork and Styrofoam—that Bhabha's assemblages are often made from. Avoiding narrative interpretation, her hybrid figures draw as readily from Arte Povera, Cubism, and African art as they do from science fiction and horror films. In a November 2010 *Art in America* interview, Bhabha noted that there is "no hierarchy" to her looking, which seeks only to solve the figurative problem at hand. Evoking ruined civilizations as much as dystopian futures, *Receiver* might be read as totem, alien, protector, or victim.—AC

ALEXANDRA BIRCKEN

APRILIA
2013, motorcycle and metal stand, 2 parts,
52 × 47 ½ × 24 ¾ in. (132 × 120.5 × 63 cm) and
44 ⅞ × 42 ⅞ × 24 ¾ in. (114 × 109 × 63 cm),
Philipp and Christina Schmitz-Morkramer
collection, Hamburg

Alexandra Bircken, born 1967, Cologne,
North Rhine-Westphalia, Germany.

Before embarking on her artistic career, Alexandra Bircken studied fashion design at Central Saint Martins in London. Upon graduating in 1995, she cofounded a label in London, and later opened a shop for accessories and other objects in Cologne. This background has deeply informed her art-making, which evinces a fascination with the human body and the way it interfaces with the world. Bircken creates sculptural assemblages from a repertoire of materials, including textiles that are commonly used for clothing: her earliest sculpture, *Berge* (*Mountains*, 2003), consists of a two-peaked mass crafted from green knitted yarn. Other times the relationship to bodies is more abstract, as in Bircken's work with motorcycles, which she sees as a kind of extension of the human form: a prosthesis that allows us to move at maximum speed. Cutting a motorcycle in half, as in *Aprilia*, is like a surgical act—exposing the innards that are usually encased in a skin of steel. In the press release for a 2014 exhibition of her work at the Museum Boijmans Van Beuningen, Rotterdam, Bircken stated, "When you cut something into pieces and put it back together again there's always a scar . . . I want to expose the inside of something, shed light on something that nobody has ever seen."—GS

HERMIT CRAB
2018, steel cement mixer, fabric, and rubber,
52 × 50 × 38 in. (132.1 × 127 × 96.5 cm), Andrew
Black collection, Los Angeles

Cosima von Bonin, born 1962, Mombasa, Kenya.

An artist who began her career in the early 1990s in Cologne, Germany, Cosima von Bonin's practice is characterized by mixing different materials such as textiles, fabrics, plush, glass, and mass-produced objects to create paintings, installations, and sculptures. Her assemblages juxtapose references from art history, pop culture, fashion, and design, aiming to transgress the bourgeois conventions of art and its respective taste. Initially, the artist turned to the collective practices that marked Cologne's cultural scene in the early 1990s, working in collaboration with other artists, musicians, and theorists. Her work is populated by her signature imagery of sea creatures in huge stuffed plush that provoke laughter and a sense of strangeness in the viewer. When asked in a 2018 interview for *The Brooklyn Rail* about her aquatic forms, the artist responded, "I grew up in Kenya by the Indian Ocean. There are decorator crabs and sea stars there. My best friends were two killer mussels. I loved it there . . ." By placing these marine figures in absurd situations, with irony and dark humor, her sculptures allude to the uncontrolled consumerism of contemporary society and its destructive character. In *Hermit Crab*, for instance, the purple crustacean's massive claws hang at the same time relaxed and lifeless from an orange cement mixer that it has made its home.—TP

MONICA BONVICINI

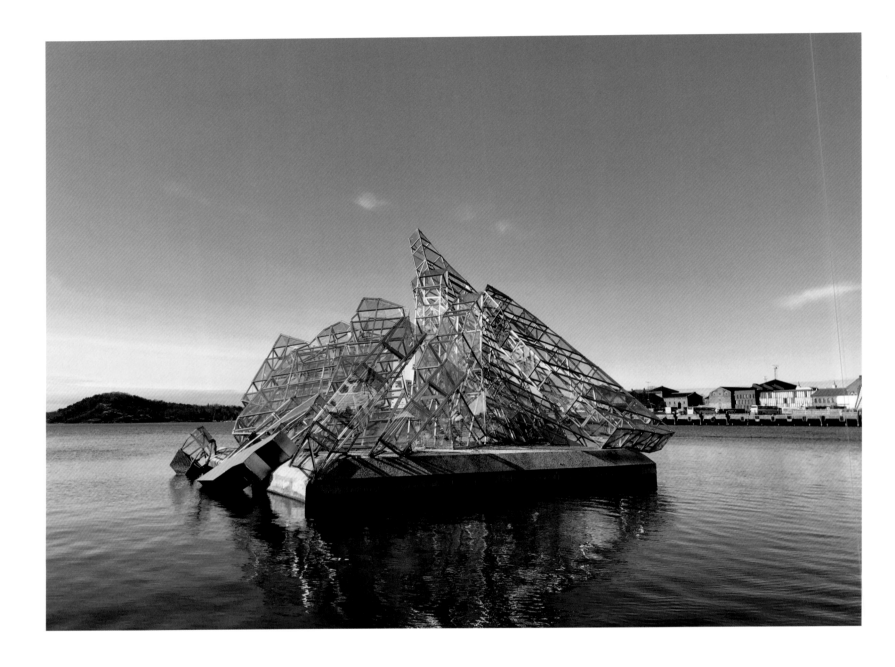

SHE LIES
2010, Styrofoam, concrete pontoon, stainless steel,
reflecting glass panels, glass splinters, and anchoring
system, dimensions above sea level,
55 ¾ × 52 ½ × 39 ⅜ ft. (17 × 16 × 12 m), Oslo

Monica Bonvicini, born 1965, Venice, Veneto, Italy.

Monica Bonvicini is best known for installations and sculptures that respond to the politics of their built environment, often demanding an active and psychological engagement from the viewer. With provocation and irony, the artist transforms everyday objects and phrases into works that challenge conventional constructs of gender and power. The ambiguity of language takes center stage in Bonvicini's art, in which titles destabilize and expand the possibilities of meaning. Drawing from historical, political, and social references, Bonvicini's interdisciplinary practice evokes familiar and foreign emotions alike. *She Lies*, a permanent architectonic structure located on the waterfront at Bjørvika in Oslo, Norway, rotates in accordance with the sea's tidal movements. Based on the renowned Romantic painting by Caspar David Friedrich (1774–1840), *The Sea of Ice* (1823–4), the work resembles a collapsing iceberg and evokes the majestic splendor of the Arctic. As the artist stated when the work was unveiled in 2010, *She Lies* represents a "monument to a state of permanent change," and establishes a new relationship between culture and ecology, all the while reminding us of Mother Nature's fickle predicament. Imagining the consequences of global warming, Bonvicini appends a new perspective to the ever-changing dialogue around the politics of our environment.—JM

IT'S SO HARD TO BE GREEN
2000, rubber tires and wood, 150 × 252 × 24 in.
(381 × 640.1 × 61 cm), installation view, *Chakaia
Booker: In and Out*, deCordova Sculpture Park and
Museum, Lincoln, Massachusetts, 2010

Chakaia Booker, born 1953, Newark,
New Jersey, USA.

With a background in sociology, Chakaia Booker completed her MFA at the City College of New York in 1993, although she has been a key figure in the East Village art scene since the 1980s. Taught to sew by her grandmother, Booker's hands-on approach to manipulating materials is fundamental to her sculptural practice, the earliest works of which involved the creation of clothing-based sculptures, including her signature, intricately wrapped headdresses, which she still wears. In the early 1990s she began incorporating discarded materials from construction sites into her sculptures, of which rubber tires have since become her primary medium. Her process is intensely physical, involving the slicing, twisting, sewing, and shredding of tires to create highly textured and tactile floor and wall-based sculptures. Imbued with energy and movement, Booker's monumental contribution to the 2000 Whitney Biennial, *It's So Hard To Be Green*, exemplifies her approach. She has noted the connections between tread patterns and her African ancestry, commenting in a 2003 interview for the television program *State of the Arts*, "I thought they looked like the textiles in African art [and traditional] scarification." For Booker, rubber tires are rich in cultural and historical associations, from environmental concerns to themes of consumerism and socioeconomic inequality.—DT

LOUISE BOURGEOIS

SPIDER (CELL)
1997, steel, tapestry, wood, glass, fabric, rubber,
silver, gold, and bone, 177 × 262 × 204 in.
(449.5 × 665.4 × 518.1 cm)

Louise Bourgeois, born 1911, Paris, France. Died
2010, New York, USA.

Louise Bourgeois is particularly renowned for her sculptures that evoke the conflicting themes
of motherhood, trauma, and loss. Much of Bourgeois's body of work is culled from childhood expe-
riences—she grew up in Antony, a commune on the outskirts of Paris, as the daughter of tapestry
restorers. Her complicated relationships with her parents led to a self-described fear of abandonment,
as reflected throughout her lifelong artistic practice. Bourgeois was devoted to her mother, who died
when Bourgeois was twenty-one years old, prompting her to pursue a career in art. She began creating
sculpture in the mid-1940s, a time in which she started to experiment with images of spiders. For
Bourgeois, the spider represented a maternal figure, its role as a weaver reflecting her own mother's
profession. *Spider (Cell)* combines this spider motif with one of Bourgeois's cells, sculptural enclosures
containing salvaged objects that, according to the artist, evoke various types of pain. The hulking
steel arachnid stands above a round metal cage decorated with tapestries, as if the cell were a web
of the spider's creation. While the spider could be perceived as threatening—especially looming over
the cage—one can imagine her guarding her child in her web, providing protection from above.—JS

POLKA DOTS
2016, found steel, stainless steel, and urethane paint,
91 × 81 × 87 in. (231.1 × 205.7 × 221 cm)

Carol Bove, born 1971, Geneva, Switzerland.

Throughout her career, Carol Bove has been a proponent of the found object, integrating it into a collage aesthetic, often juxtaposing the unexpected. Early on, she arranged books, peacock feathers, crystals, and other accoutrements of mid-century culture; more recently she has been shaping larger steel forms into crumpled, typography-like shapes, often registering the idiom of mid-century sculptors like John Chamberlain (1927–2011) or Anthony Caro (1924–2013). In her "collage sculptures," of which *Polka Dots* is one, Bove comes into dialogue with the assemblages of Louise Nevelson (p.231), aggregating found scrap metals with an unexpected color palette. The playful colors imbue these works with a sense of personality and a character that challenges expectations. There is also a spontaneity in the rumpled bends that belies the weight and heft of the found steel, its materiality suspended. The surface of selected elements of these works, painted with shiny urethane, insinuates a posture, obliquely bringing a sense of humanity to the material. Although Bove plays with the traditions of modernism, she is "more a collector than an appropriator," as the curator Laura Hoptman told the *New York Times* in 2016, "her pieces might be the children of those earlier sculptors, but they're sprinkled with a different kind of fairy dust."—KM

BEVERLY BUCHANAN

**MIZ HURSTON'S NEIGHBORHOOD SERIES -
CHURCH**
2008, acrylic on foam core, 10 × 5 ½ × 6 ½ in.
(25.4 × 14 × 16.5 cm)

Beverly Buchanan, born 1940, Fuquay-Varina,
North Carolina, USA. Died 2015, Ann Arbor,
Michigan, USA.

Raised in South Carolina, Beverly Buchanan saw her professional life start in New York and New Jersey in the 1960s and early 1970s. Equipped with graduate degrees in parasitology and public health, the artist left her career as a health educator in 1971 to enroll in the Art Students League, where she studied under Norman Lewis (1909–79). She moved back south to Georgia in 1977 and began making her *frustula*, small groupings of rectangular concrete slabs textured by surface imprints of various architectures. Buchanan experimented with tabby concrete, a localized material that used lime from oyster shells as the binding agent. Often made by enslaved people for use by colonial settlers in coastal states like Georgia, tabby concrete is arduous to produce, reflecting the artist's devotion to honoring the laboring bodies on whose backs the United States was built. Her 1980s *ruins* series are sculptures placed in nature to be subsumed by grass and moss. Buchanan ceased making concrete works by the mid-1980s and focused on her "shack" series, which she would make until her death. Comprised of works on paper, photographs, and small-scale sculptures made of brightly painted corrugated cardboard, foam core, found materials, and wood, the shacks—which include this church—reference people, real or imagined, who enlivened the structures, standing as quiet monuments to marginalized histories.—MS

HAUTRAUM (RICKS KINDERZIMMER, LINDGUT WINTERTHUR) (SKIN ROOM (RICK'S NURSERY, LINDGUT WINTERTHUR))
1987, gossamer, fish glue, latex, bamboo, and wire, c. 137 ¼ × 196 ⅞ × 196 ⅞ in. (c. 350 × 500 × 500 cm), Migros Museum für Gegenwartskunst, Zürich

Heidi Bucher, born 1926, Winterthur, Zürich, Switzerland. Died 1993, Brunnen, Schwyz, Switzerland.

Heidi Bucher initially studied fashion design at the Kunstgewerbeschule Zürich and worked as an illustrator in the late 1940s and 1950s. Bucher began making her "skinnings" in the late 1960s, works that would later cinch her legacy as an artist invested in unusual materials. She would press gauze against various objects, which she then coated in liquid latex. As the latex hardened, the artist would skin the objects; the resulting peels functioned as materialized negatives of the original forms. In the early 1970s in Los Angeles, Bucher created "Bodyshells," large-scale wearable and genderless costumes, fusing her interest in sculpture and fashion. By 1974 she had returned to Switzerland, living at a former butcher's shop in Zürich whose wood-paneled walls inspired her first spatial layerings. She coated the building's interior surfaces with latex, which she then peeled off and rubbed in mother-of-pearl pigments to achieve a twinkling surface. As if resuscitating the latex skins, Bucher imbued new life into these haunting peels. Like architectural specters, they are suspended in the space and their use value has been completely neutralized. Without doors that open and close or walls that stand taut and strong, they are speculative architectures that seem to succumb to entropic pressures, calling attention to the ways in which space at once conditions and is conditioned by humans.—MS

DORA BUDOR

ORIGIN II (BURNING OF THE HOUSES)
2019, custom environmental chamber (reactive
electronic system, compressor, valves, 3D-printed
elements, aluminum, acrylic, LED light, glass,
wood, and paint), organic and synthetic pigments,
diatomaceous earth, FX dust, and felt,
60 × 63 × 34 in. (152 × 160 × 86 cm),
Queensland Art Gallery, Brisbane

Dora Budor, born 1984, Zagreb, Croatia.

Dora Budor focuses on the built environment's psychic and infrastructural effects through sculp-
tures and installations. A trained architect, Budor draws particular inspiration from Rem Koolhaas's
concept of "junkspace," which describes today's dizzying sprawl of forgettable airport terminals,
shopping malls, and highway ramps that are constantly being demolished, renovated, or hidden
behind scaffolding. Budor's *Origin II (Burning of the Houses)* encapsulates junkspace's perpetual
churn in miniature. Beneath a glass vitrine, injectors blast swirls of organic and synthetic pigments
and diatomaceous earth in response to real-time sounds transmitted from a nearby construction
site. The natural colors of the pigments match the palette of painter J. M. W. Turner's (1775–1851)
The Burning of the Houses of Parliament (1834), one of the earliest landscapes to capture how human
activity is slowly altering the natural world. The artist explores the interdependent connections
between the human experience and structures in flux, telling *Cultured Magazine* in 2020, "For me,
constructing a transitional situation is about synergetic relationships between human and non-human
agents. I look at how meaning is constructed and circulated through materials and images, often
moving fluidly between fiction and reality."—CC

HORIZONTAL TECHNICOLOUR
2002/16, 32 waxed birchwood DMX modules (Pixel Boxes), aluminum plate, white glass, diffusion foil, cables, RGB-lighting system, DMX controller, and sound system, 13 mins 12 secs soundtrack (looped), overall 78 ¾ × 157 ½ × 21 ⅝ in. (200 × 400 × 55 cm)

Angela Bulloch, born 1966, Rainy River, Ontario, Canada.

At the core of Angela Bulloch's practice lies the complex relationship between humans and technology. Based on systems and electronic or analog mechanisms, at times produced by the artist, Bulloch's pieces reference Minimalism and employ monochromatic palettes that can be combined in colorful ways. Her work always remains unfinished, waiting for the gaze of, or interaction with, the viewer to complete it. Through this exchange, Bulloch turns the observer into a user, allowing them the agency to modify the artwork, and permitting the sculpture to become an ever-changing experience in time and space. This points to the enduring relationship and effects humans have on technology, and vice versa. *Horizontal Technicolour* includes a modular system of thirty-two "Pixel Boxes" that, in conjunction, resemble the aspect ratio of a cinemascope film format. The piece contains two abstract sequences: one a landscape filmed from within a moving vehicle and the other based on a psychedelic scene from Stanley Kubrick's sci-fi film *2001: A Space Odyssey* (1968). Each "Pixel Box" contains three fluorescent RGB tubes that are able to reproduce the same colors as computers. Like zooming into the very fabric of digital colors—pixels—the viewer experiences an abstraction of images and cycles that coalesce into a loop created by the artist's custom software.—LO

TERESA BURGA

UNTITLED / PRISMAS (B)
1968/2013, painted plywood in 5 parts,
dimensions variable

Teresa Burga, born 1935, Iquitos, Loreto, Peru.
Died 2021, Lima, Peru.

Teresa Burga blazed a trail for Conceptual art in Latin America. As well as sculpture, her multidisciplinary practice included drawings and paintings, touching on subjects such as gender, state violence, and nationality. In 1966 Burga joined Arte Nuevo, an artist collective that catalyzed Op art, Minimalism, and Pop art in Peru and Latin America more widely. Moving to the United States to study at the School of the Art Institute of Chicago, Burga cemented her Pop-Conceptual practice and experimented with installations and happenings. Her *Prismas*, a series of modular plywood sculptures adorned with bright images of geometrical figures, children, domestic objects, toys, and other abstract forms, reflect on themes of gendered labor, utility, and commercialism. Burga altered the positions of the blocks each time they were displayed, confounding a narrative and making them appear more like mass-manufactured objects than unique artworks. In fact, her original intention was for craftspeople to produce these on a commercial scale following detailed diagrams she had drawn. Thus, "the workers, like the viewers, become collaborators in realizing [the work's] vision," as noted by curator Ruba Katrib in the 2017 SculptureCenter exhibition *Teresa Burga: Mano Mal Dibujada*. Although Burga moved away from Pop after the 1960s, these earlier works exemplify her consistent investigation of art and authorship, labor and creation.—SGU

SANS TITRE (UNTITLED)
2019, terracotta, 62 ¼ × 15 ¾ × 12 ¼ in.
(158 × 40 × 31 cm)

Seyni Awa Camara, born 1945, Bignona,
Casamance, Senegal.

Raised in the Casamance region of Senegal, Seyni Awa Camara was trained in the use of clay from an early age by her mother who was also a potter. At first, Camara mastered utilitarian objects used in the household, but soon began to create sculptures of her own stories and interpretations of the diverse natural world of her village, where she still lives and works. All of Camara's totemic terracotta works—some are only 12 inches (30.5 centimeters) high, but others tower at more than 96 inches (244 centimeters)—are made and fired in an open-hearth kiln in the front yard of her home in Bignona. The color and texture of her ceramic works are achieved by bathing them in a liquid made from putrefied tree pods after firing. Human figures, animals, and spirits all appear in Camara's complex vertical structures, sometimes intertwined and with distorted faces, as seen in this untitled piece from 2019. Each work represents a vision, guided by a talisman or remembered from a dream, revealing personal truths that also evoke universal human conditions and emotions. Due to her mystical ability to manifest an unseen world, Camara is known locally as *la magicienne de la terre* (magician of the Earth).—CJ

ELAINE CAMERON-WEIR

RIGHT HAND LEFT HAND, GRINDS A FANTASIZER'S DUST
2021, concrete textile, funerary backdrop stand, neon tubing, transformers, spot lights, and silk gauze, 85 ½ × 112 × 24 in. (217.2 × 284.5 × 61 cm), installation view, *Elaine Cameron-Weir: STAR CLUB REDEMPTION BOOTH*, Henry Art Gallery, University of Washington, Seattle

Elaine Cameron-Weir, born 1985, Red Deer, Alberta, Canada.

Mechanical parts reflect on physical and bodily conditions in Elaine Cameron-Weir's sculptural installations, which reverberate with existential meaning. The artist taps into a sensibility—seemingly as inspired by the archaic or gothic as it is by science fiction and modern science—that contemplates epistemological interpretations of sacrifice and persistence. Cameron-Weir often references laboratories, the operating room, military equipment, medieval torture chambers, or fetish-dens, all spaces where the body is physically distanced from the psyche. Electric illumination and tessellated metal insinuate a sort of sensual tension into her works, a trap for the eye, flickering across cool lustrous combinations that can also incorporate organic matter, such as clamshells and leather. Cameron-Weir often uses doubles in her sculptures, telling curator Jody Graf in a 2022 interview, "I'm naturally attracted to symmetry in things and mirror images." *Right Hand Left Hand, Grinds a Fantasizer's Dust* presents symmetrical strips of neon tubing, wrapped in gauzy silk that follows their squiggled, energetic journeys across a funerary backdrop. Pairs taken together—from two eyes to mortuary stands—can reveal the larger imperfections inherent in both the viewers' perception of and the artist's attempt to create symmetry from disparate, sometimes warring, objects. In that same interview, Cameron-Weir likened this aspect of her work to "the real world and its double: which one is the original?"—KM

BRIEF SYLLABLE (TRIPLED)
2018, subsea cable, concrete, and steel,
45 ⅝ × 4 ½ × 4 ½ in. (116 × 11.5 × 11.5 cm)

Nina Canell, born 1979, Växjö, Småland, Sweden.

In an interview with *Bomb* magazine in 2016, when asked about the nature of her material process, Nina Canell replied by turning the question around and stating that "the nature of process is the material of [the] work," describing herself as working "in a syntax of relations and transfers." Form-as-process is central to a practice loaded with energy, providing Canell with not only a means of working but also an approach to subject matter. Transmission and circulation are ever-present in the materials, representations, and contextualizations of her sculptural forms, which have included viscose gum that transforms over time, as well as assemblages that utilize water, vibration, and electricity. The artist's *Brief Syllable* series comprises segments of subterranean cables, which are presented in a variety of states—frayed, truncated, or, as here, "tripled." While modest in size, their cross-sections speak about the mechanics of communicating or transporting power across great distances, immediately creating a disconnect for the viewer. They upset easy interpretation in their un-functionality: the inability of these segments of cable to connect to anything renders them useless yet open-ended. Canell comments on both the materiality of what society often considers incorporeal currents of power and information as well as the afterlife of displaced energy technologies. In their incompleteness, these sculptures stress that matter and its capacities are vital and irreducible.—CI

JODIE CAREY

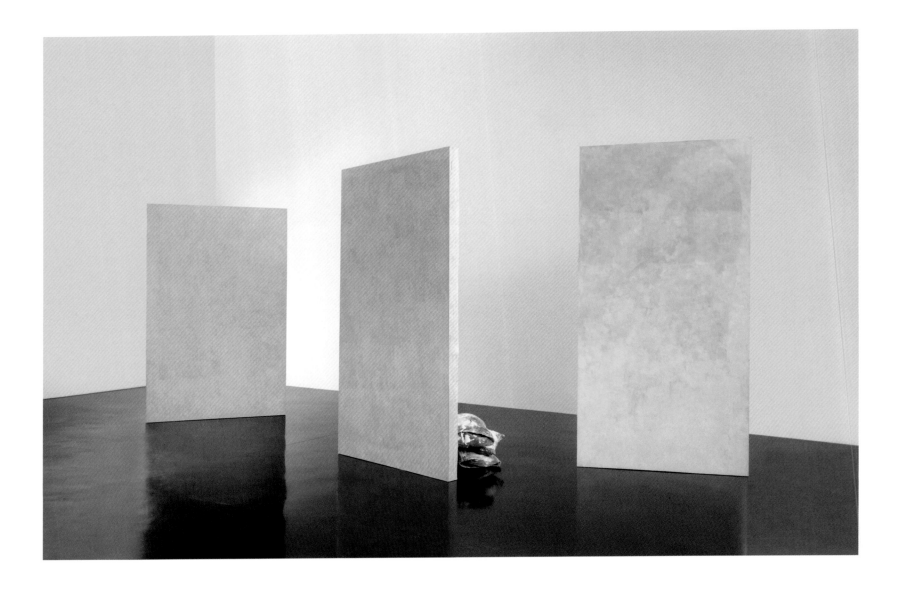

Jodie Carey describes her work as an extension of herself. She is absorbed by ideas of time, aging, forgetting, and remembering, and uses sculpture as a way to explore memory and test the notion of the monumental. Typically eschewing the traditional sculptural materials of stone, marble, and bronze, she is most often drawn to the ephemeral and the fragile. When making, she evokes her background in textiles—weaving, crochet, and embroidery—to foreground the handmade, to propose alternative ways of commemorating history, and challenge the idea that sculpture should be solid and permanent. Reminiscent of tombstones, *Untitled (Slabs)* comprises seven large pastel-colored panels, mounted on wooden armatures, and weighed down with hessian, or burlap, sandbags. The "front" of each piece has been hand-cast in plaster, commonly used in sculpture, but often considered a poor relation to harder mediums because of its propensity to crack and be damaged. Once dry, the surfaces have been painstakingly colored using pencil crayons, a material chosen for both their ubiquity and mutability. The coloring brings into relief the irregularities of the plaster, its unevenness and its reality. The rough-hewn supports and sandbags, practical solutions to stop the slabs from falling over, are included matter-of-factly and without apology.—RH

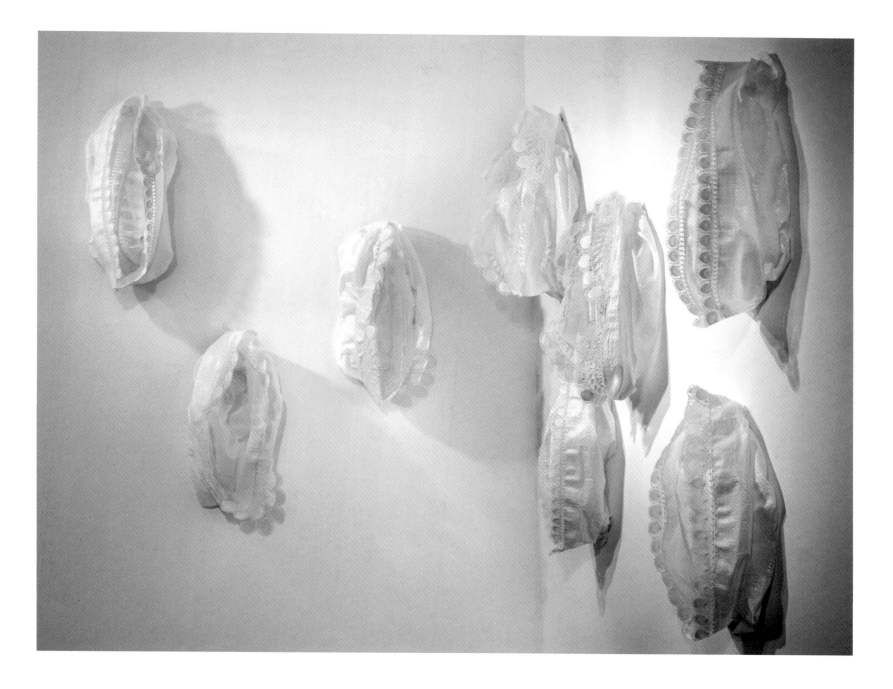

COROLLAS
2019/23, ñanduti lace made by Norma Martinez
and plastic burlap bags, dimensions variable

Claudia Casarino, born 1974, Asunción, Paraguay.

A self-defined political and conceptual artist, Claudia Casarino creates videos, photographs, and installation pieces to explore issues such as migration, identity, and gender. Regarding the latter, her artworks condemn patriarchal stereotypes, roles historically assigned to women, and gender disparities surrounding domestic labor. Casarino studied visual arts at the Universidad Nacional de Asunción in Paraguay. Drawing on her past experience working as a fashion editor and stylist, she has developed a practice in which clothing and textiles are used not for fashion but because of how they speak to the "politics of appearance," as she clarified in a 2022 interview with *Darz* magazine. In the same interview, Casarino explained that she repeatedly works with tulle since this material is frequently used in South America as a symbol of purity, while she employs cotton to reference colonialism and extractivism. For *Corollas*, she created a series of wall-mounted pieces using traditional Paraguayan ñanduti lace and plastic bags of a type employed by female agricultural workers in her country. The work's title derives from the Latin word for small crown and refers to the petals that protect a flower's reproductive organs. Through these delicate objects, Casarino sought to make a statement about the softness and virtue demanded from women who are also exploited and forced to perform harsh labor.—SGU

ROSEMARIE CASTORO

LAND OF LASHES
1976, 8 sculptures, steel, fiberglass, epoxy, Styrofoam, and pigment, 126 ¾ × 48 in. (322 × 122 cm), Museum für angewandte Kunst Vienna

Rosemarie Castoro, born 1939, Brooklyn, New York, USA. Died 2015, New York, USA.

It was while studying graphic design at New York's Pratt Institute that Rosemarie Castoro became enamored with dance, later collaborating with experimental choreographer Yvonne Rainer (b. 1934) in the 1960s. Living and working in New York her entire life, Castoro emerged as a central figure in the city's Minimalist and Post-Minimalist scenes and participated in the Art Workers' Coalition activist group, promoting artists' rights alongside figures such as Lucy Lippard (b. 1937) and Carl Andre (1935–2024). After a period painting boldly colored, geometric abstractions, she embraced Conceptual art, working in media that included Concrete poetry, architectural interventions, and performance actions enacted in the studio and on the street. From 1970 she concentrated on sculpture, working with a dancer's understanding of space and movement to create surreal, erotically charged works with a distinctly bodily character. Calling herself a "paintersculptor," she created giant wall-based monochromatic brushstrokes on Masonite from a mixture of gesso and modeling paste to which she then applied graphite. These later evolved into organic fiberglass and steel sculptures evoking trees, roots, legs, and as in *Land of Lashes*, massive eyelashes that seem to be scuttling like tarantulas. In the late 1980s Castoro learned to weld and entered a new phase of sculpting with metal, though she continued to explore all media, drawing, painting, and writing until her death.—DT

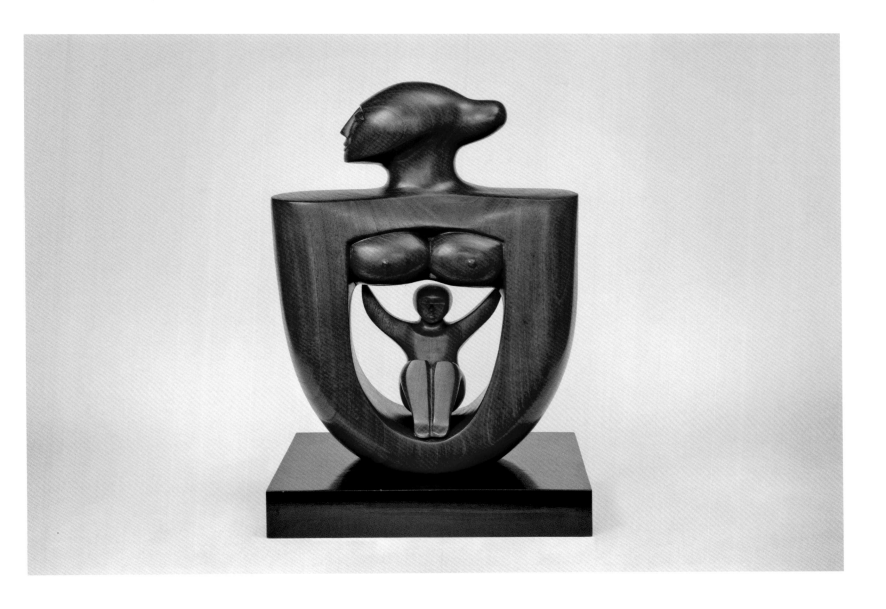

MATERNITY
1971, wood, 20 × 15 ½ × 6 in. (50.8 × 39.4 ×
15.2 cm), Samella Lewis Contemporary Art
Collection, Claremont, California

Elizabeth Catlett, born 1915, Washington, D.C.,
USA. Died 2012, Cuernavaca, Morelos, Mexico.

In powerful sculptures and prints over a seventy-year career Elizabeth Catlett strove to honor the emotional lives of women, workers, and Black and Mexican peoples, telling art historian Samella Lewis in 2003, "I have always wanted my art to service my people—to reflect us, to relate to us, to stimulate us, to make us aware of our potential." The first woman to receive an MFA in sculpture from the University of Iowa in the 1930s, Catlett initially worked in a Regionalist-inspired style of realism, but began to incorporate abstract shapes after studying modernist sculpture and lithography in Harlem, New York. She relocated to Mexico in 1946 to escape segregation and join the printmaking collaborative Taller de Gráfica Popular, where her art took a sociopolitical turn, most famously in the heroic linoleum cut *Sharecropper* (1952). An artist activist and dedicated teacher, Catlett became the first female head of the sculpture department at the Universidad Nacional Autónoma de México in 1958. Her works harmoniously synthesized figuration and abstraction, as evident in the smoothly carved sculpture *Maternity*. With rounded contours that integrate influences from modernism and traditional Mexican and pre-Columbian art, Catlett's mother form envelops the child figure in an embrace that may be read as inside or outside the womb, capturing the boundless cycle of maternal love.—OC

HELEN CHADWICK

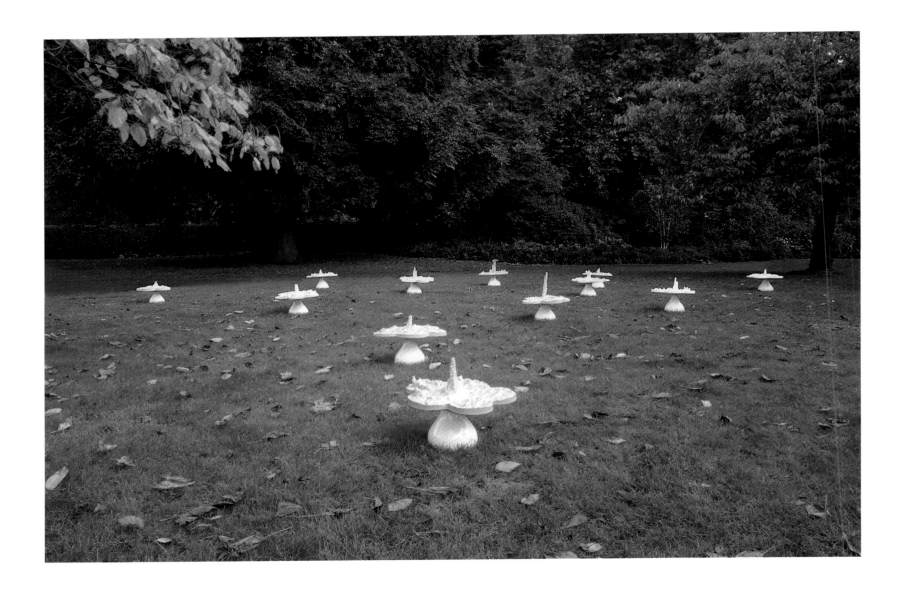

PISS FLOWERS
1991–2, bronze and cellulose lacquer,
dimensions variable

Helen Chadwick, born 1953, London, UK.
Died 1996, London.

Working across sculpture, photography, and Installation art, Helen Chadwick was one of the first women artists to be nominated for the Turner Prize, in 1987. She also taught at the Royal College of Art, Chelsea School of Art, and Goldsmiths College, all in London, where she influenced and mentored numerous members of the Young British Artists generation. In her own idiosyncratic practice, Chadwick experimented with visceral and nonconventional materials, such as meat, vegetable matter, flowers, fur, and chocolate. She was particularly engaged with querying representations and perceptions of the body, exploring concepts of identity, pleasure, beauty, and desire, in addition to challenging tropes surrounding gender and sexuality. Another prominent theme in Chadwick's work was bodily dissolution, invested in notions of nature and decay, often through a play on binary oppositions and the blurring of boundaries. Chadwick created the irreverent and playful *Piss Flowers* during an artist's residency in Banff, Canada. She and her partner, David Notarius, urinated into a flower-shaped metal mold placed on the snow. They then poured plaster into the recesses and cast the depressions made in the ground by the warmth of their urine. Inverted through the casting process, it was Chadwick's elongated stream of urine that produced the large, phallic, stamenlike rod for the "flowers."—PE

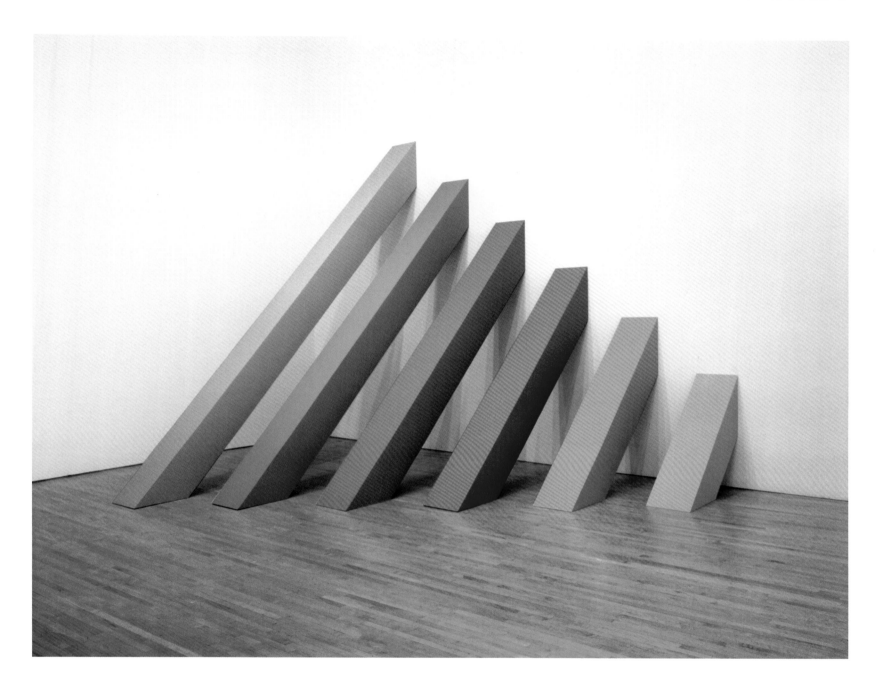

RAINBOW PICKETT
1965/2004, latex paint on canvas-covered plywood,
118 ¾ × 118 ¾ × 132 in. (301.6 × 301.6 × 335.3 cm),
private collection

Judy Chicago, born 1939, Chicago, Illinois, USA.

Feminist art pioneer Judy Chicago spent the early days of her career developing a Minimalist aesthetic. It was, at her own admission, a decision inspired by her desire to learn her male counterparts' visual language and so be accepted in their world. *Rainbow Pickett* is a prime example of her sculpture of this period. Selected by curator Kynaston McShine for his iconic exhibition *Primary Structures: Younger American and British Sculptors* at the Jewish Museum in New York in 1966, the piece was praised by the influential critic Clement Greenberg but dismissed by other writers and fellow artists as too colorful and emotional to fit in with the austerity and rigor of Minimalism. The experience prompted Chicago to distance herself from the art world and create most of her future work in isolation—a condition she deemed necessary in order to escape the patriarchy and shape an oppositional belief system. Even though Chicago is now best known for her 1974–9 epic sculpture *The Dinner Party*—a symbolic banquet celebrating some of the women who have made significant sociocultural contributions through the centuries—*Rainbow Pickett* still stands as testimony to a time in Chicago's life when she laid the foundations of her future practice. Like most of Chicago's early work, the original piece was lost and had to be remade in the mid-2000s.—MR

SALOUA RAOUDA CHOUCAIR

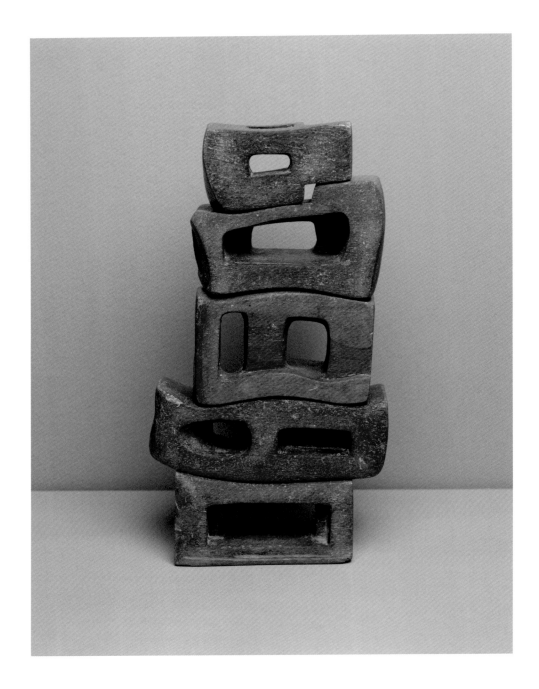

POEM
1963–5, wood, 13 × 6 ¾ × 3 in. (33 × 17 × 7.5 cm),
Tate, London

Saloua Raouda Choucair, born 1916, Beirut,
Lebanon. Died 2017, Beirut.

Although Saloua Raouda Choucair remained largely unknown outside of Lebanon until her mid-nineties, when Tate Modern staged a retrospective of her work in London in 2013, she has since gained international recognition for her melding of modernist ambitions and Islamic philosophy. Trained in figurative painting under the tutelage of established Beiruti artists Omar Onsi (1901–69) and Moustafa Farroukh (1901–57), Choucair was greatly influenced by a trip to Egypt in 1943, where she encountered the local vernacular of Islamic art and architecture. Later that decade, she spent three formative years in France, attending the Ecole des Beaux-Arts in Paris and moving in modernist circles. On her return to Beirut, she developed an idiomatic abstraction informed by Islamic ideals of geometric purity. As she wrote in a 1951 manifesto, "How the Arab Understood Visual Art," the singular pursuit of Islamic art is toward "the eternal essence that is defined neither by time nor space." She rejected the assumed superiority of European art and denied its influence in her work, instead citing Islamic design and principles as points of inspiration. In her *Poem* sculptures, like this wooden example, each form's modular, movable parts are conceived as stanzas in Sufi poetry, standing alone yet held in relation to the others, the works' temporary equilibrium suggestive of kinetic potential.—LB

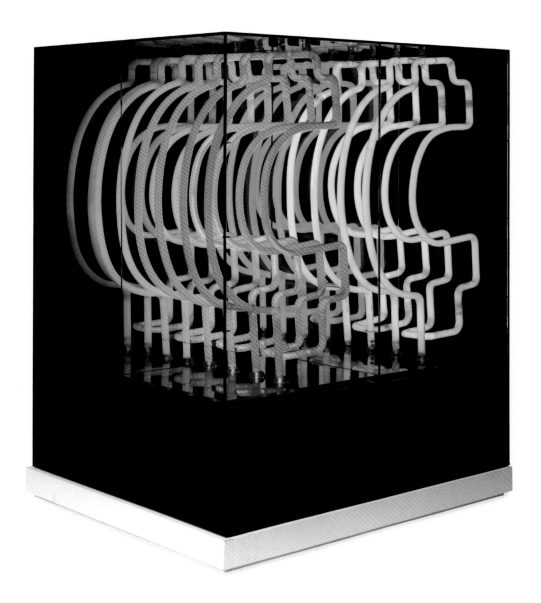

**CENTS SIGN TRAVELLING FROM BROADWAY
TO AFRICA VIA GUADELOUPE**
1968, neon tubing and Plexiglas, 43 × 35 × 28 ½ in.
(109.2 × 88.9 × 72.4 cm), Brooklyn Museum

Chryssa, born 1933, Athens, Greece. Died 2013,
Athens.

One of the first artists to use tubes of colored neon lights as a medium to create sculptures before the advent of Pop art and Minimalism, Chryssa Vardea-Mavromichali, who preferred to go by her first name only, was a trailblazer of the Light and Space art movement. After studying art in Paris and San Francisco in the early 1950s, she settled in New York in 1955, a move that would greatly influence her artistic career. Inspired by the media and lights of the city, her early work incorporated newspapers and typography before she turned to neon tubing, which she found she could use to seamlessly combine text, light, and image into a holistic artwork. Notably, Chryssa was captivated by the neon lights and signage of Times Square, which she alluded to in some of her most celebrated pieces, such as *The Gates of Times Square* (1966), even telling *TIME* magazine in 1973, "I saw Times Square with its lights and letters, and it made me realize that they were as beautiful and as difficult to make as any Japanese calligraphy." In *Cents Sign Travelling from Broadway to Africa via Guadeloupe*, the artist once again referenced the bright, buzzing lights of the Big Apple, this time to reflect on themes of economic globalization.—SGU

LYGIA CLARK

**ESTRUTURAS DE CAIXA DE FÓSFOROS VERMELHO
(RED MATCHBOX STRUCTURES)**
1964, red gouache, matchboxes, and glue,
3 × 2 ¾ × 2 ½ in. (7.5 × 7 × 6.5 cm)

Lygia Clark, born 1920, Belo Horizonte, Minas Gerais,
Brazil. Died 1988, Rio de Janeiro, Brazil.

An influential presence in the Brazilian avant-garde movement, Lygia Clark initially worked with geometric abstractions on two-dimensional surfaces in the Concrete style popular in mid-century Brazil. In the 1950s Clark emerged as a foundational figure in the Neo-Concrete movement, which sought to upend the creation of art by centering the viewer's experience of it as essential to its making. Clark's earliest works rendered in this approach are some of her most distinctive—her *Bichos* (critters) series of metal sculptures were intended to shift in shape by inviting the viewer to handle and mold them to their content. While her involvement with Neo-Concretism eventually faded, Clark's geometric aesthetic and belief that art needed to be accessible to its viewer remained crucial to her practice until her untimely death in 1988. Her *Matchbox Structures*—painted blue, black, white, gold, or red, like this one from 1964—were Clark's imagining of a home whose walls could easily be moved according to the dweller's mood. Because of her commitment to the relationship between art object and audience, Clark is considered a pioneer of participatory art and art therapy.—NM

L'HOMME PENCHÉ (MAN LEANING)
c. 1886, plaster, 16 ⅞ × 6 ¼ × 11 ⅛ in.
(43 × 16 × 28 cm), La Piscine - Musée d'Art
et d'Industrie, Roubaix, France

Camille Claudel, born 1864, Fère-en-Tardenois,
Aisne, France. Died 1943, Avignon, Vaucluse,
France.

Produced in marble, bronze, and onyx, Camille Claudel's sculptures explore the poetry and expressive possibilities of the human body. In 1882 Claudel began studying with Auguste Rodin (1840–1917), then a rising star who would go on to become perhaps the most celebrated sculptor of the nineteenth century. Claudel and Rodin became close collaborators and, soon, lovers, and would profoundly shape each other's art—indeed, they so often worked together that the hand of each artist is sometimes difficult to discern. In 1913, following the death of her father, Claudel was forcibly admitted to a psychiatric hospital, and she would remain institutionalized until her death in 1943. *Man Leaning*, made in the years shortly after she met Rodin, reflects Claudel's attentive study of human anatomy and extensive training working from nude models—a fundamental component of artistic education in the nineteenth-century French academic system, yet nonetheless off-limits to most women artists at the time. *Man Leaning* is a potent demonstration of her skillful rendering of the human body, with the subject's sinewy muscles carefully individuated. Claudel's expressive style is on display, with the tautly folded body of the male sitter seeming to dissolve into the pedestal on which he rests.—MMB

MARIE-ANNE COLLOT

BUST OF CATHERINE THE GREAT
1769, marble, height: 24 ⅛ in. (61 cm),
Hermitage Museum, St. Petersburg

Marie-Anne Collot, born 1748, Paris, France.
Died 1821, Nancy, Meurthe-et-Moselle, France.

Marie-Anne Collot was an acclaimed portraitist who at a young age rose to fame for her authentic depictions of important French and Russian thinkers and aristocrats. At age fifteen, she became a student of Etienne-Maurice Falconet (1716–91) and created terracotta busts of his associates, including the prominent Enlightenment figure Denis Diderot. After initial success in Paris, aged only eighteen, Collot accompanied Falconet to St. Petersburg, Russia, where he was commissioned by Catherine the Great to create a monumental equestrian sculpture of Peter the Great. As she had done in Paris, Collot sculpted portrait busts of members of the court, mastering the medium of marble. Catherine the Great commissioned around two dozen sculptures from her, including this one. Collot captured the spirit and resolve of the monarch in a restrained fashion, simplifying Catherine's court dress into an elegantly draped antique head covering and portraying the middle-aged sovereign without idealization. The Empress even selected Collot's model head of Peter the Great for his monumental statue, after rejecting multiple attempts by Falconet. Although Collot enjoyed such early success, she moved back to her home country in the 1770s and had given up sculpting by the time the French Revolution broke out and disrupted the aristocratic courts she had so faithfully portrayed.—ESP

UNTITLED (12 FOOT CIRCULAR MONOLITH TITANIUM)
2017, engineered aerospace carbon fiber,
144 × 40 × 40 in. (365.8 × 101.6 × 101.6 cm)

Gisela Colón, born 1966, Vancouver, Canada.

Los Angeles-based artist Gisela Colón creates sleek, luminescent objects with advanced materials from the plastics and aerospace industries. She often invokes the 1969 moon landing as a formative memory. Born to a German chemist father and a Puerto Rican painter mother, Colón lived in San Juan, Puerto Rico, until earning a law degree from the University of Southern California in 1990. She decided to pursue art full time in 2002, initially painting mosaic-like abstractions. Since 2012 Colón's sculptures have explored the variability of color and perception. Characterizing her work as "organic minimalism," a term she coined, Colón pushes the phenomenological concerns and technological craftsmanship of her predecessors in the California Light and Space movement, notably Mary Corse (b. 1945) and Helen Pashgian (p.242), into new territory. Like her numerous pods, slabs, and portals, Colón's highly polished and curvilinear monoliths seem to emanate light, wielding a wide range of hues that shift depending on viewpoint and atmospheric conditions. The shimmering, prismatic qualities of Colón's mathematically precise totems offer contingent, temporal experiences. These towering entities, which are well over human scale, summon sensations that strangely suspend easy distinctions between soft and hard, translucent and opaque, liquid and solid, phallic and yonic, ancient and futuristic, scientific and magical.—AT

MARTA COLVIN

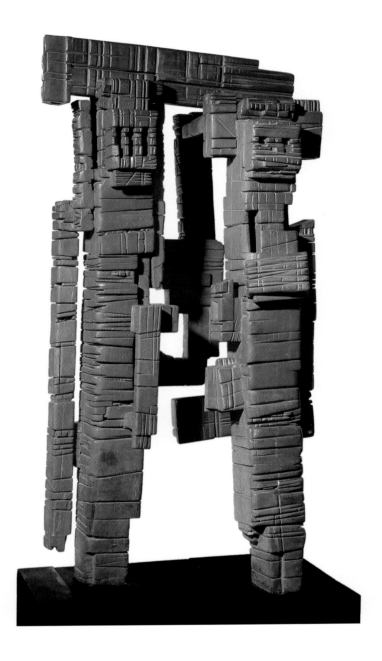

VIGÍAS (SENTRIES)
1973, assembled wood and turquoise polychrome,
78 ¾ × 39 ¼ × 29 ⅞ in. (200 × 101 × 76 cm),
Museo Nacional de Bellas Artes, Santiago

Marta Colvin, born 1907, Chillán, Diguillin, Chile.
Died 1995, Santiago, Chile.

Marta Colvin captured the monumental forces of Andean nature in sculptural works that absorbed both the influence of European modernism and the artist's interest in the abundant culture and wisdom of the pre-Hispanic cultures of Latin America. Colvin came to art-making after raising a family and taught herself how to sculpt in clay. She survived the massive 1939 earthquake in her native Chillán and moved to Santiago to study sculpture more formally at the Universidad de Chile, later becoming a professor there in 1950. Inspired by the grandiose mountain ranges of Chile and the monumental Rapa Nui anthropomorphic *moai* (statues) of Easter Island, Colvin began producing what would become her most celebrated sculptures in the 1960s. These were made of stacked stones or pieces of wood that were carefully and minimally carved, cut, and sometimes painted with geometrical yet fluid forms. For the artist, this methodology represented a merging of nature and humankind that entailed giving architectonic structure to natural forms and creating biomorphic constructions in space. *Sentries*, made of a variety of woods colored in turquoise, can be read as an undefinable abstract portrait of two entities. With her distinct approach to organic modernism, Colvin became one of Chile's most celebrated artists, earning the country's National Art Prize in 1970.—LO

UNTITLED (SHOES)
2020, bronze, each 4 ½ × 11 × 4 ¾ in.
(11.5 × 28 × 12 cm), overall 4 ¾ × 16 ½ × 11 ¼ in.
(12 × 42 × 30 cm)

Fiona Connor, born 1981, Auckland, New Zealand.

In creating near-perfect replicas of commonplace items and architectural features, Fiona Connor considers the ways in which spaces and objects recall the individuals and communities that engage them. A drinking fountain, public noticeboards, the doors of shuttered nightclubs—these are among the urban commonage to which she dedicates her careful copying. So too are everyday tools, like pencils and rulers, and the anonymous flotsam of city life: empty plastic packets, folding chairs, a municipal broom. The artist makes her facsimiles with detailed attention to surface, transcribing each with the patina of wear that marks the originals—small scuffs and stains, signs of use and misuse. Her intimate material knowledge of these objects and architectural quotations gives their replicas a novel significance as fabricated readymades. To Connor, each is analogous to a photograph. Removed from their first context, her assorted facsimiles become impressions of past moments inscribed with the residue of civic and private histories. Following an archival impulse, the artist performs the role of archaeologist and sociologist, reappraising built structures and objects as social records. *Untitled (shoes)* extends a more personal register to Connor's mimetic pursuit: the artist's Birkenstock sandals are remade in bronze, left on the floor as if she has just stepped out of them.—LB

NICOLA COSTANTINO

HUMAN FURRIERY, MALE NIPPLES CORSET
1999, silicone and fabric, c. 13 ⅜ × 32 1/16 ×
9 1/16 in. (c. 34 × 81.5 × 23 cm), Museum of Modern
Art, New York

Nicola Costantino, born 1964, Rosario,
Santa Fe, Argentina.

The daughter of a seamstress and a surgeon, Nicola Costantino was deeply influenced by her parents' professions and spent a great deal of her childhood working at her mother's garment factory in Rosario. After studying sculpture at the Escuela de Bellas Artes de la Universidad Nacional de Rosario, she became known during the 1990s for her *Human Furriery* series, which comprised silicone sculptures of fashion items and other objects seemingly covered in human skin and erotic body parts, as seen here in *Male Nipples Corset*. With this series, the artist sought to explore subjects of corporeality and consumption, as well as the mechanics of how both bodies and garments can be fashioned. Costantino delved further into these ideas with *Savon de Corps* (2004), which featured a soap sculpture made using some of the body fat she obtained after having liposuction. In other notable works, the artist employs taxidermy and mechanical engineering techniques to investigate the relationship between humans and animals. Although more recent works include performance, video, and installation elements, Costantino is consistently interested in the "transformative potential" of her art, telling the journal *Atlanticá* in 2013, "Some people say that my art is provocative; for me it is natural. The ability to cause an affect runs through all my work."—SGU

UNTITLED #1408 (THE LOST LANDSCAPE)
2015–18, specially formulated wax, pigment, silk
flowers, waxed taxidermy, tree branches, chandelier,
synthetic feathers, paint, black pearl-headed hat
pins, tape, chicken-wire fencing, wire, steel, weights,
cable, cable nuts, cable crimps, quick-link shackles,
jaw-to-jaw swivel, silk/rayon velvet, ⅜ in.-grade
30-proof coil chain, Velcro, thread, and plastic,
66 × 65 × 61 in. (167.6 × 165.1 × 154.9 cm)

Petah Coyne, born 1953, Oklahoma City,
Oklahoma, USA.

Raised in an Irish Catholic family, Petah Coyne's baroque iconography and use of ornate and idiosyncratic materials has roots in church pageantry and stylized floral displays. She has created elaborate, tactile sculptures and large-scale installations from materials as disparate as trees, mud, sand, scrap metal, taxidermy, shredded vehicles, wax statuary, glass, velvet, and human hair, exploring notions of transformation, evolution, and the sublime. Coyne derives inspiration from numerous sources, referring to film, art, history, and literature, in addition to mining her own biography to imbue her art with deep personal connotations. Rendered in dark, murky hues, *Untitled #1408 (The Lost Landscape)* depicts a stuffed bird in flight, emerging from a suspended chandelier composed of a wax-covered nest of silk flowers, tree branches, and feathers. By integrating the organic with the synthetic, Coyne stages a tension between nature and the artificial world, simultaneously playing with macabre and gothic imagery to create a magical still life. The title refers to the American novelist Joyce Carol Oates's 2015 coming-of-age memoir of the same name. Coyne often cites the work of female authors and has channeled Sawako Ariyoshi, Joan Didion, Zora Neale Hurston, and Susan Sontag, among others, over her career, transforming the literary into decadent and innovative sculptures.—PE

ANNE SEYMOUR DAMER

SHOCK DOG (NICKNAME FOR A DOG OF THE MALTESE BREED)
c. 1782, Carrara marble, overall 13 ⅛ × 15 ×
12 ⅝ in. (33.3 × 38 × 32.1 cm), Metropolitan
Museum of Art, New York

Anne Seymour Damer, born 1748, Sevenoaks, Kent,
UK. Died 1828, London, UK.

Labeled a "female genius" by her cousin Horace Walpole, Anne Seymour Damer was a British sculptor, actress, and author, famed for her classically informed depictions of people and animals. Born into an aristocratic family, Damer received traditional teachings in literature and the arts, but was also unconventionally trained in sculpture, usually barred to women due to its physical demands and study of the male nude. Her creative pursuits were championed by Walpole and the circle of progressive thinkers he gathered at Strawberry Hill House in Twickenham, west London, including David Hume and Joshua Reynolds. As one of the only known English woman sculptors of her era, Damer exhibited over thirty works at the Royal Academy between 1784 and 1818. Her Neoclassical busts of members of Georgian high society, such as Lord Nelson, Princess Caroline of Wales, and actress Elizabeth Farren, showcase her use of idealized classical forms and ability to translate subtle expressions and attitudes into terracotta, marble, and bronze. *Shock Dog*, a marble portrait of a Maltese, captures the pet's alert gaze and loose, rough coat, celebrating the vitality of this loyal companion. A lifelong sculptor and animal lover, Damer asked to be buried alongside the bones of her favorite dog and her sculpting tools at her death.—OC

MUAMBA GROVE #4
2019, steel, fiberglass, resin, and UV paint,
137 ⅛ × 76 × 44 ⅞ in. (348 × 193 × 114 cm)

Vanessa da Silva, born 1976, São Paulo, Brazil.

Born and raised in São Paulo but living in London since the early 2000s, Vanessa da Silva explores her Brazilian identity and lived experience of displacement through her multidisciplinary practice spanning sculpture, installation, textiles, and performance. Finding inspiration in the history of Brazilian carnival, capoeira dance movements, and the experiments of other Brazilian artists, such as Lygia Clark (p.68), Maria Martins (p.205), and Hélio Oiticica (1937–80), da Silva investigates conceptual links between the body and its surrounding environments, as well as the liminal spaces between the object and spectator, life and art. *Muamba Grove #4* reveals a metamorphosis of seemingly organic forms. Taking its title from *muamba*, the Brazilian slang word that refers to smuggled goods or contraband, and the roots of the mangrove tree, this work belongs to a series of six large-scale sculptures and a choreographed performance first presented in 2019 for the inauguration of Duarte Sequeira Gallery's Sculpture Park in Portugal. In 2022 *Muamba Grove #3* and *#4* were installed at Yorkshire Sculpture Park, Wakefield, UK. Considered by the artist to be an "unrooted body," growing from the ground up, *Muamba Grove #4*'s sinuous and corporeal elements create a dynamic sense of movement—a hybrid being in a permanent state of change. Probing the possibilities of color and scale, da Silva's sensorial sculptures disrupt notions of being and illustrate a symbiotic bond between the body and nature.—JM

PAULA DAWSON

MIRROR MIRROR: GRAEME MURPHY
2004, holographic print etched on bronze disk
on bronze figurine, 13 × 5 ¾ × 3 in. (33 × 14.7 ×
7.5 cm), National Portrait Gallery of Australia,
Canberra

Paula Dawson, born 1954, Brisbane, Queensland,
Australia.

A pioneer in holographic technology and its use in art, Paula Dawson is intrigued by the way objects and images channel memory and how holography relates to space and time. She created her first holograms, or three-dimensional images, for a student exhibition in 1974. Since 1980 she has devoted herself fully to holography, creating large- and small-format holograms, and is the director of the Holography Lab in Sydney. In early life Dawson was influenced by her father's work as an electronics engineer and her mother's interest in opera, as well as studies in classical dance and the techniques of Martha Graham (1894–1991) and Merce Cunningham (1919–2009). She brought together dance and light for her 1977 performance *Music and Lasers in Mazes*, and in 1978 created explosive sculptures. She has collaborated with scientific institutions internationally, including the Laboratory of General Physics and Optics in Besançon, France, where her 1977 residency led her to recreate a fully furnished Australian suburban living room for *There's No Place Like Home*, then the largest hologram ever made, and the MIT Media Lab in Massachusetts. In this work, based on caryatid mirrors from ancient Egypt, Greece, and Rome, the three-dimensional figure is Australian dancer and choreographer Graeme Murphy (b. 1950), whom Dawson met when she was studying dance.—EDW

J.L., 2005–2006
2006, wax, wood, and iron, 66 ⅞ × 16 ⅞ × 24 ⅛ in.
(170 × 43 × 62 cm)

Berlinde De Bruyckere, born 1964, Ghent, East
Flanders, Belgium.

At the core of Berlinde De Bruyckere's practice is an exploration of ambivalence: the space between vulnerability and strength, desire and disgust, decomposition and liveliness. Often working with textiles, hair, wax, animal skins, wood, and metal, her sculptures explore shifting states of matter and how they relate to bodies—both animal and human—feelings, and memory. *J.L., 2005–2006* is part of an output of work that centers the human body in postures that evoke fear, exhaustion, pleasurable submission, and magical metamorphosis. Rendered in wax, the work gives the impression of mottled flesh, at once alive and decaying, while the elongated feet and stacked wooden structure give the sculpture a precarious liveliness, suggestive of both flight and collapse. The title refers to Jelle Luipaard, who often models for the artist's drawings and sculptures. De Bruyckere's careful observation of the human body is testament to the artist's tender approach to the form in all its complexity and vulnerability. As she stated in a 2009 piece for *Modern Painters*, "I want to show how helpless a body can be, which is nothing you have to be afraid of—it can be something beautiful."—YN

AGNES DENES

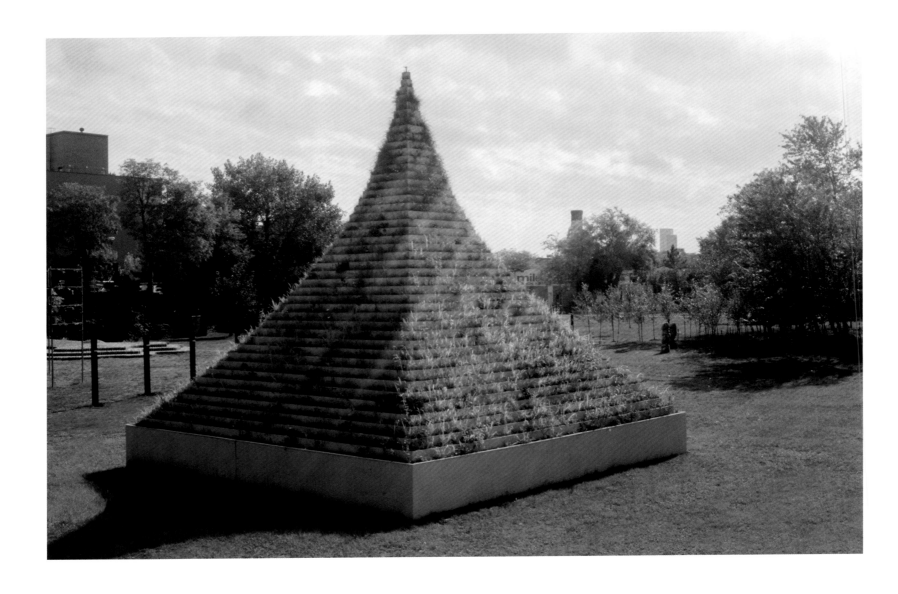

THE LIVING PYRAMID
2015, flowers, grasses, soil, wood, and paint,
30 × 30 × 30 ft. (9 × 9 × 9 m), installation view,
Socrates Sculpture Park, Queens, New York

Agnes Denes, born 1931, Budapest, Hungary.

After studying at the New School and Columbia University in New York, Agnes Denes abandoned painting for conceptually based practices, emerging as a pioneer of environmental and Land art in the 1960s and 1970s. She is renowned for ambitious projects drawing attention to ecological issues, such as *Wheatfield—A Confrontation* (1982), a two-acre wheat field planted in downtown Manhattan that called attention to world hunger and promoted agricultural renewal. The pyramid is a recurring motif in her practice, present in works such as *A Forest for Australia* (1998) in which six thousand trees of varying heights were planted into five spirals resembling step pyramids to help alleviate soil erosion. One of the largest examples, *The Living Pyramid,* is a structure of wooden terraces filled with soil and thousands of plants that sprout, flower, and variously thrive or die over the work's duration. An interactive project, audience members are invited to help sow and tend to the seedlings as a model of collective environmental stewardship before being encouraged to adopt the plants and continue nurturing them at home. Although best known for large-scale earth sculptures, Denes also produces poetry and philosophy alongside detailed diagrammatic drawings addressing scientific, mathematical, and metaphysical subjects.—DT

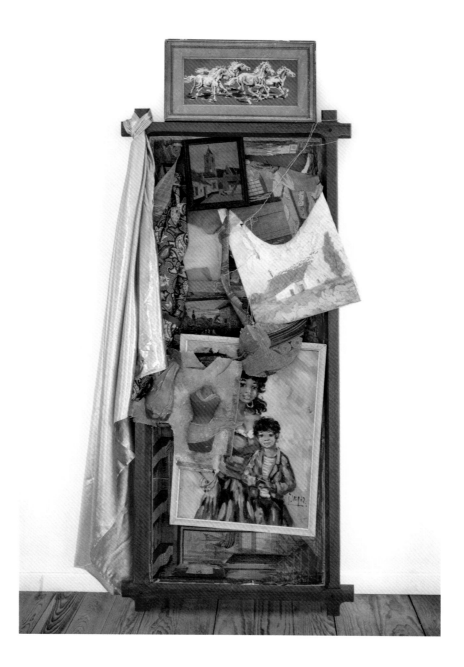

DAY 1
2017, mixed media, c. 87 ⅜ × 39 ⅜ × 11 ¼ in.
(c. 222 × 100 × 30 cm)

Abigail DeVille, born 1981, New York, USA.

Captivated by the stories and narratives that go unspoken and unacknowledged, Abigail DeVille approaches her work like an archaeologist. She begins with research into the cultural archives of a place and then forages thrift shops and landfills for architectural debris and discarded materials. *Day 1*, an assemblage of fabrics, framed prints, paintings, and relief figures against a vertical wood support, is part of a series based on Belgium's King Leopold II and his reign of terror in the Congo (1885–1908) that killed over ten million people. DeVille mainly sourced her materials from a flea market at the Place du Jeu de Balle in Brussels. Using Martin Luther King, Jr.'s 1967 text *Where Do We Go from Here: Chaos or Community?* as a primary reference point, she saw parallels between the white American backlash to the civil rights movement and the 150th anniversary of Leopold's coronation that was held—ultimately behind closed doors—despite public outcry. The artist combines references to the bronze equestrian portrait of Leopold in Brussels with fragmented images of Black figures, as well as blue elements that allude to the harrowing journey by water imposed by the transatlantic slave trade. DeVille's social critiques thus span time and place, connecting histories of imperial colonialism with the denial of the legacies of racism and subjugation of Black communities.—OZ

KARLA DICKENS

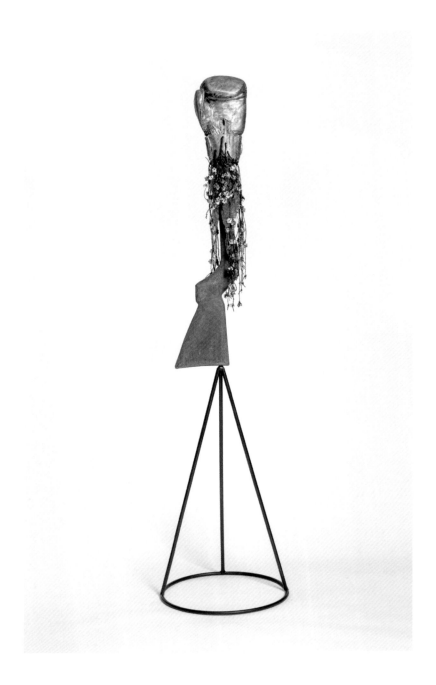

POUND-FOR-POUND #5 from the series **POUND-FOR-POUND**
2019, aluminum, vintage gun stock, waxed linen thread, stainless steel mesh, copper wire, steel, and acrylic paint, 68 ⅛ × 16 ⅛ × 16 ⅛ in. (173 × 41 × 41 cm), Art Gallery of New South Wales, Sydney

Karla Dickens, born 1967, Sydney, New South Wales, Australia.

Describing herself as a storyteller, Karla Dickens is an Aboriginal Australian artist of the Wiradjuri people, the largest Aboriginal group in central New South Wales. Her multidisciplinary work, often tinged with black humor, reflects on Australian culture, addressing issues of racial and gender discrimination, intergenerational injustice, environmental breakdown, and personal trauma. Dickens studied at the National Art School in Sydney under Roy Jackson (1944–2013). Beginning as a painter in the early 1990s, the artist later embraced a sculptural practice, repurposing found objects and scrap materials scoured from rubbish tips and street corners to create defiant assemblages and installations that reveal erased histories. Her visual language, characterized by rusty and timeworn materials, often juxtaposed with textile elements, draws on a long tradition of found objects in art. Dickens's *Pound-for-Pound* series is informed by research into Indigenous Australians who were exploited by mid-twentieth-century circuses and tent-boxing troupes and forced to conceal their Indigenous heritage. Each slender, freestanding sculpture references this history with a tasseled aluminum boxing glove mounted atop objects symbolizing the mistreatment of these young men: a crutch, scythe, boomerang, or, as here, a rifle stock. The skyward-punching glove evokes the Black Power salute and the fight for racial equality.—DT

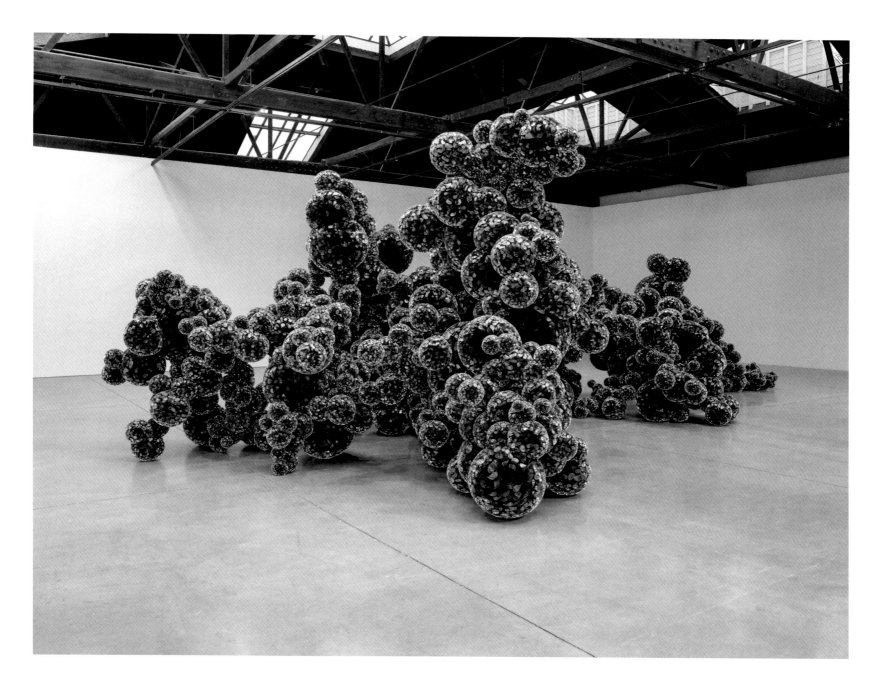

UNTITLED (MYLAR)
2011, Mylar and hot glue, dimensions variable,
site-specific installation for Pace Gallery, New York

Tara Donovan, born 1969, New York, USA.

Drawing on the legacies of post-Minimalism and Process art, Tara Donovan examines the boundaries of human perception, transforming everyday objects into sculptural forms by means of fragmentation, repetition, aggregation, and accumulation. Exploring the aesthetic potential of nontraditional and industrial materials such as disposable cups, aluminum screens, pins, toothpicks, pencils, and drinking straws since she was a student in the 1990s, the artist has developed a practice that spans sculpture, installation, drawing, and printmaking. In her work across mediums, Donovan uses a Minimalist vocabulary to harness the phenomenological idiosyncrasies and nuances of her materials. Her compositions evolve without a predetermined plan, as the artist explained in a 2006 interview with *Artnet*: "I develop a dialogue with each material that dictates the forms that develop. With every new material comes a specific repetitive action that builds the work." Ranging from small-scale studies of a given material to monumental works occupying entire spaces, Donovan's sculptures often feature intricate, undulating geometries that recall topographies or cloudscapes, as seen in *Untitled (Mylar)*. For this work, the artist twisted Mylar film into cones that she then arranged into spheres of varying sizes. These formations absorb and reflect the light around them, producing a range of tonal effects, from pale silver to black.—RM

SOKARI DOUGLAS CAMP

JESUS LOVES ME 2/2
2012, steel and acrylic paint, 61 ¼ × 33 ⅛ ×
24 ⅛ in. (155 × 84 × 61 cm)

Sokari Douglas Camp, born 1958, Buguma,
Rivers State, Nigeria.

Sokari Douglas Camp CBE has worked for over four decades, exclusively using sheet steel as a central material for her sculptures. Beginning with sketches and then progressing to welding in steel, Douglas Camp draws from both her Nigerian Kalabari heritage and wider aspects of African diasporic culture, particularly the re-emerging trope of the masquerade. Some of her sculptures use recycled oil barrels and one has fuel nozzles. Douglas Camp uses sheet steel to address sociopolitical issues including the legacies of slavery, issues of power and gender, and the climate crisis. In *Jesus Loves Me 2/2*, a striking female figure is captured mid-dance with her arms raised, gazing upward, and braided hair swaying from side to side. The sculpture is armorlike, yet parts of its welded surface are painted blue, pink, and brown, and its torso features a portrait of a Black man. The work is from the artist's *Jesus Loves Me* series that combines references to African immigrant churchgoers, dressed to the nines for Sunday service, with hip-hop and R&B dance poses. These life-size, celebratory sculptures speak to the collective resilience of Black communities past and present.—JD

THE GUARDS
2017, plastic, paint, fabric, and stockings,
dimensions variable

Mikala Dwyer, born 1959, Sydney, New South
Wales, Australia.

Over four decades, Mikala Dwyer has pursued an exploratory and exuberant practice that frequently manifests as organized chaos. Dwyer's eclectic sculptures have seen her activate materials as diverse and superficially antithetical as palm trees and polystyrene. There is, however, method in her "madness," which is guided by her conviction that "all matter is conscious," as quoted in the catalog for her 2017–18 retrospective at the Art Gallery of New South Wales. It is this belief in the alchemical and magical potential of materials that permeates the artist's otherworldly conjunctures, which invite viewers to revel in the unexpected. Dwyer's interest in the occult and other alternative knowledges, as well as her capacity to bring disparate elements into communion stems in part from the influences she absorbed from her Danish mother's modernist silversmithing and her father's experimental practice as an industrial chemist. Also discernible is an affiliation with the post-Minimal works of artists such as Lynda Benglis (p.42) and Robert Morris (1931–2018). This approach is evident in *The Guards* in which the folds of fabric evoke hard-edge paintings that have succumbed to gravity. Replete with masklike structures forged from heat-shrunk plastic, the sculpture assumes the form of castoff costumes, and alludes to the performances for which Dwyer is also known.—SL

ABASTENIA ST. LEGER EBERLE

GIRL SKATING
1907, bronze, 12 ⅞ × 11 ½ × 6 ¾ in.
(32.8 × 29.2 × 17.2 cm), Smithsonian American Art
Museum, Washington, D.C.

Abastenia St. Leger Eberle, born 1878, Webster City,
Iowa, USA. Died 1942, New York, USA.

As a child, Abastenia St. Leger Eberle made masks out of clay from her family's garden. Equipped with supplies and modeling materials gifted by one of her father's medical patients who was a sculptor, Eberle began copying local tombstones and memorials, the only public sculptures to which she had access in rural Iowa. The burgeoning artist moved to New York after high school and began classical training at the Art Students League in 1899. Eberle shared her first apartment with fellow sculptor Anna Hyatt Huntington (p.149) and would often venture to the tenements of the Lower East Side, trips that awakened in her an interest in the plight of immigrant women and children. *Girl Skating* marks the artist's first study of street life in the city and was made during a pivotal year for Eberle, who traveled to Naples, Italy, for two months to learn how to cast in bronze. Upon her return to the United States, the sculptor worked in a settlement house that aided newly arrived immigrants. Eberle's investment in the people she encountered in downtown Manhattan spurred her aesthetic interests and her work as a social reformer and suffragist, causes to which she would remain devoted for the rest of her life.—MS

NICOLE EISENMAN

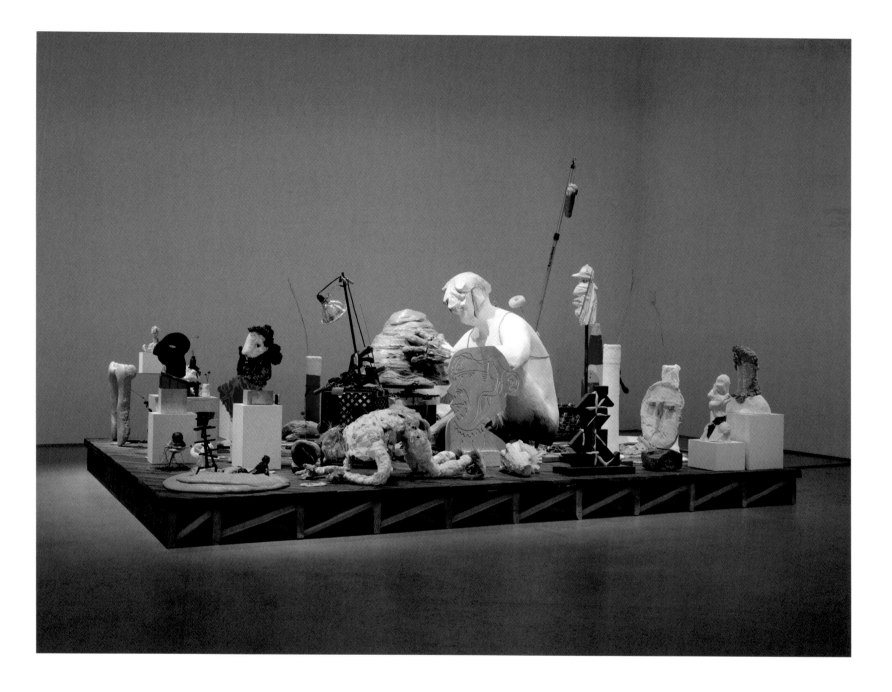

MAKER'S MUCK
2022, plaster, clay, seashell, etc., 103 ¼ × 120 × 155 ¼ in. (262.3 × 304.8 × 394.3 cm)

Nicole Eisenman, born 1965, Verdun, Meuse, France.

The child of a Freudian psychiatrist, Nicole Eisenman grew up in suburban New York. Although drawn to sculpture while at Rhode Island School of Design in the mid-1980s, she only returned to the medium in 2011. Since then, the artist, known for her radical figurative paintings that present complex, tragicomic narrative scenes, has developed a sculptural practice that extends the concerns of her two-dimensional work. In a 2019 talk at the Nasher Sculpture Center, Dallas, she explained that her commitment to figuration reflects how we gain knowledge of the world: "I understand my desires and anxieties through my body, and the desires and anxieties of our culture." Unlike the more mediated act of painting, Eisenman considers sculpture a direct, embodied pursuit. Figures, or personalities, recur in her work, as in the case of *Maker's Muck*, in which maquettes of existing pieces appear. Formally innovative and laced with irony, the vast assemblage centers on a kinetic potter's wheel; the viewer bears witness to an act of crude, unending creation. Surrounding the potter, a dizzying cast of characters speaks to Eisenman's deployment of art history and allegory to dissect contemporary culture, gender, politics, and communality, often through a psychoanalytical lens.—AC

VASKA EMANUILOVA

SEATED FEMALE FIGURE
1943, terracotta, National Gallery of Bulgaria, Sofia

Vaska Emanuilova, born 1905, Komshtitsa, Sofia,
Bulgaria. Died 1985, Sofia, Bulgaria.

Vaska Emanuilova is perhaps Bulgaria's most important woman sculptor, with a career that spanned six decades. After graduating from the State Academy of Arts in 1927, Emanuilova cofounded the Society of New Artists in 1931 and later joined the Association of Independent Artists, both collectives dedicated to developing a distinctly Bulgarian modern art. Working in a style of illustrative naturalism, Emanuilova obsessively captured forms in portrait busts and female nudes made of terracotta, which she favored for its rough and organic qualities. In a 1979 interview she proclaimed, "in works cast in bronze or hammered out of stone, originality is lost in the process. And with terracotta it remains—what the artist has done." The traditional recumbent silhouette of her *Seated Female Figure*, for instance, articulates a natural immediacy, as if it has only just been molded from the earth. After Bulgaria became a Soviet republic in 1946, Emanuilova was forced to abandon the nude for a Socialist Realist style. Inspired by the sculptures of Käthe Kollwitz (p.166), she infused her portrayals of shepherds and herdswomen with natural, emotional expression. By the 1970s Emanuilova had moved back to her native village and traded sculpting anonymous peasants for her neighbors, returning to the nude and a naturalistic idiom that celebrated the human form in Bulgarian life.—OC

TRACEY EMIN

THE MOTHER
2022, bronze, height: 29 ½ ft. (9 m),
Inger Munch's Pier, Oslo

Tracey Emin, born 1963, London, UK.

Working across painting, drawing, video, and sculpture, Tracey Emin's expansive practice explores the human condition with radical candor. Achieving notoriety for her early work *My Bed* (1988)—an installation of her unmade bed strewn with cigarettes, stained clothing, and condoms—her art is unflinchingly personal. From an early age, Emin has been fascinated by the work of Norwegian painter Edvard Munch (1863–1944), whose psychologically charged compositions inspired her to become an artist. In 2018, following an international competition, Emin's sculpture *The Mother* was selected to be permanently sited outside the Munch Museum in Oslo. In a 2020 interview with Jonathan Jones for *The Guardian*, Emin explained that as "Munch's mother died when he was very young . . . I want to give him a mother." Nestled among a meadow of wild flowers, the kneeling figure hunches over an invisible child and is Emin's largest work to date. In a White Cube press release announcing the sculpture's arrival overseas, Emin said: "*The Mother* sits like a Sphinx. Waiting for the tide. Looking out to sea, protecting the home of Munch. Her legs open towards the Fjord. She is welcoming all of nature." Rendering the creases and soft folds of the mature female body in bronze, the sculpture is a monument to both motherhood and aging.—CF

AYŞE ERKMEN

PLAN B
2011, water purification units with extended pipes
and cables, dimensions variable, installation view,
ILLUMInations, 54th Venice Biennale

Ayşe Erkmen, born 1949, Istanbul, Turkey.

Growing up next to the Bosphorus, Ayşe Erkmen developed a heightened sensibility to the forces
of nature that continues to inform her practice. She makes site-specific, immersive pieces that use
evanescent elements such as water and air to illuminate history and sociopolitical realities, imprinting
deeply upon collective memory. Often integrated into architectural features or appropriating indus-
trial materials, her artworks manipulate everyday objects and situations while employing spectacle and
humor. Her method of working involves a long process of distillation that results in a simplicity that
avoids didactics or documentary. *Plan B*, first installed at the 54th Venice Biennale in 2011, is highly
demonstrative of Erkmen's interests and approach. The artist created a fully functional apparatus
that diverted water from a canal visible from the exhibition space and cleaned it before returning it to
where it came from. This industrial filtration system was arranged in a circuit, with mechanical, sculp-
tural-looking structures linked using extended pipes, everything color-coded according to the part
it played in the process. Formally reminiscent of the network of canals that characterize Venice, *Plan B*
evoked daily systems and processes, from blood circulation to the flow of capital and resources.—RH

ECLIPSE from the series **MUROS DINÁMICOS (DYNAMIC WALLS)**
1968, lacquered wood, 79 ⅛ × 29 ⅞ × 28 ¾ in. (201 × 76 × 73 cm), Museu d'Art Contemporani de Barcelona

Helen Escobedo, born 1934, Mexico City, Mexico. Died 2010, Mexico City.

The daughter of an English mother and a Mexican father, Helen Escobedo moved to London at sixteen to study sculpture on a scholarship at the Royal College of Art. She began her career focusing on bronze as her preferred material, although she soon pivoted to a completely different approach, centering space and experimenting with environments in her sculptural and installation practice instead. Escobedo also worked across a range of mediums, including drawing, architecture, and design, and was recognized for her contributions to the Land art movement during the 1970s. In a quote that appears on the Museu d'Art Contemporani de Barcelona website referencing the works in her brightly colored *Dynamic Walls* series, one of which is shown here, the artist explained, "my intention is that my sculptures do not exist as works of art, but that they can be mass-produced in any dimension and in the necessary colors. They can serve as decorative elements, structural walls, or toys." Escobedo also devoted a great deal of her life to advancing the arts in her hometown of Mexico City, where she directed influential cultural institutions, such as the Museo Universitario de Ciencias y Arte and the Museo de Arte Moderno.—SGU

TAMAR ETTUN

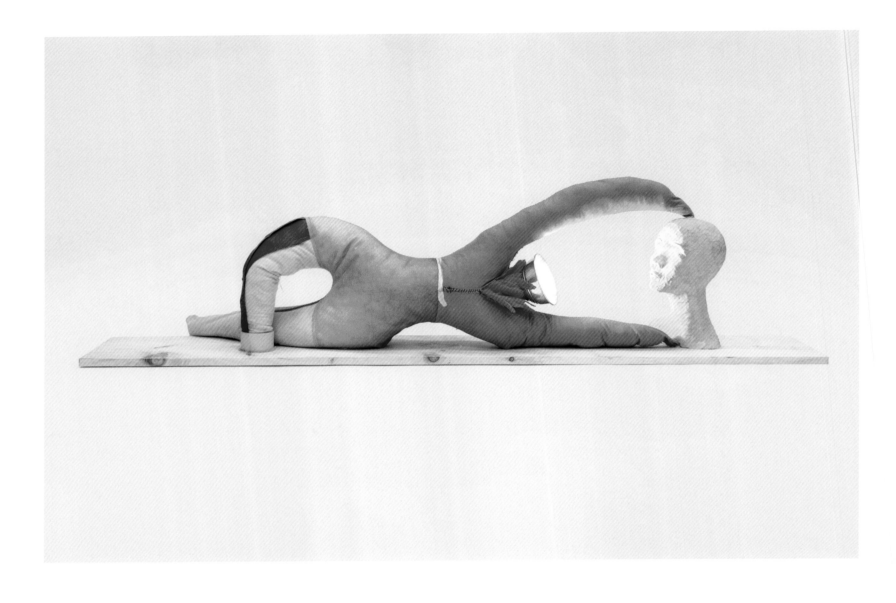

DOREEN from the series **THE CREATURES**
2018, fabric, thread, feathers, fiber fill, paint,
duct tape, wooden board, epoxy clay, clamp light,
lightbulb, and motion sensor light, 6 ½ × 14 × 73 in.
(16.5 × 35.5 × 185.5 cm)

Tamar Ettun, born 1982, Jerusalem, Israel.

Tamar Ettun's artworks probe concepts such as radical empathy, trauma, interdependence, secular and spiritual rituals, color symbology, and institutionalized violence. Ettun works between sculpture, performance, textiles, and drawing, often using parachute fabric to create inflatables and temporary installations. From 2013 to 2018 she led a performance collective with fellow artists, called The Moving Company. The group explored somatic empathy—a pre-intellectual understanding of others' feelings— through collaborative movement. Incorporating everyday objects, their works included improvisational play, durational tasks, and stillness. In 2016 Ettun said in a Fridman Gallery press release, "I see stillness as an expression of trauma that is repetitive and unchangeable. Trauma damages the ability of an individual to feel empathy towards the other." *Doreen* from the series *The Creatures*, a work that is activated by motion sensors, exemplifies Ettun's interactive and playful approach to sculpture. While her performances often include motionless moments, her sculptures distill dynamic gestures. Here, the form of a horizontal leaning body with crossed legs and a plume of orange feathers grips a plaster head, illuminated with a light. This hybrid of human, animal, and object invites multiple interpretations, releasing viewers from a prescribed narrative.—WV

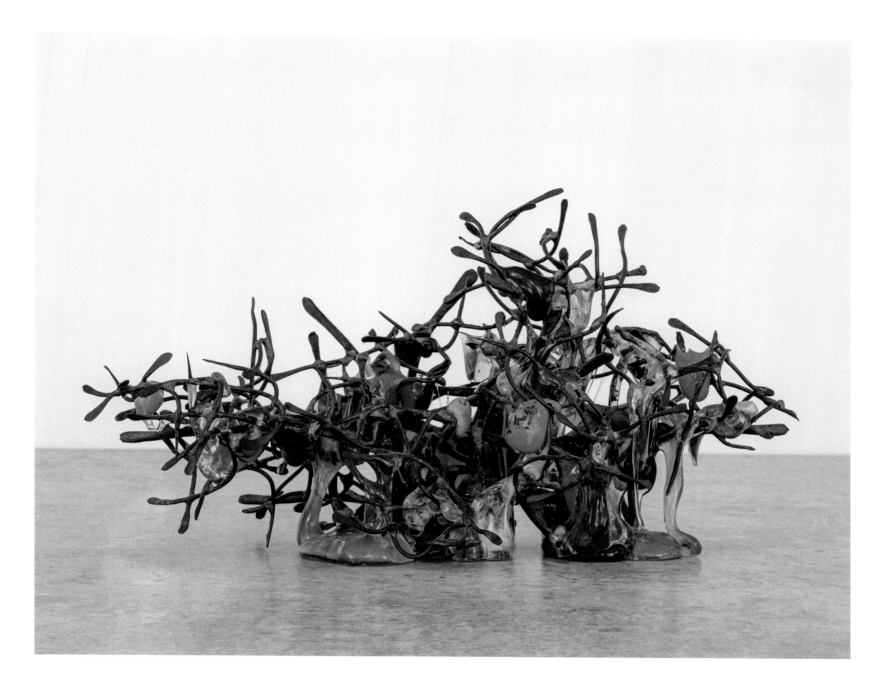

UNTITLED
c. 1970, copper and glass, 6 ⅞ × 13 × 6 ¾ in.
(17.5 × 33 × 17.1 cm)

Claire Falkenstein, born 1908, Coos Bay, Oregon,
USA. Died 1997, Los Angeles, California, USA.

In the 1930s and 1940s Claire Falkenstein was a fixture of the San Francisco Bay art scene. Her family moved there during her adolescence, and she subsequently studied, taught, and exhibited extensively at many of its institutions. Ceramic and wood sculptures sustained her until the mid-1940s, when metal became her primary material. She also began to make jewelry—such as hatpins and necklaces—and experimenting at a small scale helped her gain command of metal techniques that she would employ in her sculpture practice. Thus, Falkenstein was at the forefront of bringing these approaches, traditionally designated craft and gendered female, into the realm of fine art. In Paris, her headquarters from 1950 to 1962, she garnered support from avant-garde circles for her use of nontraditional materials and developed a mature sculptural style characterized by a lattice structure that she would adapt throughout her career. The calligraphic network of metal lines in these works—what Falkenstein called "wire delineations"—drew comparisons to the gestural freedom associated with Abstract Expressionist painting. Her deep engagement with Möbius strips, Klein bottles, and other non-orientable surfaces in mathematics informed her works' resistance to demarcating outside/inside and front/back. Increasingly embedding colored glass in sculptures such as *Untitled*, she also pioneered a method for fusing glass and metal.—AT

ALIA FARID

PALM ORCHARD
2022, plastic, concrete, metal and LED lights,
dimensions variable, installation view, *Quiet as It's
Kept*, 2022 Whitney Biennial, New York

Alia Farid, born 1985, Kuwait City, Kuwait.

Alia Farid works predominantly in film and sculpture to reflect on the everyday, recover histories, rituals, and traditions, and reconcile the past with the present. The time Farid spends with her chosen subjects is palpable: the relationships she develops with the protagonists of her films and the intimacy with which she treats objects bear a beguiling intensity. In all her work, the ecological crisis in the Arabian Gulf looms large; the ensuing scarcity of water and how this impacts people and landscapes is a recurring theme. The paternal side of Farid's family is from Kuwait as well as southern Iraq, an area renowned for its waterways and palm groves until the Iran–Iraq War (1980–8) began the accelerated decline of this area and its lush vegetation. Texturally, the artificial trees of *Palm Orchard* have nothing of the plants they represent. Tough, fibrous trunks are transformed into glowing, Vegas-style columns; lively fronds become spiky sticks that flash on and off like sparklers. Visually attractive, the immersive experience of walking between the trees enchants, notwithstanding the artist's description of the work for the 2022 Whitney Biennial as demonstrative of "how nature and landscapes are weaponized, harnessed, and destroyed by governments and extractive industries."—RH

FOURTH FAMILY HEXAGON
2013, reverse painted glass, mirrored glass,
and plaster, 42 ½ × 47 ½ × 14 ½ in.
(108 × 120.7 × 36.8 cm)

Monir Shahroudy Farmanfarmaian, born 1922,
Qazvin, Iran. Died 2019, Tehran, Iran.

Over a six-decade career of living and working in the United States and Iran, Monir Shahroudy Farmanfarmaian merged Islamic traditions of geometric ornament with the conceptual possibilities of interlocking shapes and arrangements. She was deeply influenced by the visual lexicon of Minimalism in 1950s New York, where she worked as a graphic designer. In the 1970s she embarked on her primary technique of mirror mosaic constructions, in which she shaped slivers of glass and set them in a plaster matrix with a predetermined pattern. The artist responded to the inherited visual traditions of her native Iranian culture, which has practiced the craft of patterned mirrored surfaces since the sixteenth and seventeenth centuries. In her *families* sculptures, Monir explores a single concept or form through varied polygon shapes. Her *Fourth Family* wall sculptures consist of eight interlinked mirrored low-relief forms from triangle to decagon. The mirrors looping around with no starting or end point create myriad reflections of any passerby. As Monir expressed in a 2011 interview with curator Hans Ulrich Obrist, "With the reflections, you're also a part of the art piece. Your own appearance, your own face, your own clothing—if you move, it is a part of the art. You're the connection: it is the mix of human being and reflection and artwork."—OZ

SIMONE FATTAL

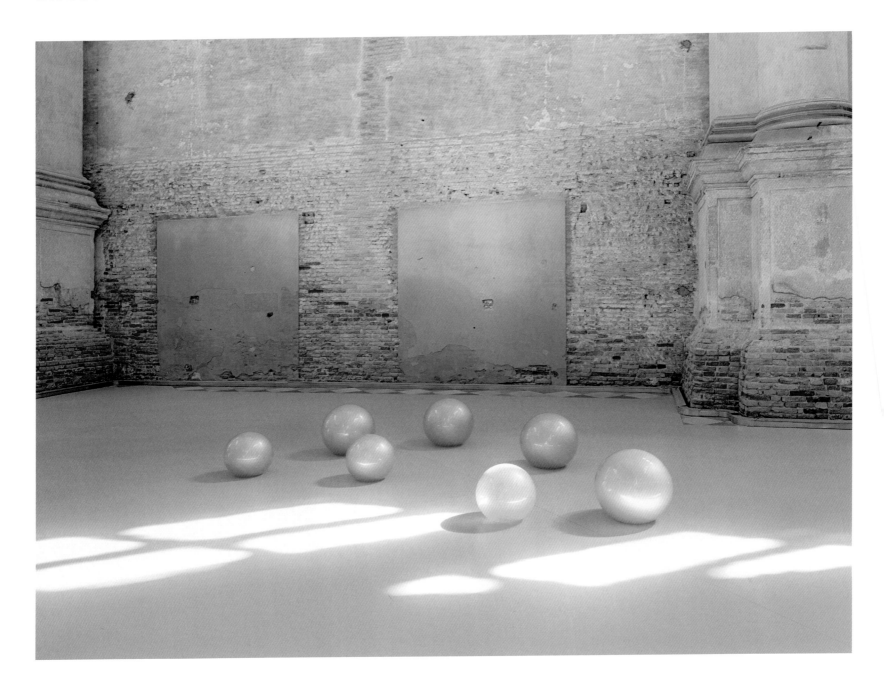

PEARLS
2023, 7 blown and hand-engraved Murano glass
pearls, dimensions variable, installation view, *Thus
waves come in pairs*, Ocean Space, Venice

Simone Fattal, born 1942, Damascus, Syria.

Motivated by her belief that present and past are eternally interwoven, Simone Fattal's practice
is based on a long view of history, one encompassing comingling narratives of people and place that
predate modern nation-states. After educational stints in both Lebanon and Paris, in 1969 Fattal
returned to Beirut where she first began to paint, working in pale, abstract forms derived from the
landscape surrounding her. At the outbreak of civil war, she and her partner, the artist Etel Adnan
(1925–2021), fled to San Francisco where Fattal founded the Post-Apollo Press and began her initial
experimentations with sculpture. Working primarily in ceramics, stoneware, and porcelain, Fattal
makes frequent references to literature and mythology, specifically seeking stories that transcend
contemporary borders, belonging more to a land or a region than a country. Made from Murano
glass, Fattal's seven pink pearls are engraved with an anonymous Florentine poem from the four-
teenth century, the "Contrasto della Zerbitana" (The Conflict with the Woman of Djerba). The text
is etched in lingua franca, a language historically used in Mediterranean ports that blends Italian,
Arabic, French, and Spanish. While referencing the dominance of the pearl trade, which served as
a main artery connecting East and West for centuries, Fattal's lettering argues that poetry remains
equally vital as a site for cross-cultural exchange.—MH

LAMPE DE L'ARCHANGE SAINT MICHEL (LAMP OF THE ARCHANGEL SAINT MICHAEL)
1830, bronze (patinated, gilded, silvered, and painted polychrome), glass, and lapis lazuli, 35 ³/₈ × 13 ³/₈ × 14 ¹/₈ in. (90 × 34 × 36 cm), Musée du Louvre, Paris

Félicie de Fauveau, born 1801, Livorno, Tuscany, Italy. Died 1886, Florence, Tuscany, Italy.

Perhaps the first-known French woman sculptor to make a living from her art, Félicie de Fauveau spearheaded a medieval revival in mid-nineteenth-century sculpture and decorative arts, becoming as famous for her independent lifestyle and monarchist devotion as her creative output. After relocating from Italy to France in 1827 at the height of the Bourbon Restoration, Fauveau learned painting and later taught herself sculpture. Rejecting the period's Neoclassical trends, she developed a passion for the art of the Middle Ages, translating medievalism into commissioned busts and reliefs of aristocrats, portraits of saints, and unique decorative pieces, such as the troubadour-style lamp pictured here, noted for its use of color and precious materials. When, in 1830, political upheaval replaced King Charles X with Louis Philippe I of Orleans, Fauveau became involved in the counterrevolution as a fervent Bourbon Legitimist, even designing heraldry-inspired emblems for other rebels. She was arrested and exiled to Florence in 1833, where she opened "casa Fauveau," her studio that became a successful business, producing not only sculptures, but objects as diverse as daggers, picture frames, sword hilts, and jewelry for tourists and the nobility. A generation before Rosa Bonheur (1822–99), Fauveau represents an early example of an independent woman artist, as well as a precursor to the Romantics' medieval-inspired synthesis of decorative and fine arts.—OC

LARA FAVARETTO

THE MAN WHO FELL ON EARTH
2016, 2 sculptures c. 400 kilos of confetti each,
35 ⅜ × 35 ⅜ × 35 ⅜ in. (90 × 90 × 90 cm),
installation view, *COLORI: Emotions of Color in Art*,
Castello di Rivoli Museo d'Arte Contemporanea,
Rivoli, 2017

Lara Favaretto, born 1973, Treviso, Veneto, Italy.

Lara Favaretto employs a variety of media to emphasize the impermanence of the art object, the ambivalence of aesthetic form, and the cyclical nature of time, often with an irreverent edge. Favaretto's works stand out for their formal precision and diversity of materials, which range from kinetic car-wash brushes to overhead scaffolding. With the 2009 installation *The Swamp*, she began her *Momentary Monument* project, where she makes sculptural interventions into public spaces to explore the spectrum of order and disorder, simultaneously using and critiquing the format of "permanent" commemorative monuments. In 2006 Favaretto started to create cubes made from confetti in the work *Only If You Are the Magician*. The contrast between form and material characterizes the later *The Man Who Fell On Earth*, which directly refers to the perfection and solidity of Minimalist geometry but is also made up of paper confetti, a perishable material susceptible to deformation or total disintegration as soon as the work is installed. Although initially simple and solid in space, the confetti cube's ephemeral nature leads to its inevitable decay, activating a tension in both the viewer and the area where it is installed. It is precisely this opening up of energy caused by destruction that drives Favaretto's work, as she pronounced to *Artforum* in 2012, "So often, art is made to be put in an institution and preserved in perpetuity under Plexiglas. Yet, to me, this model no longer makes sense."—TP

THE VIRGIN AND CHILD
1630–40, alabaster, 16 × 6 ¾ × 4 ¾ in.
(40.7 × 17.1 × 12.2 cm), Victoria & Albert
Museum, London

Maria Faydherbe, born 1587, Mechelen, Antwerp,
Belgium. Died 1643, Mechelen.

One of the earliest named woman sculptors in northern Europe, Maria Faydherbe carved religious artworks in the first half of the seventeenth century in Malines, now known as Mechelen, Belgium. In fact, she is the only seventeenth-century professional woman sculptor from this region whose signed pieces survive. The daughter of a brewer, Faydherbe became a sculptor alongside her two older brothers, although the identity of her teacher and nature of instruction is unknown. In addition to alabaster works such as this intricately carved religious sculpture of the Virgin and Christ Child, she also sculpted in wood. In her time, both alabaster and boxwood were luxury materials, and Faydherbe's use of them emphasizes her skill and esteem as a sculptor. Most of her surviving oeuvre, save a Crucifixion, depicts the Virgin Mary affectionately holding her child, as seen here. Even more unique for a woman artist from this period, an extant legal document from 1633 concerns her creative practice: in it, she critiques male members of the artists' Guild of Saint Luke in Mechelen after she was not accepted, though her artistic gifts are superior, particularly to those who mass-produced devotional works in stone and polychromed wood. In response, the men challenged her to a sculpting competition that never came to fruition. Based on Faydherbe's artistry illustrated here, however, modern readers can envision who would have emerged victorious.—ESP

RACHEL FEINSTEIN

THE SHACK
2001, wood, cedar shingles, wire, plaster, nylon fabric, mirror, gold leaf, and enamel,
125 × 91 × 74 in. (317.5 × 231.1 × 188 cm)

Rachel Feinstein, born 1971, Fort Defiance, Arizona, USA.

Drawing on references from Disney World to Rococo porcelain, Hollywood filmsets to pornography, Rachel Feinstein's multidimensional practice is preoccupied with how fantasy, identity, and taste are constructed. Feinstein plays with the disturbing and humorous collisions of two apparently antithetical worlds in works that challenge a quick dismissal of what may be considered "merely" ornamental, kitsch, or superficial. As the artist noted in a 2023 interview for *ArtReview*, "In my work, I like having reality present with fantasy at the same time." Through its title, its loping, Rococo forms, and contradictory mix of precious and cheap materials, *The Shack* suggests both destitution and luxury, use and superfluity. Part of an exhibition at Marianne Boesky Gallery in New York in 2001, the sculpture was shown alongside Feinstein's transformation of the rear gallery into a faux Rococo salon inspired by the imperial palaces of Munich and Vienna. Opulent and playful and yet reminiscent of the transitory nature of a theater set, *The Shack* and the exhibition probed both the pleasurable seduction and melancholic disappointment associated with fantasy and illusion. Feinstein's reworking of the Rococo—a style and period often condemned as frivolous and tasteless—is indicative of how she mines histories of taste and beauty to unsettle any notion that such concepts are "timeless" or "pure."—YN

SONJA FERLOV MANCOBA

**MASKE (KRIGENS UDBRUD)
(MASK (OUTBREAK OF WAR))**
1939, bronze with black patina, 13 ¾ × 11 × 5 ⅛ in.
(35 × 28 × 13 cm)

Sonja Ferlov Mancoba, born 1911, Charlottenlund,
Greater Copenhagen, Denmark. Died 1984,
Paris, France.

A long-overlooked figure of European modernism, Sonja Ferlov Mancoba is today recognized for her syncretic sculptures, which pair an idiomatic formalism with spiritual idealism. Initially trained as a painter in Copenhagen and aligned with Surrealism, she moved to Paris in 1936 and was greatly influenced by French avant-garde sculptors. There she met Ernest Mancoba (1904–2002), a Black South African modernist, and the two married in 1942 in a French transit camp following his internment by occupying forces. Shortly after, the Mancobas left postwar France for Denmark, where they became loosely affiliated with Cobra, a progressive movement that championed "spontaneous" art. While the couple's Danish period was productive, it was overshadowed by hostility toward their interracial marriage, and they grew increasingly reclusive. Returning to France in 1952, they continued to produce art in isolated poverty. Throughout her practice, Ferlov Mancoba was drawn to primitivist motifs, particularly that of the mask, in her pursuit of a universal spiritual substance. "The artist interprets the eternal reality of human nature," she wrote in an undated manuscript. Shaped in clay and plaster, only a handful of her sculptures—*Mask (Outbreak of War)* among them—were later cast in bronze. This early work, emblematic of her symbolic abstraction, anticipates the Nazi occupation of France in 1940.—LB

TERESITA FERNÁNDEZ

FIRE
2005, silk yarn, steel armature, and epoxy,
96 × 144 in. (243.8 × 365.8 cm), San Francisco
Museum of Modern Art

Teresita Fernández, born 1968,
Miami, Florida, USA.

Teresita Fernández is a sculptor who explores landscape writ large—the physical rocks and soil beneath our feet, an articulation of ownership or moral philosophy, and the material memory of historical violence. Born in Miami to Cuban parents living in exile, Fernández studied sculpture at Virginia Commonwealth University in Richmond before eventually moving to Brooklyn. Often described as a conceptual artist, Fernández harnesses multitudinous sculptural materials—charcoal maps that illustrate the migration of land masses or malachite and pyrite assemblages—to conjure what she referred to in a 2022 interview with the National Gallery of Art in Washington, D.C., as the "somatic remembering" of materials and land. Fernández undermines assumptions about the "American landscape," insisting on the specificity of what "American" has meant at different points in history and from different points of view and unpacking the political and expansionist interests embedded in the art historical concept of the sublime. Beyond firm materiality, Fernández follows the powerful processes that form land and landscape—water, air, and fire. Inspired by the walls of warp threads spread across large mechanical looms, for *Fire*, Fernández created an installation of silk yarn that evokes the dynamic behavior of fire. As the viewer circumambulates the sculpture, the threads shift to create the optical illusion of a dancing flame.—MK

UNTITLED (SOFT ROCKET)
1995, mixed media, 78 ¾ × 47 ¼ in. (200 × 120 cm)

Sylvie Fleury, born 1961, Geneva, Switzerland.

Sylvie Fleury began exhibiting in the early 1990s, gaining notable attention for her *Shopping Bag* series. First shown at the Galerie Rivolta, Lausanne, in 1991, for these works Fleury arranged a group of luxury designer shopping bags on the gallery floor, each containing their original purchased item, repurposed as a readymade artistic object. Over three decades, her varied artistic practice has explored gender, identity, and popular culture, often continuing to utilize the mechanisms of consumer culture. Fleury places strategies of advertising and fashion in dialogue with art history, and playfully questions the hegemony of the modernist art object. She has used the archetype of the rocket as the subject of her ongoing sculptural series, *First Spaceship on Venus*. By referencing Venus, a planet that is typically gendered as feminine, Fleury subverts the machismo mythology surrounding travel to outer space and science-fiction narratives. In works such as *Untitled (Soft Rocket)*, she fabricates the flying machine out of soft materials, with the sculpture slouching against the gallery wall, and also undermines the hyperbolic symbol of phallic masculinity, instead presenting a cartoonish, childlike rendering. Other notable rockets in the *Venus* series have been constructed from fiberglass, coated in shades of iridescent pink and red paint, with Fleury wryly courting associations with lipstick tubes and the apparatus of superficial femininity.—PE

CEAL FLOYER

MIRROR GLOBE
2014, ready-made mirror ball in modified globe
stand, 14 ⅛ × 11 ¾ × 11 ¾ in. (36 × 30 × 30 cm)

Ceal Floyer, born 1968, Karachi, Sindh, Pakistan.

Ceal Floyer's sculptures, films, and installations upend everyday objects, transforming them into absurd and wry statements, often reliant on a title pun. Graduating from Goldsmiths College, London, in 1994 in the early days of the Young British Artists generation, Floyer's constrained approach distinguished itself with its sophisticated and muted humor. Using a deceptively minimal aesthetic, Floyer has flipped over an umbrella and filled it with water, removed struts from an aluminum ladder, and glued lines of dominos across a gallery floor to create witticisms that, grounded in the poetics of the everyday, encourage sustained consideration and are aimed at inspiring existential musings. For *Mirror Globe*, in a characteristically concise and playful gesture, a ready-made disco ball is paired with a globe stand. The glistening and stationary orb replaces the familiar representation of the world and refreshes the object's function. Floyer is notoriously enigmatic about her work and cultivates an open approach that encourages her audience to provide its own readings. Here, perhaps, the coating of reflective tiles offers the possibility of centering the viewer in the work's conceptual interpretation.—CRK

BLUE GIRL WITH DEMONS
2018, Jesmonite, steel, fabrics, and mixed media,
50 ¾ × 24 ⅛ × 20 ½ in. (129 × 61 × 52 cm)

Laura Ford, born 1961, Cardiff, Wales, UK.

Laura Ford, in a 2016 interview with *The Independent*, described her humorous yet unsettling works as "sculptures dressed as people dressed as animals." Her artistic output manifests as a cast of imagined beings crafted in bronze, textile, ceramic, and found materials, often taking the form of humans merging with animals or with organic matter to form hybrid creatures. Ford plays with both material and conceptual ambiguity, cultivating a sense of the uncanny. She often subverts the appearance of materials and uses fabrics that convey an illusion of softness and comforting domesticity to shroud a hard, industrial structure of steel scaffold poles and Jesmonite. Her subjects—reminiscent of fanciful children's toys, myths, or fairy tales—suggest playfulness, while surprising details impress a sense of vulnerability or imminent threat. Ford grew up on a fairground and then a farm (formerly a zoo), so the whimsy and danger that coexist in the carnivalesque and animal folktales permeate her work. Her sculptures are reflections of unguarded psychological states, as seen in *Blue Girl with Demons*, in which a cartoonlike figure with knitted blue flesh stoops forward, her arms overflowing with demonic creatures who clamber over her. The figure is overpowered by these strange long-legged beings; as the title suggests, the surreal scene brings to life a subconscious state.—LJ

MARÍA FREIRE

FORMA AMARILLA (YELLOW FORM)
1970, painted wood, 25 ¾ × 5 ⅞ × 1 ¾ in.
(65.5 × 15 × 4.5 cm), Museo de Arte
Contemporáneo Atchugarry, Manantiales, Uruguay

María Freire, born 1917, Montevideo, Uruguay.
Died 2015, Montevideo.

A pioneer of the Uruguayan Concrete art movement, María Freire realized a distinctive approach to color, geometry, and movement through her practice. Having studied painting and sculpture at the Círculo de Bellas Artes in Montevideo from 1938 to 1943, Freire became interested in abstraction in the 1940s. Informed by Cubism as well as African and pre-Columbian art, she developed a characteristic visual vocabulary, relying on elementary shapes and primary colors combined with anthropomorphic references. In 1950 Freire came into contact with Arte Madí, a group of artists based in Buenos Aires who produced irregularly shaped canvases and denounced figurative painting. Soon after, in 1952, she cofounded the Grupo de Arte No Figurativo with José Pedro Costigliolo (1902–85) and participated in the first exhibition of nonfigurative art in Montevideo. After encountering the work of internationally renowned abstract artists at the Bienal de São Paulo in 1953, Freire traveled to Europe in 1956, where she became well versed in European Constructivism and geometric conventions in Western culture. Her art introduced an industrialist aesthetic previously unseen in Uruguay, in which artisanal elements were favored over hard abstraction. Later works by the artist reflect her growing interest in color, symbolism, and totemic forms, as exemplified in *Yellow Form*.—JM

EXPOSED ANGER
1988, terracotta, 11 × 12 ⅛ × 6 ½ in.
(27.9 × 30.5 × 16.5 cm)

Nancy Fried, born 1945, USA.

The visceral sculptures of Nancy Fried evoke the body—especially the nude feminine form—and its capacity for pleasure, pain, love, and transformation when confronted with dislocation or disfigurement. In the wake of the feminist movements of the 1960s and 1970s, Fried's artwork questioned the standards imposed on the female body, ideals of beauty, and societal expectations about womanhood. The artist draws on autobiographical experiences, such as her trauma as a woman who has undergone radical mastectomy, bilateral ovarian cystectomy, and an appendectomy, and embraces these procedures' effect on her physical selfhood to redefine female beauty as a dissident body. Since 1986 Fried has been creating terracotta torsos of women and often uses herself as the model. In a 1995 statement for *Feminist Studies*, she declared: "My work dealt with having had breast cancer, the loss of a breast, the emotions that were part of the process of healing." The raw intensity of these feelings is clearly visible in pieces like *Exposed Anger*, which are often headless with a single breast and screaming or pained faces. Although Fried also works beyond the self-portrait, exploring other emotions and erotic tones, her sculptures upset the art historical tradition of the nude, mourning and celebrating a new universal form through vehemently unidealized figures.—TP

ELISABETH FRINK

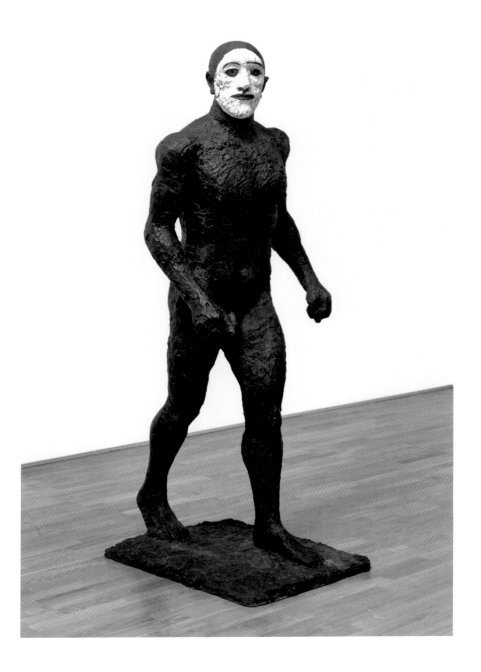

RIACE I
1986, bronze, 83 ½ × 31 ½ × 39 ¾ in.
(212 × 80 × 101 cm), Tate, London

Elisabeth Frink, born 1930, Great Thurlow, Suffolk,
UK. Died 1993, Blandford Forum, Dorset, UK.

The terrors of World War II marked Elisabeth Frink's upbringing. Her father was a decorated brigadier in the British army, and her family lived near an airfield in the Suffolk countryside, where she witnessed aerial bombardments. While attending Chelsea College of Art from 1949 to 1953, she fixed on what was to be a lifelong preoccupation with conflict and cruelty as expressed in bronze sculptures of both animals and solitary male figures. While still a student, the Tate Gallery in London acquired her menacing *Bird* (1952), and birds continued to be important subjects for Frink's investigation of aggression, connecting her loosely with the Geometry of Fear artists, a group of British sculptors attuned to the postwar anxieties of the atomic age. Frink's sculptures of men (usually naked, muscular, and either sitting, standing, or striding) are pared down in both form and emotional range. Her textured and sometimes painted surfaces enhance the confrontational presence of these men, as evident in the *Riace* warriors, a group of four bronzes she produced between 1986 and 1989. Inspired by the fifth-century Greek bronzes of ancient mercenaries that were discovered off the southern Italian coast in the 1970s, Frink's series sought to capture the contradictory qualities of humankind, conveying the potential for both violence and vulnerability.—AT

OKTOPUS (OCTOPUS) (DETAIL)
2006/9, metal, polyester, acrylic paint, and wood,
55 ⅛ × 47 ¼ × 47 ¼ in. (140 × 120 × 120 cm)

Katharina Fritsch, born 1956, Essen, North Rhine-
Westphalia, Germany

Katharina Fritsch upends viewers' expectations by transforming familiar imagery into uncanny sculptures using shifts in scale, color, and texture. Fritsch's sculptures of rodents are larger than life, and depictions of religious iconography are rendered in bright monochromes. The artist draws inspiration from a variety of sources, including fairy tales, myths, domestic objects, art history, and her own memories. As she told the *New York Times* in 2020, "I think everything can be a sculpture for me. From the beginning, I wanted to create a kind of middle world that took you behind the object again by yourself, a world that really surprises people like they haven't seen the object before." To produce her carefully crafted sculptures, Fritsch casts detailed molds in both plaster and polyester, resulting in lush, tactile, and finely textured surfaces. These are painted with matte, mostly self-made paint in saturated custom colors spanning from fluorescent yellows to deep blacks. *Octopus* is inspired by a childhood memory; in jest, Fritsch's father would show the frightened young artist a vivid and detailed image of an octopus. Despite its playful and seductive bright orange color, this specimen has a miniature black-suited diver firmly within its clutches, commanding attention and authority in its sterile surroundings. —MM

META VAUX WARRICK FULLER

BUST OF A YOUNG BOY (SOLOMON FULLER, JR.)
1914, painted plaster, 18 × 11 × 7 ⅜ in.
(45.7 × 27.9 × 19.4 cm), Danforth Art Museum
at Framingham State University, Massachusetts

Meta Vaux Warrick Fuller, born 1887, Philadelphia,
Pennsylvania, USA. Died 1968, Framingham,
Massachusetts, USA.

Educated in Philadelphia but influenced by France's Post-Impressionist avant-garde, Meta Vaux Warrick Fuller forged a singular path during a crucial time in African American history. Fuller moved to Paris in 1899, becoming a protégé of Auguste Rodin (1840–1917) and collaborator of sociologist and civil rights activist W. E. B. Du Bois. There, she honed a politically conscious and realist style that captured the pathos of human suffering. Once back in the United States, she was commissioned by the federal government for official commemorations, her figurative sculpture ranging from the intimate to the monumental. While perhaps best known for her Egyptologically inflected *Ethiopia* (1921)—a touchstone of the Harlem Renaissance during the 1920s—this bust of her son is emblematic of Fuller's approach. Working from a private studio in Framingham, she built up likenesses from plaster, juxtaposing zones of rough materiality and high finish. She often applied paint to their surfaces for a polychromatic effect not unlike that found in Mediterranean antiquity. While earlier projects were notably dreamlike, shot through with gothic undertones, later works such as this center Black subjects, many drawn from her own orbit, rendered with self-possessed serenity. While Fuller's art cannot be easily reduced to one movement, it was an important beacon at a time of renewed violence, activism, and cultural reinvention in the United States.—IB

SUE FULLER

STRING COMPOSITION #530
1965, lucite sheet, silk thread, and plastic on plywood base with fluorescent light fixture, overall 23 ⅝ × 25 ¹/₁₆ × 6 ¼ in. (60 × 63.7 × 15.9 cm), Whitney Museum of American Art, New York

Sue Fuller, born 1914, Pittsburgh, Pennsylvania, USA. Died 2006, Southampton, New York, USA.

Over the course of her career, Sue Fuller explored printmaking, glassmaking, calligraphy, and lace-making, integrating the techniques culled from these various approaches into her artworks. Early on, Fuller studied at the renowned experimental printmaking workshop Atelier 17 in New York and with Bauhaus artist Josef Albers (1888–1976). Albers impressed upon Fuller the core tenets of the Bauhaus philosophy, emphasizing geometric and simplified forms. Fuller began her career as a print-maker, creating works using soft-etching techniques that bore the imprint of stretched, warped, and knotted textiles. She used a variety of fabrics, including string, netting, lace, and thread to create intricate and textured compositions. In 1950 Fuller transitioned from printmaking to sculpture, moving away from depicting fabric in relief and toward presenting layered textile artworks in three dimensions. The resulting sculptures, such as *String Composition #530*, are balanced compositions of taut lines and fragmented negative space. Fuller highlighted the delicate tension of the silk filaments while rendering them solid and immovable, suspending them between sheets of plastic with built-in lighting, a technique she patented in 1967.—MM

ANYA GALLACCIO

DOUBLE DOORS
2003, double door, 100 *Gerbera* daisies, wood,
and glass metal fixings, 108 ¼ × 67 ¾ × 2 ⅞ in.
(275 × 172 × 7.2 cm)

Anya Gallaccio, born 1963, Paisley, Scotland, UK.

Mindful that our experience of modern life is increasingly mediated and sanitized, Anya Gallaccio creates sculptures and installations that confront viewers with the realities of death and decay. Her transitory works, made with perishable materials such as flowers, fruit, chocolate, ice, and salt, are left to decompose over time, often leaving little or no trace of their original form. After studying at Kingston Polytechnic in London, Gallaccio attended Goldsmiths College, emerging as part of the influential generation of Young British Artists. Combining influences from Minimalism and Land art while referencing the tradition of memento mori, her projects have involved leaving a ton of oranges to rot in a gallery; painting a room with chocolate; and pouring molten sugar onto the floor of Tate Britain's Duveen Galleries. In *Double Doors*, a colorful arrangement of daisies is pressed between panes of glass in a pair of old doors. As the plants wither and decompose, their bright colors fade, leaving behind a pungent mass of putrefying matter. As with most of Gallaccio's works, the sculpture's appearance shifts constantly, beyond the artist's control. Existing for a moment in time, it is preserved in the memory of those who experienced it.—DT

CÓPULA CÓSMICA (COSMIC COPULATION)
1970, bronze, 21 ⅝ × 8 ⅝ in. (55 × 22 cm), Museo
de Artes Visuales, Santiago

Lily Garafulic, born 1914, Antofagasta, Chile. Died
2012, Santiago, Chile.

A sculptor who also had a significant output of works on paper, Lily Garafulic was part of Chile's
Generación del 40, a group of artists who graduated in 1940 for whom Impressionism and Fauvism
were inspirational art movements, and who gained public recognition at the Official Salon exhibition
at Santiago's Museo Nacional de Bellas Artes in 1941. In 1944 Garafulic was awarded a Guggenheim
Fellowship in New York, where she studied at the printmaking workshop Atelier 17. Her versatility with
sculptural materials led her to work in marble, terracotta, wood, bronze, and stone, which she used
for a series of sixteen monumental statues representing prophets for the Basílica de Lourdes in Santiago,
where they encircle the base of the main dome. Garafulic was appointed Director of the Museo Nacional
de Bellas Artes in 1973, a position she held until 1977, and in 1995 she was the recipient of the prestigious
National Art Award. In this work, which displays the symmetry and archetypal symbolism often found in
Garafulic's work, a pair of nearly identical, but inverted polished bronze forms are set on marble blocks,
their biomorphic curves anticipating a union that the work's title, *Cosmic Copulation*, confirms as a sexual
and universal event.—EDW

ADEBUNMI GBADEBO

Employing Black people's hair as a medium, Adebunmi Gbadebo roots her practice in the individuals, history, and culture of the African Diaspora. By using this nontraditional material containing human DNA, the artist connects her paintings, sculptures, and prints to Blackness while intentionally avoiding representation. A visit in 2020 to the Lang Syne and True Blue Plantations in South Carolina, where her enslaved ancestors were forced to cultivate indigo, cotton, and rice, marked an important turning point for Gbadebo. As a way of commemorating her family lineage, she created a series of monumental, blue-dyed collaged paintings and ceramic vessels that incorporated soil from the land where her ancestors labored and were buried. Gbadebo's vessels were included in the Metropolitan Museum of Art in New York's acclaimed 2022 exhibition *Hear Me Now: The Black Potters of Old Edgefield, South Carolina*, which juxtaposed the work of contemporary artists with nineteenth-century African American potters. This emotive sculpture, whose lyrical title is taken from the text marking a grave at True Blue cemetery, resembles something between a gravestone and a funerary receptacle. Human hair sprouts through fissures in the unglazed clay made from the cemetery soil in a tribute to the resilience of the artist's ancestors. The work becomes a repository of memory and trauma, a kind of family archive.—EF

SPHERE
1959, welded brass and painted steel, diam: 22 in. (55.7 cm), Museum of Modern Art, New York

Gego, born 1912, Hamburg, Germany. Died 1994, Caracas, Venezuela.

Born Gertrud Goldschmidt, Gego graduated in engineering from the University of Stuttgart, Germany, in 1938. The following year, she moved to Venezuela to escape Nazism. After working in design, architecture, and landscaping, Gego turned to the visual arts in 1953. In less than a year her work evolved from figuration to abstraction. At this point she was already interested in the relationship between line and space. Living in Caracas since 1956, her work was encouraged by Venezuelan proponents of geometric abstraction such as Alejandro Otero (1921–90) and Jesús Rafael Soto (1923–2005). Despite producing a significant body of drawings and prints, Gego's radical contribution came in the field of sculpture, with the creation of open-form works using small, linking metal pieces to create netlike structures. For her *Reticulárea* series, first exhibited in 1969 at the Museo de Bellas Artes in Caracas, she made weblike installations that occupied the exhibition space in an original way and extended her interest in the interaction of geometric forms with space, light, emptiness, and the gaze, seeking to make the invisible visible through perceptual abstraction. *Sphere* was included in the important 1965 exhibition *The Responsive Eye* at the Museum of Modern Art in New York, alongside work by other Op and kinetic artists.—TP

ISA GENZKEN

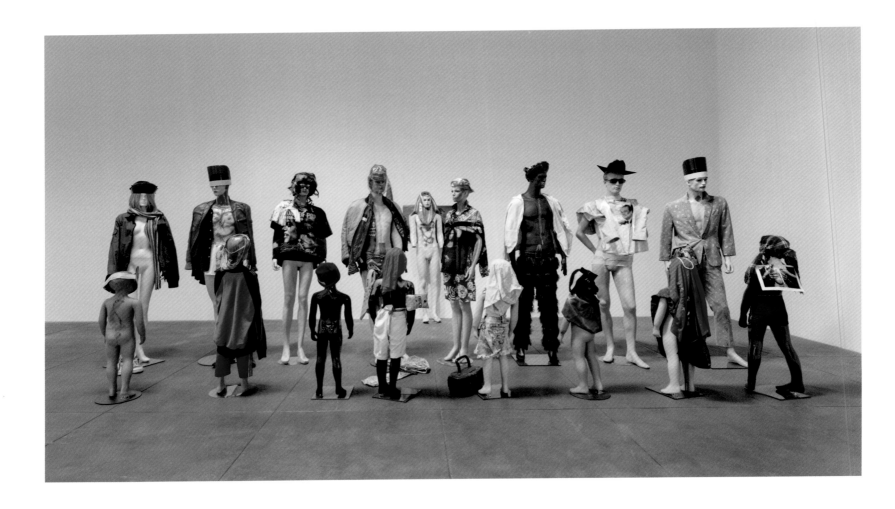

SCHAUSPIELER (ACTORS)
2016, 17 mannequins, mixed media, fabric, leather,
wool, shoes, wigs, sunglasses, lampshade, sunshade,
plastic, printed paper, mirror foil, lacquer, tape,
radio, and glass, dimensions variable

Isa Genzken, born 1948, Bad Oldesloe, Schleswig-
Holstein, Germany.

Since the 1970s Isa Genzken's pieces have redefined sculpture by escaping the confines imposed
by modernism. Focused on materiality, objecthood, and exhibition methodology, the artist's oeuvre
is characterized by its diversity and intentional perspective that cuts through the multitudes inherent
to her works. Influenced by a love for film and modern urban cities, Genzken's practice primarily
consists of sculptures and installations that construct dislocated narratives by way of surprisingly
beautiful assemblages of unforeseen objects. Her work reflects the contemporary condition of our recent
past and immediate present, as observed in the contradictory shifts between critique and humor, horror
and beauty, color and absence, harmony and chaos, mass media and high art. Despite these, one can
find clear critical statements within her meticulously placed plastic montages. Genzken's ongoing series
Actors features staged mannequins dressed in the artist's clothes and other generic accessories of street-
wear. The use of paint and the real-life scale of the figures animate the sculptures, humanizing the figures
and thus making them more relatable. Working as a kind of mirror, the piece speaks about representation
through portraiture in a media-saturated world. Not interested in readymades, but rather in the meaning
of the sum of the parts, Genzken's sculptures embody a familiar yet uncanny narrative.—LO

**SKINNER AND THE WASHERWOMAN
IN THE GARDEN OF EDEN**
2022, mixed-media assemblage, 39 × 26 × 15 ¼ in.
(99.1 × 66 × 38.7 cm), Mount Holyoke College Art
Museum, South Hadley, Massachusetts

vanessa german, born 1976, Milwaukee,
Wisconsin, USA.

A self-described citizen artist, vanessa german is as much engaged with sculpture, performance, photography, and ritual as she is with community, exploring art as an act of healing and restorative justice. She credits her mother, Sandra German (1948–2014), a fiber artist, quilter, and activist, with instilling within her children faith in the strength of the imagination and a capacity to be creative. german founded Love Front Porch in 2011 and ARThouse in 2014, arts initiatives that invited community members to her home and communal studio in her then-neighborhood of Homewood, Pittsburgh. Strolls around Homewood are a source for the fabric, beads, wood, glass, charms, and other found materials she incorporates into what she calls "power figures," such as *SKINNER AND THE WASHERWOMAN IN THE GARDEN OF EDEN.* Also drawing inspiration from Nkisi sculptures and folk art traditions, the artist has described these figures as protectors of Black people as well as manifestations of freedom. In a 2023 interview with writer Spencer Bailey, she noted, "Being an artist is a complete human identity. It is not merely a vocation. It actually isn't even a practice. It is a way of being alive as a human being. So yes, my survival is here, my existence is here, but also my *insistence* is here. My *resistance* is here. My medicine is here. That is a wholeness."—MKM

SONIA GOMES

UNTITLED (TORÇÃO SERIES) | SEM TÍTULO (SÉRIE TORÇÃO)
2021, stitching and bindings, various fabrics and laces, and galvanized wire, 44 ½ × 32 ⅝ × 18 ⅛ in. (113 × 83 × 46 cm), Pérez Art Museum Miami, museum purchase with funds provided by Jorge M. Pérez

Sonia Gomes, born 1948, Caetanópolis, Minas Gerais, Brazil.

Through a practice that incorporates touch, time, and an acute sensitivity to material—specifically, clothes and fabric pieces that are gifted to or found by the artist—Sonia Gomes constructs biomorphic works of sculpture that serve as both conduits for and repositories of memory. The artist's treatment of fabric acknowledges the often-anonymous histories of female labor, both emotional and physical, upon which so much of the world relies; yet Gomes also views this fabric as imbued with the stories and life force of those who wore or utilized the material before it comes to her hands. Her own work honors and extends these legacies through careful manipulation, as seen in her *Torção* series, where she wraps, torques, bunches, ties, stretches, and sews bits of fabric and lace around irregularly shaped armatures made of wire. *Untitled*, from this series, hangs from the wall like a fantastical multi-textured web, a taut circulation system capturing memory, labor, and lived experience.—AR

CARMEN
1949, plaster, 23 ⅝ × 12 ¼ × 7 ⅞ in.
(60 × 31 × 20 cm), Dorich House Museum,
Kingston University, London

Dora Gordine, born 1895, Liepāja, Kurzeme,
Latvia. Died 1991, Kingston upon Thames,
Greater London, UK.

The first woman sculptor to have work acquired by the Tate collection in 1928, Dora Gordine was renowned for her charismatic portraits and figurative works in bronze. Born in Latvia to a Jewish family and raised in Estonia, Gordine joined the Noor Eesti (Young Estonia) artist group as a young woman in Tallinn and later settled in Paris, earning a place at the prestigious Ecole des Beaux-Arts in 1928. She also traveled extensively throughout her life, living in Singapore in the early 1930s and visiting Cambodia, Thailand, Malaysia, London, and Paris. Gordine integrated the forms and techniques culled from these regions into her artworks, many of which feature visual and titular references to Southeast Asian and Estonian culture, as well as the Art Nouveau movement. In 1935 Gordine moved to London, where she quickly became famous for her spirited bronze busts, varying the sculptures' patina and finish to better represent the sitter. In addition to her signature heads, Gordine sculpted figures, often shown in dynamic poses that evoke a sense of movement. *Carmen* demonstrates Gordine's graceful depiction of motion through the dancer's asymmetrical pose, as well as her ability to realistically render the weight and form of the human body even in the lighter medium of plaster.—MM

SHEELA GOWDA

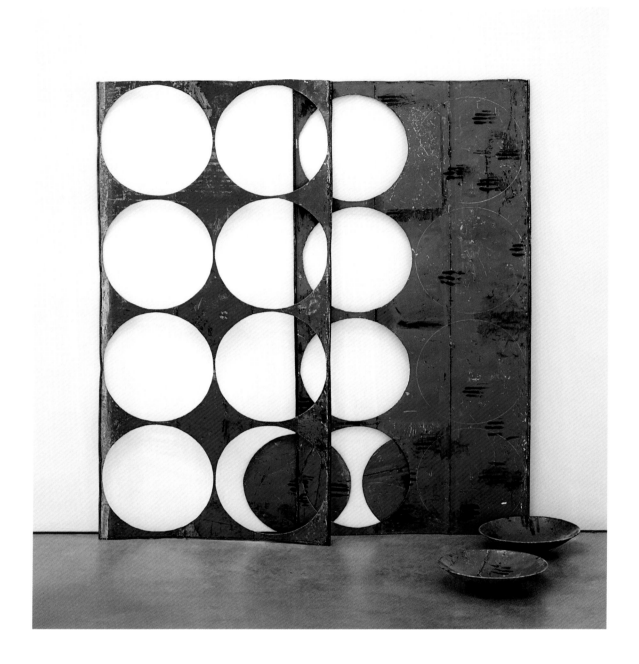

WHAT YET REMAINS
2017, recycled metal drums, dimensions variable,
installation view, Ikon Gallery, Birmingham, UK

Sheela Gowda, born 1957, Bhadravati, Karnataka,
India.

Sheela Gowda's turn to sculpture, after completing her master's degree in painting at the Royal College of Art, London, was provoked by India's economic boom in the 1990s and the rise of reactionary politics in the country. Finding an inability to articulate her response to these stark ideological changes through painting alone, Gowda began working with the commonplace objects surrounding her to produce engulfing installations. Ranging from cow dung to human hair, incense ash, and tar drums, Gowda's materials often have symbolic associations that speak to ritual practices, faith, and the politics of labor. The flattened metal drums, once filled with tree resin and now cut away, that comprise part of *What Yet Remains* are evocative of manual production processes. Each circle is cut by hand and compressed into the shallow bowls (*bandlis*) laid in front. The vessels, used in construction to ferry building matter including cement, are stand-ins for India's workforce. Their shape and holding capacity are conducive to the human form, and in their presentation, Gowda signals to India's pace of urban development and the threat to these nonindustrialized methods.—CRK

SUNSET LIGHT
1967, neon, Plexiglas, and steel,
86 ¼ × 11 ¾ × 11 ¾ in. (219 × 30 × 30 cm)

Laura Grisi, born 1939, Rhodes, South Aegean,
Greece. Died 2017, Rome, Italy.

The variety of Laura Grisi's artistic practice over time defies easy categorization—she has been linked to movements including Pop art, Arte Povera, Minimalism, and Op art, among others. Born to Italian parents, Grisi studied art in Rome and Paris before marrying an Italian documentary filmmaker, Folco Quilici (1930–2018). Initially, she dedicated herself to documentary photography but, in the mid-1960s, she began to explore approaches to painting. She attracted attention for her *Variable Paintings*, consisting of sliding panels that the viewer could move to alter the image, and *Neon Paintings*, which incorporated materials such as Plexiglas and neon lights. In fact, Grisi was one of the first artists to experiment with neon. Her brightly colored paintings are usually associated with Pop, but she was simultaneously using the same materials to make overtly Minimalist sculptures such as *Sunset Light*. Installation was also becoming an important part of her practice: on one occasion, Grisi presented these Plexiglas columns on steel bases filled with tubes of glowing neon in an environment filled with artificial fog. While the phases of Grisi's work may seem discrete, they are united by a deep fascination with the nature of perception—especially how it alters depending on the viewer's vantage point and the surrounding conditions.—GS

NANCY GROSSMAN

UNTITLED
1968, leather, wood, epoxy, and metal hardware,
16 ⅞ × 7 ½ × 8 ¾ in. (42.9 × 19.1 × 22.2 cm)

Nancy Grossman, born 1940, New York, USA.

Raised on a farm in Oneonta, New York, by parents working in the garment industry, Nancy Grossman developed an affinity for textiles at an early age. In 1962 the artist completed her studies at Pratt Institute in Brooklyn, and at the age of twenty-three, had her first solo show at Krasner Gallery, displaying paintings and collages that reflect the favored abstract style of the time. In 1965 she began incorporating leather into her assemblages, thanks to a gift from the artist and mentor David Smith (1906–65). Although she mastered various disciplines, Grossman became best known for busts such as *Untitled*. Carved out of found wood, covered in enamel and leather, and adorned with metals such as zippers, buckles, and straps, these erotic sculptures recall the aesthetics of sadomasochistic tendencies, operating at the intersection of sexual pleasure and violence. Despite giving prominence to the male body, Grossman considers the series self-portraits, suggesting an embrace of gender fluidity and underscoring feminist principles of subjectivity. In the 1970s, at the height of the women's liberation movement and following the intensified opposition against the war in Vietnam, Grossman began strapping axes and guns to her iconic heads, shedding light on the connections between the body and sociopolitical acts of protest.—JM

INKSTONE WITH PHOENIX DESIGN
c. 1700s, limestone, 5 ¹⁄₁₆ × 3 ¾ in. (12.9 × 9.5 cm),
Metropolitan Museum of Art, New York

Gu Erniang, flourished 1700, China. Died c. 1727,
probably Suzhou, Jiangsu, China.

Gu Erniang was an eighteenth-century Chinese inkstone artist who lived in the Zhuanzhu xiang area
of Wumen, now modern-day Suzhou in Jiangsu province, during the Qing dynasty and the reign
of the Kangxi Emperor. Married into a family of inkstone carvers, where she learned and refined her
artistry, she was famous in her time and is considered one of the finest and most innovative Qing-
period artisans. Inkstones are ubiquitous and deeply significant in East Asian material culture, but
the object is lesser known in the rest of the world. Inkstones, often bearing carved texts and images,
are instruments used by writers and painters to grind and hold ink "before the invention of the
fountain pen," as explained by Dorothy Ko in her 2019 lecture "Gender and Material Culture: The
Female Artisan Gu Erniang and the Craft of Inkstone-Making in Early Modern China" at Cornell
University. Additionally, the inkstone is a collectible object of art, a token of exchange between
friends or sovereign states. *Inkstone with phoenix design*, attributed to Gu, was carved and polished
from a limestone rock. The phoenix was a popular motif in the artist's work, alongside swallows
and apricot blossoms.—PE

GUAN XIAO

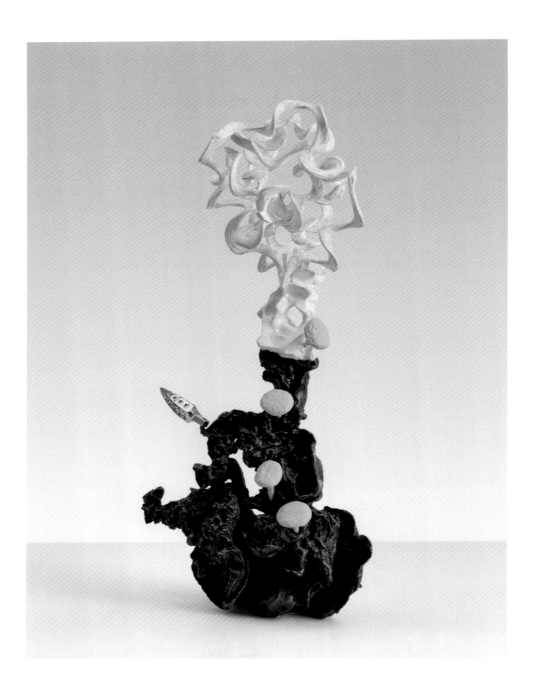

MUSHROOM
2021, brass, stainless steel, and burnt acrylic color,
37 × 18 ½ × 11 ⅜ in. (94 × 47 × 29 cm)

Guan Xiao, born 1983, Chongqing, China.

Combining industrial materials with ancient artifacts and historical visual references, Guan Xiao's sculptures and installations marry both visual and conceptual dichotomies, destabilizing the viewer's perception of technological progress and, most especially, of what is considered "new." Professionally trained in film, Guan picked the discipline initially due to the flexibility it afforded her. Studying at a time when art students in China were rigorously focused within their medium of choice, cinema allowed her to experiment with a more interdisciplinary approach. Across her work, Guan continually investigates how context—temporal, geographic, and cultural—furnishes an identity or an object with meaning. Where her videos are meticulously planned, Guan's sculpture is more spontaneous, juxtaposing found and recast objects in quirky assemblages such as *Mushroom*. While aspects of the piece are fleetingly familiar—the silver blade glinting with undertones of science fiction, or the rootlike structure atop which the sculpture blooms—the total effect is otherworldly. The work, consistent with Guan's wider practice, makes the case that understanding is fluid, entirely dependent on the perspective from which an object is viewed.—MH

SHILPA GUPTA

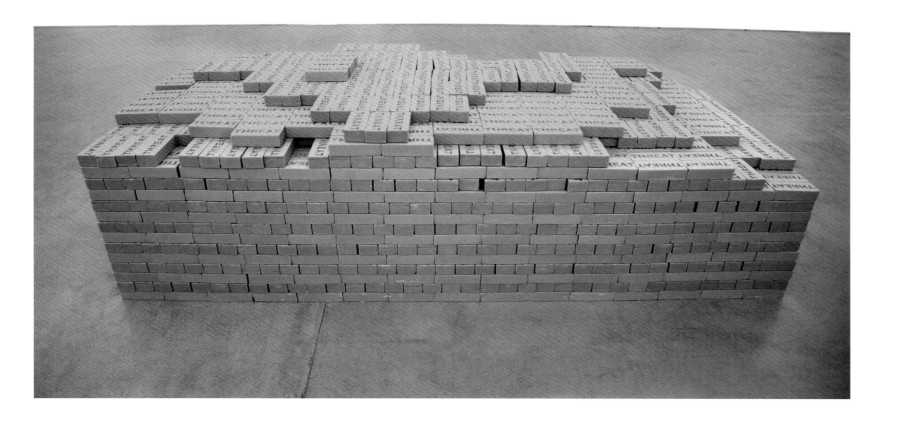

THREAT
2008–9, stack of 4,500 bathing soaps,
each 5 ⅞ × 2 ½ × 1 ⅝ in. (15 × 6.2 × 4 cm), overall
28 ⅜ × 90 ⅛ × 42 ⅛ in. (72 × 229 × 107 cm)

Shilpa Gupta, born 1976, Mumbai, Maharashtra,
India.

Over three decades, Shilpa Gupta has marked her place as a pioneer of new media art. She was trained in the 1990s at Mumbai's Sir J. J. School of Fine Arts, already engaging in the internationally emerging style of neo-conceptual Installation art rather than the formalism preferred by her peers. Gupta tackles the psychological borders in the political landscape created by societal and religious divides, commerce, terrorism, environmental degradation, gender structures, and human rights. Although her work frequently comments on particular conflicts or locales, it transcends those specifics to touch on universally pertinent themes. *Threat*, an audience-participatory installation, is a wall made of bricklike soap bars imprinted with the single word of the title. The work might appear to connote something burdensome, dangerous, or potentially violent, but instead it signals a catharsis or resolution. Each viewer is invited to take a brick home at their discretion so that the wall is slowly dismantled and the audience's collective actions neutralize and erase the "threat." By providing viewers with thought-provoking messages and the opportunity to connect with global concerns in a more personal way, Gupta challenges observers to be active participants in creating her work anew each time it is encountered.—OZ

FIONA HALL

HOLDFAST (MACROCYSTIS ANGUSTIFOLIA; GIANT KELP)
2007, aluminum fish tin, 11 × 10 ⅝ × 1 in.
(28 × 27 × 2.5 cm)

Fiona Hall, born 1953, Sydney, New South Wales, Australia.

Fiona Hall studied painting and, subsequently, photography at the East Sydney Technical College, and quickly gained recognition for her photographs. In 1985 she produced a suite of large-format Polaroids of *mise-en-scènes* that she modeled in aluminum from soft-drink cans, shaping the metal with a *repoussé* (relief) technique. From these early low reliefs, Hall's practice expanded to encompass a range of materials that assumed new life in her hands. In 1989 she began a series of sculptures titled *Paradisus Terrestris* (Earthly Paradise) that consider links between the reproductive systems of humans and plants, crafting these artworks from aluminum and sardine cans. In this and several further series, she created modern-day peep shows, rolling down the lids of the cans, which she crowned with various plant species, to reveal glimpses of genitalia. *Holdfast*, made in the same vein although without the sexual content, features a seaweed that grows in shallow waters off South Australia, where the artist lived for many years. Hall has indicated that the "holdfast" of the title refers to the root structure that fastens seaweed to rock faces or the seafloor, and to Holdfast Bay, Adelaide, South Australia. The inscription on the repurposed can suggests a reference to Australian-born RAF pilot Squadron Leader Robert Wilton Bungey DFC, who lived adjacent to the Bay and died tragically.—SL

MY HOPE
2022, mixed media, c. 152 × 214 × 125 in.
(c. 386.1 × 543.6 × 317.5 cm), Museum of Modern
Art, New York

Lauren Halsey, born 1987, Los Angeles,
California, USA.

Lauren Halsey's work is rooted in the neighborhood of South Central Los Angeles, a historic hub for African Americans and home to the artist's family over multiple generations. While as a child she had dreamed of becoming a basketball player, Halsey also enjoyed making stage sets for plays at church and briefly studied architecture at college before switching to fine art. This architectural background is evident in her current practice, which often involves the building of three-dimensional structures that serve simultaneously as archives of her urban environment and prototypes of imagined worlds. These sculptures and installations are like collages, dense assemblages of both found and fabricated materials that—inspired by the freewheeling spirit of Afrofuturist funk—collapse the past and present, the real and the mythic. *My Hope*, for instance, features stacks of boxes painted with local signs ("Chili Cheese!" and "Topflight Exotics") alongside palm trees, golden pyramids, and statues of ancient Egyptian kings and queens. Also visible is a small-scale model of Summaeverythang Gardens, named after the community center founded by Halsey in 2020, which distributes organic produce to homes in her neighborhood. For Halsey, art and activism are closely intertwined as tools for collective healing and liberation.—GS

ANTHEA HAMILTON

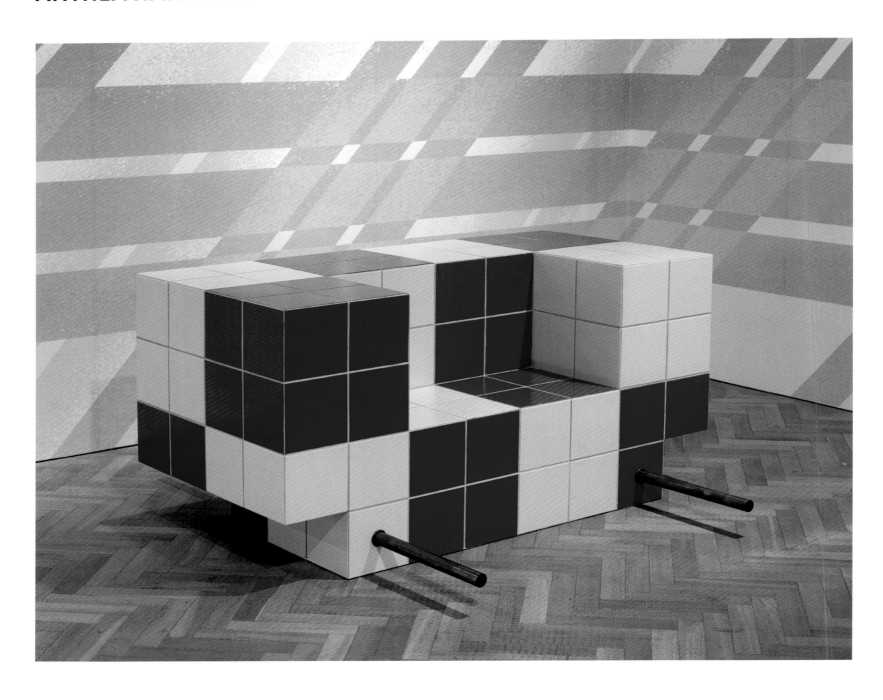

WRESTLER SEDAN CHAIR
2019, spruce plywood, porcelain tiles, and grout,
31 ¾ × 63 ⅜ × 31 ½ in. (80.5 × 161 × 80 cm)

Anthea Hamilton, born 1978, London, UK.

Mashing up references from fashion, food, pop culture, architecture, and art, Anthea Hamilton delights in provocative cultural collisions. She often creates immersive installations and performances, culling her imagery from high and low sources. Her vocabulary includes appropriated cartoons of muscular women by R. Crumb (b. 1943), 1960s-era platform boots, fetish wear, and butterflies—a motif of transformation—all rendered in unexpected materials, from plexiglass to marble and wood. Hamilton's practice combines painstaking research with a witty, often kinky irreverence for norms of gender and sexuality. Her sculpture *Project for a Door (after Gaetano Pesce)*—an 18-foot-tall (5.5-meter) foam sculpture of a man's naked rear end—earned her a Turner Prize nomination in 2016. The work was inspired by an unrealized proposal by Pesce (1939–2024), an Italian architect, for a New York apartment building entrance. For *Wrestler Sedan Chair*, Hamilton reimagined a Baroque-era couch in a starkly geometric form, adorned with red-and-white porcelain tiles. Introduced to Londoners in the seventeenth century, the sedan chair became popular among members of the gentry, consisting of an enclosed cabin for passengers mounted on poles and carried by "chairmen." "Even these rigid forms become theatrical pastiches of their dour ancestors," wrote J. J. Charlesworth about the work in a 2019 piece for *ArtReview.*—WV

MICROORGANISMS 2
2022, marble, 7 ⅞ × 7 ⅛ × 7 ⅛ in.
(20 × 18 × 18 cm)

Han Sai Por, born 1943, Singapore.

Against the backdrop of the Japanese occupation (1942–5) followed by renewed British colonization, Han Sai Por's family struggled to find secure housing during her youth. Her playground was the abundant forest of the Changi region, her toys, its fruits and fauna. She initially worked as a school-teacher, painting in her spare time and raising funds to travel to the UK, where she studied fine art at Wolverhampton Polytechnic in the early 1980s. Han encountered the work of sculptors Barbara Hepworth (p.138) and Henry Moore (1898–1986) at *British Sculpture in the Twentieth Century*, a 1981–2 exhibition at London's Whitechapel Gallery, and began teaching herself to carve stone, a practice she honed on her return to Singapore. Han believes a sculpture's essence lies in its raw materials. Working mainly in marble, granite, and wood, she describes the physical sculpting process as a conduit for unlocking deep childhood memories of environments now destroyed by urban development and defor-estation. She eschews treating objects from nature as still-life models. Instead, imagined biomorphic forms such as *Microorganisms 2* derive inspiration from the energy and movement of the natural world, the shapes, lines, and regenerative qualities of seeds, fungi, and leaves. In 1995 Han became only the second woman to receive Singapore's Cultural Medallion.—AC

SIOBHÁN HAPASKA

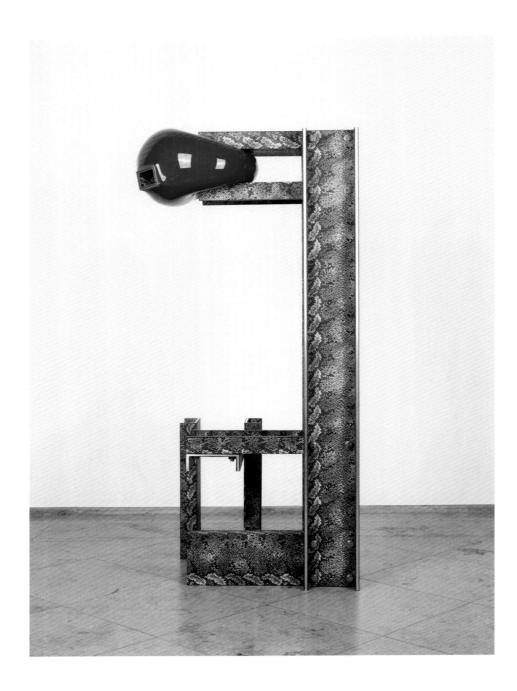

SNAKE & APPLE
2019, artificial snakeskin on steel and gloss paint
on glass fiber, 54 ⅜ × 19 ¼ × 18 ½ in.
(138 × 49 × 47 cm)

Siobhán Hapaska, born 1963, Belfast,
Northern Ireland, UK.

Distinguished by anarchic combinations of artificial and organic materials, Siobhán Hapaska's work is sometimes abstract, sometimes hyperreal, and on occasion kinetic or accompanied by light, sound, and even smell. Hapaska has cited among her influences rock pools, window seats on airplanes, and shoe insoles. Before making a work, she begins with an entire idea and mental image of how it will look. Her formally complex sculptures and installations are bold and visually arresting yet leave room for the viewer to exercise their imagination to complete the work. In assembly, her sculptures appear slick and industrial, seemingly put together with the utmost precision and with all individual components retaining their own integrity, despite their intricacy. *Snake & Apple* is one of a family of six sculptures that share variants of the title and composite elements—all have a clamped sphere or spheres made of lacquered fiberglass and held by a vicelike aluminum framework covered in fake snakeskin. Inspired by the biblical story in Genesis in which Eve is tempted by a serpent to eat the forbidden fruit, Hapaska presents a symbolic reference to humankind's fall from grace and expulsion from paradise. Musing on the Bible's narrative in the context of her sculpture series, the artist told *frieze* in 2019, "I'm on the snake's side."—RH

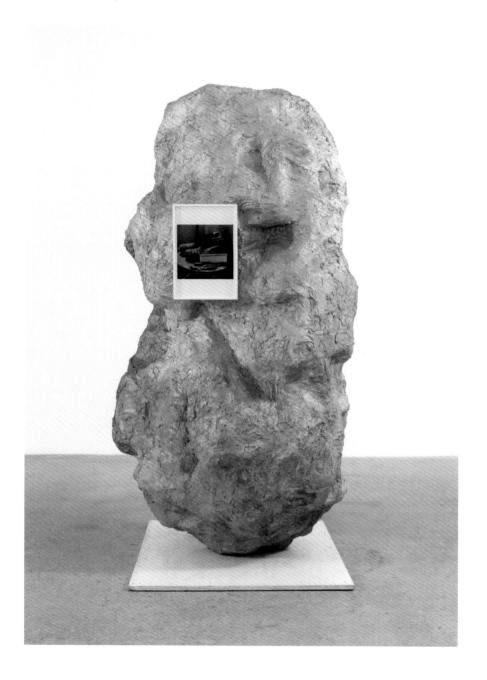

SCULPTURE WITH BOOTS
2017, wood, polystyrene, chicken wire, cardboard, burlap, cement, acrylic, steel, and pigmented inkjet print, 93 × 60 × 46 in. (236 × 152 × 116 cm), Glenstone, Potomac, Maryland

Rachel Harrison, born 1966, New York, USA.

Rachel Harrison creates "forms that can't be described," as she told Peter Schjeldahl for the *New Yorker* in 2014. Harrison began developing her distinctive sculptural language in the early 1990s, after graduating with a fine arts degree from Wesleyan University in Middletown, Connecticut, in 1989. Her three-dimensional works toe the line between sculpture and painting, creating fields of bright, lurid color that are often interrupted by nods to pop culture and art historical movements, including neo-Dada, Minimalism, and Conceptual art. These sculptures, in combination with Harrison's witty inclusions of photographs, plastic figurines, and detritus, play with accepted notions of fine art and compel the viewer to find meaning in the juxtaposition between object and sculpture. Harrison's works are self-referential, frequently invoking art historical tradition while simultaneously subverting it. *Sculpture with Boots* combines a towering abstract sculpture reminiscent of geological formations with a photograph of Abstract Expressionist painter Lee Krasner's (1908–84) painting boots. The undulating and bulbous shape of the multimedia work is painted with a grid of alternating colors that morph into fields of gold and shimmering iridescence. Simultaneously recalling process and product in its inclusion of paint-splattered boots on a vibrantly painted surface, Harrison stages an ode to a female artist who came before her, one who also refused to be bound by artistic conventions.—JS

EMMA HART

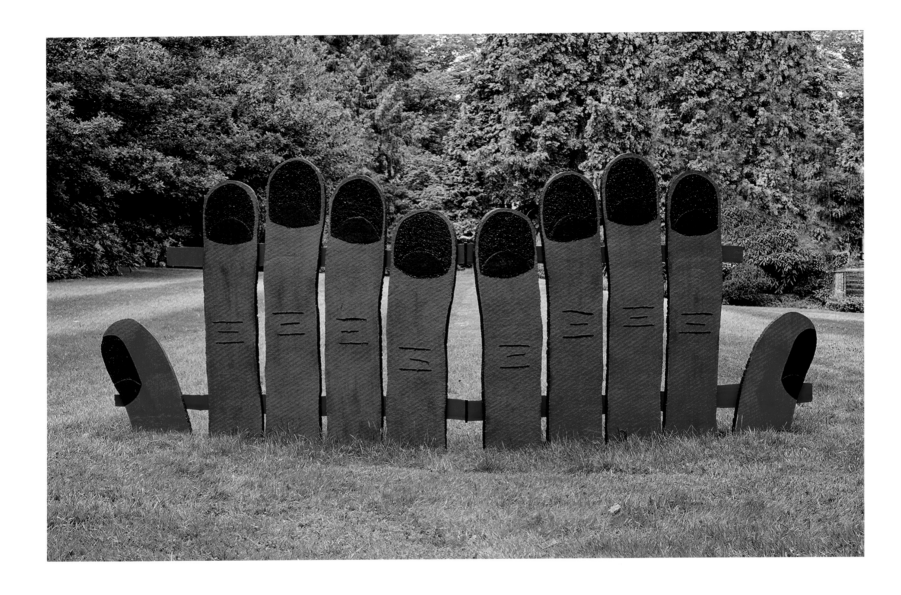

Emma Hart works mostly with ceramics to create sculptures that channel what she calls the "real"—experiences and emotions that would be impossible to capture in, for instance, a photograph. She originally studied photography; it was only in 2012, the penultimate year of her PhD at Kingston University in London, that she discovered the medium of clay, learning techniques mostly via YouTube videos. While Hart is not interested in following the conventions of pottery, she has since developed her skill—in 2016, as the winner of the Max Mara Art Prize for Women, she studied traditional techniques with ceramicists in the Italian city of Faenza. Her now-distinctive style consists of rough-hewn, brightly painted ceramics in the form of recognizable symbols, objects, or body parts—a speech bubble, a car's windshield, a pointed figure—that are arranged in space so as to directly engage the viewer. The works are also replete with verbal and visual puns: in *Red and Green Should Never Be Seen*, for example, a pair of outstretched hands is connected via a hinged wooden support so that they also resemble a picket gate: a structure that might make the viewer feel like a trespasser, a welcome visitor, or both.—GS

OX V1
2021, 3D model, Whitney Museum of American Art, New York

Auriea Harvey, born 1971, Indianapolis, Indiana, USA.

Belgian American artist Auriea Harvey studied sculpture at Parsons School of Design, New York, before transitioning to a career in web and video game design in the 1990s and moving to Rome, where she currently lives and works. She also became involved in the net art movement, often collaborating on digital projects with her husband Michaël Samyn (b. 1968). But in 2017 she returned to sculpture, developing a novel approach to the medium that, informed by her background, merges physical and virtual forms. As the artist told *Right Click Save* in 2022, "the history of sculpture is a history of technology." Her work begins with 3D scans—of her own and others' bodies, of found and constructed objects—which she assembles into a 3D model: a hybrid figure often replete with references to ancient and Classical sculpture. In *Ox V1*, a bust of the artist's head with ram's horns appears as the crown atop an oxlike creature whose legs are based on those of a cherub from St. Peter's Basilica in Vatican City. Harvey considers the polygons used in computer graphics to build 3D models as her primary material. However, her sculptures have multiple manifestations, from onscreen to offscreen. They can be viewed in augmented and virtual reality environments, and are sometimes minted as NFTs, but thanks to 3D printing they can also be encountered in galleries, rendered in materials like resin and bronze.—GS

MAREN HASSINGER

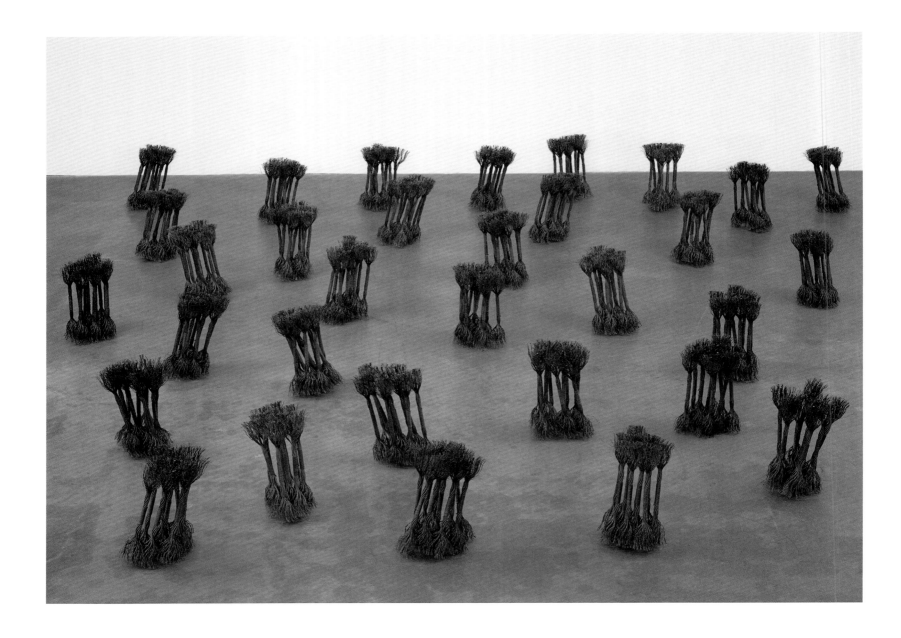

LEANING
1980, 32 bundles of wire rope and wire, height: each 16 in. (40.6 cm), Museum of Modern Art, New York

Maren Hassinger, born 1947, Los Angeles, California, USA.

Maren Hassinger's practice interrogates the social relationship between humans and their environments through sculpture, film, dance, performance, and public installations. An artist and devoted educator, Hassinger employs everyday materials like fallen tree branches, newspaper, cardboard boxes, leaves, plastic bags, dirt, and her signature wire rope, which she encountered in a Los Angeles junkyard in the 1970s during her graduate studies in fiber arts. In an audio recording for the Museum of Modern Art, New York, she described wire rope as "being like a flowing river, a blowing branch in the wind, leaves, twigs . . . yet, on the other hand, it's steel." During this time, Hassinger met fellow sculptor and dancer Senga Nengudi (p.229), with whom she would establish a decades-long friendship and collaboration of activating each other's performative sculptures. Living between Los Angeles and New York throughout the 1970s and 1980s, Hassinger works with industrial materials and organic forms, all the while calling attention to the viewers' bodies as a critical component in her works. A dancer since childhood, Hassinger regularly encourages movement. In *Leaning,* viewers are invited to meander between the wire-rope bundles, which themselves seem to dance in imagined wind. Combining nature with industry and the formal rigor of Minimalism with handicraft aesthetics, Hassinger reveals the sexist machinations of traditional "women's work," and offers new phenomenological and aesthetic possibilities.—MS

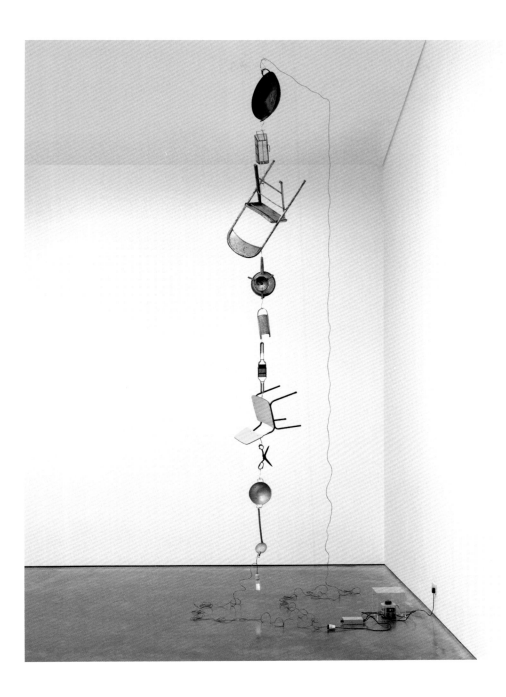

ELECTRIFIED (VARIABLE II)
2014, kitchen utensils, furniture, electric wire,
lightbulb, and variable transformer,
226 ⅜ × 126 ¾ × 82 ¼ in. (575 × 322 × 209 cm)

Mona Hatoum, born 1952, Beirut, Lebanon.

Celebrated sculptor Mona Hatoum has lived and worked as a product of displacement, first as the child of Palestinian parents who were exiled from Haifa to Beirut, later as a visitor in London whose return home was thwarted by the Lebanese Civil War. Her works consistently blend the geopolitical and the personal, and Hatoum often employs domestic objects and the body in order to examine and unsettle the idea of belonging itself. The suspended assemblage *Electrified (variable II)* strings together a series of metal household items, which tumble from ceiling to floor and terminate in a single illuminated lightbulb. Here the recognizable immediately turns strange: the mundane intimacy of these objects (including a cheese grater and pair of scissors) is charged by the ominous electric current coursing through them, like a pulse that unifies random parts into a single animated force. The association with kitchen-work further points to gendered divisions of labor, and the razor's edge between home as a place of security and one of hostility or entrapment.—AR

HOLLY HENDRY

BODY LANGUAGE
2022, Jesmonite, pigment, rock, steel, and paint,
40 ¾ × 30 ¼ × 6 ⅞ in. (103.5 × 77 × 17.5 cm)

Holly Hendry, born 1990, London, UK.

In sprawling, sinuous site-specific installations and sculptures, Holly Hendry evokes the invisible insides of buildings or bodies. Born and raised in London, the urban metropolis and its clashes with the human body preoccupy Hendry's works. Using a variety of elements that refer to bodily processes, architectural sites, and scientific research, Hendry's works often take the form of assembled landscapes—networks of futuristic organisms that intermesh man and machine. Exploring themes and ideas about industrialization and productivity, Hendry is known for tubular structures, reminiscent of pipes or intestines, and works inspired by the skin, a surface that is both a barrier and a permeable point of contact. *Body Language* is a droll evocation of how bodies bend to fit their environment: a wall-mounted sculptural piece that reads like an anatomical puzzle, with contorted limblike shapes and a dangling hand, the parts seem to struggle to hold together. Through the introduction of unexpected materials—foam, grit, soap, and lipstick have appeared in other works—the artist creates tactile allusions to familiar objects and body parts, and examines material transformation and reuse, where items perceived as junk or waste might become purposeful once again. Buoyant, cartoonish colors and forms, and experiments with flatness and fullness lend a humorous twist to Hendry's sculptural observations on the mechanics of modern life.—CJ

CONTROLOGY
2016, bronze, 72 × 86 ⅝ × 68 ⅛ in.
(183 × 220 × 173 cm), installation view,
*Days are Dogs: "Carte Blanche" to Camille
Henrot*, Palais de Tokyo, Paris, 2017

Camille Henrot, born 1978, Paris, France.

Known for distilling contemporary dread into charmingly whimsical forms, Camille Henrot uses film, painting, and sculpture to draw out the contradictions inherent to modern life. Her bronze sculptures combine recognizably human or animal shapes and objects with contorted, almost fairy-tale-like abstractions. Constantly questioning what it means to be alive in what many consider a technologically saturated and overstimulated world, Henrot's works are thoroughly researched and studded with references to literature, psychoanalysis, and anthropology. However, despite the gravity of many of her themes, the individual pieces are often infused with a light humor, underscoring Henrot's enduring interest in dichotomy and opposition. First exhibited in 2016 at the Fondazione Memmo in Rome, *Contrology* is part of a series of sculptures and frescoes exploring the feelings conjured up by a Monday: namely the delight of renewal at the beginning of a week, coexisting with the melancholy of returning to an imposed routine. The sculpture takes its title from a term coined by Joseph Pilates in 1945 to describe his newly developed exercises, its unwieldy legs and flattened torso a playful nod to the elegance and control commonly associated with the routine's motions.—MH

BARBARA HEPWORTH

SPRING
1966, bronze with strings, 30 ¼ × 20 × 15 in. (76.8 ×
50.8 × 38.1 cm), Arts Council Collection, London

Barbara Hepworth, born 1903, Wakefield, West
Yorkshire, UK. Died 1975, St. Ives, Cornwall, UK.

A leading proponent of British modernism, Barbara Hepworth is notable for her engagement with
empty space as a compositional element in her "closed form" sculptures. After graduating from the
Royal College of Art, London, in 1924, she traveled to Italy, where she studied marble carving with
master sculptor Giovanni Ardini in Rome. Returning to London in 1926, Hepworth championed
direct carving, an approach initially proposed by Constantin Brancusi (1876–1957), where the artist's
chisel is set in direct relation with the medium, foregoing any preparatory study. In 1934 Hepworth
abandoned figuration to pursue a wholly abstract expression of nature inspired by the landscapes
of her native Yorkshire. Formal tension was central to this pursuit: the pairing of hard, immovable
material with sensuous, rounded forms; polished exteriors with rough interiors; emptiness with matter.
In 1939, with the approaching threat of war, Hepworth moved to St. Ives in Cornwall, where she
transcribed the Cornish coastline in taut wire thread strung across her sculptures. From 1956 onward
Hepworth produced a series of bronzes, some shaped first in plaster of Paris, others cast from wooden
originals. To the latter group belongs *Spring*, its oval form and opening, converging strings, and
contrasting patination characteristic of the artist's lyrical abstraction.—LB

KATHLEEN RAINE
1954, bronze on wooden base, 20 × 19 ½ × 13 in.
(50.8 × 49.5 × 33 cm), Tate, London

Gertrude Hermes, born 1901, Bromley, Kent, UK.
Died 1983, Bristol, UK.

While Gertrude Hermes was an acclaimed printmaker and key to the revival of wood engraving in Britain in the early twentieth century, her first love was sculpture. In 1922 she enrolled at the Brook Green School of Painting and Sculpture in Hammersmith, London, which was founded and run by Leon Underwood (1890–1975). During World War II, she fled to Canada, returning to Britain after the hostilities had ended to teach engraving, printing, and life drawing at London art schools. Her figurative sculpture encompassed two distinct strands: dynamic carvings in wood inspired by animals and the fecundity of nature, and keenly observed representational portraits of family, friends, and commissioned subjects, such as this bronze portrait bust depicting the British poet Kathleen Raine (1908–2003) deep in thought. As with her other busts, the treatment of the face is naturalistic and classical, although atypically, the subject's arms and hands are included, resulting in an unusual pose that emphasizes the sitter's scholarly demeanor. Hermes also designed architectural features, door knockers, and car mascots, while her commercial illustrations were published by Penguin Books. She was a determined woman, maintaining her practice while raising three children as a single mother. She exhibited regularly at the Royal Academy and became a full Academician in 1971.—DT

EVA HESSE

REPETITION NINETEEN III
1968, 19 tubular fiberglass polyester resin units,
each 19 to 20 ¼ in. (48 to 51 cm) × 11 to 12 ¾ in.
(27.8 to 32.2 cm), Museum of Modern Art,
New York

Eva Hesse, born 1936, Hamburg, Germany.
Died 1970, New York, USA.

Unlike her Minimalist peers—most of whom were men—who often worked with strict grids, identical units, and hard-edged materials, Eva Hesse embraced idiosyncrasy, biomorphic forms, and tactile surfaces, including latex, rubber, rope, and fiberglass, becoming a foundational figure of post-Minimalism. She was drawn to sculpture for its spatial and material potential; for Hesse, sculpture could exist on the wall, the ceiling, and the floor, free of parameters. She believed her life and art to be inseparable, and her childhood trauma—her family fled Germany during World War II and her mother committed suicide soon after—framed her practice. In a 1970 interview for *Artforum*, Hesse expressed her interest in exploring "the total absurdity of life," by embracing both contradiction and the meaningful exaggeration achieved by repetition. *Repetition Nineteen III* is one of her earliest works in fiberglass, an industrial material that would become one of her favorites for its malleability and the way it transformed (discoloring and deteriorating) over time. Despite their resemblance, each of the vessels has a distinct shape, their wonky profiles and soft translucence lending them a sensual, almost living presence, which Hesse herself, in the same interview, described as having an "anthropomorphic" and "sexual connotation." The work's irregularity in both form and arrangement suggests a nonconformity that is a defining characteristic of Hesse's work.—LJ

NOWHERE TO GO
2022, pigmented acrylic fiber, dimensions variable, installation view, *Sheila Hicks: Off Grid*, The Hepworth Wakefield, UK

Sheila Hicks, born 1934, Hastings, Nebraska, USA.

Having turned away from painting after discovering pre-Columbian textiles while studying at Yale School of Art in Connecticut, Sheila Hicks received a Fulbright scholarship to study ancient Andean weaving traditions in Chile and travel throughout South America, then lived in Mexico from 1959 to 1964. Relocating to Paris, she became part of an international Fiber Art Movement of the late 1960s and 1970s. Her subsequent career can be characterized by an unwavering commitment to threads and textiles as a viable medium for an ambitious and innovative art practice. Defying preconceptions of sculpture as hard and unyielding, and textiles as mere craft, Hicks's art is also notable for its diversity: in her multifarious processes—weaving, wrapping, twisting, and piling; in her different methods of display, from rectangular wall-based relief works that echo abstract paintings to vertical ceiling-to-floor cascading columns; and in her extremes of scale, from the pocket-sized woven *Minimes* she has made throughout her fifty-year career, to monumental installations, such as *Nowhere To Go*, and the companion work *Escalade Beyond Chromatic Lands* (2016–17), made for the 57th Venice Biennale in 2017. Bundles of vivid fabrics are gathered in nets to form an avalanche of soft, colorful boulders, described in *Sculpture* magazine in 2022 as "pure seduction."—RM

NANCY HOLT

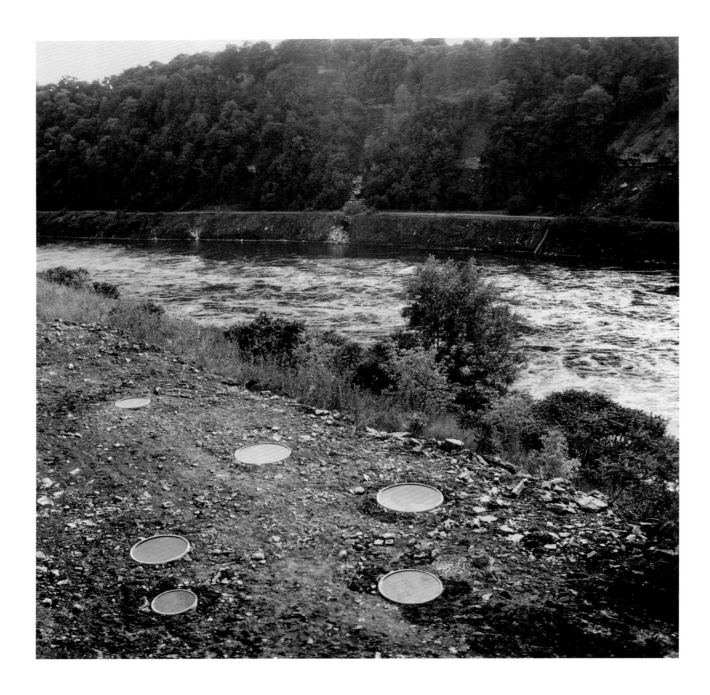

HYDRA'S HEAD
1974, concrete, earth, and water, overall
334 ⅝ × 744 ⅛ in. (850 × 1,890 cm), along the
Niagara River, Artpark, Lewiston, New York

Nancy Holt, born 1938, Worcester, Massachusetts,
USA. Died 2014, New York, USA.

An integral figure in the overlapping artistic movements of the 1960s and 1970s, Nancy Holt helped to pioneer the expansion of Land art, fueling the wider turn toward monumental, site-specific projects and helping to redefine the traditional boundaries of an artwork. Holt is recognized for her films, photography, and most especially, for her sculptural interventions made directly into the landscape. Both Holt and her husband, the artist Robert Smithson (1938–73), were fascinated by the tricks of human perception. Building on the Minimalist interest in phenomenology, Holt's practice emphasized the experience of her viewers and frequently challenged them to reinterpret their relationship to natural phenomena that might overwise be taken for granted. Commissioned in 1974 as a temporary, site-specific artwork, *Hydra's Head* comprises six circular basins, formed from industrial-sized concrete pipes embedded flush with the earth and filled with water. The pools mirror the eponymous constellation, referring back to the many-headed sea monster from Greek mythology who constantly morphed shape, regenerating to evade death. Located on the bank of the Niagara River in Lewiston, the basins were filled with gravel following Holt's residency.—MH

JENNY HOLZER

HEAP
2012, with text from *Truisms*, 1977–9, 7 LED signs
with amber, blue, green, and red diodes, 104 ¼ ×
95 × 95 in. (266.2 × 241.3 × 241.3 cm), installation
view, *Chosen*, 5 Beekman Street, New York, 2013

Jenny Holzer, born 1950, Gallipolis, Ohio, USA.

Jenny Holzer's research-based practice spans different media and centers her interest in the relationship between the written word, typography, light, electrical technological devices, and, sometimes, public space. After her initial experiences with painting and abstraction, the artist began experimenting with ways in which printed text could be considered an image. In her iconic *Truisms* series, which she began in 1977, the artist uses maxims disseminated on a variety of printed surfaces that are often shown in public spaces, inviting passersby to interpret them in diverse ways. These phrases are unique but also have a commonplace feel, sometimes sounding like universal truths that have echoed in several cultural moments—as in the more recent use of "Abuse of power comes as no surprise." The works' conjoining of few words plays with a format familiar from ancient Greek aphorisms to the slogans of big brands. *Heap* takes some of these phrases and recodifies them into sculptural language, expressed through the fast pace of public LED signage. The false permanence of the written word is dispensed with, and just like passersby on the street or in transit lounges, now it is the words that move before the spectators' bodies. The work reminds us how the language of sculpture can be informed by writing, digital technology, and the appreciation of something always in transformation.—RF

REBECCA HORN

Renowned for her unwieldy wearable sculptures that evoke prostheses, torture instruments, and bondage gear, Rebecca Horn has long been concerned with the tension between the body's edges and the space around. A long period of convalescence from lung poisoning occasioned by working with toxic materials set her on this path. Confined to her hospital bed, she began designing appendages that extended the body's limits; these would inform her sculptures, performances, and films through the 1970s. Building on the legacy of Surrealism, these sensuous "body extensions" included elongated "finger gloves," a face mask fitted with sharpened pencils, and a contraption attached with an oversize unicorn horn. Later, Horn substituted the body with kinetic sculptures that combined an erotic playfulness with a sense of menace. She has created mechanized feathered wings, hammers that tap at their own reflections, and a pair of kissing rhinoceros horns on the end of gigantic steel arms. *Untitled (Records on the Floor)*, a kinetic piece that recalls a pair of dancing stilettos Horn made the same year, exemplifies the often-neglected humor in her work. Instead of using the records to play elegant music, she has turned them into feet or wheels at the end of long, striding stick-legs.—EF

GOLD MATS, PAIRED—FOR ROSS AND FELIX
1994/2021, 99.99 percent (4-9 pure) gold foil,
fully annealed, 2 units, each 0.0008 × 52.5 ×
66 in. (0.002 × 133.4 × 167.6 cm), installation view,
*Roni Horn: A dream dreamt in a dreaming world is not
really a dream … but a dream not dreamt is*, He Art
Museum, Foshan, China, 2023

Roni Horn, born 1955, New York, USA.

Roni Horn's work exudes ambiguity, paradox, and mutability, qualities that also act as the overarching themes of her photographic installations, drawings, texts, and sculptures. Over more than four decades, Horn has persistently interrogated the perplexing nature of perception, using her practice to reveal how nothing remains as one stable thing. In her sculptural work she translates this concern by exploring the properties of her chosen materials, here working with thin sheets of gold. The daughter of a pawnbroker, Horn has long been intrigued by gold—particularly the way that the element is imbued with economic and historic importance. *Gold Mats, Paired—for Ross and Felix* pushes against these cultural associations; two fine gold sheets are laid one on top of the other, directly on the floor without a barrier, allowing the viewer to experience the work's materiality. The sculpture is dedicated to fellow artist Felix Gonzalez-Torres (1957–96) and his lover Ross Laycock (1959–91), who was at the time dying of AIDS-related causes. After first viewing Horn's sculpture *Gold Field* (1980/2) in 1990, Gonzalez-Torres struck up a moving friendship with the artist. In *Gold Mats, Paired—for Ross and Felix*, the peaks and troughs in the gleaming surfaces conjure a new topography: at once monumental, fragile, and hopeful.—CJ

HARRIET HOSMER

BEATRICE CENCI
1857, marble, 17 ⅜ × 41 ⅞ × 17 ¼ in.
(44.1 × 106.3 × 43.8 cm), Art Gallery of
New South Wales, Sydney

Harriet Hosmer, born 1830, Watertown,
Massachusetts, USA. Died 1908, Watertown.

Raised by her widowed father after the rest of her family succumbed to tuberculosis, Harriet Hosmer benefited from an untraditional education that fostered female independence, even allowing her to study human anatomy. As women were typically barred from formal anatomy classes, Hosmer moved to St. Louis for private lessons at Missouri Medical College. In 1852 she sailed for Rome and entered the studio of the British sculptor John Gibson (1790–1866). Popular among tourists, Hosmer established an independent sculpture studio in Rome in the 1860s. Steeped in Neoclassicism, the artist based her works on ancient sculptures. Similarly to Edmonia Lewis (p.185), who was based in Rome at the same time, Hosmer claimed to carve all her own marble when most sculptors had assistants. She also focused almost exclusively on heroines as subjects, like Beatrice Cenci. Depicted by many artists, Cenci was publicly executed in 1599 in Rome for killing her father after he sexually assaulted her. Hosmer shows Cenci resigned to her fate, resting her head on her arm and praying the rosary. Hosmer had close friendships with the poets Robert Browning and Elizabeth Barrett Browning as well as the writers Nathaniel Hawthorne, who based a character in *The Marble Faun* (1860) on the sculptor, and Henry James, who famously referred to her as a member of the "marmorean flock" of female sculptors in nineteenth-century Rome.—ESP

UNTITLED from the series **TO INFINITY**
2023, stainless steel frame, cotton thread, linen tow, combed tow, linen yarn, and natural dye colors, 137 ¼ × 90 ½ in. (350 × 230 cm)

Klára Hosnedlová, born 1990, Uherské Hradiště, Zlín, Czech Republic.

Through her world-building art, Klára Hosnedlová proposes a new vision of temporality, contending with histories of modernity, archaeology, gender, and technology. Informed by influences as disparate as Central Eastern European Brutalist architecture, folkloric customs, and science fiction, Hosnedlová conceives ambitious installations and enigmatic performances. The artist told curator Laura Gritz in 2021 that she regards her multifaceted work as "one living organism," often experienced in composite architectural environments. *Untitled* belongs to the series *To Infinity*, presented at Kestner Gesellschaft, Hanover, in 2023. A sculptural arrangement set against an all-immersive backdrop, *To Infinity* was activated through documented performances deliberately enacted without an audience. Despite its large scale, organic smell from the natural materials, and amorphous form, *Untitled* carries a human quality and projects sensuality through the hyperrealistic embroidered panel rooted in the center of the sculpture. What appears to be a purple slit in the primordial being depicts parts of a fragmented human body in an unsettling yet seductive light. Blending abstraction and figuration with influences from the natural world, *Untitled* concurrently invokes a sense of nostalgia and futurity, and illustrates Hosnedlová's ability to physically and psychologically absorb viewers through complex and mind-bending frameworks.—JM

MARGUERITE HUMEAU

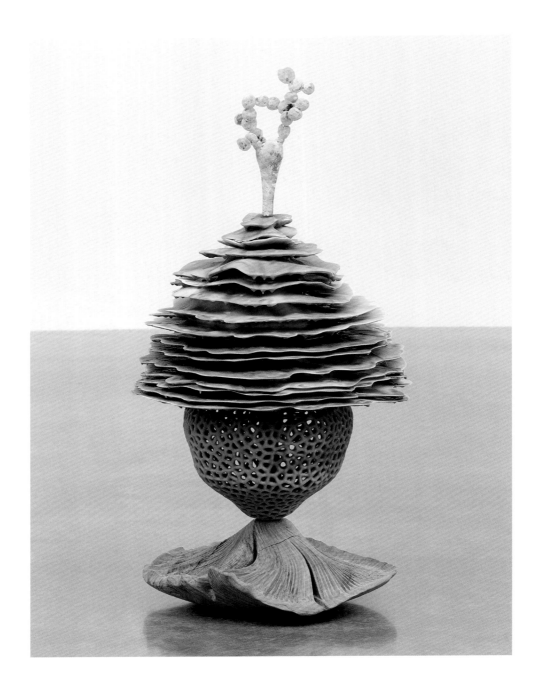

THE GUARDIAN OF TERMITOMYCES
2023, microcrystalline wax, pigments, 150-year-old
walnut (cause of death: unknown), and handblown
glass, 36 ¼ × 17 ⅜ × 17 ⅜ in. (92 × 44 × 44 cm),
edition 1 of 3

Marguerite Humeau, born 1986, Cholet,
Maine-et-Loire, France.

Marguerite Humeau is interested in speculation, especially in the face of annihilation—whether reimagining the voices of prehistoric creatures or simulating the breathing of fish adapting to increasingly precarious ecosystems. Her work often takes the form of immersive installations, sometimes incorporating organic matter and even smell, which manifest her interest in myths, ecological crises, and enforced changes in animal and human behavior in the service of survival. Often working closely with experts ranging from paleontologists to clairvoyants, Humeau develops new conceptions of how living beings might exist in the world. For her 2023 exhibition *meys* at White Cube, London, which included her series of *Guardian* sculptures, she reflected: "There are forms of life that will survive us. How can we take them as our guides or companions to understand how to navigate our own futures?" These works take the communal practices of eusocial insects (ants, termites, bees) as their inspiration; *The Guardian of Termitomyces* represents the symbiotic relationship between termites and fungus, each component crafted in tactile materials as various as wax, glass, and wood eaten by fungi, collaged together to form a totemlike being. These relationships led the artist to consider analogous rituals in human society, for example the centrality of yeast—integral to both beer and bread—in human gatherings.—LJ

REACHING JAGUAR
c. 1918, cast bronze, 9 × 6 in. (22.9 × 15.2 cm),
Isabella Stewart Gardner Museum, Boston

Anna Hyatt Huntington, born 1876, Cambridge,
Massachusetts, USA. Died 1973, Redding,
Connecticut, USA.

Anna Hyatt Huntington achieved great success in the first half of the twentieth century for her sculptures of animals. Her father, a paleontology and zoology professor in Cambridge, Massachusetts, encouraged her early interest in animal anatomy. Receiving formal artistic training in Boston and New York, she also spent many hours sketching animals in zoos. With its taut, muscular limbs fully engaged, the back of the jaguar illustrated here is gracefully arched, preparing to pounce or step down from its perilous perch. This bronze is a smaller variant of the artist's life-size stone sculptures still in situ at New York's Bronx Zoo. In addition to making smaller-scale works, Huntington also received many public sculpture commissions, including *Joan of Arc* on the Upper West Side of Manhattan, which was erected in 1915 and was the city's first public monument to commemorate a historical woman. In 1923 already established as a sculptor, she married Archer Huntington, heir to a railroad fortune. Together they founded Brookgreen Gardens in South Carolina in 1931—the first outdoor museum devoted to sculpture in the United States—as well as a dozen other museums and wildlife reserves. In 1927 she contracted tuberculosis and struggled for years. After this illness, she experimented with lighter materials like aluminum, continuing to produce sculpture until almost the end of her life, aged ninety-seven.—ESP

CRISTINA IGLESIAS

PHREATIC ZONE I
2015, aluminum hydraulic mechanism and water,
200 ⅜ × 85 ⅛ × 204 ⅜ × 83 ½ in.
(509 × 217 × 519 × 212 cm)

Cristina Iglesias, born 1956, San Sebastián, Basque
Country, Spain.

In Cristina Iglesias's practice, sculpture is conceptualized as a means of creating places where the viewer's perceptions and thoughts can be challenged. By exploring the confluence of antagonistic concepts, such as nature and culture or reality and fiction, Iglesias creates passages or thresholds in the form of multisensory installations. Her works are constructed from traditional sculptural materials—glass, concrete, steel, aluminum, bronze, resins—alongside organic components such as water or sometimes organisms and plants. This combination of matter simultaneously creates a sense of familiarity and presents an oddness that captures the viewer's attention, slowing their sense of time and producing a space for contemplation. In the series *Phreatic Zones*—the geographical term for the saturated layer beneath the Earth's water table—Iglesias considers the immense world that lies below our feet. Cutting windows into the floor, she creates a strange type of water feature that merges the inside with the outside. A hydraulic mechanism slowly circulates water across aluminum forms that seem to imitate the natural elements found beneath the Earth's surface, such as gnarled roots, dark pools, and rock piles. Such sculptural interventions in the existing landscape or architecture raise questions around the historical, cultural, or topographic legacy of those sites, and make visible the connections between them, aiming to amplify the ways humans perceive the world.—LO

HERITAGE STUDIES #22 from the series
HERITAGE STUDIES
2016, painted wood and vinyl text, 26 ¾ ×
26 ¾ × 96 ½ in. (68 × 68 × 245 cm), San Francisco
Museum of Modern Art

Iman Issa, born 1979, Cairo, Egypt.

Familiarity is central to Iman Issa's practice. Her work plays with the degrees to which something can appear more or less recognizable and the viewer's ability to identify the specific qualities that trigger such a connection. Display is as much her medium as sculpture itself: in her work, different parts often rely on and interact with each other and their surroundings. In the series *Heritage Studies*, sculptural forms and texts are paired together. The title of the series alludes both to the kind of collections that Issa visited for inspiration and the artist's interest in the field's pragmatic relationship with the present in order to study the past. Between text and object, the works communicate something about their essence, or the place they occupy in the world. *Heritage Studies #22* comprises conic shapes and a wall text that alludes to prototypes of a legendary "ziggurat"—possibly the inspiration for the biblical story of Babel, the tower that was meant to reach heaven. The joining of the blue-green and white cones similarly evokes the juncture of earth and sky in a synthesis of this mythological story. Issa calls the *Heritage Studies* a "speech act," as if her objects were yelling or coughing up their raison d'être.—CI

ANN VERONICA JANSSENS

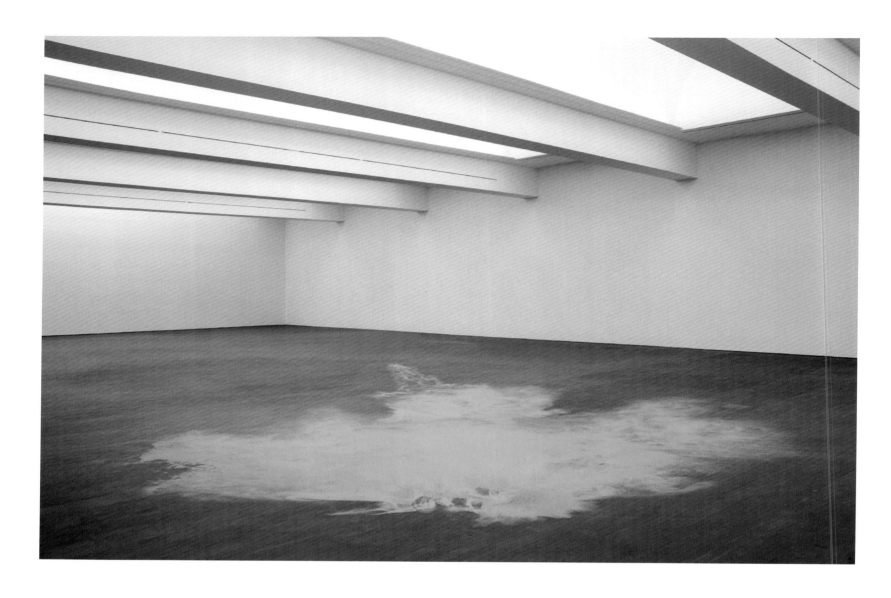

UNTITLED (BLUE GLITTER), OPEN SCULPTURE #3
2015–, polyester, dimensions variable

Ann Veronica Janssens, born 1956, Folkestone, Kent, UK.

Ann Veronica Janssens creates ephemeral sculptures and spatial interventions that toy with perception. Since the mid-1980s Janssens has been developing an experimental practice consisting of "propositions," whereby the viewer's interactions with the spaces and forms constructed by the artist are part of the works themselves. In these interchanges, Janssens endeavors to move "from one reality to another . . . between two states of perception," as she said in an undated statement for Micheline Szwajcer gallery. Janssens uses various media to enact these experiences, including mist, glass, and glitter—all relating and responding to light. *Untitled (blue glitter), open sculpture #3* comprises a mass of aqua-colored powder spilled across the floor of the gallery space. The glitter is purposely flung unevenly and moved around to produce an imperfect field. The diaphanous nature of the material invites viewers to become acutely aware of their own movements and even their breathing, as one small exhalation could send the powder cascading in all directions. Stepping around the installation, particles of glitter shift and glint, creating new hues of blue—and encouraging the viewer to experience space and sensation differently.—JS

LA DOULEUR (PAIN)
1886, marble, 10 ¼ × 6 ¼ × 6 ⅛ in.
(26 × 16 × 15.5 cm), Palais des Beaux-Arts de Lille

Madeleine Jouvray, born 1862, Paris, France.
Died 1935, Meudon, Hauts-de-Seine, France.

As is all too common among women artists, Madeleine Jouvray's practice remains largely unknown, mostly because of the lack of available documentation. However, it can be inferred that her interest in sculpture started early, due to her family ties to craft. Despite the conservative social context of the end of the nineteenth century, Jouvray lived through a period in France that saw the art ecosystem flourish and was able to study in Paris under sculptors Auguste Rodin, Alfred Boucher, and Honoré Icard, and at the Académie Colarossi. This historical context, and Jouvray's social ties, allowed her the opportunity to exhibit at the center of artistic life in the city. Her practice engaged with the Feminist Symbolist movement, which strove to express truths by favoring the representation of mythologies and allegories through a female gaze. This discourse enabled Jouvray to sculpt nudes that rejected the erotic depictions typical of the male point of view, and to experiment with form and imagination by leaving parts of the sculptures unfinished. This last quality makes evident Rodin's influence on her practice, as do the iconography, the sensual expression, and the combination of a male face surrounded by a cloth wrapping traditionally worn by women in the marble sculpture *Pain*.—LO

KATARZYNA JÓZEFOWICZ

"CITIES"
1989–92, paper, 98 ⅜ × 66 ⅞ × 19 ⅝ in. (250 ×
170 × 50 cm), Pedro Álvares Ribeiro collection

Katarzyna Józefowicz, born 1959, Lublin, Poland.

Over more than four decades, Katarzyna Józefowicz has constructed a body of work remarkable for its consistency and its encapsulation of labor. Cutting, gluing, folding, and tucking newspapers, magazines, paper, and cardboard seemingly ad infinitum, the rigors of repetition and control are rendered manifest. Józefowicz links the forms and subject of her modular works to the structures in which she has lived: from renting university flats in monolithic post-Soviet blocks whose austerity inspired fear in her to the act of building her own house to share with her family. She uses everyday materials, working at home, on her own. The means are modest, but the cumulative effect and impact are compelling. *"cities"* is a piece made while living in alienating apartments, and although the shapes might appear scratchy and confused, in the context of borrowed space the artist found them grounding, a tool to help her feel like she belonged. Delicate and not fit for habitation, its elements are too numerous to count. There is no fixed message here, rather it is the act of making and the emotions of looking that are captured. Monumental yet vulnerable, the work stands tall, a fragile survivor of a time and place.—RH

PENITENT MAGDALENE
1717, polychrome wax, painted paper, glass, tempera
on paper, and other materials, 23 ¼ × 21 × 4 ½ in.
(59.2 × 53.2 × 11.5 cm), Detroit Institute of Arts

Caterina de Julianis, born 1670, probably Naples,
Campania, Italy. Died 1743, probably Naples.

Caterina de Julianis sculpted in wax, which became a more common medium for sculpture in the late seventeenth century, including for anatomical study. Some biographies state that de Julianis was a nun, but there is no evidence to support this claim. Even though her teacher, Gaetano Giulio Zumbo (1656–1701), made both anatomical models and religious subjects in wax, de Julianis appears to have made only religious works, and possibly portraits, in this material alone. The great majority of her surviving sculpture can be found in religious institutions in Naples, where she was likely born and worked as an artist. This multimedia diorama intended for private devotion depicts the repentant Mary Magdalene, modeled in wax, on bended knee with her right hand at her heart and her left outstretched. Her head is tilted toward the heavens and Christ is on the cross in miniature behind her. The book and skull typically used by the saint for her meditations are at center. Having retreated from human society to repent, she finds respite in nature and the animal kingdom. De Julianis has rendered the flora and fauna surrounding the Magdalene in astounding variety and detail, fabricating the ducks with real feathers, shaping the snail in pigmented beeswax, and using mirrors to mimic water, reflect light, and delight the eye.—ESP

NADIA KAABI-LINKE

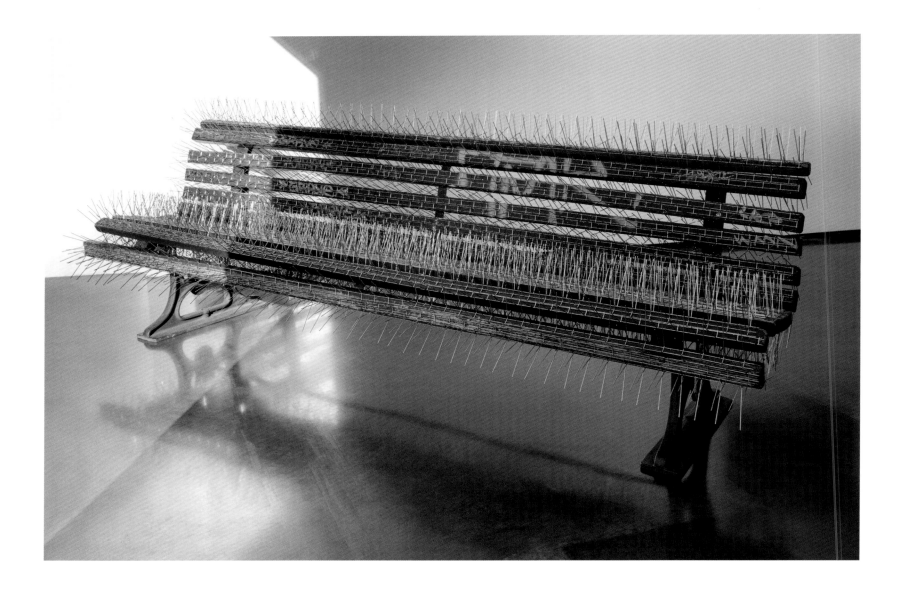

"THE BANK IS SAFE" (IN MEMORY OF WILHELM VOIGT)
2018, iron, wood, and steel, 36 ¼ × 98 ⅜ × 33 ½ in. (92 × 250 × 85 cm)

Nadia Kaabi-Linke, born 1978, Tunis, Tunisia.

Nadia Kaabi-Linke's transnational identity—with a childhood spent between Tunis, Kyiv, and Dubai before relocating to Berlin—shapes her sculpture. People and place are foregrounded, with Kaabi-Linke often creating her work in situ at the exhibition site. In doing so, she responds to the locational context, sensitively observing and honing in on the individuals, social concerns, and phenomena that are habitually overlooked in the area—like the street salesmen in Venice she referenced in *Flying Carpets* (2011), shown at the 54th Venice Biennale that year. Kaabi-Linke often highlights immigrant communities, and considers their plight and experience of resettlement. *"The bank is safe" (in memory of Wilhelm Voigt)* speaks to the marginalization of such groups while also commemorating the German Friedrich Wilhelm Voigt who, while impersonating an army officer, led soldiers to execute a financial theft. Pigeon spikes, normally used as a preventative measure to stop birds dwelling on flat surfaces, cover a graffitied park bench, found by the artist, rendering it unusable. The hostility evoked by the thorny surface reflects the contradictory nature of Western societal value systems—where the emphasis on individual freedom and performative inclusivity is undermined by intensive surveillance and monitoring of people's movements.—CRK

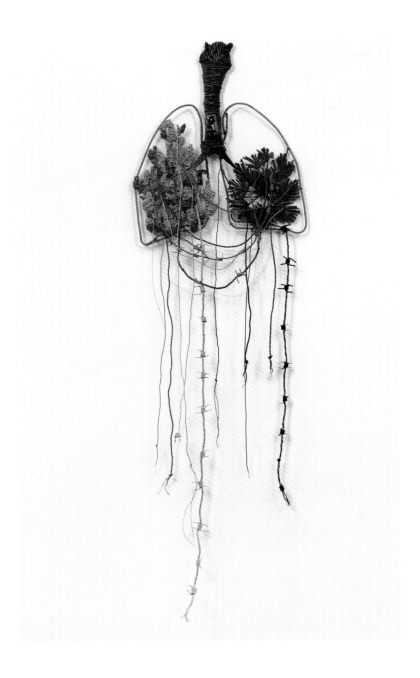

SIAMESE TREES (RATCHYRA-PALM)
2018–19, electric wires, metal, circuit board, and fittings, 24 ⅛ × 20 ⅞ in. (61 × 53 cm)

Reena Saini Kallat, born 1973, Delhi, India.

Reena Saini Kallat is concerned with how the apparatus of authority is used to manifest division and promote tension and conflict between nations and communities. These themes, in part, reflect her family's experience of the Partition of India in 1947. Spanning sculpture, photography, drawing, and video, her work challenges the basis of such polarizing endeavors, often using bureaucratic instruments—such as official stamps and electrical wire—that embody the assertion of power and assist in organizing and connecting people and place. Such ideas also relate to her interest in the motif of the line as a cleaver that has facilitated the arbitrary designation of terrain into national territories. Kallat has considered rivers as subversions of the separation of land, highlighting through collage the shared waters that connect areas in conflict. *Siamese Trees (Ratchyra-palm)* similarly looks to the natural world to expose the artificiality of national division. Two upturned trees created from colored lengths of electrical wire are conjoined by their trunk and shared root system. The vegetal forms, configured to appear as human lungs, are representative of a species of palm considered the national tree of both Thailand and Cambodia, a symbol shared by neighboring countries engaged in a border dispute.—CRK

EDITH KARLSON

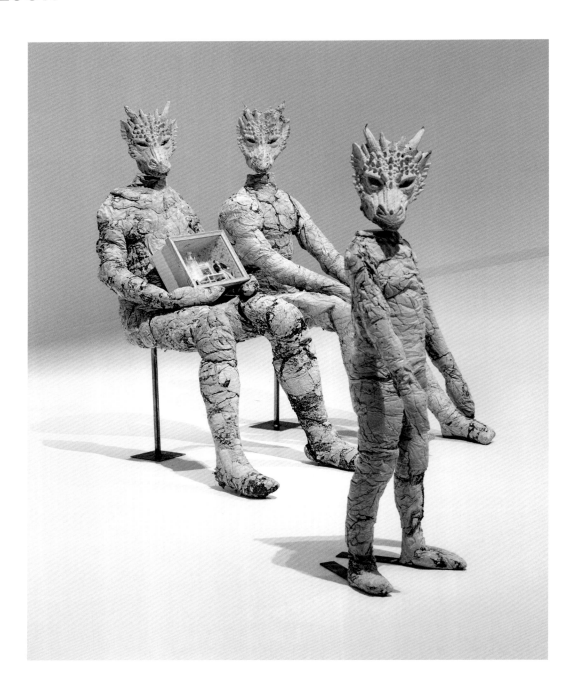

FAMILY
2019, concrete, metal, and mixed media, dimensions variable, Contemporary Art Collection of the European Parliament, Brussels

Edith Karlson, born 1983, Tallinn, Estonia.

Believing that the most powerful dramas are played out in the human mind, Edith Karlson delves deep into her psyche to find inspiration for her enigmatic sculptures. Working with materials ranging from fine porcelain to raw concrete, she creates disquieting tableaus in which monstrous animals and anthropomorphic beasts evoke dark myths and fairy tales. These fictional creatures are allegorical in nature, embodying the artist's anxieties about contemporary life, from world events to personal conflicts. Karlson studied at the Eesti Kunstiakadeemia, Tallinn, in the 1990s, when traditional sculptural practice was being superseded by more radical approaches. Emerging as part of a new generation of young Estonian sculptors, her playful and highly imaginative approach places great emphasis on the relationship between material, subject, and space. She often conceives her works as installations, with aspects of the exhibition space becoming integral to their presentation. Since becoming a mother, she has reflected on the physical and psychological impact of parenthood with works such as *Doomsday* (2017), a porcelain chandelier made from casts of her own body, and *Family*, in which she wryly questions the nature of the traditional household unit, presenting three reptilian figures—a child and its parents—in a bright, clinical environment.—DT

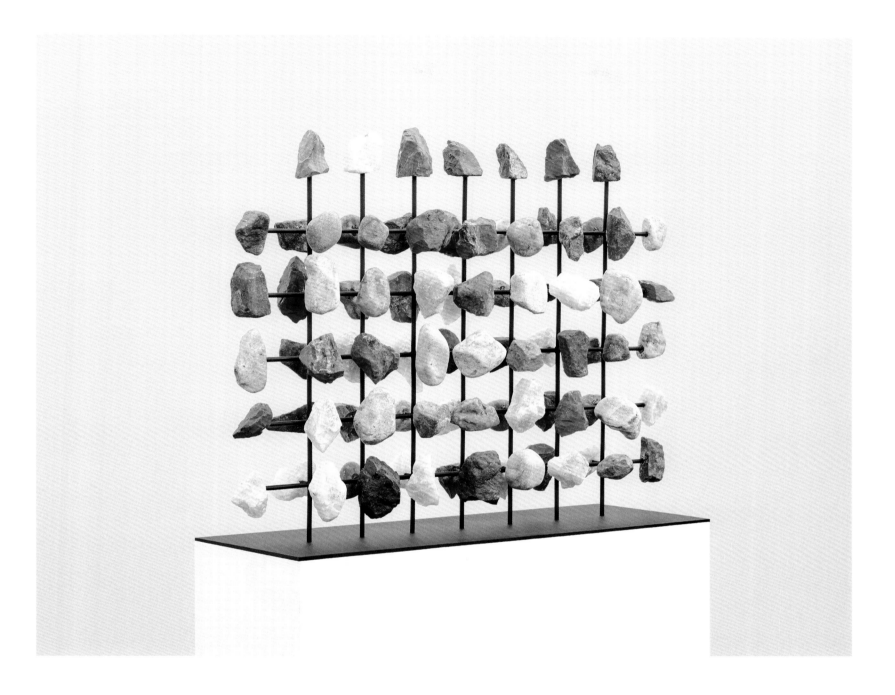

/XABI (SPURT OF WATER FROM THE MOUTH)
2021, hoerikwaggo, river stone, iron ore, jasper, coal, rose quartz, mild steel, copper-coated carbon steel, hemp twine, and sound, dimensions variable

Bronwyn Katz, born 1993, Kimberley, Northern Cape, South Africa.

Growing up in post-Apartheid South Africa and deeply influenced by her heritage and ancestral storytelling, Bronwyn Katz uses her body and mother tongue Afrikaans as well as !Ora—a language spoken along the Southern Cape coast at risk of extinction—to offer fictitious narratives that both counter and challenge historical accounts that erase colonial acts of violence. Working across sculpture, video, installation, and performance, Katz uses a range of natural and machine-made materials, such as steel, iron ore, precious stones, and discarded mattresses, to unearth forgotten or overlooked meanings. The title /xabi comes from an !Ora word meaning "spurt of water from the mouth." For this installation, the artist assembled rocks into a fixed grid supported by a steel structure. This is accompanied by the sounds of the artist swishing saltwater in her mouth, soothing the site of an extracted tooth. The work refers to Driekopseiland, a renowned petroglyph site in South Africa's Northern Cape. Covered by water in the rainy season, the engraved rock images become visible only during times of drought. Katz is interested in the role of water in revealing these symbols and signs. Positing language as a tool of healing, she draws connections between the washing over of the literal and figurative scars present in both body and earth.—JD

CLEMENTINE KEITH-ROACH

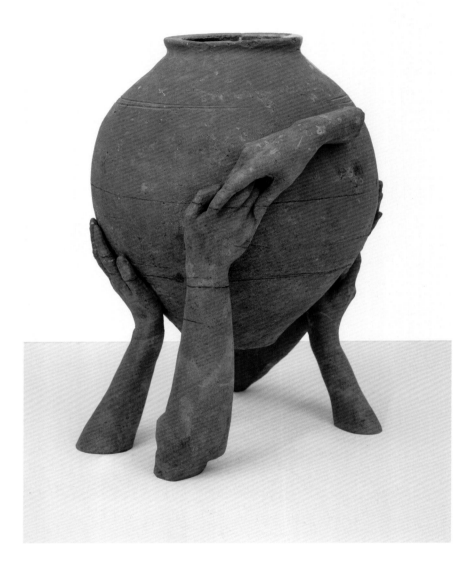

KNOT
2022, terracotta vessel, Jesmonite, and paint,
27 ½ × 13 ¾ × 13 ¾ in. (70 × 35 × 35 cm)

Clementine Keith-Roach, born 1984, London, UK.

Interested in the allure of historical objects, Clementine Keith-Roach creates assemblage sculptures often combining plaster-cast limbs with found amphorae sourced from Turkey and Greece. She incorporates her appendages into the vessels with careful trompe l'oeil detailing, at times accentuating the signs of age on the ancient surfaces to create pieces that feel at once Classical and also somehow ahistorical. Keith-Roach first began taking molds of her body during pregnancy, when the forms she pulled from herself served as a catalog of the physical changes she was then undergoing. Her practice continues to be informed by how the female body is itself recurringly understood as a vessel, not only quite literally, but also more abstractly as a container for tenderness, love, and nurturement. Casting both the limbs of her own body, and also frequently those of her friends, Keith-Roach pays special attention to hands, which are seen symbolically as vehicles of care. Staging two hands clasped around the front of a terracotta vase, *Knot* accentuates the tactility of Keith-Roach's work, emphasizing how the artist's practice straddles both the playful and elegant, the ancient and modern, to ultimately arrive at something that appears to exist outside of time.—MH

UNDER ARMOUR II
2022, mixed media, 70 ¾ × 43 ¾ × 109 ¾ in.
(180 × 111 × 279 cm)

Zsófia Keresztes, born 1985, Budapest, Hungary.

The sculptures of Zsófia Keresztes combine biomorphic abstraction with recognizable forms, such as oversize tears, eyes, human innards, and spiders. In 2016 she began working with her signature materials of polystyrene and hand-cut glass tiles, carving sculptural bases out of Styrofoam and fiberglass, and then applying mosaic pieces. Keresztes's style has been likened to Catalan Art Nouveau, religious iconography, Surrealism, Niki de Saint Phalle's *Tarot Garden* installation (p.266), and digital imagery. The artist stresses the importance of fragmentation in mosaic art, explaining in a 2021 interview with curator Mónika Zsikla, "You always have to find the angle at which [these smaller pieces] can fit together the most perfectly. This system works similarly to the nature of human relationships." Keresztes created *Under Armour II* for the 59th Venice Biennale in 2022, where she mounted a solo show in the Hungarian Pavilion. In this sculpture, Keresztes includes chains and metal shelving along with her signature tiled forms. A rectilinear base is covered with violet-tiled orbs; atop this base stands a construction that resembles human organs and enlarged teardrops. The pulsating and tessellated figures "depic[t] the different stages and possibilities of the formation of a personality," said Keresztes of the exhibition in the same interview, giving form to the systems and methods people use to fashion themselves and connect with one another.—WV

RACHEL KHEDOORI

BUTTER CAVE
2007, foam, plaster, and wax,
24 × 36 × 60 in. (61 × 91.4 × 152.4 cm)

Rachel Khedoori, born 1964, Sydney, New South
Wales, Australia.

In the work of Rachel Khedoori, real and tangible architectural spaces merge into imagined or uncanny ones. Known for her walk-in installations, she combines elements of architecture, sculpture, and film to challenge perceptions of placemaking. In 2007 Khedoori began to create miniature-dollhouse versions of these life-size spaces. More expansive abstractions morphed into universes like *Butter Cave*, a large, smooth block covered in yellow wax with roughly textured caverns. Although seemingly random, these holes match the places where traditional openings, doorways, and windows would go, suggesting function and use. This tension—the space is unusable for humans not just in literal scale but metaphorically as an environment composed of an organic, meltable material such as butter— makes the absence of people, as well as their psychological presence, more palpable. As Eva Scharrer wrote for *Artforum* in 2008, *Butter Cave* "evokes various motifs from childhood memory: the difficult movement of nightmares, when space turns into dense, sticky matter, [or] the desire to build caves and hideaways." Here, the viewer plays a critical role; even though they cannot physically enter the cave, the work invites them to project themselves into the space, which references both historical places of human shelter and mysterious openings to the unknown. In her interweaving of the physical space with the mental, Khedoori conceptualizes the complexities of lived, shared human experiences.—OZ

STRANGE ATTRACTOR
2021, resin, wax, wool, wood, marble, neon, and clay, 68 ⅛ × 28 × 42 ⅛ in. (173 × 71 × 107 cm)

Bharti Kher, born 1969, London, UK.

"As a sculptor, one of the first questions for me is the idea of transformation," Bharti Kher shared in a 2021 profile in *Vogue India*. She continued, "When I break things, I'm really opening them up to the possibilities of what they can be." Drawn to a broad range of objects, including wooden ladders, fabric swatches, and dolls, Kher allows her works to evolve and come together over a period of several years into compositions that turn the mundane into the magical. In sculptures composed of found objects, or made with more traditional materials like fiberglass, wood, or plaster, as well as drawings composed from dizzying spirals of bindi dots, her practice collapses the scientific and spiritual. Kher's fascination with the metaphysical world is reflected in *Strange Attractor*, named for a mathematical term in chaos theory that describes apparently unpredictable systems and patterns. Led by this theoretical concept, Kher's sculptural process is itself dynamic and unstructured. The gender-ambiguous human-ape hybrid is adorned with an illuminated yellow halo, while from its bowels protrudes a wooden spear atop which rests a model house made of clay. The figure is at once loaded with possibilities and contradictions, a body of multitudes that is all things at once and in perpetual flux.—CRK

KIMSOOJA

BOTTARI
2005/17, used Korean bedcovers and used clothing,
dimensions variable, National Museum of
Contemporary Art, Athens

Kimsooja, born 1957, Daegu, North Gyeongsang,
South Korea.

Kimsooja, a one-word name, conjures intentional ambiguity in gender, sociopolitical standing, and place of origin, harmoniously resonating with the artist's ongoing investigations into identity. In early performances she assumed anonymous personas—*A Needle Woman* (1999–2009), *A Beggar Woman* (2000–2001), *A Homeless Woman* (2000–2001)—to contemplate the human condition, often facing away from the viewer, acting as both a void and vessel. Her practice has evolved to interrogate and transform materials beyond her body, combining sculpture, performance, film, photography, and installation. Kimsooja often utilizes elements of textile culture, such as sewing and weaving, that have historically been associated with women and craft in order to contextualize feminine domestic labor within contemporary art. For more than thirty years she has used *bottari*—bundles wrapped in the fabric used for bed covers—as a recurring motif. Although, for her, the origins of this packaging are Korean, this way of carrying possessions is globally recognizable and bears clear reference to the displacement of people. As she told *Art21: Art in the 21st Century* in 2008, she found "the inner structure of the world," while sewing a bedcover: "When I was putting a needle into the silky fabric . . . I felt the whole energy of the universe pass through my body and to this needle point through the fabric." Through this physical investigation of the domestic, Kimsooja transcends borders and boundaries, answering larger questions about human existence.—RH

KATARZYNA KOBRO

SPATIAL COMPOSITION NO. 6
1931, steel and oil paint, 25 ¼ × 9 ⅛ × 5 ⅞ in.
(64 × 25 × 15 cm), Muzeum Sztuki w Łódź

Katarzyna Kobro, born 1898, Moscow, Russia.
Died 1951, Łódź, Poland.

A key figure in the international avant-garde, Katarzyna Kobro was born in Moscow to a family of German heritage but lived most of her life in Poland. In 1917 Kobro enrolled at the Moscow School of Painting, where she came into close contact with Constructivist aesthetics and the art of Kazimir Malevich (1879–1935). Settling in Poland in 1922, Kobro was instrumental to the nation's budding cultural scene. Together with her husband, Władysław Strzemiński (1893–1952), she established the collection of the revered Museum Łódź, wrote the book *Composition of Space: Calculations of Space-Time Rhythm* (1931), and formed part of leading artistic groups such as Blok (1924), Praesens (1926), and "a.r." (1929–36). Central to Kobro's multidisciplinary practice spanning sculpture, painting, and industrial design was her vision for art to service society at large. Her architectural sculptures, including *Spatial Composition No. 6*, educed a distinctive spatial-temporal awareness, which she achieved by considering shapes and negative space from all perspectives as well as their surrounding environments. Although most of her work was lost during World War II, Kobro's explorations and theoretical writings left an indelible mark on the history of twentieth-century art, and predate principles examined in later decades such as those associated with Minimalism and kinetic art.—JM

KÄTHE KOLLWITZ

PIETÀ (MOTHER WITH DEAD SON)
1937–9, bronze, 15 × 11 ¼ × 15 ⅝ in.
(38 × 28.6 × 39.6 cm), Käthe Kollwitz Museum
Köln, Cologne

Käthe Kollwitz, born 1867, Königsberg, Germany
(now Kaliningrad, Russia). Died 1945, Moritzburg,
Saxony, Germany.

Käthe Kollwitz was a committed socialist and feminist whose politically engaged and emotionally resonant prints and sculptures earned her the description of the "mother" of Expressionism. She was the first woman to be admitted to the Prussian Academy of Arts and would later teach there as an honorary professor. Her work was not only formally and technically innovative but also intently political, depicting labor uprisings, war, hunger, and grief. The motif of a mother mourning her dead son was one Kollwitz began exploring early in her career through a series of graphic and sculptural works that allude to the art historical trope of Mary and the dead Christ—and, specifically, to Michelangelo's famous marble *Pietà* in St. Peter's Basilica in Rome. However, this later sculpture was one Kollwitz produced following the death of her own son in World War I, both a form of tribute and part of what she called "sculptural experiments" portraying aging. Kollwitz's small-format original was reproduced at a larger scale in 1993 and installed in Berlin's Unter den Linden as a memorial to the victims of war and dictatorship, where it remains today.—MMB

BREATHING DANCE
c. 1928, plaster, 11 ¼ × 6 ¾ × 2 ¾ in.
(28.5 × 17 × 7 cm), Magyar Nemzeti Galéria,
Budapest

Elza Kövesházi-Kalmár, born 1876, Vienna, Austria.
Died 1956, Budapest, Hungary.

Although Vienna had historically been the creative capital of eastern Europe, at the turn of the twentieth century its women sculptors trailed behind their French and British counterparts in opportunity and training, only being allowed entry into sculpture courses at Vienna's Universität für angewandte Kunst in 1900. Elza Kövesházi-Kalmár, however, was able to learn sculpture as early as 1896 or 1898, quickly becoming known for her Art Nouveau portrait busts, nudes, and plaster reliefs. A prominent sculptor in Vienna's gallery scene, Kövesházi-Kalmár exhibited with the Secession for the first time in 1899 and became a member of the artist groups the Hagenbund and Kéve in 1907 and 1911, although, as a woman, she was only granted honorary membership to the former. Her sculptures utilized the Secessionists' formal approach but were also unmistakably influenced by Art Deco, expressionist dance, and the choreography of Isadora Duncan, on whom Kövesházi-Kalmár based many of her bronzes. Dance and movement remained major subjects even after she eventually settled in Budapest in 1920: *Breathing Dance*, for instance, demonstrates a translation of her modernist sculptural language into smaller decorative and ceramic art pieces. Although she continued to sculpt, Kövesházi-Kalmár took up shoemaking in the 1930s to provide for herself and her daughter, who, influenced by her mother's work, had become a dancer.—OC

BRIGITTE KOWANZ

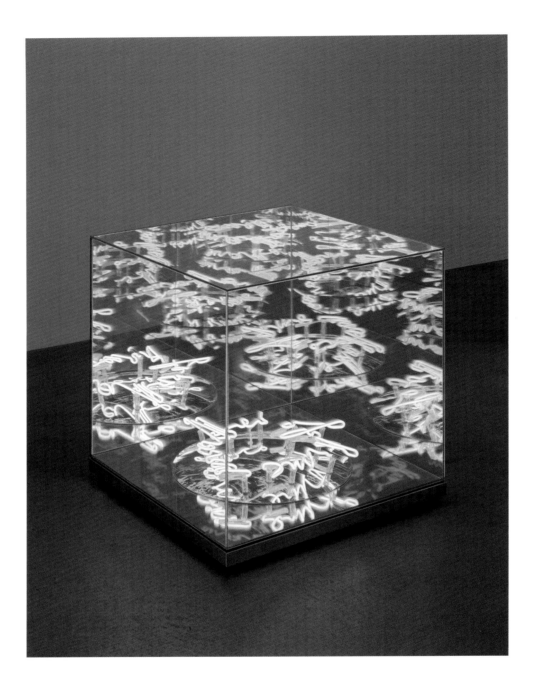

MATTER OF TIME
2019, neon and mirror, 27 ½ × 27 ½ × 27 ½ in.
(70 × 70 × 70 cm)

Brigitte Kowanz, born 1957, Vienna, Austria. Died
2022, Vienna.

Brigitte Kowanz celebrated the possibilities of light—as both medium and subject. Beginning her career in the 1980s, when the field of Light and Space art had long been dominated by male artists, Kowanz worked to manipulate the material into expansive environments, consisting of three-dimensional "light objects" and virtual spaces, transforming ephemerality into tangibility. By layering transparent and reflective surfaces with neon tubes, the artist endowed a spatial presence upon the elusive medium. In the 1990s Kowanz began incorporating words into her illuminated works, both in the form of written text and Morse code, relating language and light as "information carriers." In a 2021 interview with *STIRworld* magazine, she claimed, "Light makes everything visible, yet itself remains invisible/unnoticed. Light is language. Light is a code. Light is information. Light is what we see. Everything we see and know, we know through light." Her mirrored objects allow the viewers to enter this realm of knowledge through their reflections, involving them and their immediate surroundings in the work itself. *Matter of Time*, one such light object, comprises the titular phrase set in a circle of neon tubing in a mirrored cabinet. The geometry of the cube and the words are multiplied internally, the illuminated words repeating infinitely.—JS

UNTITLED
2006, ice, ink, and lightbulb, 5 ⅛ × 7 ⅞ × 9 ⅞ in.
(13 × 20 × 25 cm)

Kitty Kraus, born 1976, Heidelberg, Baden-
Württemberg, Germany.

Kitty Kraus creates works with agency; her sculptures undergo transformations while exhibited, sometimes changing shape or even disappearing altogether. Kraus graduated from the Universität der Kunste, Berlin, in 2006 with an MFA in sculpture, developing a practice of crafting entropic artworks that move toward degeneration before the viewer's eyes. As the artist stated in a 2016 interview with *Berlin Art Link*, she endeavors to "free [her objects] from the biggest of all restrictions (permanence), as well as involv[e] fragility." Because her sculptures are so inherently unstable, they break down into new representations of themselves, no longer forced to exist in the molds in which they were created. Since 2005 much of Kraus's work has involved the use of lightbulbs, often enclosed in such a way that instead of providing illumination, the light serves as a destructive force. This untitled work from 2006 comprises a lit bulb encased inside a cube of ink-dyed ice. As the heat from the lightbulb slowly warms and melts the ice, the ink begins to trickle—and then flow—across the floor of the gallery. Eventually, all that is left of the work is a dried-ink topography of the melting ice's meandering path.—JS

SHIGEKO KUBOTA

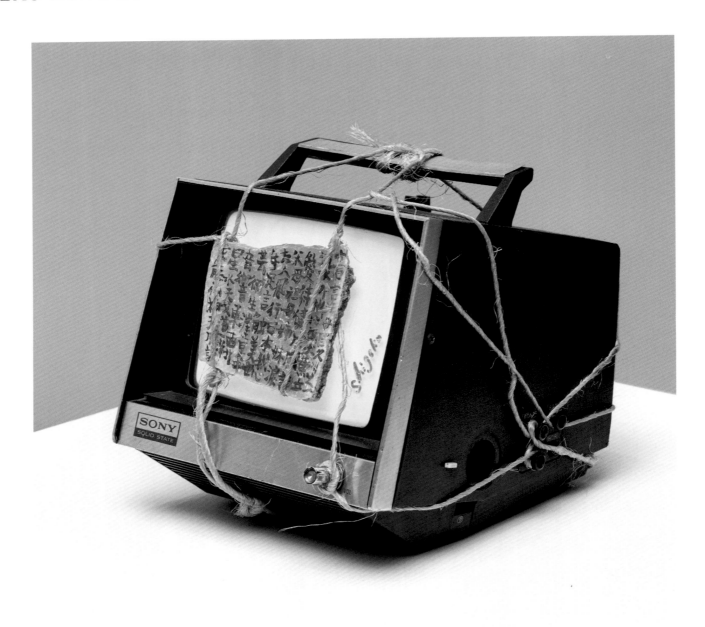

BERLIN DIARY: THANKS TO MY ANCESTORS
1981, cathode-ray tube monitor, crystal, ink, and
twine, 9 × 8 × 11 in. (22.9 × 20.3 × 27.9 cm),
Museum of Modern Art, New York

Shigeko Kubota, born 1937, Niigata, Japan.
Died 2015, New York, USA.

An integral member of the Fluxus movement and pioneer of video art, Shigeko Kubota participated
in Tokyo's avant-garde scene of the 1960s but, as a woman, found recognition elusive. On the invitation
of Fluxus founder George Maciunas (1931–78), she moved to New York, where she gained notoriety
with her 1965 *Vagina Painting* performance, using a brush attached to her underwear to paint in what
was interpreted as a critique of the machismo of Abstract Expressionist painters such as Jackson
Pollock (1912–56). Kubota found her language in video technology, embracing the hefty physicality
of the early portable video camera, which she compared to a "new paintbrush." She created a series
of video sculptures inspired by Marcel Duchamp (1887–1968) and poetic installations that drew on the
Japanese tradition of spiritual landscapes, juxtaposing water and mirrors with video monitors projecting
imagery. Exploring the intersection of identity, nature, and technology, these works heralded digital
art. *Berlin Diary: Thanks to My Ancestors* features the names of Kubota's ancestors on a slab of crystal
backlit by a TV monitor, and unites the ancient and new, personal and abstract. Bound with string like
an important package, the uncanny monolith might almost be a time capsule for future generations.—EF

(DINOSAUR 37)
2017, stoneware, 26 ½ × 15 ¾ × 15 ¾ in.
(67.3 × 40 × 40 cm), The Broad, Los Angeles

Shio Kusaka, born 1972, Morioka, Iwate, Japan.

Shio Kusaka is known for her playful and innovative approaches to ancient Egyptian, Japanese, and Greek ceramic techniques integrated into contemporary practice. Kusaka, who was honored with the Isamu Noguchi Award in 2021, has been inspired by the elegant dishes and cups that her grandmother used in traditional Japanese tea ceremonies, as well as the simple, functional, and unglazed forms of the pottery of the Yayoi period in Japan (300 BCE to 300 CE). Kusaka's stoneware pots and porcelains are both functional and artistic, and bring together sculpture, painting, and drawing by "deliberately relocat[ing] some of abstract art's staples—grids, parallel lines, repeating marks—to ceramics," as critic Roberta Smith noted for the *New York Times* in 2010. While her practice does take up traditional ceramic processes, she combines hand-building and wheel techniques in her unique approach to the medium. The final shape of Kusaka's objects is often offbeat, as in the case of the colorful pieces called *fruits*, or her vases depicting patterned animal prints. In *(dinosaur 37)*, Kusaka unites the tradition of Greek black-figure urns with the contemporary universe, through drawings of cheeky dinosaurs that appear to have wandered out of children's books or films.—TP

YAYOI KUSAMA

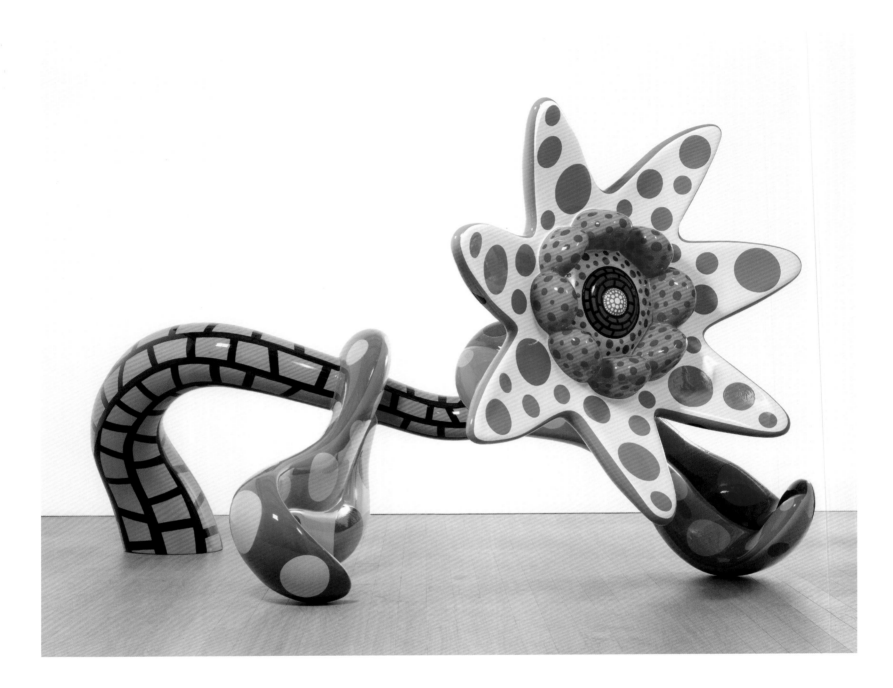

FLOWERS THAT BLOOM TOMORROW
2010, fiberglass reinforced plastic, metal,
and urethane paint, 78 ¾ × 133 ⅞ × 78 ¾ in.
(200 × 340 × 200 cm)

Yayoi Kusama, born 1929, Matsumoto,
Nagano, Japan.

Spanning a wide range of media including sculpture, Yayoi Kusama's multidimensional practice
became codified in the late 1950s upon her move from Japan to the United States. Although the artist
had academic training in painting in Kyoto in the late 1940s, she destroyed these early works ahead of
her move to New York where she would become part of the city's avant-garde circles. Kusama experi-
enced hallucinations as a child wherein fields of dots would overwhelm her vision; as an adult in the
late 1950s, she began creating her *Infinity Net* paintings made of marks that seemed to continue indef-
initely, refusing the limits of the canvas. Kusama made "accumulation" sculptures of everyday objects
covered in fabric phallic forms. She also created her first *Mirror Rooms*, environments that gave
viewers a sense of occupying limitless space. Kusama returned to Japan in 1973 and in 1977, by her
own volition, moved into a psychiatric hospital where she continued to make art and write poetry and
fiction. In 2000 the artist began making monumental outdoor fantastical flower sculptures, starting
with *Flowers of Shangri-la*. These works, of which *Flowers That Bloom Tomorrow* is one, reflect Kusama's
investment in complex natural forms, biological cycles of life and death, and "flower power," a joyous
complement to her antiwar politics.—MS

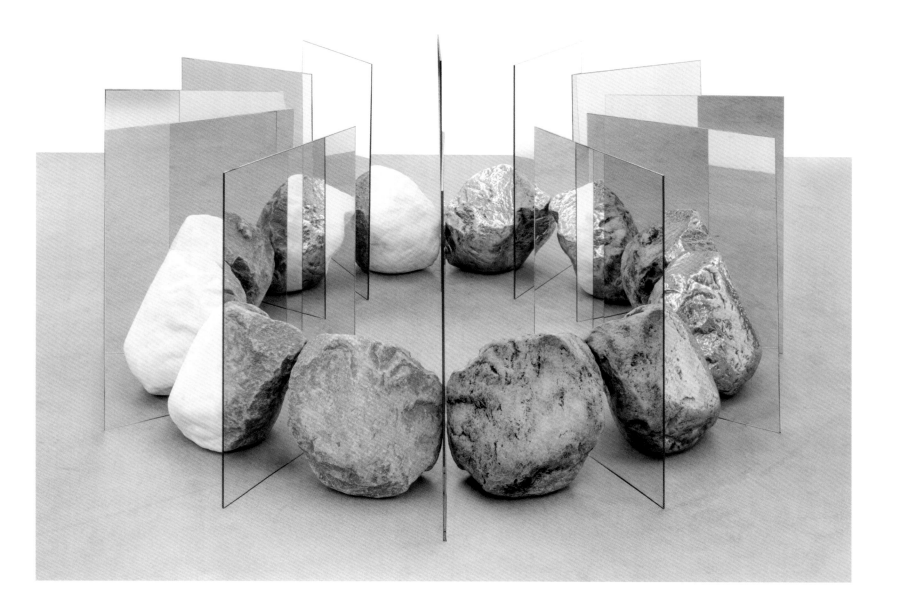

DUODECUPLE BE-HIDE
2020, granite, patinated bronze, mirror, and marble,
43 ½ × 88 ⅝ × 88 ⅝ in. (110.4 × 225 × 225 cm)

Alicja Kwade, born 1979, Katowice,
Silesia, Poland.

For Alicja Kwade art functions as a tool to question universally accepted ideas of time, space, and science. These philosophical investigations, driven by extensive scientific and mathematical research, sometimes take the form of photographs, videos, or other digital work, but Kwade is primarily known for her ambitious sculptural installations. Seeking to break down frames of perception and often without a predetermined starting point, Kwade's sculptures transform as the viewers move around them, conjuring infinite possibilities. Depending on the project, she uses different materials and objects, selecting them for their symbolic resonances. The work *Pars pro Toto* (2017), first exhibited at the 57th Venice Biennale that same year, comprised an arrangement of thirteen perfectly round stone spheres sourced from, and meant to symbolize, the Earth's various continents. In recent years Kwade has increasingly worked in the public realm, creating vast installations that respond to the architecture and the phenomena of different environments. *Duodecuple Be-Hide* explicitly references the natural landscape, using one found rock and eleven replicas—cast in bronze, marble, and stone. Positioned in a clocklike circle, separated by double-sided mirrors, the stone and its counterparts overlap seamlessly in reflection, appearing to transform into one another as the viewer circles the sculpture, creating a parallel world.—GS

NICOLA L.

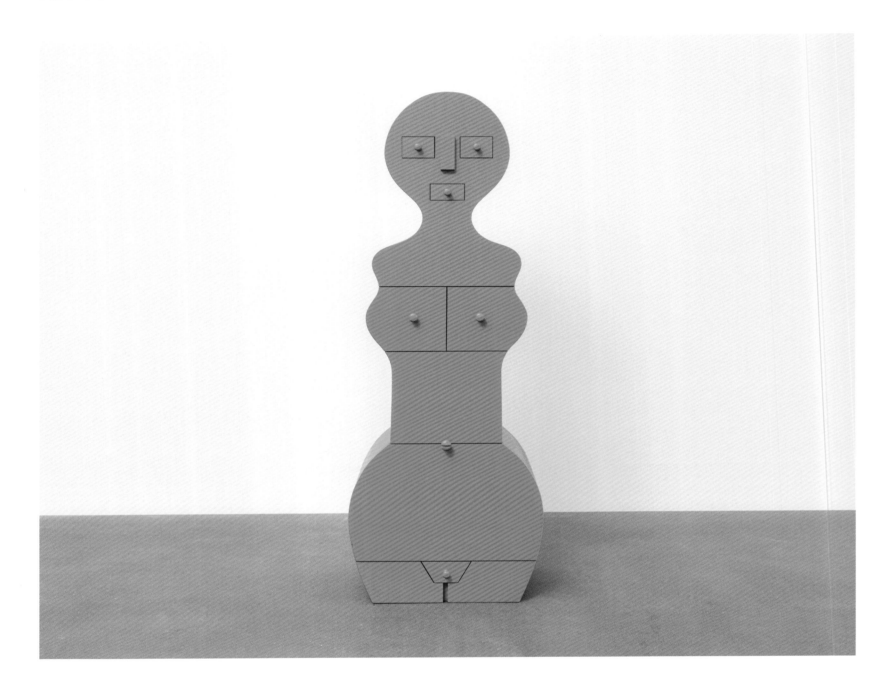

ORANGE FEMME COMMODE
1969/2008, lacquered wood, 67 × 25 ¼ in.
(170 × 64 cm)

Nicola L., born 1932, Mazagan, El Jadida, Morocco.
Died 2018, Los Angeles, California, USA.

Nicola L.'s diverse practice consistently addressed the bodily experiences of both individuals and collectives—from performances in which she invited participants to dress themselves in a vast multi-person coat to paintings reflecting on the trope of the femme fatale. After studying painting in Paris, the artist (born Nicola Leuthe) dropped her surname and became close with the Nouveau Réalistes, many of whom incorporated everyday objects into their work. Nicola L. moved to New York in 1979, where she lived at the Chelsea Hotel for over three decades. Her bold, playful works refuse easy definition, blurring boundaries between mediums and subverting expectations around gendered stereotypes. She described her anthropomorphic sculptures—from foot-shaped sofas to eye-shaped lamps—as "functional art." Her *Femmes Commodes* were lacquered wood cabinets that transformed the shape of a woman into a stylized piece of furniture, divided up into drawers. These works directly confronted the objectification of women's bodies and their socially inscribed domestic roles. Similarly, her *Pénétrables* were sculptural paintings, which could be activated by viewers placing their hands, face, or feet into body part-shaped openings in the canvas, wearing them like a second skin. Proclaiming her work as "an ephemeral monument to freedom," in a 2015 Tate Artist Interview, Nicola L.'s feminist practice manifests a belief in the political power of shared experience.—LJ

INFIRMIÈRES SOIGNANT UN BLESSÉ (NURSES TREATING AN INJURED PERSON)
1915, bronze, diam: 2 ⅞ in. (7.4 cm),
Musée d'Orsay, Paris

Marcelle Renée Lancelot-Croce, born 1854, Paris,
France. Died c. 1938, France.

Born to a family of artists, Marcelle Renée Lancelot-Croce was blessed with a prodigious talent for medal carving and bas-relief. Having studied under her father, Dieudonné Lancelot (1822–94), an engraver, and the sculptors Hubert Ponscarme (1827–1903) and Eugène Delaplanche (1836–91), she exhibited at the prestigious Salon des Artistes Français in 1878. After a decade honing her craft, she was awarded a medal and a travel grant by the Salon—an unprecedented honor for a woman. The artist used the funds to travel in Italy, where she eventually settled. She became a member of the Accademia di San Luca and made medals for the Italian authorities, while continuing to exhibit at the Parisian Salon. A gold medal at the 1900 world's fair and the French government's award of the Knight of the Legion of Honor marked the pinnacle of her success. Despite such triumphs, her 1913 application for chief engraver of the Italian Mint was blocked on grounds of her gender. This small roundel was one of several she created during World War I. In the poignant scene, Lancelot-Croce conveys a wealth of detail, capturing the suffering on the patient's face and tender expressions of the nurses, and demonstrating her compositional skill.—EF

ARTIS LANE

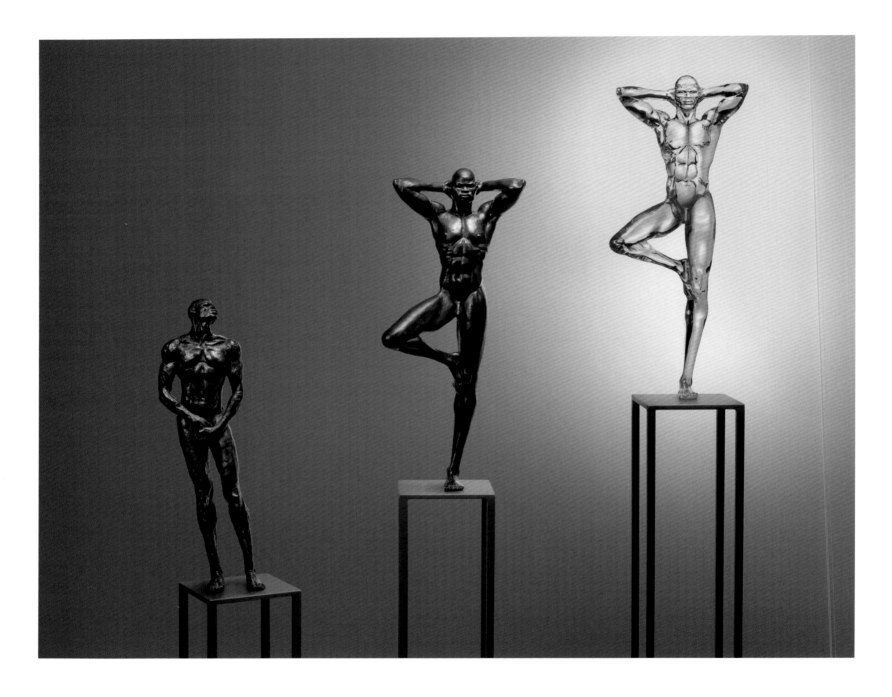

FIRST MAN, NEW MAN, and **SPIRITUAL MAN**
1997, bronze and black patina, 29 × 10 × 13 in.
(73.7 × 25.4 × 33 cm); 1993, bronze and black
patina, 32 × 13 × 8 in. (81.3 × 33 × 20.3 cm); 2004,
kaolinite, 32 × 13 × 8 in. (81.3 × 33 × 20.3 cm)

Artis Lane, born 1927, North Buxton, Ontario,
Canada.

Artis Lane is a devoted portraitist who has rendered some of the most important political and cultural
figures of her time. As a descendant of enslaved people from the American South who sought passage
through the Underground Railroad and settled in Canada, Lane has always been curious about her
African heritage and invested in the condition of Black people in North America. The artist has
remained committed to civil rights education through her practice, evinced in her portraits of activists
like Dorothy Height, Rosa Parks—a close friend of Lane's—and Sojourner Truth. Born in Canada and
raised in the United States, Lane took up painting as a child and would use clay from her grandfather's
farm to sculpt, before pursuing a formal arts education as a young adult. From the 1950s through
the 1980s the artist became known for her commissioned portraits of politicians and celebrities,
an area that has remained a cornerstone of her practice. Since the 1990s Lane's work has become more
expressionistic, harnessing the artist's interest in spirituality. Lane's *Emerging* series reveals her interest
in metaphysics and transcendence, which she demonstrates in works like *First Man*, *New Man*, and
Spiritual Man by retaining the foundry elements of her casting process, thereby materially signaling
stages of growth.—MS

JACQUELINE KENNEDY DOLL
1986, fabric, wire, glass, human hair, acrylic paint, and matte medium, 27 × 8 × 3 in. (68.6 × 20.3 × 7.6 cm), G.L.A.M. (Greer Lankton Archives Museum), New York

Greer Lankton, born 1958, Flint, Michigan, USA. Died 1996, Chicago, Illinois, USA.

Greer Lankton was a vital member of the revolutionary art scene that had its hub in New York's East Village in the 1980s. Her room-sized environment *It's all about ME, Not You* (1996), on permanent display at the Mattress Factory in Pittsburgh since 2014, is populated by dolls and mannequins of all sizes—from portable to life-size—a trope that recurs throughout her work. Perched on wire structures, painted and sewn with mastery, and complete with realistic touches such as glass eyes and human hair, the dolls are often staged theatrically. Some are part of "a kind of club-crowd crush of priapic trolls, hermaphrodites, and addicts," as the *New York Times* described them on the occasion of the artist's 2014 retrospective at Participant Inc., New York, but others are film stars, celebrities, or other inspirational figures drawn from Lankton's entourage. They all offer insightful commentary on the body, sexuality, and gender identity. In *Jacqueline Kennedy Doll* the malleable aspects of femininity and glamour are played with in the figure's androgynous and oversize face. Dressed in the outfit she was wearing when her husband, President John F. Kennedy, was shot, the former First Lady's look includes the bouquet of roses she had carried earlier that day, anticipating tones of bloody red in her otherwise impeccable appearance.—CI

LIZ LARNER

MEERSCHAUM DRIFT (BLUE)
2020–1, refuse plastic and acrylic paint,
37 × 240 × 346 ¾ in. (94 × 609.6 × 880.7 cm)

Liz Larner, born 1960, Sacramento, California, USA.

After studying photography at the California Institute of Arts in the mid-1980s, Liz Larner exchanged image-making for direct engagement with the materiality of the world. She interrogates the possibilities of sculpture using a dizzying range of styles and materials, from the conventional—such as bronze, ceramic, and steel—to the unorthodox: false eyelashes, surgical gauze, and explosives. Her early *Cultures* series (1987–) addressed transformation and decay, combining organic and inorganic ingredients in petri dishes and leaving them to fester. In the 1990s her interest in the phenomenological experience of art led to heterogeneous, freestanding abstract sculptures and architecturally responsive installations exploring color, space, and volume. From 2009 her ceramic works embraced the unpredictability of the firing and glazing process in an untitled series of wall-mounted slabs covered with resin that appear like geological excavations. More recently, environmental concerns have come to the fore, as in *Meerschaum Drift (Blue)*, a sprawling agglomeration of painted plastic consumer waste that evokes a frothing sea. At once a formal investigation of her material and an allusion to the disastrous problem of marine plastics pollution, the floor-based sculpture exemplifies Larner's restless experimentation and enduring curiosity about the world and its structures.—DT

MONSTER: BLACK
1998/2011, fabric, fiberfill, stainless steel frame,
sequins, acrylic paint, dried flower, glass beads,
aluminum, crystal, and metal chain,
85 ⅜ × 73 ⅝ × 67 ⅜ in. (217 × 187 × 171 cm)

Lee Bul, born 1964, Yeongju-si, North Gyeongsang,
South Korea.

The child of dissident parents during Park Chung-Hee's military dictatorship, Lee Bul was a non-conformist from the outset. Lee came to prominence in the late 1980s with provocative performances that challenged patriarchal structures and gender roles. In *Sorry for suffering – You think I'm a puppy on a picnic?* (1990), she wandered the streets of Tokyo sporting a bodysuit-cum-sculpture with protu-berances and tentacles. Always muddying distinctions between beauty and revulsion, nature and artifice, her breakthrough exhibition at New York's Museum of Modern Art in 1997 closed early due to the putrid odor emitted by a sculpture containing plastic bags of dead fish. An international icon today, she is best known for her futuristic sculptures of metamorphosing monsters and fragmented cyborgs, as well as her installations of glittering architectural landscapes. *Monster: Black* seems to endlessly sprout serpentine limbs, evoking a science-fiction Gorgon or a fiendish plant with prolifer-ating roots. Although composed largely of synthetic materials such as metallic sequins, glass beads, and crystals, the sculpture appears uncannily alive. Lee's disquieting forms prompt questions about progress and the relationship between humanity, technology, and nature. Her biomorphic sculptures and labyrinthine utopian environments encapsulate the doomed search for perfection that defines the human condition.—EF

MARIE-LOUISE LEFÈVRE-DEUMIER

COURONNE DE FLEURS (CROWN OF FLOWERS)
1861, marble, Cour Carrée, Musée du Louvre, Paris

Marie-Louise Lefèvre-Deumier, born 1812,
Argentan, Orne, France. Died 1877, Paris, France.

Born to a bourgeois family, Marie-Louise Lefèvre-Deumier began sculpting as a hobby, but would go on to exhibit publicly at the Paris Salon of 1850. She soon earned the favor of the French court, working often for the emperor, Napoleon III, and his wife, Eugénie. A bust she sculpted of Napoleon III was reproduced en masse, with fifty copies being distributed across French municipalities. She also worked as a journalist under the male penname Jean de Sologne. In 1861 Lefèvre-Deumier received a commission from the French state to produce a sculpture, illustrated here, to decorate the central court of the Louvre palace, the Cour Carrée (or Square Court). Along with Claude Vignon (p.304) and Hélène Bertaux (1825–1909), Lefèvre-Deumier thus became one of only three women who had received state commissions for outdoor public spaces in Paris. For the Louvre, she depicted Glycera, a flower seller from Greek antiquity known for making splendid garlands of flowers, like the one she is shown holding here. According to Pliny the Elder, Pausias, the painter who loved Glycera, honed his talents by mimicking in paint her varied floral creations. She, in turn, developed ever-more complex designs to test his skill. This episode serves as a demonstration of the artistic drive to imitate nature—an ultimately impossible task that nevertheless spurs creativity onward.—MMB

2020, stoneware, 26 ¼ × 12 ¾ × 14 ½ in.
(67 × 32 × 37 cm)

Simone Leigh, born 1967, Chicago, Illinois, USA.

Simone Leigh studied philosophy and cultural studies, eventually coming to art through an interest in material culture. Leigh also trained as a ceramicist, and she layers references from pottery, architecture, and portraiture to evoke feelings of shared experience and cultural history. Through series such as *Anatomy of Architecture* (2016–), Leigh combines architectural elements ranging from Batammaliba architecture in West Africa to the American South with figurative forms. Works such as *Titi (Cobalt)* show individually hand-formed rosettes atop the head of a woman whose neck has been elongated to suggest a column or the base of a building. Leigh constructs busts of Black women that oscillate between abstraction and figuration, referencing the collective design of architecture alongside individual creations such as face jugs from the southern United States. The works build on associations between Black women and domesticity, contradicting the assumptions of female fragility with the strength and durability of architecture. Beyond her art practice, Leigh convenes writers, filmmakers, poets, theorists, and fellow artists in the landmark symposia series *Loophole of Retreat*. Hosted first at the Guggenheim Museum in 2019, the series was expanded at the 59th Venice Biennale in 2022, when Leigh represented the United States at the U.S. Pavilion.—MK

JAC LEIRNER

PRISMS
2022, 64 pouches (vinyl, magnets, and Styrofoam)
and 5 IPE 300 I-beams, overall length:
393 ¾ in. (1,000 cm)

Jac Leirner, born 1961, São Paulo, Brazil.

Jac Leirner's meticulously created sculptures use everyday objects and ephemera that often have a personal connection to her, such as airline tickets, cigarette packs, shopping bags, and business cards. In one of the works from her series *Pulmão* (*Lung*, 1985–7), for instance, she strung together 1,200 deconstructed Marlboro cigarette packs, saved from her years of smoking, to create a beautifully stacked and suspended artwork that not only was a musing on the artist's own consumption but also acted out the precisionist tropes and colors of Minimalist, Pop, and Concretist sculpture. Similarly, *Prisms* is composed of small numbered fabric pouches normally utilized by Brazilian parking attendants to identify their clients' vehicles. The result is a multicolored assemblage that alludes to the artist's interest in mathematics and systems, as well as the obsolescence of objects that will eventually cease to circulate. Speaking about her fascination for found objects in the 2011 publication *Jac Leirner in Conversation with Adele Nelson*, the artist stated: "In silent ways materials tell their stories . . . They belong to networks and systems where they assume new positions, including, finally, that of an artwork placed in a museum. In the end, what I do in all the works is to create a place for things that don't have one."—SGU

"LA FORTUNE" (AFTER MAN RAY): 4
1990, mahogany, felt, and billiard balls, overall
33 × 110 × 60 in. (83.8 × 279.4 × 152.4 cm),
Whitney Museum of American Art, New York

Sherrie Levine, born 1947, Hazleton, Pennsylvania,
USA.

"Every word, every image, is leased and mortgaged," Sherrie Levine wrote in a 1981 artist's statement. "A picture is a tissue of quotations drawn from the innumerable centers of culture." Trained in painting and printmaking, Levine deployed collage in her early work as a postmodern mechanism to challenge understandings of originality and authenticity in art-making. She first rose to prominence among the Pictures Generation in the late 1970s, a cohort of New York–based artists that critically engaged mass media and its strategies of representation. In 1981 Levine found her métier with the photographic series *After Walker Evans*, which exactly reproduced the Depression-era photographer's images. The work's logic—the direct quotation of existing artworks in their original form—guided her proceeding practice and cast Levine as a leading appropriation artist, radical in her fidelity to the artwork copied. Remade in a new context, and by a woman artist, these facsimiles extended novel considerations on value, authorship, and modernism's myth of (male) genius. Levine's reprographic impulse later expanded to include the reproduction of art historical references in mediums unfamiliar to the original. In *"La Fortune" (After Man Ray): 4*, she cites the billiard table featured in the Surrealist artist's series of paintings begun in 1938, translating the oil motif into a fabricated object.—LB

HANNAH LEVY

UNTITLED
2022, nickel-plated steel and glass,
48 × 38 ½ × 54 in. (121.9 × 98 × 137.2 cm)

Hannah Levy, born 1991, New York, USA.

Alluring yet dangerous, familiar yet alien, Hannah Levy's sculptures draw on the language of high-end design furniture, medical equipment, and even the world of BDSM. The artist, who trained at Cornell University in Ithaca, New York, and the Städelschule in Frankfurt am Main, Germany, is best known for her works utilizing silicone and steel to create sleek, fleshy sculptures that feel at once bodily and industrial. Her creations include a chandelier-like form fashioned from a silicone corset stretched impossibly tight by metal claws; a baby swing set within gigantic spidery legs; and stiletto heels perched on talons. Four of Levy's cyborgian sculptures were included in the 59th Venice Biennale in 2022. This work has a similar science-fiction aspect, calling to mind a menacing futuristic spider or a perfidious plant, perhaps a cousin of the Venus flytrap, with its spiky thorns and sack waiting to catch prey. Levy has made versions with silicone, but here the use of brown curving glass bestows an organic naturalness, deceptively suggesting a tactile pliable body that counters the angular polished steel stalklike legs. This seductive work invites the viewer to come closer, braving the sharp thorns, but were they to place their hand in the sack, it might just snap shut.—EF

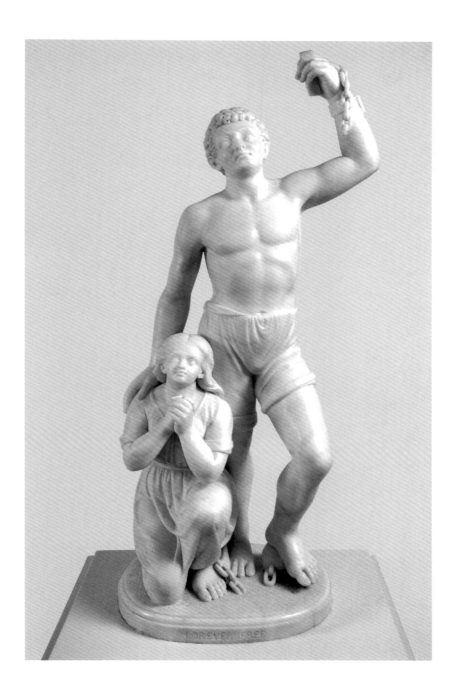

FOREVER FREE
1867, Carrara marble, 41 ¾ × 21 ½ × 12 ⅜ in.
(106 × 57.2 × 31.4 cm), Howard University Gallery
of Art, Washington, D.C.

Edmonia Lewis, born c. 1844, Greenbush, New
York, USA. Died 1907, London, UK.

Born to a Haitian father and part-Chippewa mother, Edmonia Lewis was orphaned at an early age and raised in upstate New York by her maternal family who called her "Wildfire." With the sponsorship of her half-brother, Lewis enrolled at Oberlin College, Ohio, in 1859, where she was exposed to both fine arts training and abolitionist activity. After being subjected to a racially motivated assault campaign, Lewis left Ohio without her degree and relocated to Boston by 1863, where she befriended many abolitionists who came to support and motivate her creative endeavors. Lewis encountered enough financial success from sales of her early clay and plaster medallions and busts of abolitionists like John Brown and Union war heroes like Robert Gould Shaw to finance her relocation to Europe, where she would start working in marble. Lewis honed her Neoclassical style, making figurative sculptures of biblical and historical scenes. After traveling in London, Paris, and Florence, Lewis settled in Rome by the mid-1860s. Like Harriet Hosmer (p.146), who was in Rome at the same time, Lewis chiseled completely on her own, whereas other sculptors often enlisted assistance. Made during the artist's time in Italy and in the immediate wake of emancipation in the United States, *Forever Free* is emblematic of Lewis's political and ethical commitment to depicting icons of antislavery.—MS

TAU LEWIS

RESURRECTOR
2022, steel, enamel paint, repurposed leather, fur,
suede, shearling, coat linings, silk, chalk pastel,
organic cotton twill, and coated nylon,
116 × 110 ½ × 37 in. (294.6 × 280.7 × 94 cm),
private collection

Tau Lewis, born 1993, Toronto, Ontario, Canada.

In her sculptural practice, Tau Lewis uses recycled materials to create enigmatic figures that cite a host of spiritual and worldly references. Lewis's artistic education lies outside academic systems, stemming instead from close studies of the work of artist mentors and peers, such as Atlanta-based Lonnie Holley (b. 1950) and the Gee's Bend Quilting Collective. As a Jamaican Canadian artist, Lewis connects her use of found materials to practices of resourcefulness and repurposing seen throughout global Black diasporic communities. She is especially drawn to using fabrics, leathers, furs, shells, and bones in her work—porous materials with close ties to the sites in and of the Earth that collect and hold memories of where they have been—and she strives to honor these histories even as she transforms them, hand-sewing them into large-scale figurative sculptures. *Resurrector* is from a series in which Lewis cites inspiration from Yoruba, ancient Greek, and Christian mythologies in larger-than-life masks, which the artist, speaking to *ARTnews* in 2022, described as "portals" to a spiritual realm. The visage of *Resurrector* looms large over the viewer, its eyes closed in contemplation. Both human and animalistic, materially earthly and, in Lewis's transformation, rendered otherworldly, it invites communion with unknown forces beyond the viewer's sight.—CD

HEADWIND
2023, hand-colored limewood and stainless steel,
40 ½ × 51 ⅛ × 31 ⅞ in. (103 × 130 × 81 cm),
Sof:Art, Bologna

Liao Wen, born 1994, Chengdu, Sichuan, China.

Liao Wen's visceral, anthropomorphic sculptures are rooted in her training in the creation of mario-nettes, which she studied in Prague in 2017 through an international program at the Central Academy of Fine Arts in Beijing. The jointed and movable nature of her wooden figures mimics the malleability of puppets' limbs, which are able to be manipulated by the user. Liao often tries out several poses for each work before deciding upon the final positioning—frequently they are set in anatomically improb-able postures, twisted into contortions that invoke a deep-rooted sense of tension and anxiety. For Liao, her sculptures represent what people cannot achieve due to the limits of the human body: "The sculp-tures are my androids; they are my puppets; they can endure it. They are perfect actors. They are much better than human beings," she stated in a 2023 interview with *Elephant*. One of Liao's jointed forms, *Headwind*, is bent backward and twisted to the side, lifted onto its tiptoes, as if confronting an invisible force. Although most recognizable human characteristics are missing—it has no eyes, nose, or even arms—the tension invoked by the being is tangible. Even though the figure is technically expression-less, its ability to balance in extreme movement provokes an empathic response, acting as a model for dealing with life's occasional tumult.—JS

LILIANE LIJN

MARS KOAN
2008, glass fiber, polyester resin, fluorescent red
and orange and green Perspex, motorized turntable,
and fluorescent light, base diam: 37 ¼ × 21 ⅝ in.
(94.5 × 55 cm)

Liliane Lijn, born 1939, New York, USA.

Interests in science and technology, combined with philosophical and material concerns, underpin the work of London-based artist Liliane Lijn. Initially influenced by the automatic writings of the Surrealists she encountered while studying art history and archaeology in Paris in the late 1950s, Lijn first developed rotating sculptures in her *Poem Machines* series (1962–8): text-covered cylinders that turned at different speeds to alter how the words were read. Cone-shaped *Poemcons* followed in 1965, their form partly inspired by images Lijn had seen in a book of the intricately carved towers of Angkor Wat in Cambodia, as well as the conic symbol of Greek hearth goddess Hestia—a white ash mound. In 1969 Lijn replaced words with angled elliptical planes dividing the conical form, and adopted the homonym "Koan"—a paradoxical phrase used to aid meditation in Zen Buddhism—in her titles to reinforce these works' contemplative qualities. Another key interest for Lijn has been the physics of light and numerous of her works since the late 1960s have incorporated mechanisms that reveal light's effects in motion. *Mars Koan* features internal illumination and the light-transmitting properties of Perspex to generate a hypnotic, continuous flow of undulating, colored lines as it rotates at a constant speed.—RM

PEGASUS
1962, bronze, 41 × 20 ⅛ × 5 ⅞ in.
(104 × 51 × 15 cm)

Kim Lim, born 1936, Singapore. Died 1997,
London, UK.

Born to Chinese parents, Kim Lim left Singapore for London in 1954 to study sculpture at Central Saint Martins School of Art, where she was taught by Anthony Caro (1924–2013) and Elisabeth Frink (p.108), before transferring to the Slade School of Fine Art in 1956 to study printmaking. She remained in Britain for the rest of her life, making an important contribution to postwar British art with works influenced by the natural world and her extensive international travels. Lim's abstract sculptures of the 1960s and 1970s in wood and bronze are characterized by elegant geometries, the hemispherical forms of *Pegasus* typifying her ability to transform elementary shapes into a refined sculptural presence. From 1980 she focused on stone-carving with an increased emphasis on the subtleties of surface, texture, and line, while continuing to make prints and drawings. Travel was an important aspect of Lim's development, and, with her artist husband William Turnbull (1922–2012), she experienced a rich variety of art and culture in China, Indonesia, Egypt, Malaysia, Cambodia, Greece, and Turkey. Consequently, her taste for archaic motifs, Cycladic art, Shang bronzes, and Han sculpture—artifacts marked by a formal simplicity—is reflected in many of her nonfigurative works.—DT

WON JU LIM

KISS T3
2015, plexiglass and light, 7 ¼ × 94 ½ × 17 in.
(18.4 × 240 × 43.2 cm), private collection

Won Ju Lim, born 1968, Gwangju, South Korea.

Won Ju Lim's multimedia sculptures are lucid expressions of real and imagined spaces, reconstructed through memories and fantasy to examine the fluidity of identity and the transient nature of existence. References to Baroque cathedrals, American cityscapes, science-fiction films, and the artist's own home can be traced in the formal and conceptual elements of Lim's works. Her sculptures play with notions of inside and outside, materiality and metaphor, synthesizing influences from the serial Minimalism of Donald Judd (1928–94) to the early-twentieth-century writings of Marcel Proust. Suggestions of architecture permeate the crisp geometries of Lim's mixed-media assemblages: encased within her series of colored plexiglass and light works—of which *Kiss T3* is an example—are architectural models based on plans for the "Case Study Houses," affordable, residential mid-century modern homes built primarily in Los Angeles between 1945 and 1966. Lim, who also works with collage, painting, and film, favors ephemeral and fragile materials such as found glass, foam core, cardboard, or foil, and sculpts with light and shadows to create shifting, uncertain, and illusory environments, inviting the viewer to project their own responses and emotions into the work.—CJ

LEVIANES #5
2021, tulle and dry ice, 24 ⅛ × 31 × 5 in.
(61 × 78.7 × 12.7 cm)

Laura Lima, born 1971, Governador Valadares,
Minas Gerais, Brazil.

Although in the lineage of Brazilian traditions that incorporate the viewer as part of the work of art—such as the Neo-Concretism of Lygia Pape (p.240)—Laura Lima's destabilizing practice escapes categorization. In her works, the life of the piece and the body of the spectator are entangled in a choreography. Her staged encounters skillfully reinvent the contours of what perception is and the behavior it elicits, proposing a reconfiguration of social relations. Lima's exhibitions appear to be living organisms, too: in continuous movement, her subjects, objects, and the surrounding architecture fuse into a new experiential conversation. Many of the artist's works appear to be suspended or in flux, as exemplified in her group of works named *Levianes*. Here, the dry ice and lightweight fabric interact in an interdependent but disparate dance, inspired by gravity, changing material states, and human influence. Presented under dramatic spotlights, people periodically place fragments of dry ice within the folds of these floating sculptures. As the ice evaporates, it produces an atmospheric smoke effect that travels throughout the sculptures' porous surfaces. Lima has often described her body of work as composed of "images": in the crossing orbits of ice, gas, tulle, light, and human intervention an unstable but distinct visual articulation lingers.—CI

MAYA LIN

BLUE LAKE PASS
2006, 20 blocks of Duraflake particleboard,
each 36 × 36 in. (91.4 × 91.4 cm), overall
5 ⅜ × 17 ½ × 22 ⅜ ft. (1.7 × 5.3 × 6.8 m)

Maya Lin, born 1959, Athens, Ohio, USA.

Trained both as an architect and a sculptor, Maya Lin makes decisively ecologically engaged structures and installations. She rocketed into the public consciousness when her design for a Vietnam veterans memorial was selected in a national competition and subsequently constructed in Washington, D.C. in 1982—Lin entered the contest while still a student at Yale University. Lin's memorial, a minimalistic granite wall covered in the names of veterans, provoked a heated conversation around the memory of the Vietnam War and the role of public monuments. Although Lin would continue to produce large-scale works, including a civil rights memorial, she has also produced an array of smaller sculptures and art installations. In *Blue Lake Pass*—shown in the artist's U.S. touring exhibition *Systemic Landscapes* (2006–9)—Lin recreated the topology of a Colorado mountain pass that holds personal significance as the site of her family's summer home. She reproduced this terrain sculpturally in layers of stacked particleboard, rendering the natural world with a human-made material constituted from waste wood. Lin sliced the landscape up into a grid, placing distance between each segment so that visitors can walk through the resultant gaps. This offers a mode of traversing the environment that would usually be entirely impossible.—MMB

MORE OR LESS THE SAME (SMALL) 2
2012, polyurea, yarn, silk threads, and stainless steel stands, c. 31 ½ × 19 ¹¹/₁₆ in. (c. 80 × 50 cm)

Lin Tianmiao, born 1961, Taiyuan, Shanxi, China.

As a child Lin Tianmiao would unpick the white cotton gloves provided to state-workers so her mother could make clothing and decorative furnishings from the thread. Lin's father was a painter in the realist Gongbi style, and she studied art before moving to New York with her husband, video artist Wang Gongxin (b. 1960). Working as a textile designer, Lin lived in a Brooklyn warehouse housing multidisciplinary artists before returning to China in the mid-1990s. Faced with censorship and a lack of institutional infrastructure, Lin and Wang founded the nonprofit Loft New Media Art Space in their Beijing home. The model was radical for what the artist described in a 2017 interview with *The Brooklyn Rail* as its "unapologetically individualist" ethos. Favoring materials that reflect the textures and politics of daily life, particularly women's work, Lin's early installations incorporated objects laboriously bound in, or formed from, the white thread of her childhood chore. Interested in the way materials, including the body, evolve with use and time, Lin turned to color following her mother's death in 2011. In *More or less the same (small) 2*, the difference between synthetic bones and tools is blurred, suggesting life beyond the body's decay as well as the prospect of mechanized labor.—AC

TAYEBA BEGUM LIPI

THE RACK I REMEMBER
2019, stainless steel razor blades and stainless steel,
55 × 60 × 18 in. (139.7 × 152.4 × 45.7 cm)

Tayeba Begum Lipi, born 1969, Gaibandha,
Rangpur, Bangladesh.

Using stainless steel razor blades and safety pins as her primary sculptural medium, Tayeba Begum Lipi recreates everyday household objects like ironing boards, shoes, strollers, accessories, and garments. Lipi's works reflect on social issues of gender rights as well as current political affairs. The razor blades allude to the violence faced by women in her native Bangladesh and to female marginality at large. Commonly used by both men and women, they also reference childhood memories of seeing her father and brother use razors to shave, as well as their function as the main tool for home birth deliveries in small towns and villages. The inviting nature of the gleaming metal juxtaposes with the risk of danger and pain if one were to fully engage with the sharp objects, producing a palpable push-and-pull tension. Since 2010 Lipi has switched from ready-made to custom-manufactured blades to allow greater artistic freedom in constructing works at different scales. In *The Rack I Remember*, razor-blade skirts, dresses, and sleeveless tops hang on a clothes rack like merchandise for sale. Lipi's non-functional commodities comment on the way women have been exploited in advertising and consumer culture, but they also explore how people, and by extension societies, continue to define themselves through these consumerist possessions.—OZ

FORMA, ESPACIO Y LUZ (FORM, SPACE, AND LIGHT)
1953, marble, Museo Nacional de Bellas Artes de Cuba, Havana

Rita Longa Aróstegui, born 1912, Havana, Cuba. Died 2000, Havana.

Rita Longa Aróstegui is renowned for her outdoor sculptures made of bronze, marble, and wood. With a celebrated career spanning over forty years, the sculptor left an indelible mark on the urban landscape of Havana—many of her works can still be found in churches, cultural centers, hospitals, and theaters across the city. Shortly after completing her studies in 1940, Longa produced her first commissioned piece for a private residence, which prompted her to embrace the environment as an integral part of her practice. Since then, she considered her artistic output to be intricately intertwined with its surroundings. Informed by elements of Art Deco, religious iconography, and the human body, Longa's distinctive visual language is considered by many to be emblematic of twentieth-century Cuban art. Among the artist's best-known works, *Form, Space, and Light* is located at the entrance of the Museo Nacional de Bellas Artes in Havana and can be appreciated from all perspectives. With its undulating surface and organically shaped crevices, the harmonious composition presents human and biomorphic forms in unity. Sinuously elegant, the sculpture epitomizes Longa's adept experimentation with materiality and space, light and shadow, figuration and abstraction.—JM

LIZA LOU

AGGREGRATE: PRIMARY
2018, glass beads, thread, and epoxy resin,
22 ½ × 13 ½ × 11 ½ in. (57.2 × 34.3 × 29.2 cm)

Liza Lou, born 1969, New York, USA.

From her early figurative works to her sustained engagement with abstraction, Liza Lou continues to make visible otherwise hidden labors in intricately beaded sculptures. She first came to prominence in her early twenties with *Kitchen* (1991–6), a full-scale replica of the titular domestic interior made with millions of glass beads and five years' effort, now in the collection of the Whitney Museum of American Art in New York. Women's work and gendered craft were stated subjects in this and other similarly ambitious, setlike pieces. In 2005 the artist established a studio with Zulu artisans in KwaZulu-Natal, South Africa, and found a more abstract expression of her feminist themes and social concerns. Collective making became integral to her works' conceptual framing—the many women's hands through which the beads passed united in their shared purpose. Repetition, tedium, and transcendence remain central to the artist's material meditations, as does a painterly attention to color and subtle variations in the beads' luminosity. Her *Aggregate* series, to which *Aggregate: Primary* belongs, offers "a relationship with color itself," as the artist said in a 2021 feature for Artsy; "a bead is a unit of color, a droplet, all of which reminds me of the splatter and drips of Abstract Expressionism."—LB

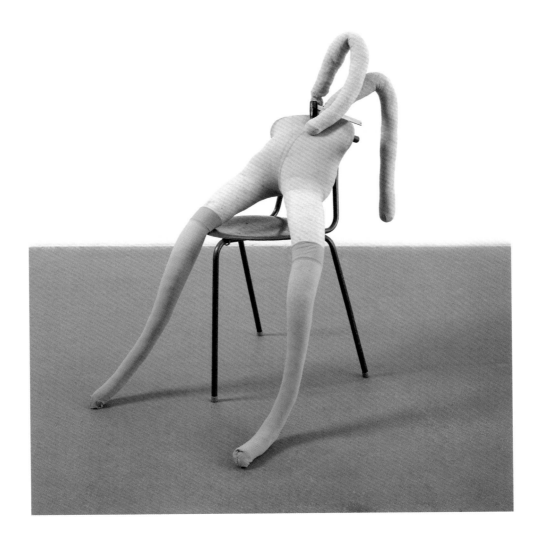

SUFFOLK BUNNY
1997–2004, tan tights, blue stockings, chair, clamp, kapok, and wire, 37 ¼ × 25 ¼ × 35 ⅜ in. (96 × 64 × 90 cm)

Sarah Lucas, born 1962, London, UK.

"Provocative," "irreverent," "rowdy"—these are among the adjectives given to Sarah Lucas's wide-ranging practice. Lucas came to prominence with the Young British Artists, a loose cohort that dominated the UK art scene in the 1990s with their disregard for public propriety. Her first solo exhibition, *Penis Nailed to a Board* (1992), which centered on the salacious sexism of tabloid culture, set the tone for her ongoing engagement with gender politics, using visual puns, euphemism, and synecdoche to critique misogynistic imaginings with biting humor. Hers is an itinerant practice—the artist's assemblages and sculptures made in improvised, ad-hoc studios. Lucas's artworks are similarly make-do, composed of—among other things—fruit, tights, furniture, cigarettes, and cooked and uncooked eggs (and the more commonplace mediums of cement and bronze). Arranged in spare compositions reminiscent of bodies with the suggestion of genitals, breasts, and ambiguous limbs, the resulting works are minimal and makeshift, at once compelling and discomfiting for their allusions. First conceived in 1997, Lucas's "bunnies" populate her work, their cotton-stuffed forms suggestive of feminine figures reduced to sexual objects, left limp in the absence of agency. In *Suffolk Bunny*, with its blue pull-up stockings and ominous clamp, the effect is both absurd and unsettling.—LB

SAVIA MAHAJAN

LITHIFIED LIVES 7 from the series **RESURGŌ**
2019, paper, clay, wood ash, potassium dichromate-based slips ($K_2Cr_2O_7$), found copper (Cu), iron oxide (FE_2O_3), and stains, fired at 950°C and refired at 1220°C, post-firing addition: epoxy,
8 ¾ × 8 ½ × 3 ½ in. (22.2 × 21.6 × 8.9 cm)

Savia Mahajan, born 1980, Mumbai, Maharashtra, India.

Savia Mahajan began her practice as a painter following studies at Mumbai's L.S. Raheja School of Art. After a decade, she relinquished the medium and, in 2010, started experimenting with ceramics, especially in the medium of clay. Mahajan was drawn to the material's paradoxical qualities of strength and fragility, finding this resonant with her grappling with mortality, life cycles, decay, and renewal. Clay, for Mahajan, is also interconnected with the body; as part of the earth's structure, it is fundamental for human existence and supports human activity. Her pieces expose this relationship and use the organic matter in a manner that echoes the artist's philosophical interest in the impermanence of the material world. As such, Mahajan's process—in works such as *Lithified Lives 7*—relies on degeneration and the structural tenacity of the clay. A book is smeared with wet paper clay and fired two separate times at temperatures that burn out the pages. After firing, the book is drenched in epoxy. The result is a fossilized form aged with metal compounds. Although the fire destroys the book, the clay hardens around its traces and ossifies, as Mahajan described in a 2017 interview with *The Hindu*, the subtle liminal thresholds between existence and destruction, begging the question, "does the material really die?"—CRK

NA HORIZONTAL (ON THE HORIZONTAL)
2014–16, copper wire and Raku ceramic on metal
structure, 111 × 59 × 9 ⅞ in. (282 × 150 × 25 cm)

Anna Maria Maiolino, born 1942, Scalea,
Calabria, Italy

Anna Maria Maiolino immigrated to Latin America as a child in 1954, first arriving in Venezuela and eventually settling in Brazil in 1960, where she still lives and works. Widely recognized for her radical contributions to Brazilian contemporary art, her prolific practice includes drawing, film, performance, poetry, and sculpture, and questions conceptions of displacement, identity, and subjectivity. In the 1960s and 1970s, through multimedia experiments and involvement with the New Figuration and New Brazilian Objectivity movements, Maiolino probed a new understanding of the art object within Brazilian visual culture. Much of her work from this period critiqued the hunger and social injustices ever-present during the Brazilian military dictatorship, and eventually the reciprocity between food and bodily functions, as well as the political implications of free speech, became recurrent themes. In 1989 she began exploring the tactile possibilities of clay and malleable materials, producing sinuous coiled forms alluding to natural corporeal movements and domestic processes. For *On the Horizontal*, the artist employed the Japanese Raku firing technique to create an array of earth tones in suspended cylindrical ceramics, which suggest organic matter. Exemplifying a continued interest in gesture, materiality, and serial repetition—both of objects and the body's actions in creating them—Maiolino's later sculptures such as this disrupt fixed notions of Minimal art, reconnecting abstraction to visceral being.—JM

ANINA MAJOR

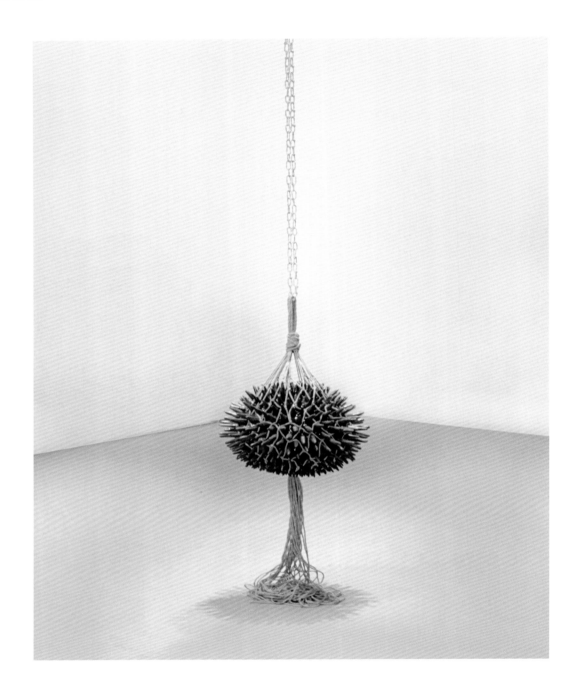

SUNBURST
2016, glazed stoneware, rope, and chain,
diam: 24 in. (61 cm), private collection

Anina Major, born 1981, Nassau, The Bahamas.

Working mostly with clay, Anina Major weaves intricate lattices to form vessel-like objects of varied sizes, often inspired by the forms and color palette of the natural world. The material's tactile and haptic qualities lend themselves well to Major's explorations of self and place, drawing on her experiences growing up in The Bahamas and relocating to the United States. Alongside her contemporaries Phoebe Collings-James (b. 1988) and Adebunmi Gbadebo (p.114), Major is reinventing uses for clay in contemporary art, digging into the emotional complexities inherent in the manipulation of the material. *Sunburst*, from a group of works named *Balance Acts*, features a large, spiky, round clay object, whose sharp points resemble the protective stance of a pufferfish, suspended—or ensnared—close to the ground with a vibrant yellow rope net and chain. As Major told the Rhode Island School of Design's Nature Lab in 2017, "The abstract object of power and aggression is suspended vertically by net and chain with gravitational balance to suggest a moment of stability." In other works, themes of balancing amid translocation, transplantation, and displacement are worked through by creating sculptures via a distinct layering of braids and plaits. The long tradition of Bahamian straw work, a type of plaiting with rich roots in the region, helps Major further understand her identity and reconnect to aspects of her Caribbean heritage.—JD

**MUJER RECLINADA O RECOSTADA
(RECLINING WOMAN)**
1964, artificial stone, Museo de Arte Moderno,
Mexico City

Tosia Malamud, born 1923, Vinnytsia, Ukraine.
Died 2008, Mexico City, Mexico.

Tosia Malamud sculpted dynamic busts and abstract works that searched for motion in the static materials of stone and bronze. Malamud's Jewish family fled Ukraine when she was a child, settling in Mexico City in 1927. Despite the difficulties of studying sculpture as a woman, she became one of the first women to graduate from Mexico's Escuela Nacional de Artes Plásticas in 1943 alongside sculptor Helen Escobedo (p.91). Malamud's style departed from nationalist art and Mexican muralism, which dominated contemporary aesthetics, instead taking inspiration from the abstraction of the international avant-garde. While her busts were energetic yet generally faithful depictions, her abstract works focused on movement, reflective poses, and maternal or feminine bodies. The recumbent pregnant figure in *Reclining Woman* is emblematic, wherein Malamud captured gentle and sensuous motion with simple forms that seem to undulate, settling themselves into the relaxed posture. María Teresa Favela Fierro emphasized the artist's feminist approach to sculpture in the 2007 book *Tosia Malamud: La materia tras la forma*, "As a woman, it was necessary to demonstrate that she could have the same capacity as a man and create monumental work. That is, motherhood is not a feminine art, nor is monumental work a masculine art, but is rather an art of a true artist."—OC

REBECCA MANSON

GALE
2021, porcelain, glaze, steel, adhesives, foam, hardware, enamel, and magnets, 88 × 68 × 72 in. (223. 5 × 172.7 × 182.9 cm)

Rebecca Manson, born 1989, New York, USA.

Ceramics have been an obsession for Rebecca Manson since she started taking classes at the age of eight, fascinated by the way the material transforms in the process of firing. Since graduating with a BFA from the Rhode Island School of Design in 2011, Manson has constructed freestanding sculptures and wall reliefs from thousands of small, glazed porcelain pieces affixed to metal armatures and combined with other materials. Vibrant colors have become increasingly prominent in this meticulous handmade process. Like Arlene Shechet (p.278) and Lynda Benglis (p.42), who were both featured alongside her in *Hard and Soft* at ACME Gallery in Los Angeles in 2015, her first major group show, Manson pushes the limits of ceramics as sculpture and blurs the boundaries between the two mediums. *Gale*, part of a 2021 body of work in which variegated leaves swirl, spill, and stack, evinces an almost trompe l'oeil effect up-close, where other elements—a tangled hose, a lost tennis ball, a coiled crustacean—can be deciphered. Manson's playful representational sculptures align her with an earlier generation of women artists, particularly Patti Warashina (b. 1940) and Sally Saul (b. 1946), who challenged the utilitarian standards and marginal status of ceramics in the contemporary Western art world.—AT

LA PROMESA (THE PROMISE)
2012, sculptural blocks made out of ground-up remains of a demolished house from Ciudad Juárez, Mexico, 22 tons of rubble, installation view, *Mundos*, Musée d'art contemporain de Montréal, 2017

Teresa Margolles, born 1963, Culiacán, Sinaloa, Mexico.

Through a radical conceptual approach, Teresa Margolles critically examines structural violence and its sociopolitical repercussions. Born in Culiacán, Mexico, broadly represented in the media as one of the most dangerous cities in the country, and with a background in forensic medicine, the artist chooses mediums and subjects that embody death and directly engage with victims of violence in her homeland. She often deploys controversial materials—bullets, bloodstained fabric, and water from morgues—which she recovers from crime scenes and sites of destruction, many caused by the consequential ramifications of the illegal drug trade. Margolles's recent projects have focused on raising awareness of the global ripple effects of displacement and migratory movements. *The Promise* is a site-specific sculpture and performance created originally for the Museo Universitario de Arte Contemporáneo, Mexico City, in 2012. For this piece, the artist placed the walls of an abandoned subsidized government house from Ciudad Juárez into the gallery context. While the work was exhibited, Margolles conceived a performance for which she invited volunteers to slowly scrape away the home's remains, rendering what was once considered the state's promise of economic opportunity to a somber mound of debris.—JM

MARISOL

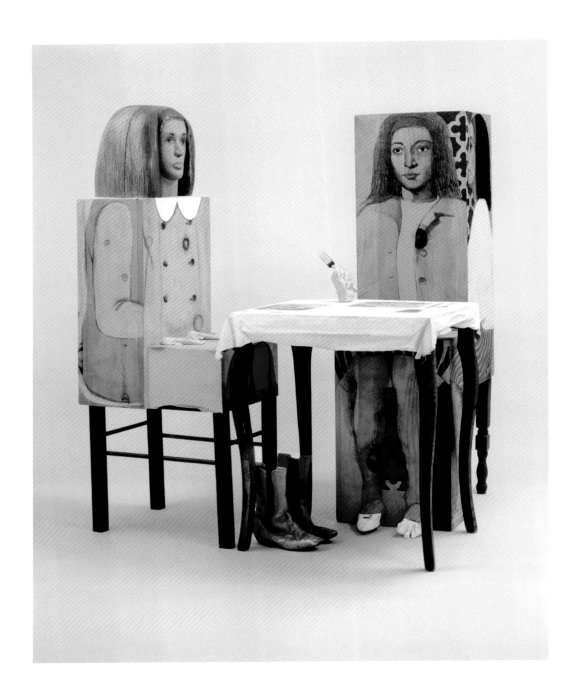

DINNER DATE
1963, painted wood, plaster, textiles, oil on canvas,
metal fork, leather boots, paint, and graphite,
55 × 53 ½ × 44 in. (139.7 × 135.9 × 111.8 cm),
Yale University Art Gallery, New Haven,
Connecticut

Marisol, born 1930, Paris, France.
Died 2016, New York, USA.

Marisol was a sculptor and printmaker known for her layered assemblages that combine carved wood, painted portraits, and found objects into life-size tableaus. Born María Sol Escobar to Venezuelan parents, she lived in Europe, the United States, and Venezuela in her childhood. While living in New York in the 1960s, Marisol integrated elements of the Pop movement and mass-media references into her work, combining marketing tropes and images of celebrities with references to folk art techniques, Dadaism, and Cubism. Marisol's artworks often complicate notions of gender, class, and expected societal roles through satirical depictions that challenge the boundaries of propriety.
In *Dinner Date*, the artist seats two wood self-portrait sculptures at a table, effectively dining with herself. One figure features a carved head atop an uncarved, painted block for a torso, with plaster hands neatly folded on its lap and a pair of real leather boots. The second figure is essentially a rectangular piece of wood, painted on each side to portray the artist from different angles. A plaster hand brandishing a fork seems to emerge from the canvas tabletop, on which are two painted dinners. The artist parodies expectations of feminine domestic life in the 1960s, depicting herself with a sense of humor in response to critiques of her lifestyle as an unmarried, childless woman.—MM

THE IMPOSSIBLE III
1946, bronze, 31 ½ × 32 ½ × 21 in.
(80 × 82.5 × 53.3 cm), Museum of Modern Art,
New York

Maria Martins, born 1894, Campanha, Minas
Gerais, Brazil. Died 1973, Rio de Janeiro, Brazil.

Despite living much of her life abroad, Maria Martins was a pivotal figure in the development of Brazilian modernism. She began her studies in sculpture in 1934 in Brussels with Oscar Jespers (1887–1970), and developed most of her artistic career in the United States between 1939 and 1947. After her first solo exhibition in 1941 in Washington, D.C., she began attending the studio of Cubist sculptor Jacques Lipchitz (1891–1973) and started working with bronze. Her first sculptures were figurative and developed themes related to Brazilian culture. After establishing her own studio in New York, in 1942 she met André Breton (1896–1966) and Marcel Duchamp (1887–1968). Inspired by Amazonian mythology, she began exploring the metamorphosis of the human figure into tangles of leaves and branches, and it was this interest in the connection between wild nature and culture that drew her close to Surrealism. Martins traced links between the mysteries of cosmological forces and the feminine, as well as the energies of the unconscious and the erotic, producing sculptures of enigmatic creatures. In *The Impossible III* the ambiguous figures—part human, part animal, part vegetal—point to what she saw as the tension between desire and violence, attraction and repulsion at the core of the relationship between the female and the male, and their unavoidable incompatibility.—TP

REBECA MATTE

ECO, ENCANTAMIENTO O ENSOÑACIÓN (ECHO, ENCHANTMENT, OR DREAM)
1900, marble, 55 ⅞ × 30 ¼ × 42 ⅛ in. (142 × 77 × 107 cm), Museo Nacional de Bellas Artes, Santiago

Rebeca Matte, born 1875, Santiago, Chile. Died 1929, Paris, France.

The daughter of a diplomat, Rebeca Matte was born into an aristocratic yet culturally progressive family in Santiago. She was educated in the arts and humanities by her father and grandmother, and her studies intensified when the family moved to Paris in the 1890s. At a time when women were not allowed to study the figure, Matte was a trailblazer due to her family's social and political connections. She studied under the Italian sculptor Giulio Monteverde (1837–1917) in Rome, before eventually returning to Paris and working under the auspices of Paul Dubois (1829–1905). The intensity with which her figures are rendered is typical of the realist style practiced in Europe at the turn of the twentieth century, but Matte's bronze and marble sculptures have a distinct emotional gravity. This is evident in the fervent facial features of *Echo, Enchantment, or Dream*, one of several of Matte's sculptures that depict scenes from Greco-Roman myth. Here, the nymph Echo leans forward dynamically with parted lips, forever cursed to repeat the last words spoken to her. With the commission of *Le spectre de la guerre* (*The Specter of War*, 1914), a monumental bronze sculpture in The Hague, Matte became the first Chilean woman to be commissioned for a public work of art.—NM

ARENA
1997, Twaron and wood, 156 × 1,188 × 792 in.
(396.2 × 3,017.5 × 2,011.7 cm), installation
view, *Rita McBride. Public Tender*, Museu d'Art
Contemporani de Barcelona, 2012

Rita McBride, born 1960, Des Moines, Iowa, USA.

Sharing her time between California and, since 2003, Düsseldorf, Germany, where she teaches at the Kunstakademie, Rita McBride has investigated forms and structures based on architecture and sculpture since the mid-1980s. Working across mediums including bronze, glass, and rattan, as well as high-tech materials such as carbon fiber, lasers, and waterjet-cut brass, she creates sculptures at various scales, from a series of small bronze models of parking garages to multi-room installations that involve the audience, sometimes choreographing their movement, as with a work based on roadside guardrails that guide viewers on a specific route through the gallery. Inspired by furnishings and devices found in public space, such as awnings, fences, and barricades, McBride has collaborated with architects, engineers, physicists, and artists, and in 2018 told *Mousse* that her work "put[s] together a vocabulary of modernism . . . taking stock of modernism's promises and eventual manifestations." In 2001 she began producing experimental publications featuring anonymous and collectively generated writing, and in 2018 launched a science-fiction anthology. A modular amphitheater made of plywood and synthetic fiber comparable in strength to steel wire, *Arena* is a nonhierarchical, democratic structure activated by audiences and all types of programming. Viewers can download copyleft instructions, made accessible and stewarded by the Dia Art Foundation, which enable them to reimagine and remake the work.—EDW

ANDREA DE MENA

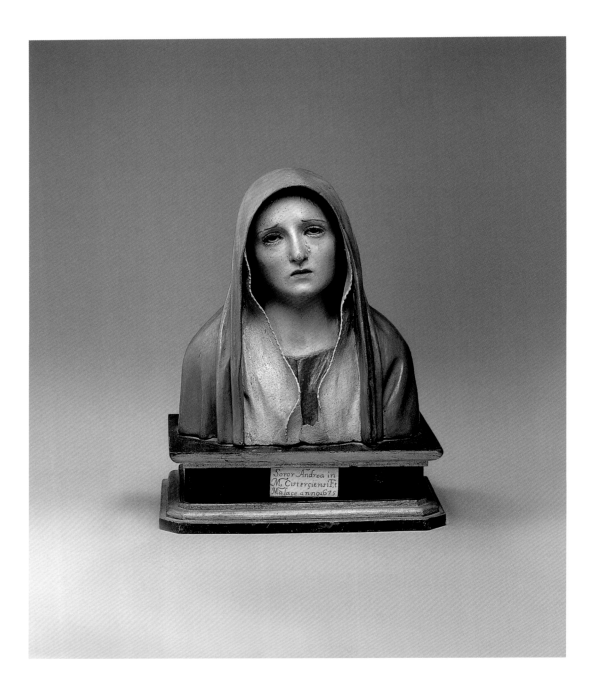

MATER DOLOROSA
1675, polychromed wood, height: 6 ¾ in. (17 cm),
The Hispanic Society of America, New York

Andrea de Mena, born 1654, Spain. Died 1734,
Spain.

Trained under her father, the sculptor Pedro de Mena (1628–88), Andrea de Mena worked in the Spanish polychrome tradition, in which a wood sculpture was carved by one artist and painted by another to achieve a brilliant surface effect. Andrea de Mena is the most known of Pedro's daughters, but her sister Claudia also sculpted. They likely trained in their father's studio prior to 1672, when they entered the Cistercian convent of Santa Ana de Recoletas Bernardas in Málaga, where busts of Saint Benito and Saint Bernardo (c. 1680) can be attributed to them. De Mena's *Mater Dolorosa*, an interpretation of the traditional Christian image of the "sorrowful Madonna," is similar to an early-1670s version by her father and shares Pedro's naturalistic approach by employing glass eyes and tears, as well as real hair for the eyelashes of the Virgin. With her upturned gaze and tear-stained face, this Madonna is the epitome of suffering, and such a work would have aided worshippers in their religious devotions. At the convent, de Mena's ability to sculpt would have facilitated the creation of both devotional works for the nuns' prayers as well as items to sell on the art market to support their convent financially.—ESP

CRAWLING IN MY SKIN
2021, glazed ceramic, 11 × 7 × 7 in. (29 × 18 × 19 cm)

Lindsey Mendick, born 1987, London, UK.

Lindsey Mendick's works often teem with bugs, sprout tentacles, or grow unexpected body parts. The artist's exuberant ceramic creations frequently draw on her personal experiences of vulnerability, while tackling societal taboos and expectations around women's bodies and mental health. Her works are distinctive for their acerbic humor and playful materiality, frequently using horror as a tool for subversion and challenging hierarchal attitudes toward craft as a gendered, domestic, or inferior practice. Working across sculpture, painting, film, and more, Mendick often places her ceramics within life-size multimedia installations. *Crawling In My Skin*, featured in the artist's immersive exhibition *Hairy on the Inside* at Cooke Latham Gallery in London in 2021, drew on her own experience of polycystic ovary syndrome. The gallery was transformed into a fertility clinic waiting room, with werewolf-like women awaiting treatment. Here, two glazed ceramic feet, clad in Crocs, act as vases. An otherwise mundane scene is transformed into a monument to grotesque glory: cockroaches clamber out from holes in the ankles and long toes bulge from the shoes, sporting talonlike red toenails. Associations of both glamour and the bestial collide. Mendick's practice has extended to supporting communities of artists through Quench Gallery, which she cofounded with artist Guy Oliver (b. 1982) in Margate, Kent, during the COVID-19 pandemic.—LJ

MARISA MERZ

UNTITLED
1968, nylon thread and iron nails, each 2 × 7 ⅞ ×
2 ¾ in. (5 × 20 × 7 cm), Fondazione Merz, Turin

Marisa Merz, born 1926, Turin, Piedmont, Italy.
Died 2019, Turin.

Marisa Merz played a key role in the irreverent and influential Italian Arte Povera movement of the
1960s and 1970s. She was the only woman member of the group, whose name translates literally
to "poor art." Its members sought to subvert hierarchies and norms of art-making, using detritus as
materials to undermine the sanctity of fine art and probe its valuation within the commercial system
of galleries, auction houses, and museums. Working with a wide variety of unusual materials, Merz
created idiosyncratic sculptures, some very large and some miniscule. She worked out of her kitchen,
assembling her creations from aluminum foil, thread, wax, copper wire, and sometimes unfired clay.
Merz's untitled sculpture, illustrated here, is a typically diminutive and unimposing work, constructed
from quotidian materials and easily overlooked. It belongs to a series of works Merz created called
Scarpette (Little Shoes)—these impractical objects, knit loosely from nylon thread, take the form of
slippers, designed to fit the feet of Merz and her daughter. This particular pair is shot through with nails,
their sharp, industrial forms in direct contrast to the delicate, handmade "shoes" themselves.—MMB

SACS PLASTIQUES ÉCHEVÉLES
2005–12, plastic bags, fake hair, fan, and ropes,
82 ⅝ × 39 ⅜ in. (210 × 100 cm)

Annette Messager, born 1943, Berck-sur-Mer, Pas-de-Calais, France.

Using often banal materials, such as the plastic bags arranged in this installation, Annette Messager transforms the everyday through the techniques of assemblage. In works that span media as diverse as sculpture, construction, and textiles, Messager elevates what is often seen as mundane into the fantastic, romantic, or, even, the grotesque. Here, the arrangement of brightly colored "disheveled" bags alludes to the body and consumption. A fan whirs continually, disturbing the bags and creating the fluttering sound of plastic coming into contact with more plastic. Daily, viewers encounter such disposable materials, random bits of rubbish put to use. As with much of Messager's work, this is not a chance encounter: the addition of an auburn-colored hairpiece is a deliberate materialization of both mortality and erotic desire, as well as playful abjection. The mussed hair and the "skin" of the bags address hidden contradictions, the combination of mundane functional materials with the stage-prop wig introducing a sense of mischief, perhaps violence, definitely ambivalence. The fake hair transforms the sacks, producing a complicated soft sculpture suspended and hovering in front of the spectator, revealing more than the sum of its parts, a serious and provocative parody from this artist who has often self-identified as a trickster.—KM

MARTA MINUJÍN

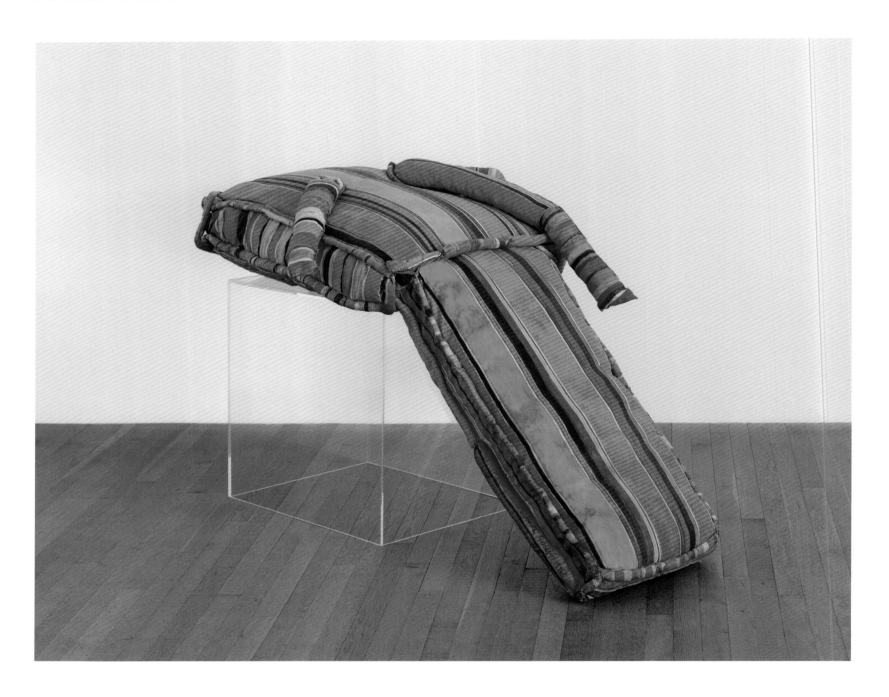

COLCHÓN (MATTRESS)
1962, mattress and paint, 85 ¼ × 28 ⅞ × 15 ¾ in.
(216.5 × 73.5 × 40 cm), Tate, London

Marta Minujin, born 1943, Buenos Aires, Argentina.

Critiquing mass media, popular culture, and the artifices of capitalism, Marta Minujín creates tongue-in-cheek installations, sculptures, and performances that question the idea of art as object. Born in Buenos Aires to a Russian Jewish family, Minujín's work is deeply informed by the intellectual circles that formed around the Instituto Torcuato Di Tella in the 1960s, a university that fomented avant-garde writers and *artistas plásticas*, or "visual artists." A decade later, Minujín would live through the Argentine military dictatorship that disappeared many of her peers for their left-leaning views, shaping her view of art as an act of protest and camaraderie. Her immersive installations and performances often bend viewers toward interaction and reveal their position within the mass consumerism apparatus. A pioneer in soft sculpture, Minujín's *Mattress* series sees the artist contorting and re-stitching found mattresses—an object on which "half of your life takes place," as she told the *New York Times* in 2023—into bodily figures, painting fluorescent stripes emblematic of the range of influences she encountered in her sixty-year career. Having collaborated with artists like Niki de Saint Phalle (p.266), Andy Warhol (1928–87), and Christo (1935–2020), Minujín is widely considered one of the most significant artists to emerge from Buenos Aires.—NM

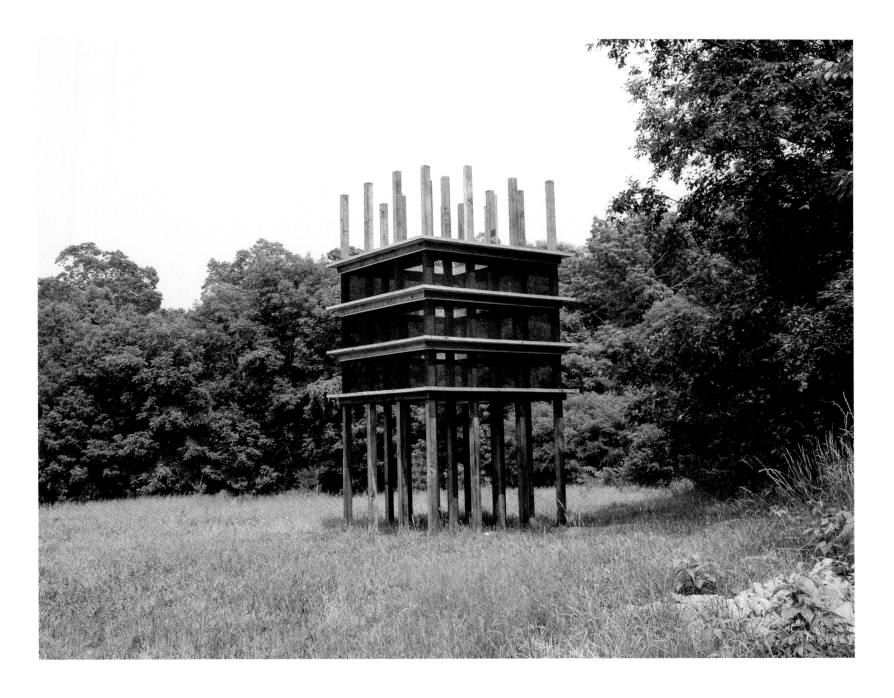

PERIMETERS/ PAVILIONS/ DECOYS
1977–8, site-specific installation for Nassau County
Museum of Art, Roslyn, New York

Mary Miss, born 1944, New York, USA.

A foundational figure in environmental art, Mary Miss is influenced by international architectural history, landscape and garden design, and Minimalism. As a child she visited Native American and historical sites and abandoned mines with her father. A summer sculpture course in Colorado introduced her to the work of Minimal and Land artists, and she later studied sculpture in California and Maryland. Since the early 1970s her projects have innovated how sculpture is created within the public realm, encouraging viewers to explore different perspectives and positions, and experience familiar places in new ways. Her site-specific works include a temporary memorial around New York's Ground Zero and a series of framing devices emphasizing historical aspects of the city's Union Square Subway station. Environmental and social sustainability are central concerns for Miss, who has worked with historians, hydrologists, and botanists and, in 2009, initiated the organization City as Living Laboratory to encourage collaboration between artists and experts including scientists and urban planners. In this work, as visitors explore three wood and metal towers of varying heights, two earthen mounds, and a concealed underground courtyard accessed via a ladder, they realize how their initial perception of the site offered but a mere hint of the actual built and excavated environment.—EDW

KAZUKO MIYAMOTO

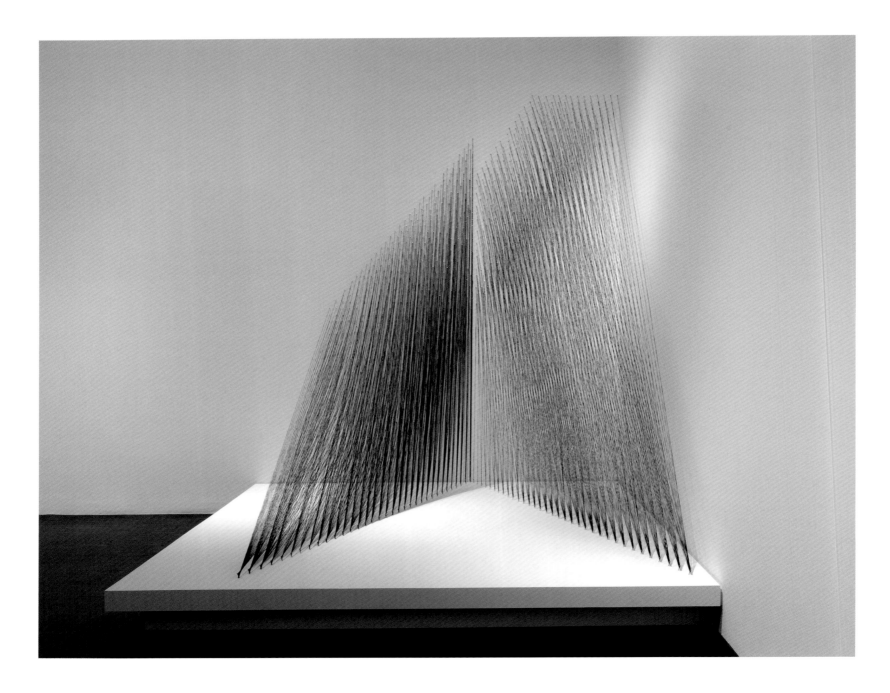

UNTITLED
1977, string and nails, 100 × 100 × 100 in.
(254 × 254 × 254 cm), Metropolitan Museum
of Art, New York

Kazuko Miyamoto, born 1942, Tokyo, Japan.

Arriving in New York in 1964 to study at the Art Students League, Kazuko Miyamoto quickly became embedded in the downtown art scene. She met sculptor Sol LeWitt (1928–2007) during a fire drill outside their shared building and began working as his studio assistant. They became lifelong friends. Initially a painter, Miyamoto started exploring the spatial facets of lines after executing LeWitt's wall drawings, which systematically explore the limits of two-dimensionality. Often planned through sketches, Miyamoto's string constructions employ an economy of materials but are laborious to make; thread is held taut by thousands of nails, sometimes arranged in accordance with the architectural detail of the site—masonry lines or brickwork. The effect is a rhythmic mass, drawings suspended in air, which, in the case of works like *Untitled*, create a shifting, cocoonlike enclosure or void. Despite its relationship to Minimalism, Miyamoto's work foregrounds the body and her experiences as a woman of color. In the 1980s she photographed herself naked in angular positions in front of LeWitt's cubes. In 1974 Miyamoto became a member of the first cooperative gallery for women artists in New York, A.I.R. Gallery, which bases its program on the principles of skill-sharing and mutual support.—AC

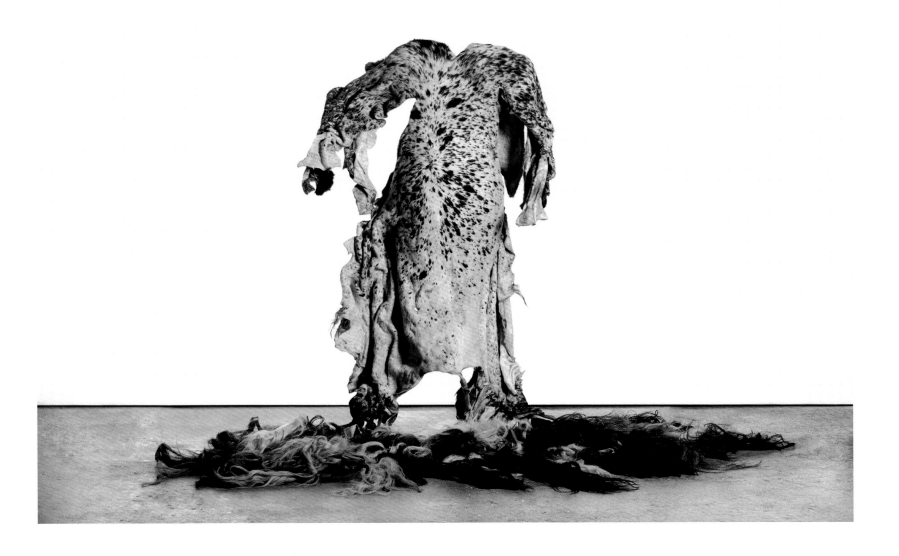

ENCHANTMENT
2012, cow hide, tails, horn, and resin,
59 × 82 ⅜ × 42 ¼ in. (150 × 210 × 110 cm)

Nandipha Mntambo, born 1982, Mbabane,
Eswatini.

Although she works in a range of media, Nandipha Mntambo is best known as a sculptor of organic materials, especially the hides of herbivores that populate the African veld, or the open rural landscapes of the continent's southern region. She reshapes these hides into figures molded from the human body, articulated with animal horn and, as in *Enchantment*, wreathed in hair fibers in many hues. The identity of these transmuted beings is ambiguous—their flowing materiality evokes various masquerade traditions, while their hybridity conjures creatures drawn from ancient mythology. In a way, Mntambo's sculptures are rooted in the textures of the region, including her natal country of Eswatini, where livestock is not merely a source of income, but also a store of wealth and social prestige. Yet she recalls the cow arriving to her in a dream, as a universal connector. In this sense, her art evokes a broader trend in post-Apartheid South Africa, in which artists look to precolonial forms of aesthetic meaning, and erodes the lines between human and nonhuman, spiritual and immanent.—IB

ANNA MORANDI MANZOLINI

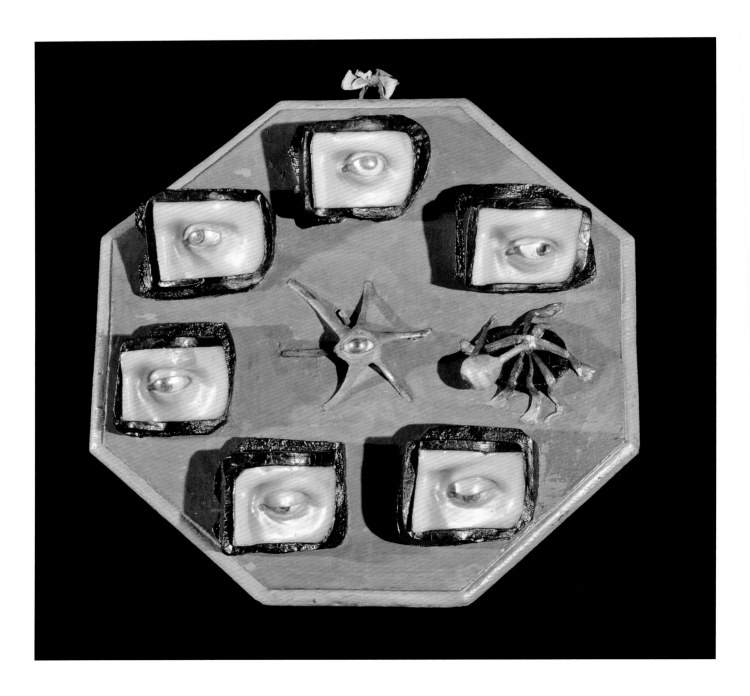

ANATOMICAL MODELS OF THE EYE AND ITS EXTRINSIC MUSCLES
c. 1755–69, wax model and wood, Museo di Palazzo Poggi, Bologna

Anna Morandi Manzolini, born 1714, Bologna, Emilia-Romagna, Italy. Died 1774, Bologna.

Anna Morandi Manzolini is distinctive not only because she is a known woman sculptor from the Baroque period but because of her chosen artistic subject: the human body, primarily in wax, which she then colored to great naturalistic effect. Morandi Manzolini studied drawing and sculpture under local Bolognese artists and married the anatomical wax sculptor Giovanni Manzolini (c. 1700–1755) in 1740. After his death, she continued to operate the family studio and Pope Benedict XIV granted her an annual stipend to lecture on anatomy at the University of Bologna. Morandi Manzolini's body of work largely comprises wax anatomical models such as this piece, in addition to devotional waxworks and busts, including a famous self-portrait in which she dissects a brain. The artist's focus on sensory organs and body parts conveys a larger interest in the interplay between reality and artifice in science and art. Here, she offers eight different positions of a left eye. Both accurate and surreal, the central oculus stares straight at the viewer, its six extraocular muscles, which allow the eye's directional movement as depicted, fanned out like the limbs of a starfish. Although she was praised during her lifetime, Morandi Manzolini's key role in the artistic, scientific, and intellectual circles of Bologna during the Enlightenment has only recently gained recognition.—ESP

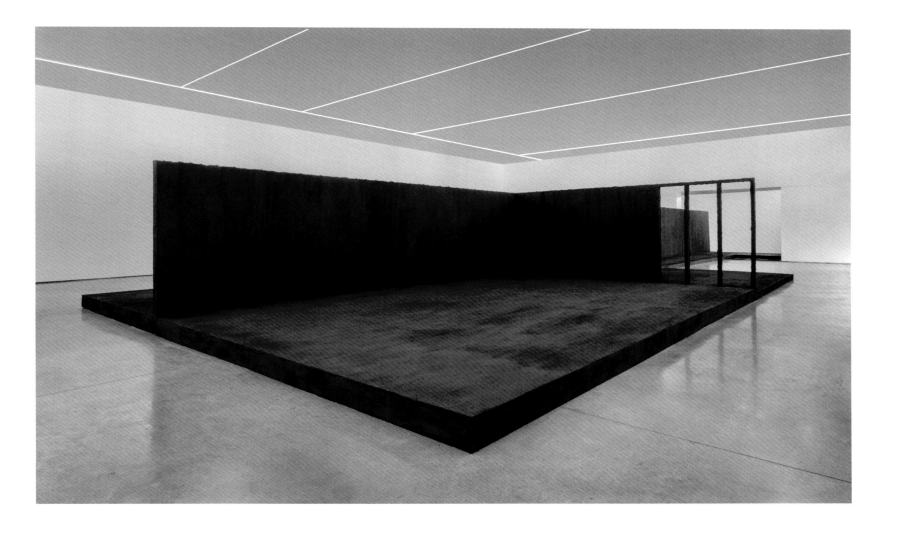

MOTHER'S SURFACE
2019, clay, soil, water, ground cloves, and cocoa powder, dimensions variable

Delcy Morelos, born 1967, Tierralta, Córdoba, Colombia.

With a decades-long career and multifaceted practice comprising painting, drawing, sculpture, and installation, Delcy Morelos prompts deeper explorations of our cyclical relationship with nature. Initially experimenting with different hues of red, Morelos began to incorporate primarily umber tones into her color palette, ultimately embracing soil as her preferred medium. In 2012 she turned her attention to producing large-scale installations mainly built of earth and other organic matter. Making reference to Andean and Amazonian customs and mythologies as well as her own Indigenous heritage, Morelos alludes to the Earth's feminine and divine qualities. *Mother's Surface* is typical of the artist's work for its monumental scale and use of raw and scented materials, enveloping the viewer through a multisensory experience. Abstract yet associative, Morelos's minimalist language urges us to reflect on larger affairs taking place beyond the gallery space, including ecological and sociopolitical concerns affecting her native country. While reminding us of the Earth's fertility and our ephemerality, she brings attention to issues of resource and land ownership, which have been central to the violent and decades-long Colombian armed conflict. Defying systems of scale, Morelos presents the earth as a restorative power, vital to human life and regeneration.—JM

MARIKO MORI

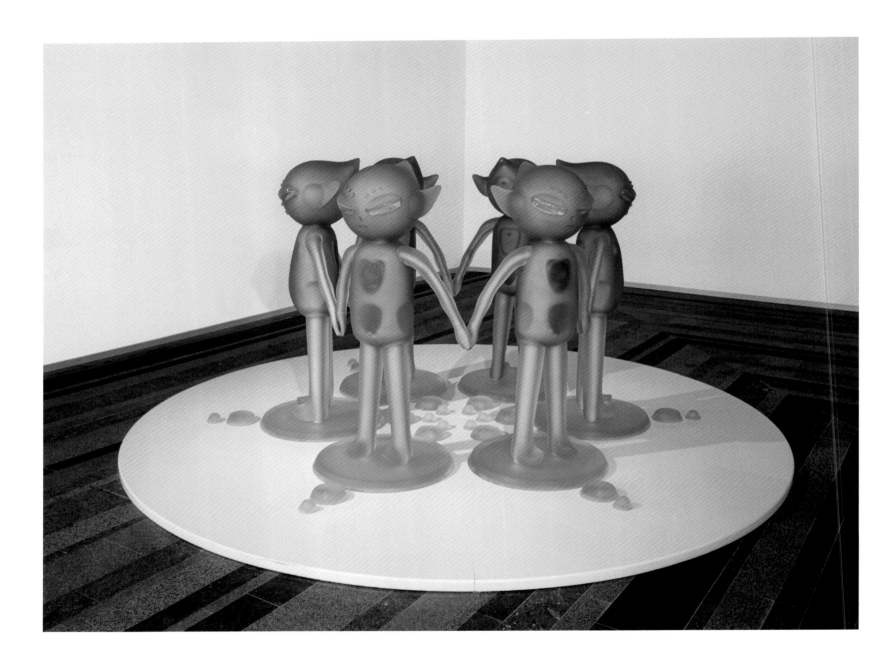

ONENESS
2003, Technogel, acrylic, cast aluminum, and magnesium, each 53 ⅛ × 29 ¾ × 14 ¾ in. (135 × 75.6 × 37.4 cm), overall 94 ⅛ × 446 ½ × 207 ⅞ in. (493 × 1,134 × 528 cm), edition of 3 + 1 AP

Mariko Mori, born 1967, Tokyo, Japan.

Mariko Mori creates sculptural installations that fuse art and technology to promote the interconnectedness of living things. Although Mori gained prominence for her performance-based photography and videos in the 1980s and 1990s, she stopped using her own image around 1999 in favor of constructing environments, such as *Wave UFO* (1990–2002) or *Oneness*, which invited participation and combined interests in spirituality, technology, and science. In *Oneness* viewers were encouraged to kneel and clasp the child-sized "alien" forms, which were made out of a soft, fleshlike material molded over metal frames. When one of the six figures was hugged, its eyes lit up and its heart began to beat; if all six were embraced, the entire base lit up. A visualization of the pleasure of acceptance, *Oneness* reflects Mori's larger creative vision as told to *Sculpture* magazine in 2015: "Even though space is so large [and] even though we see differences, our life energy is identical, equal, and connected." Mori's more recent work tackles these concepts on a more abstract level: the luminous *Ring*, for instance, was installed above a waterfall in Rio de Janeiro ahead of the 2016 Olympics as the inaugural project of her Faou Foundation, established with the goal of celebrating oneness through public art placed in nature in each of the Earth's six inhabited continents.—OC

IN THE VILLAGE
1910, bronze, 2 ½ × 1 ¾ in. (6.4 × 4.4 cm),
Yale University Art Gallery, New Haven,
Connecticut

Blanche-Adèle Moria, born 1859, Paris, France.
Died 1926, Paris.

Unlike many young women of her generation in France in the nineteenth century, Blanche-Adèle Moria received a liberal education, attending the Académie Julian in Paris, where she received instruction in sculpture. She also studied medal etching under Jules-Clément Chaplain (1839–1909). From 1883 Moria began to exhibit her work publicly in the Salons, gaining a reputation for her finely crafted figurative medals, plaquettes, and sculptures, and mastered many materials, working in bronze, marble, and stone. She was commissioned on numerous occasions by the French state to create monuments and busts, including for the Muséum national d'Histoire naturelle, Paris. A teacher at the Lycée Molière for more than three decades, Moria was a dedicated feminist and tireless campaigner for women's rights and education; her works often depicted allegorical scenes advocating for women's access and emancipation or celebrating quotidian French life. The plaquette *In the Village* is one such serene vignette, featuring a woman sewing on cottage steps that have been carved with precision by Moria to capture their rustic nature. The larger village depicted on the reverse side appears at rest, the well in the foreground perhaps having just been used. In 1927, a year after her death, the Union of Women Painters and Sculptors organized a retrospective of Moria's works in recognition of her contributions.—CJ

ANNIE MORRIS

STACK 9, ULTRAMARINE BLUE
2021, foam core, pigment, concrete, steel, plaster,
and sand, height: 137 ¾ in. (350 cm)

Annie Morris, born 1978, London, UK.

Having studied under the Italian sculptor Giuseppe Penone (b. 1947) at the Ecole Nationale Supérieure des Beaux-Arts, Paris, Annie Morris completed her education at London's Slade School of Fine Art in 2003. Working across sculpture, tapestry, painting, and drawing, the artist's practice is informed by childhood memories, personal experiences, and the subconscious. Her dynamic works reflect the great delight she takes in process and materials and, although they display a childlike playfulness, many are underpinned by moments of adversity. Morris's ongoing series of richly colored "stack" sculptures began in 2014 while she was grieving the loss of her first child to stillbirth. These precarious-looking columns comprise irregularly shaped spheres placed one on top of the other, seemingly defying gravity. Recalling the ancient totems found in virtually every Indigenous culture throughout history, each one begins life as a watercolor sketch before being sculpted in plaster and sand or cast in bronze. Morris is obsessive about color, and each component part is painted with carefully sourced raw pigments such as vivid ultramarine blue, viridian green, and yellow ocher. With their rounded, fecund forms deliberately evoking the swell of pregnancy, Morris considers her stacks as metaphors for hope, standing defiantly amid tragedy and the fragility of life.—DT

UNTITLED (THE STORM)
c. 1980, bronze, 10 × 23 × 14 in.
(25.4 × 58.4 × 35.6 cm)

Meera Mukherjee, born 1923, Kolkata, West Bengal,
India. Died 1998, Narendrapur, West Bengal, India.

Meera Mukherjee focused her practice on sculpture after a period in Germany at the Akademie der
Bildenden Künste München between 1953 and 1956 that followed her diploma at the Delhi Poly-
technic in 1947. Returning to India, Mukherjee apprenticed with Dhokra sculptors in Chhattisgarh,
Central India, where she learned the lost-wax method of metal casting. Subsequently, she researched
Indigenous sculpting techniques, visiting makers across India and publishing her findings with the
Anthropological Survey of India. Mukherjee absorbed the various metalwork processes and, connecting
tradition with modernity, developed a style that was dynamic and imbued her bronzes with movement.
Her subject matter resided in the daily life of India, including workers as well as festivals and popular
myths. Such was Mukherjee's commitment to civic life that she opened a school in rural Bengal near
Kolkata in the 1980s, around the time when *Untitled (The Storm)* was made. The sculpture, depicting
fishermen navigating a storm, is emblematic of her ability to animate metal. The lithe figures, captured
with intricate detailing including strands of hair, are treated tenderly as if testimony to Mukherjee's
lifelong interest in Indian life.—CRK

MRINALINI MUKHERJEE

JAUBA (HIBISCUS)
2000, hemp fiber and steel, 56 ¼ × 52 ⅜ × 43 ¼ in.
(143 × 133 × 110 cm), Tate, London

Mrinalini Mukherjee, born 1949, Mumbai,
Maharashtra, India. Died 2015, New Delhi, India.

Over four decades, Mrinalini Mukherjee experimented with natural fibers, ceramics, and bronze in sculptures that took inspiration from flora and Indian mythologies. Born to artist parents—the painter Benode Behari (1904–80) and sculptor Leela (1916–2009)—Mukherjee initially studied painting, mural design, and printmaking, before becoming part of a generation of post-Independence artists who worked against the tradition of figure painting. Encouraged by her mentor K. G. Subramanyan (1924–2016), a former student of Mukherjee's father, she began working with natural rope and synthetic dyes in the early 1970s. She hand-knotted the fibers, which would remain through the 1990s the artist's primary form of textile manipulation as she never used a loom. Mukherjee's earliest works were wall hangings, which she would eventually suspend from the ceiling to enhance their biomorphic qualities. By the 1980s she abandoned wall, ceiling, and pedestal supports in favor of letting her increasingly large sculptures stand free, as seen in *Hibiscus*. Mukherjee never used preparatory sketches, and instead worked intuitively while harnessing her interest in Indian historic sculpture, modern design, nature, and local craft traditions. As her favored materials became more difficult to find in an age of textile industrialization, she turned to ceramics by the mid-1990s, and bronze by the 2000s, likely influenced by her mother's small-scale sculptural work in the medium.—MS

MIR (PEACE)
1954, Volgograd, Russia

Vera Mukhina, born 1889, Riga, Latvia (then
Russian Empire). Died 1953, Moscow, Russia.

Vera Mukhina was one of the foremost artists of early Soviet Russia who sculpted monumental public works. As an art student and costume designer in Moscow and Paris in the mid-1910s, Mukhina encountered various avant-garde movements but was ultimately uninspired by abstraction. She instead synthesized interests in Neoclassical sculpture with the 1917 Russian Revolution's creative impetus to generate a new Soviet art. In 1918–19 she joined Monolith, a collective dedicated to replacing czarist public art with large-scale works as part of the so-called Plan for Monumental Propaganda. Throughout the 1920s and 1930s she solidified her style of Socialist Realism and created large commemorative sculptures as well as smaller portraits and heroic representations of Russian workers. Mukhina's most famous work is the 78-foot- (24.5-meter-) tall *Worker and Kolklhoz Woman* who strode on top of the USSR's pavilion at the 1937 world's fair in Paris, capturing the energetic joy of Soviet collectivity. She declared in her 1953 book, translated in 1960 as *A Sculptor's Thoughts*, "a larger statue should be simple, it should express itself 'in a word,' so as to add to the visual and psychological impact upon the viewer's perception." Classic yet impactful forms continued to be a lasting thread until her final work: this simple depiction of *Peace*, which still stands atop the Volgograd Planetarium.—OC

PORTIA MUNSON

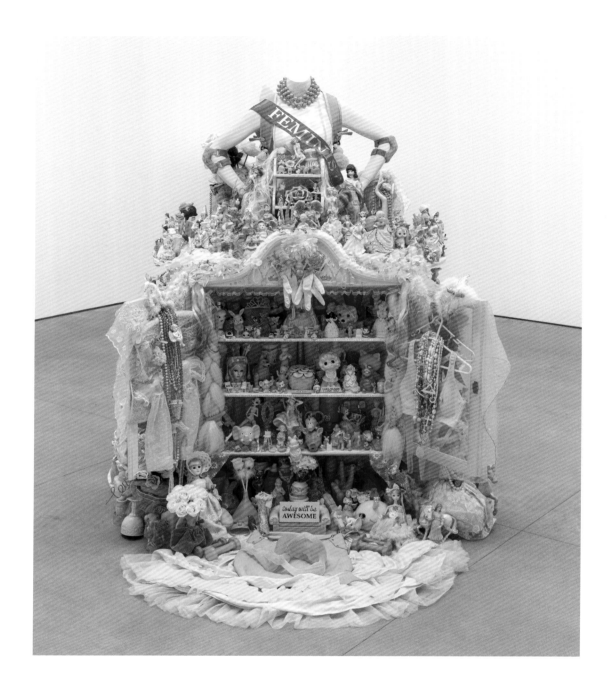

TODAY WILL BE AWESOME
2022, found pink objects, pink synthetic fabric
and cloths, mannequin, salvaged round bar table,
and deconstructed secretary desk/cabinet,
72 × 60 × 70 in. (182.9 × 152.4 × 177.8 cm)

Portia Munson, born 1961, Beverly,
Massachusetts, USA.

Both playful and somber, Portia Munson's sculptural installations comment on consumer waste and cultural scripts. She attracted critical attention when her *Pink Project* (1994)—an installation strewn with thousands of mass-produced objects designed for women and girls—was exhibited in the 1994 exhibition *Bad Girls* at the New Museum in New York. Munson has continued to produce sculptures, as well as drawings, paintings, and prints, that address environmental degradation and gendered kitsch. Munson began exploring the color pink and discarded objects during her undergraduate studies at the Cooper Union, New York. There, her professors included the conceptual artists Barbara Kruger (b. 1945), Martha Rosler (b. 1943), and Hans Haacke (b. 1936). In an interview published in *TENbyTEN* in 2000, Munson explained that working with color was considered rebellious in that context: "It was a challenge—how can I make work that is political and also pretty?" In *today will be AWESOME*, Munson's glut of rose-colored objects illustrates the way femininity is commodified, infantilized, and sexualized. The work contains a dizzying array of merchandise, from a dildo to toys to free weights. A headless mannequin at the apex sports a sash with the word "feminist"—suggesting an uneasy relationship between intellectualism and the commercial rebranding of female empowerment.—WV

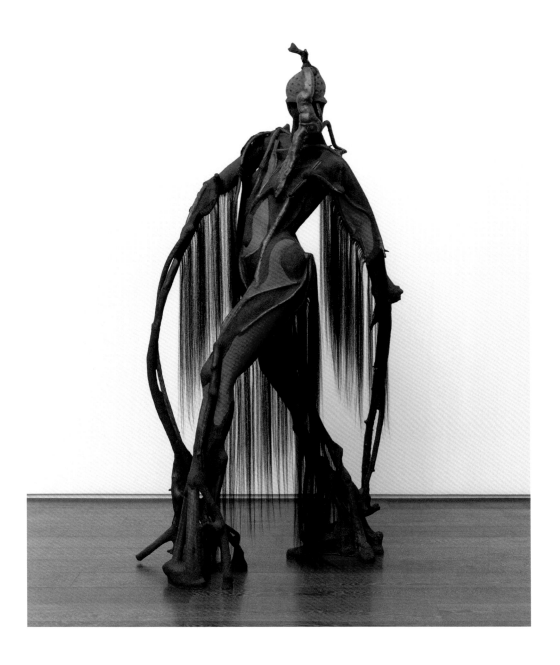

SHE WALKS
2019, red soil, charcoal, paper pulp, wood, wood
glue, steel nails, and synthetic hair,
82 ⅝ × 39 ¾ × 20 ⅛ in. (210 × 101 × 51 cm)

Wangechi Mutu, born 1972, Nairobi, Kenya.

Majestic, otherworldly female figures populate Wangechi Mutu's lush collages, sculptures, and films. Evoking powerful deities of a hallucinatory matriarchal universe, they are elaborate amalgamations of cultural and mythological references drawn from science fiction, fashion, and African traditions. The artist, who moved to New York to study art in the 1990s, now divides her time between Nairobi and Brooklyn and the influences of the two are inseparably intertwined in her practice. Mutu participated in the 2019 Whitney Biennial and that same year received the inaugural commission to create sculptures for the facade niches of the Metropolitan Museum of Art in New York. This statuesque sentinel exemplifies Mutu's use of unconventional materials to conjure hybridized forms that are human in shape but composed of artificial and natural media. With synthetic tresses cascading from elongated arms that extend to the ground like roots, the towering figure strides forward on muscular booted legs reminiscent of mangroves. Her face obscured by a mantislike wood carving perched on her shoulder, she glares defiantly at the viewer as if daring them to challenge her authority. Mutu's sculptures depicting vigorous women refuse the passive roles assigned them by society; like modern oracles they point up the excesses of consumer culture and environmental degradation, drawing strength from their richly composite nature.—EF

ETHEL MYERS

A LADY
c. 1919, bronze, 11 ½ × 5 ½ × 5 in. (29.2 × 14 ×
12.7 cm), Delaware Art Museum, Wilmington

Ethel Myers, born 1881, Brooklyn, New York, USA.
Died 1960, Cornwall, New York, USA.

Humorous sculptures of women in the 1910s comprise the bulk of Ethel Myers's small but distinctive oeuvre. Whether bronze or painted plaster, most of her extant statuettes are under a foot tall and single-figured. These works are based on Myers's observations of passersby in New York, an artistic approach rooted in the everyday comedies and dramas of street life. Myers married painter Jerome Myers (1867–1940) in 1905, after her six years of study at the New York School of Art. She raised a daughter, shared studio space with her husband, supported his career above hers, and promoted his legacy following his death. Yet she also produced sartorially expressive caricatures in three-dimensions: sculptures that poke fun at the manners and fashions of upper-middle-class women in flamboyant, unwieldy hats. Her witty critiques of haughty society matrons strutting up Fifth Avenue, like *A Lady*, won her critical praise when exhibited at the seminal Armory Show of 1913 and elsewhere. The periodical *Arts and Decoration* recognized her uncommon position in a 1914 article: "To be the home maker, general business manager, besides being a successful artist were no small achievement." Financial straits made it difficult to cast many bronzes and may have motivated her later shift to ceramics and clothing design.—AT

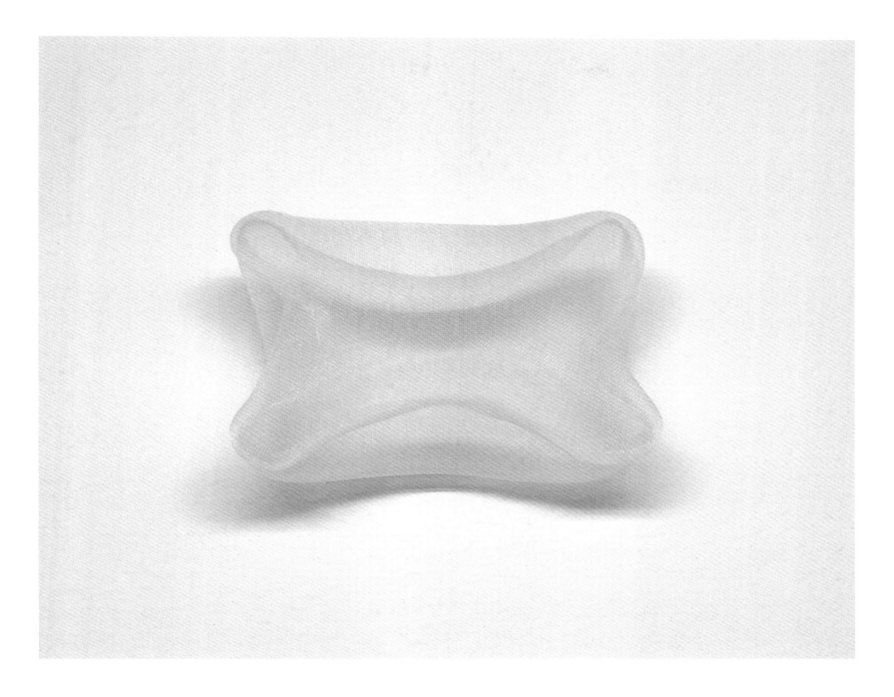

PILLOW FOR THE DEAD
2023, silk organza and thread, 2 ⅜ × 1 ⅞ × 1 ¼ in.
(6 × 4.8 × 3.3 cm)

Rei Naito, born 1961, Hiroshima, Japan.

Recognized for her poetic and frequently ephemeral artworks, Rei Naito works with natural elements such as water, wind, and light to create site-specific installations that illuminate the porous boundary between the self and its surroundings, this life and the next. Her practice hinges on the fleeting and the fragile, qualities that both pique her interest conceptually and are physically manifest in the delicate constructions of many of her artworks. In 1997 Naito installed 304 tiny organza pillows in the Carmelite Monastery in Frankfurt, Germany, titling her work *Being Called*. Directly inspired by the painted figures in the monastery's dining halls, each pillow corresponded to one of the characters depicted in the frescoes, serving as an imagined and filigreed resting place for the absent dead. Arranged at the edge of the mural and lit, en masse the pillows took on a spectral, otherworldly presence. *Pillow for the Dead* derives from this installation—a single of these minute translucent pillows displayed independently. Where in the installation each pillow was linked to a specific saint, martyr, or one of their persecutors, here the phantom figure who might seek rest is left ambiguous, opening up the work to become a more expansive memorial to the lost and the forgotten.—MH

ANA NAVAS

PECERA (FISHBOWL)
2019, clothing rack, plastic, textile, and acrylic
paint, 16 ½ × 31 ½ × 66 ½ in. (42 × 80 × 169 cm)

Ana Navas, born 1984, Quito, Ecuador.

Ana Navas's work is the outcome of speculative investigations into the relationship between art and everyday objects. By tracing the circulation of aesthetics between spheres of culture, Navas produces pieces that arise from combination and, consequently, create the possibility for new complex narratives parallel to hegemonic ones. Her sculptures and installations review this circulation via the translation and assimilation present in the use of mundane items, questioning accepted categorizations and the assigned value of things. The results are strange yet familiar mash-ups that reframe concepts like originality and utility. *Fishbowl* uses a clothing rack as a stretcher for painted textiles, conciliating the contemplative purpose of an artwork with the utilitarian quality of an item, while also creating tension by linking sculpture and painting. The abstract, floating, hand-painted forms in the artwork mimic the relief murals and now rusty metalwork from emblematic Modernist buildings, although the citation is fuzzy. As the artist told curator Manuela Moscoso in a 2020 interview, *Fishbowl* "does not have a specific author as a reference . . . In this case, and I like this, the result is far from the original source." Navas's practice blends these unknown referents—what can be observed in places as disparate as an appliance store, a kitchen, and a museum—into singular works from which an uncategorizable world can emerge.—LO

WATER COMPOSITION III
1969–70/2018, heat-sealed vinyl, colored water, and rope, 45 ½ × 48 × 27 ½ in. (115.6 × 121.9 × 69.8 cm)

Senga Nengudi, born 1943, Chicago, Illinois, USA.

Senga Nengudi's conceptually driven work bridges sculpture and performance, and has long defied expectations of both genres. While studying both art and dance at California State University, Los Angeles, she encountered Gutai—a Japanese avant-garde movement that emphasized the use of found materials as well as ephemeral gestures and the performative act of creating. Inspired by this philosophy, she moved to Japan to study Japanese culture and theater traditions. When she returned to Los Angeles in 1967, she became part of a burgeoning Black Arts Movement and joined the loose collective Studio Z, alongside artists David Hammons (b. 1943), Maren Hassinger (p.134), and others. It was around this time that Nengudi began making her *Water Compositions*—vinyl bags filled with dyed water, alternately suspended with rope, draped over pedestals, or resting on the floor. In their embrace of the most quotidian of materials, the soft and malleable forms of the *Water Compositions* are in striking contrast to the rigid delineations of traditional sculptural materials. Initially, Nengudi intended the *Water Compositions* to be handled by visitors, inviting the viewer to connect directly with the material and impact the form of the sculpture, lending a participatory and performative element to the works.—CD

RIVANE NEUENSCHWANDER

BALA-BALA
2012, wooden table, caramel sugar, and paper,
33 ½ × 59 ⅛ × 33 ½ in. (85 × 150 × 85 cm),
edition of 3 + 1 AP

Rivane Neuenschwander, born 1967, Belo
Horizonte, Minas Gerais, Brazil.

An interest in psychoanalysis fuels Rivane Neuenschwander's work, which encompasses film, installation, performance, and sculpture. Unpacking identity—from the perspective of her Brazilian heritage and, more widely, from how we collectively come to understand ourselves—forms the foundations of her practice. Embracing elements of chance, her artistic actions use both human and animal subjects to navigate an often unpredictable world. Soap bubbles, fruit, and water drops are recurring materials used to explore the chaos and logic governing their temporality. Her most recent work is deeply concerned with fear, examining how it can both distort and protect perceptions of reality, and consequentially, how people move through the world. Although Neuenschwander, at times, addresses bleak issues, such as the rise of the far right, climate change, and colonization, her work is often whimsical and full of color. She activates sensory imagination, welcoming participants to question their behaviors and uncover societal truths through interactive play. In *Bala-bala*, the artist presents the popular Brazilian treat of caramels, wrapped neatly in paper cones, mirroring how a street vendor would typically sell these childhood treats. Viewers are invited to take a piece only to find that the candies are cast from bullet casings. Neuenschwander transforms a moment of nostalgic levity to foreground the threats of violence experienced by some communities within Brazil.—NM

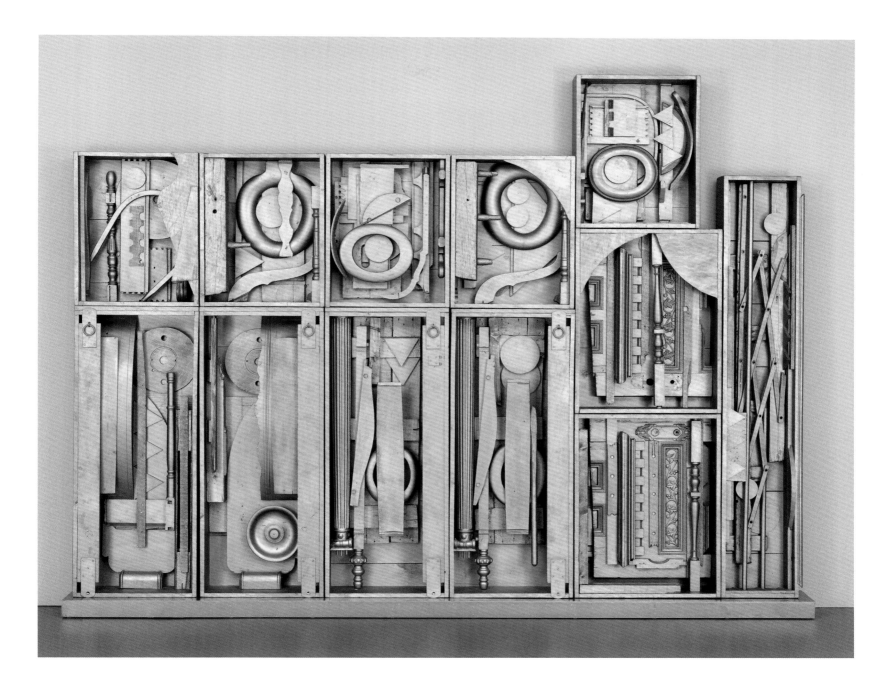

ROYAL TIDE II
1961–3, painted wood, 94 ½ × 126 ½ × 8 in.
(240 × 321.3 × 20.3 cm), Whitney Museum of
American Art, New York

Louise Nevelson, born 1899, Pereiaslav, Kyiv,
Ukraine (then Russian Empire). Died 1988, New
York, USA.

Louise Nevelson is renowned for her pioneering work in assemblage and site-specificity. Nevelson gathered cast-off materials such as banisters, columns, balustrades, and wood shards from the streets of her home in New York and transformed them into captivating monochromatic compositions. She produced several public artworks around the world, including Louise Nevelson Plaza and the Nevelson Chapel in St. Peter's Church, both in Manhattan and dated 1977, when the artist was in her late seventies. Throughout her career, Nevelson challenged traditional gender roles to become one of the few prominent female sculptors of her time. In a 1973 interview for the Archives of American Art, Nevelson described society's "pre-conceived cliches" about gender, art, and creativity, declaring, "That's what I've been trying to break down all my life." Her artistic vision and wide recognition have influenced generations of artists. *Royal Tide II* is part of a series of gold-colored sculptures that combine architectural fragments, including finials, folding gates, and toilet seats, with abstract geometric forms in a stacked grid of front-facing boxes. These works were Nevelson's first use of gold paint, inspired by Japanese Noh robes she saw at the Metropolitan Museum of Art that moved her to tears. In the 1980 book *Atmospheres and Environments*, Nevelson explained: "Life is worth living if a civilization can give us this great weave of gold and pattern."—GH

OTOBONG NKANGA

IN PURSUIT OF BLING
2014, metal modulated structure of 30 elements:
9 photographic prints on Galala limestone slabs,
6 slabs with minerals in layered concrete,
4 levitation modules with minerals (various mica),
3 texts printed on Galala limestone slabs, 2 textile
pieces, 2 single-channel HD videos with sound,
1 micanite sheet, 1 lightbox with 30 inkjet-printed
archival images on plexiglass, 1 copper sheet with
malachite head piece, and 1 compressed makeup
powder tray, overall dimensions variable, installation
view, *Bruises and Lustre*, Museum van Hedendaagse
Kunst, Antwerp, 2015–16

Otobong Nkanga, born 1974, Kano, Nigeria.

Combining textiles and sculpture with film footage and found natural objects, Otobong Nkanga constructs installations based on extensive research into land usage and colonial dynamics, both past and present. Focusing on the consequences of displacing objects, resources, and people, Nkanga roots her practice in the understanding that nothing is fixed, but that by the same token, nothing vanishes. Across her work, she traces hauntings and memories that she sees as lingering in both the land and what is taken from it. The multilayered installation *In Pursuit of Bling* catalogs the artist's study of mica and malachite mining, two minerals frequently extracted from the Global South and prized as key ingredients in many cosmetics. The work follows the trajectory of these raw materials through a system of exchange that remaps colonial trade routes and transforms the substances into tools of beautification. In her critique of how extraction from one place fuels the production of wealth in another, Nkanga illuminates how greed is so often linked to the destruction of nature, a recurrence made possible by humanity's ever-increasing estrangement from the land itself.—MH

UNTITLED (MONUMENT TO EIGHTY YEARS OF JAPANESE IMMIGRATION)
1988, 4 elements of reinforced concrete, each 98 ⅛ ft. (30 m) long, São Paulo

Tomie Ohtake, born 1913, Kyoto, Japan. Died 2015, São Paulo, Brazil.

Tomie Ohtake arrived in Brazil in 1936 and began studying painting with fellow Japanese artist Keisuke Sugano (1909–63) in 1952. The following year, she joined Grupo Seibi: a circle of Japanese Brazilian artists who had been meeting to paint and exhibit in São Paulo since 1935. After a brief period dedicated to figurative art, Ohtake turned to abstraction, a language that would mark her artistic production until the end of her life. Between 1959 and 1962 she created her series of *Blind Paintings*, in which she covered her eyes with a blindfold during the painting process in order to explore the limits of the relationship between perception, intuition, and gesture. Influenced by Zen Buddhist philosophy, the works present organic forms in which color, line, and materiality are in perfect balance. Starting in the 1980s Ohtake made large sculptures for public spaces, such as this wave-shaped concrete monument in honor of Japanese immigration to São Paulo. As an evocation of the gentle movement of water, the work stands out for the delicacy of its design and the harmony of its colors, which evoke nature, in contrast to the industrial, gray appearance and chaotic congestion of the surrounding urban landscape.—TP

PRECIOUS OKOYOMON

NOT YET TITLED (BLOOD MEMORY)
2021, raw wool, yarn, dirt, and blood,
25 × 25 × 25 in. (63.5 × 63.5 × 63.5 cm)

Precious Okoyomon, born 1993, London, UK.

For poet and artist Precious Okoyomon, their mixed-media sculptures and installations give visual form to their poetry on complex human entanglements with nature. They use organic materials like plants, fibers, live animals, and their own bodily fluids to explore themes of Black and Queer identities, and the racialized histories of invasive species and their impact on Indigenous ecosystems. Interested in new modalities of being, Okoyomon creates habitats that allude to unknown parallel or future worlds and simultaneously reference their ancestry. Made out of raw lamb's wool and donning vermillion red yarn, the deity figure in *Not Yet Titled (Blood Memory)* raises its arms as if in ritual ceremony or a protective stance. The work is inspired by the effigy-like dolls fashioned from sticks and hay that the artist's grandmother made for them and their siblings when they were children in Nigeria. Okoyomon views elements of the Earth as inseparable from violent histories of colonization and enslavement, while also celebrating nature's ability to endure and thrive amid human-made catastrophes. As they told *frieze* in 2021, "My material is everything that is living and dying, and decaying and growing. Usually, things that can't be destroyed. Water. Rocks. Dirt. Life."—OZ

FÜSUN ONUR

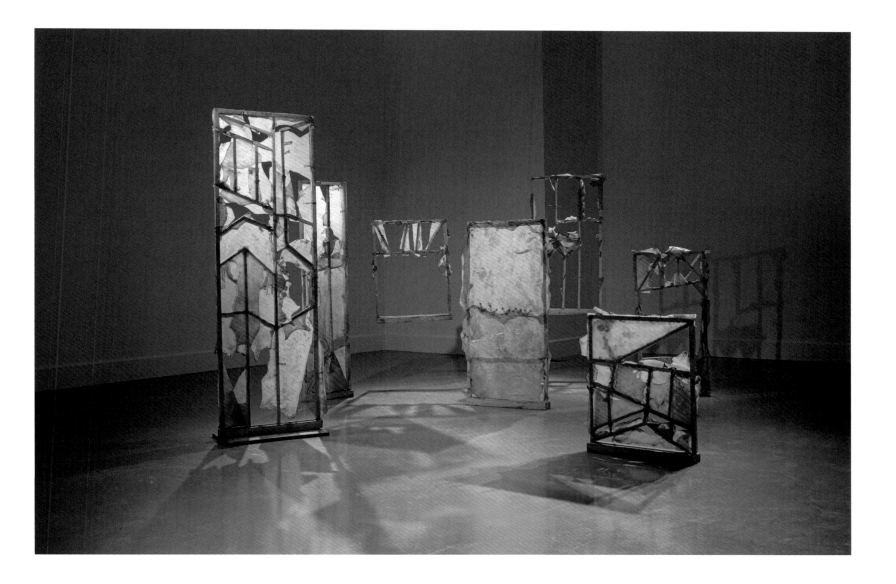

ICONS OF TIME
1990, installation, wood, leather, metal, and paint,
Arter Collection, Istanbul

Füsun Onur, born 1938, Istanbul, Turkey.

Only the second woman to enroll in the sculpture course at Istanbul State Academy of Fine Arts, Füsun Onur studied under the influential sculptor Ali Hadi Bara (1906–71). In 1962 she traveled to Washington, D.C. on a Fulbright scholarship to study philosophy, before switching to sculpture at the Maryland Institute College of Art. Citing, in a 2022 interview with İstanbul Kültür Sanat Vakfı, her desire to be "useful to Turkey," she returned to her childhood home on the banks of the Bosphorus in 1967, where she still resides. Within an underfunded art scene, Onur began producing installations using found objects sourced from her home or neighborhood. She professes a complete disinterest in her past work and a strong urge to explore new methods of storytelling as soon as a piece is complete. Deeply influenced by music, Onur's work explores temporality, the relationship between volume and space, and the rhythms of daily life. Her practice remains resistant to categorization. *Icons of Time* sees scraps of translucent leather partially fill the frames of crudely constructed portals—doorways or windows. Prompting a play of light and shadow, the installation evokes a degraded stage set for traditional Turkish shadow puppetry.—AC

MERET OPPENHEIM

**MA GOUVERNANTE · MY NURSE · MEIN
KINDERMÄDCHEN**
1936/67, metal plate, shoes, string, and paper,
5 ½ × 13 × 8 ¼ in. (14 × 33 × 21 cm), Moderna
Museet, Stockholm

Meret Oppenheim, born 1913, Berlin, Germany.
Died 1985, Basel, Switzerland.

Meret Oppenheim moved to Paris in 1932 when she was only eighteen to attend the Académie de
la Grande Chaumière, and soon after became a key figure in Surrealism. One of few women in the
movement, her gender and youth led the group to celebrate her as the ideal Surrealist woman, whose
proximity to childhood meant she was closely connected to the unconscious and dreams. She appeared
in era-defining photographs by Man Ray (1890–1976), but far from being a passive muse, Oppenheim's
pioneering attitude led her to create some of the most provocative sculptural assemblages of the
twentieth century. Foremost among these is *Object* (1936), a fur-lined teacup, saucer, and spoon,
which caused a sensation when it was first shown. The same year, the artist's first solo exhibition was
a hit, but fans and critics assumed she was male, commenting on the success of "Mr." Oppenheim's
show, which also included this quintessentially Surrealist sculpture that serves up ordinary objects
in a surprising way to summon up unexpected associations. Made from a pair of women's white high
heels trussed up like poultry and crowned with refined paper frills, it is both virginal and seductive,
conveying respectability and eroticism. Although it resembles a nourishing dish, the well-worn soles
make this meal thoroughly unappetizing.—EDW

**WOMAN WITH A FAN (PORTRAIT OF YVANNA
LE MAISTRE)**
1920, wood, 36 ¼ × 15 × 17 ¾ in. (92 × 38 ×
17 cm), The Israel Museum, Jerusalem

Chana Orloff, born 1888, Kostiantynivka, Donetsk,
Ukraine. Died 1968, Ramat Gan, Tel Aviv, Israel.

Deemed "the most important sculptress living today" by *Vanity Fair* in 1929, Chana Orloff was a major figure in modernism who documented the creatives of Paris in sculpture. An early Jewish settler in Palestine, Orloff initially arrived in Paris in 1910 as a dressmaker's apprentice. Her artistic abilities quickly earned her places at the Ecole Nationale des Arts Décoratifs and Académie Russe, where she became part of the constellation of avant-garde artists known as the School of Paris. Although she experimented with other materials, her most celebrated sculptures are her bronze portraits. Of her nearly 500 sculpted works, 259 are recognizable people from Parisian society, many of them women. *Woman with a Fan*, a unique portrait in wood of the elegant Russian painter Yvanna Le Maistre (1893–1973), is indicative of Orloff's ability to reduce her sitters to their most essential elements—while still communicating their personalities—through sleek, elongated forms and masklike, geometric faces. Orloff was one of the only women featured in the groundbreaking 1937 exhibition *Les Maîtres de l'art independent* at the Petit Palais in Paris, but the Nazi occupation interrupted her meteoric rise. After the war, she became a champion of Jewish art, dying days before a major retrospective opened at the Tel Aviv Museum of Art on her eightieth birthday.—OC

VIRGINIA OVERTON

UNTITLED (HILUX)
2016, Toyota Hilux 1996, 149 ¼ × 182 ¼ × 94 ⅛ in.
(379 × 463 × 239 cm), Whitney Museum of American
Art, New York

Virginia Overton, born 1971, Nashville,
Tennessee, USA.

Virginia Overton's sculptures have the uncanny power to communicate a sense of intimacy and famil-iarity despite their large size. Although Overton's deployment of found, mundane materials plays a big part in making her work relatable, the subtle poetic vein that informs their inception and construc-tion, coupled with an attentive examination of the setting where they are installed, is what ultimately sets her sculptures apart from other assemblages. *Untitled (HILUX)*, for example, was made on the occasion of Overton's participation in the outdoor exhibition *Parcours* in Basel in 2016. Placed in front of the building of the Bau- und Verkehrsdepartement (the local Transportation Department), the piece consists of a pick-up truck where all the elements have been dismantled and crammed into the vehicle's bed. Initiated by the artist's fascination with ideas of migration and mobility associated with trucks, the auto-conflation of *Untitled (HILUX)* indicates both the desire to challenge car culture as well as the very monumentality of the sculpture itself. Overton's habit of breaking apart her pieces at the end of an exhibition cycle and reusing their components for future endeavors contributes to this sense of perennial flux—a trait made even more tangible when she partially distances herself from the ready-made approach to sculpture by using raw construction materials such as wood planks, metal pipes, and stone bricks.—MR

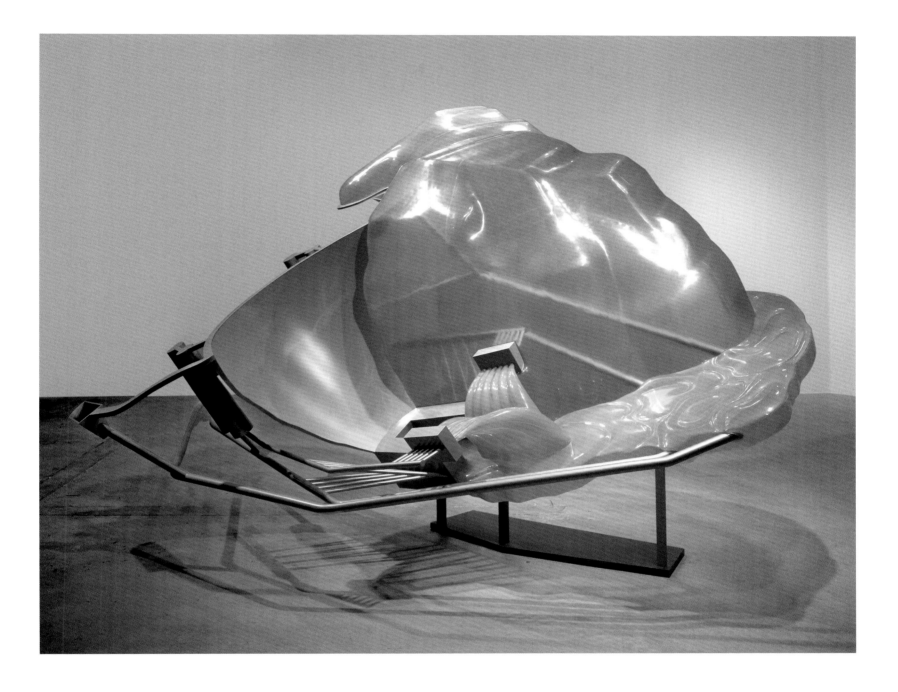

THE PERFECT RIDE (DAM)
2003, steel, aluminum, and plastic, 102 × 108 × 153 in.
(259.1 × 274.3 × 388.6 cm)

Jennifer Pastor, born 1966, Hartford, Connecticut,
USA.

Often basing her works on years of extensive research, Jennifer Pastor's sculptures display a baroque-like theatricality. Unapologetically dramatic, her installations combine painstakingly constructed replicas presented together in unexpected formations to appear expressly unfamiliar. Her representational works are both exactly true to life and so obviously distorted that the viewer is left to wander Pastor's simulacra like an abandoned stage set. *The Perfect Ride* is an installation comprising three works that draw on the culmination of Pastor's research into different systems of energy circulation, a topic she initially began investigating in 1998. First exhibited at the 50th Venice Biennale in 2003, *The Perfect Ride (dam)* captures the artist's attention to the uncanny. Although the objects she depicts are rendered as near-perfect reproductions, Pastor abstracts her subjects by drastically varying their scale. Here, the monumentality of the Hoover Dam in Nevada is reduced to something room-sized, shrunk to proportions closer to the human body. Turned on its side and stripped from its context in the desert landscape, the dam appears almost like a toy, the unmistakable artifice of it injected with Pastor's humorous flair for light-touch kitsch.—MH

KATIE PATERSON

REQUIEM
2022

Katie Paterson, born 1981, Glasgow, Scotland, UK.

"Dust to dust" is a powerful metaphor to comprehend mortality. For humanity, the mood of our existence is often somber: destruction goes hand in hand with creation, generating chaos and uncertainty. Katie Paterson embraces the Earth's elemental qualities in expansive works that reflect on the component accretions of the world from the dawn of solar time in order to discuss impending ecological collapse. This singular project comprised 364 vials, each holding 21 grams of dust, or powdered matter, representing the weight of a human soul as per early-twentieth-century experiments, which are now refuted. A temporary sculptural installation at Edinburgh's Ingleby Gallery, *Requiem* provided a space where participants would pour the matter from the vials into a handblown, clear glass urn, similar in shape to traditional funerary vessels, for nine weeks until the urn was full. Having collected the component elements from scientists at geological and paleontological agencies, such as the Danish Geologic Survey, the European Space Agency, the British Antarctic Survey, and various institutions in Washington, D.C., Paterson methodically constituted nature both in time and through climate shifts that reveal the birth and life of our planet, a summation of eternity through layers of residual materials.—KM

DOUBLE PALIMPSEST
2012, Cor-ten steel, 138 × 84 ⅛ × 60 in.
(350.5 × 213.4 × 152.4 cm)

Beverly Pepper, born 1922, New York, USA.
Died 2020, Todi, Umbria, Italy.

Working with a vocabulary of geometric abstraction, Beverly Pepper is celebrated for her large-scale public sculptures and site-specific works in iron and steel. Born in the United States, she initially studied industrial design before enrolling at the Académie de la Grande Chaumière, Paris, where she was taught by Fernand Léger (1881–1955). Having established herself in the 1950s as a painter, Pepper turned to sculpture in the early 1960s after becoming enamored with the spatial forms of the immense Cambodian temple complex Angkor Wat. Starting with small wood and clay sculptures, she progressed to working with metal on a monumental scale, learning to weld in preparation for the 1962 Festival of Two Worlds in Spoleto, Italy, for which she produced several major steel sculptures. This included the acclaimed *The Gift of Icarus* (1962), which still stands in Spoleto to this day. Defying gender expectations, she was one of the few women of her generation to work firsthand in foundries. By the late 1960s, she was producing highly polished steel structures, although became best known for using Cor-ten steel with its characteristic rust-hued patina; produced on a range of scales, some of her works in this material are tall and columnar, while others, as here, curve gracefully in the landscape.—DT

JUDY PFAFF

BLUE VASE WITH NASTURTIUMS
1987, enamel on steel and plastic laminate on wood,
115 × 102 ½ × 66 ⅛ in. (292.1 × 260.3 × 167.7 cm),
Museum of Modern Art, New York

Judy Pfaff, born 1946, London, UK.

For almost half a century, Judy Pfaff has been at the forefront of experiments in sculpture. After a migratory adolescence—her family relocated to the United States after World War II and she left home at sixteen—Pfaff studied painting at Yale University under Al Held (1928–2005), who inspired her to create boundary-breaking works in three dimensions. While her contemporaries were pioneering Minimalism in the early 1970s, Pfaff was choreographing large, vibrant, multipart environments that occupied entire rooms. She begins each work in pursuit of a specific feeling, trying to build a scenario that will engender the sensation she seeks, until the original intention is superseded by the work taking on a life of its own. Usually tethered to the wall but projecting out into the room, her sculptures are frequently described as "painting in space." *Blue Vase with Nasturtiums* riffs on the title of an 1879 painting by the Impressionist Claude Monet (1840–1926), which depicts a decorated pitcher containing undulous orange flowers and sitting on a round table. By alluding to Monet's painting while creating a radically different work, Pfaff explodes both its form and meaning. Bright-colored, patterned circles jostle like atoms in direct contrast to the notion of "still life," their saturated tones fighting the romantic hues of modernisms past.—RH

NOURISHER
2022, ceramic, medical PVC tubes, stainless steel, and steel cable, 69 ½ × 32 × 24 in. (177 × 81 × 61 cm), Marieluise Hessel Collection, Hessel Museum of Art, Center for Curatorial Studies, Bard College, Annandale-on-Hudson, New York

Julia Phillips, born 1985, Hamburg, Germany.

Julia Phillips grew up in Hamburg before moving to New York in 2013. Working predominantly in sculpture, she uses ceramic, stone, metal, and plastic in works that merge biomorphic elements with utilitarian, mechanical, or industrial components. Influenced by psychoanalysis and Black feminist thought, she told *Mousse* in 2018, "I think of the body as a symbol to make psychological, social, and emotional experiences and relations visually accessible." Often incorporating ceramic casts of her own body, her sculptures hint at states of physical and psychological vulnerability and strength, while metal hardware and seemingly functional objects evoke institutional contexts. Although Phillips's fragmented bodies are defined by gaps and absences, titles such as *Manipulator*, *Protector*, *Aborter*, and *Impregnator* define actions and relations involving people or objects. Phillips's experience of pregnancies that did not result in a birth and of motherhood led her from concerns around hierarchical power dynamics to more horizontal relationships, among people or within the self, such as those between body, soul, and spirit. She created *Nourisher* while processing stress and emotions from breastfeeding, reflecting on the resources and intimate gazes shared by mother and infant.—EDW

PATRICIA PICCININI

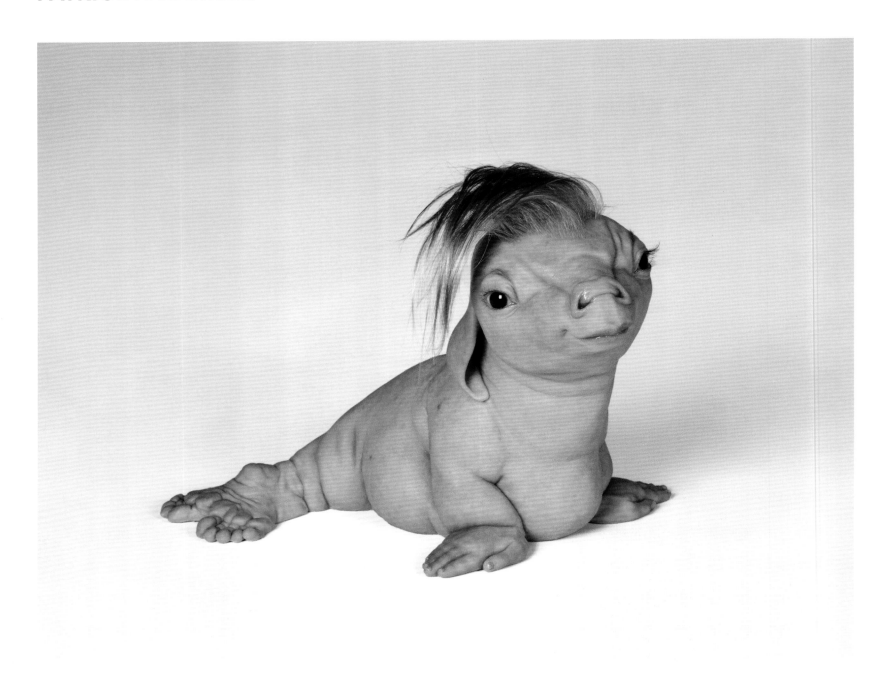

THE NATURALIST
2017, silicone, hair, and resin, 10 ¼ × 13 ½ × 10 ½ in.
(26 × 34 × 27 cm), edition of 6 + 2 AP

Patricia Piccinini, born 1965, Freetown, Sierra
Leone.

Pairing biotechnology with speculative imaginings, Patricia Piccinini's hyperreal sculptures ask after humanity's ethical position in a genetically engineered future. While studying toward a degree at the Victorian College of the Arts in Melbourne in the early 1990s, Piccinini found her singular preoccupation in the pathologies and anatomical aberrations among the preserved specimens in medical museums. Her interest in biological mutations proved foundational in her ongoing engagement with transgenic possibilities (the transplanting of genes from one organism into another), informed by developments in stem cell technology and genome editing. "What is our relationship with—and responsibilities toward—that which we create?" the artist asked in a 2014 interview with *The Condition Report*. This inquiry first found sculptural expression in the artist's series of machinelike hybrid forms—part animal, part automotive—that explore the porous boundaries between the ecological and artificial worlds. Following these, Piccinini began creating the near-human creatures for which she is best known: fleshy beings at once beguiling and discomfiting, remarkable for the realism of their invented image, each produced from the artist's drawings by a team of technicians in industrial and natural materials (among them human hair). Such is *The Naturalist*, vulnerable and sweetly seal-like, unsettling for its strangeness and compelling for its assumed naturalism.—LB

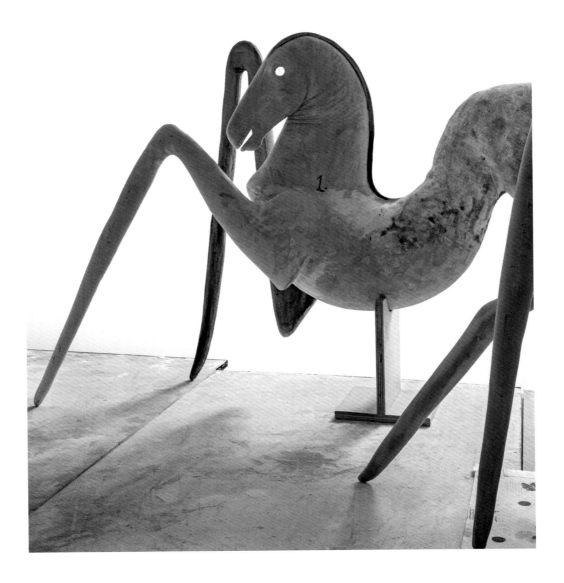

ON THE TABLE
2023, fabric, plaster, straw, resin, car filler, paint, masking tape, rubber, linoleum, paper, glitter curtain, and wood, 65 × 120 × 39 ¼ in. (165 × 305 × 100 cm)

Cathie Pilkington, born 1968, Manchester, UK.

Cathie Pilkington creates ambivalent and unsettling forms, using the uncanny and surreal to question sculptural hierarchies. Her works feature a tactile interplay of media, from clay and resin to fabrics, ribbons, and wood, and are often presented as an immersive installation. She has a democratic attitude to materials, presenting the everyday and domestic alongside traditional practices. *On the Table* shows the artist poking at the Classical histories of sculpture. Horses featured prominently in ancient Greek and Roman statuary, in mythological narratives, and historical commemorations. The horse's muscular form was sculpted with anatomical precision and often accompanied heroic figures, gods, or emperors, enhancing their grandeur and symbolizing power, conquest, and authority. Pilkington's horse does no such thing. It can barely stand. The head is reminiscent of toy hobbyhorses and it is propped up by what looks like a temporary and rickety wooden stand—a deliberate and direct visual comparison with the grand plinths upon which so many bronze horses rear up onto powerfully conceived hind legs. This translation of traditional equine sculpture into a flailing fabric form, made of unexpected materials, creates a narrative tension, hinting at the struggle between the rational and the instinctual, and evoking both discomfort and fascination.—JB

PAOLA PIVI

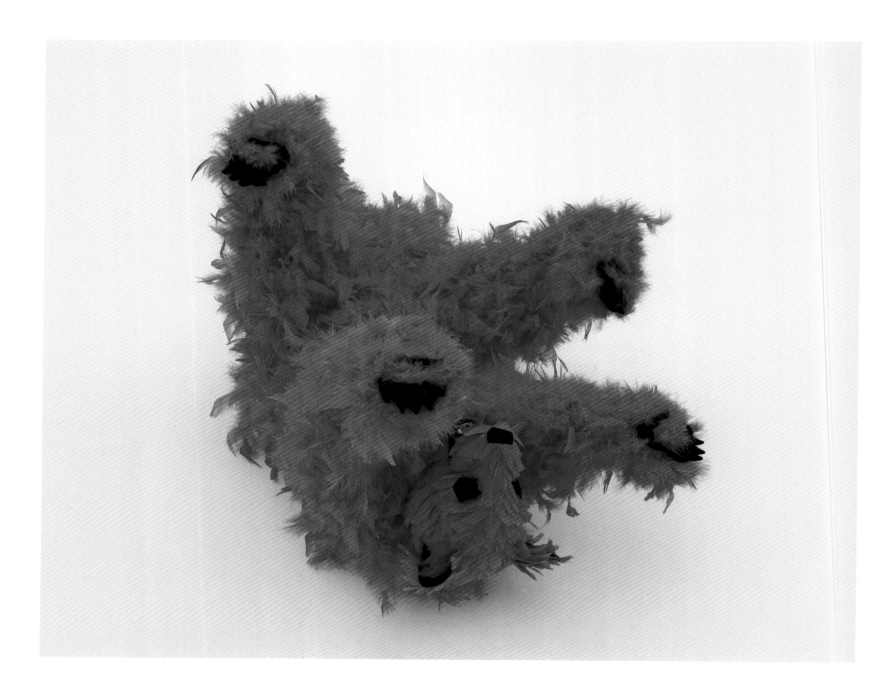

ARE YOU THE MANAGER?
2019, urethane foam, plastic, and feathers,
19 × 27 × 22 in. (48.3 × 68.6 × 55.9 cm)

Paola Pivi, born 1971, Milan, Lombardy, Italy.

After abandoning her university studies in chemical-nuclear engineering, Paola Pivi enrolled in Milan's Accademia di Belle Arti di Brera, although she again left before completing the course. This did not prevent her from creating a string of ambitious and spectacular works characterized by the manipulation, modification, and recontextualization of objects and animals. An eighteen-wheeler truck was tipped on its side for *Camion* (1997), while a G-91 fighter jet was exhibited upside down in *Untitled (airplane)* (1999). Pivi's surreal photographs of animals in unlikely habitats have included horses at the Eiffel Tower, zebras on a snow-covered mountain, and a donkey in a small boat, floating on the Mediterranean Sea. Bears have been a recurring motif since Pivi moved to Alaska in 2006, and she has become known for her brightly colored, life-size bear sculptures covered in artificial plumage and positioned in improbable poses (swinging on a trapeze, practicing yoga, or doing handstands, for instance). These whimsical pieces spawned a series of similarly colored infant bears, including this curiously titled, Day-Glo pink example. While such works revel in Pivi's trademark surreal humor, they simultaneously raise awareness of the ecological threats to these creatures and their habitats.—DT

NAIL from the series **FORCED LABOR**
2008, figurine on wooden cube and nail,
3 × 3 ½ × 2 in. (7.6 × 8.9 × 5.1 cm),
private collection

Liliana Porter, born 1941, Buenos Aires,
Argentina.

Liliana Porter's art practice began in the 1950s with printmaking and painting. Having moved to New York in 1964, and influenced by Minimalism and Pop art, she cofounded the New York Graphic Workshop with Luis Camnitzer (b. 1937) and José Guillermo Castillo (1938–99). This endeavor favored a conceptual rather than technique-based approach to printmaking, thus broadening the limits of the medium while also elaborating a critical position that challenged the economic, material, and institutional systems of art production. These reflections were of crucial importance to the formation of Porter's artistic language, influencing the concerns still present in her work: representation and reality, humor and distress, space and time. Through her practice she disputes the meaning of these concepts and explores their relation to human perception. In *Nail*, an inanimate object is presented as a character. Separated from its surroundings by a white void—a recurrent aesthetic feature in Porter's work—the figurine is confronted with an absurd or impossible task. Porter carefully selects objects that evoke an everyday familiar awareness, but at a second glance become metaphors for something deeper. The viewer actively participates in the translation and finishing of the artwork, be it by performing willingly in the piece itself or by completing the narratives suggested within a given work.—LO

MARJETICA POTRČ

CARACAS: GROWING HOUSES
2012–18, building materials, energy,
communications, and water-supply infrastructure,
dimensions variable, installation view, *Hello World:
Revising a Collection*, Hamburger Bahnhof –
Nationalgalerie der Gegenwart, Berlin

Marjetica Potrč, born 1953, Ljubljana, Slovenia.

An artist, architect, and educator, Marjetica Potrč's practice cuts across disciplines to merge art, architecture, ecology, and anthropology to document and examine contemporary architectural practices and how people coexist within built environments. She is especially interested in how community-based knowledge helps organize and regulate cities, and highly attuned to energy infrastructure and water use. Deeply appreciative of existing alternative building structures and methods of resource management, she maintains a firm eye on strategies for future living in an increasingly challenging world. *Caracas: Growing Houses* is one of Potrč's "architectural case studies," a house constructed in a gallery space as a three-dimensional portrait of an urban landscape in a place that is often halfway around the globe from where it is shown. Her case studies, which she describes as theatrical objects, embody the environmental, social, economic, and political conditions of their place of origin. This particular case study takes as its subject the informal architecture of parts of Caracas, Venezuela, where the artist undertook a residency in 2002. The reference to "growing" in the work's title alludes to the idea that this is a self-built structure to which another floor will eventually be added, as well as to the likelihood that over time more people and families will be living here.—RH

CLARA RILKE-WESTHOFF

PORTRAIT OF PAULA MODERSOHN-BECKER
1899, plaster, 18 ¼ × 16 ½ × 14 ⅜ in.
(46.5 × 42 × 36.5 cm), Kunsthalle Bremen

Clara Rilke-Westhoff, born 1878, Bremen, Germany.
Died 1954, Fischerhude, Lower Saxony, Germany.

Once relegated to the shadows of her artistic circle, Clara Rilke-Westhoff is now celebrated as an important voice in modern German art. Initially a painting student, Rilke-Westhoff followed the artist Fritz Mackensen (1866–1953) to Worpswede, a village north of her native Bremen, where he led a group of artists in portraying the local landscape and peasant life in a manner akin to the French Barbizon school. There, she took up sculpture, cementing a lifelong interest in portraying the human figure and capturing her sitters' unique faces. She also met the poet Rainer Maria Rilke, whom she married in 1901, and befriended fellow artist Paula Becker (later Modersohn-Becker; 1876–1907), forging two relationships that have sometimes obscured her own contributions to the art historical canon. Rilke-Westhoff and Modersohn-Becker developed an enduring bond, often working alongside each other from the same models in Mackensen's studio. They also began a mutual portrait practice that commemorates their generative artistic exchange: Rilke-Westhoff sculpted this plaster bust of Modersohn-Becker while at Worpswede, and Modersohn-Becker, a noted portraitist herself, would go on to paint Rilke-Westhoff in 1905. Rilke-Westhoff settled in Fischerhude, a fishing village in northern Germany, in 1919, where she remained for the rest of her life, eventually returning to her artistic origins in paint after a lifetime of sculpting portraits.—MMB

LUISA ROLDÁN

**THE MYSTICAL MARRIAGE OF
SAINT CATHERINE**
1692–1706, polychromed terracotta, 14 ⅜ ×
17 ¾ × 11 ⅝ in. (36.5 × 45 × 29.5 cm), The
Hispanic Society of America, New York

Luisa Roldán, born 1652, Seville, Andalusia, Spain.
Died 1706, Madrid, Spain.

One of the only known women sculptors from Spain's Baroque period, Luisa Roldán was likely trained by her father, the polychrome sculptor Pedro Roldán (c. 1624–99). Her earliest sculptures are primarily polychromed carved wood, while her later work chiefly consists of painted terracotta, such as this piece created and signed around the turn of the eighteenth century in Madrid, where she had moved in 1688 with the hope of receiving royal commissions and titles. Around 1692 she was finally awarded the title of *escultora de cámara* (court sculptor), where one period writer recorded that he saw her terracotta works at the Spanish court "in glass cases." To support herself, Roldán made small-scale terracotta groupings like this one. A complex, horizonal composition of five figures, this work depicts Saint Catherine kneeling at right atop her attribute, the wheel, receiving Christ's favor in the form of a gold ring with a red stone before her martyrdom. Roldán artfully captures the concept of the mystical wedding by imbuing the figures with a gentle devotional intensity seen in the rhythmically bowed heads and muted palette of reds and blues. As painted terracottas were popular in Madrid's secular and religious spaces, Roldán both capitalized and innovated on this late-seventeenth-century sculptural trend.—ESP

DROOVE
2012, slip over glazed and fired ceramic and rubber
inner tube, 13 × 20 × 16 in. (33 × 50.8 × 40.6 cm)

Annabeth Rosen, born 1957, Brooklyn,
New York, USA.

For over thirty years, Annabeth Rosen has both built upon and challenged the history and process of ceramics to present a new take on the possibilities of the medium, creating strikingly uncommon sculptures. Offering unexpected shapes in clay animated with slip, glaze, paint, and various organic materials, her sculptural practice defies easy categorization. She brings to her ceramic assemblages an aesthetic of accumulation, organizing and chronicling raw and sometimes unruly abstract silhouettes. As Rosen described in her 2020 induction biography for the American Craft Council's College of Fellows, "my process of building, breaking, and putting back together becomes part of an interior process as well as a means of fabrication." In works such as *Droove*, Rosen's inner world manifests as the gathering of disparate, yet surprisingly interrelated, forms. Numerous vaselike shapes—a couple of which have white, cracked surfaces while the rest are painted with moss-colored brushstrokes—nestle together, almost like pears, bound by black rubber tubing. Flopping casually atop the mound of vessels is a bundle of striated black and white ceramic tubular forms, recalling a host of organic references, from bamboo canes to arterial segments. *Droove*, perhaps an amalgamation of the words "drive" and "groove," captures the artist's motivation to challenge the boundaries of ceramic and sculptural media with her ever-present tongue-in-cheek frisson.—ESP

PROPERZIA DE' ROSSI

JEWEL WITH CARVED CHERRY STONE
1510–30, gold, diamonds, enamel, pearls,
and cherry stone, 1 ⅝ × ⅞ in. (4.2 × 2.3 cm),
Museo degli Argenti, Palazzo Pitti, Florence

Properzia de' Rossi, born c. 1490, Bologna,
Emilia-Romagna, Italy. Died 1530, Bologna.

As the earliest woman sculptor in the Renaissance, Properzia de' Rossi stands alone. She is the only woman artist to be given a separate biography in Giorgio Vasari's widely influential first edition of *The Lives of the Most Excellent Painters, Sculptors, and Architects* in 1550. Vasari suggests that de' Rossi started out by carving peach pits, such as the intricately carved object at the center of this bejeweled work, albeit here a smaller cherry pit. This success enabled her to transition to sculpture in marble, such as the relief panels for the facade of San Petronio in Bologna, for which she is most famous. These two panels depict episodes in the story of Joseph and Potiphar's wife—a subject that Vasari linked directly to de' Rossi's own biography. He misogynistically suggests that it represents her love for another man while already wed. Surprisingly, Vasari omitted—or was unaware of—documentary evidence that de' Rossi was charged with disorderly conduct and assault in the 1520s. Instead, he focused on gendered stereotypes, presenting her as exceptionally beautiful and a gifted musician—all markers of virtue for women in the Renaissance. Although she ended her career by engraving copperplates for prints, de' Rossi is most remembered for her sculpture, made at a time when the art form was typically thought to be reserved for men.—ESP

ALPINE
2022, resin plaster, stainless steel, and gesso,
52 ⅜ × 31 ⅞ × 33 in. (133 × 81 × 84 cm)

Eva Rothschild, born 1971, Dublin, Ireland.

With vertiginous height, spindly legs, and (seemingly) gravity-defying feats of balance, Eva Rothschild's distinctive pylonlike and totemic sculptures are predominantly abstract. Soon after showing with the Modern Institute, Glasgow, in 1999—the same year that she completed her MFA at Goldsmiths College, London—she gained the attention of curators and critics for her unorthodox materials, including leather, Perspex, and rubber; her making processes (stacking, knotting, and wrapping); and her dominant use of black, which led her work to be described in *frieze* magazine in 2002 as "full of unspecific menace" and in *The Guardian* in 2008 as having "allusions to S&M." Following the prestigious Tate Britain Duveen Galleries commission in 2009, Rothschild was chosen as the inaugural solo exhibition at The Hepworth Wakefield, UK, in 2011, cementing her position in the history of modernist sculpture alongside Barbara Hepworth (p.138), and she subsequently represented Ireland at the 58th Venice Biennale in 2019. Having begun to incorporate bold colors, especially red and green, into her works in the 2010s, *Alpine* demonstrates a chromatic departure, using soft, pastel shades and eliminating black. The precarious tangled composition of ribbed cylinders, however, provides continuity with earlier works, and demonstrates Rothschild's ongoing fascination with giving form to equilibrium.—RM

MICHAL ROVNER

DATA ZONE, CULTURES TABLE #3 (DETAIL)
2003, steel table, 6 petri dishes, 4 monitors, glass
plates, lighting, and digital files, National Museum
of Women in the Arts, Washington, D.C.

Michal Rovner, born 1957, Tel Aviv, Israel.

Largely known for her photographic practice, Michal Rovner also works in installation, printmaking, drawing, sculpture, and video, dealing with human dynamics and their interaction with the environment. Trained in photography throughout the 1970s and 1980s, the artist often subverts the medium's supposed documentary status by transforming her images so that they fuse the real and the imaginary. Upon her relocation to New York from Israel in 1987, Rovner's practice became more interdisciplinary. Her medias coalesce in *Data Zone, Cultures Table #3,* a detail of which is seen here: laid across a metal table are petri dishes that seem to contain swimming bacteria or other biological matter. The specks are actually projected recordings of people taken by the artist from a bird's eye view. Contained within the circular barriers, the formations of people whose particularities are denied because of their tiny scale read like microscopic data points in a laboratory. What seemed to be abstract groupings become almost legible figures, a visual concept inherent to the artist's works. Emblematic of her interest in the human condition, *Data Zone* combines Rovner's sensitivity toward the bodies' choreographies with her interest in the technological apparatuses that condition humans.—MS

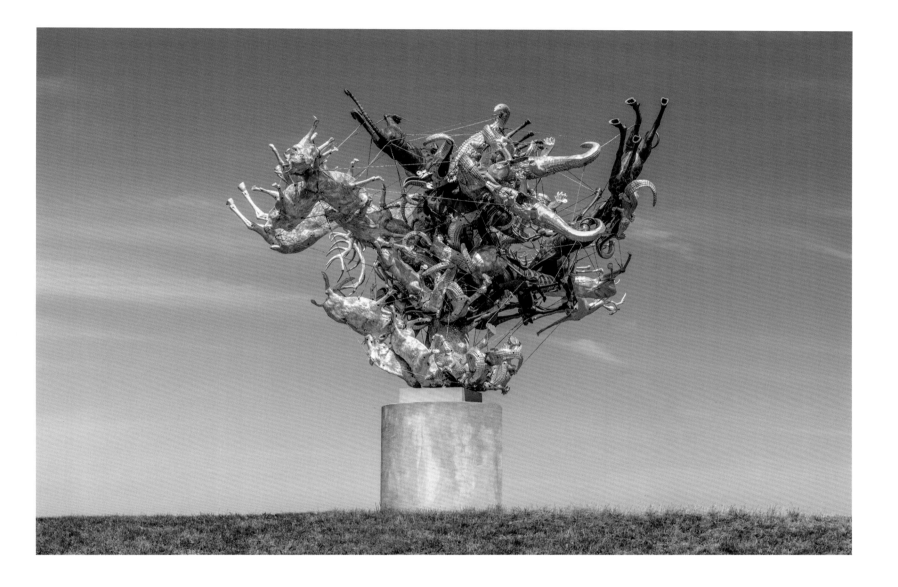

AGRIFOLIA MAJORIS
2017, cast aluminum, brass, bronze, stainless steel armature, and stainless steel wire cable,
171 × 231 × 213 in. (434.3 × 586.7 × 541 cm)

Nancy Rubins, born 1952, Naples, Texas, USA.

Nancy Rubins developed an early interest in how objects maintain their balance in space. Her experience with clay as an undergraduate at the Maryland Institute College of Art in Baltimore led her to the University of California, Davis, where ceramicist Robert Arneson (1930–92), one of her teachers, was closely allied with the Bay Area Funk art movement. Using discarded materials like appliances, mattresses, canoes, and airplane parts, Rubins's sculptures mix junk aesthetics and the quotidian objects of bricolage. After receiving an MFA in 1976, Rubins lived in San Francisco and created, among other works, a concrete wall 22 feet (6.7 meters) in length embedded with television sets. Rubins moved to Southern California in 1982 and taught at University of California, Los Angeles until 2004. The artist cites as pivotal inspiration the experience of seeing walls buckling during an earthquake and her carefully balanced and wired-together conglomerations of metal detritus eventually grew even larger, achieving a gravity-defying buoyancy. Recent works have included gleaming animal figures and been installed outside, questioning the role of commemorative public sculpture, as seen here. These graceful feats of engineering suggest concerns about consumption, obsolescence, and waste but also offer, as Rubins put it in a 2013 interview for the book *Nancy Rubins: Drawing, Sculpture, Studies* (2014), "a kind of visual education in physics."—AT

KATHLEEN RYAN

BAD LEMON (THIRSTY)
2020, citrine, garnet, hessonite, amber, limestone, aventurine, lava rock, yellow marble, jasper, pink opal, amethyst, magnesite, agate, canyon marble, feldspar, Italian onyx, tiger eye, labradorite, bamboo, coconut shell, brown lip shell, mother-of-pearl shell, bone, freshwater pearl, glass, and steel pins on coated polystyrene, 18 ⅞ × 18 ⅛ × 16 ⅞ in. (48 × 46 × 43 cm)

Kathleen Ryan, born 1984, Santa Monica, California, USA.

Kathleen Ryan's incisive critique of American culture juxtaposes excess and decay in larger-than-life-size sculptures of fruit, car parts, discarded beach toys, and other consumer detritus. Rendered from found objects like bowling balls, Airstream doors, or polystyrene foam, Ryan's sculptures are adorned with glittering gemstones, beads, and rare minerals to underscore the dissonance of decadence in the face of wealth inequality and climate catastrophe. To create her collective of works known as *Bad Fruit*, which she began in 2017, the artist literally watches produce spoil, recording the gradual changes in its shape and color as it turns moldy and rotten. Once she has captured the process in photographs, Ryan shapes polystyrene foam into the forms of the fruit and uses an array of precious materials to mimic its textures and colors. This juxtaposition—the allure of amber, limestone, or lava rock to illustrate a process of decay, as in *Bad Lemon (Thirsty)*—recalls the seventeenth-century vanitas tradition, a practice where painters referenced mortality through decadently realistic still lifes. In the work, Ryan recreates the oversize lemon's fleshy center and moldering skin, pinning each material into the foam in undulating tiers to imitate its decomposition. It can take up to two months to complete one sculpture, mirroring the slow process of putrefaction her practice represents.—NM

VERONICA RYAN

COLLECTIVE MOMENTS XV
2022, hairnet, cartridge paper stack, Sculpey,
twine, hairband, and ink, 7 ⅞ × 6 ¼ × 6 ¼ in.
(20 × 16 × 16 cm)

Veronica Ryan, born 1956, Plymouth,
Montserrat.

Objects and forms inspired by the natural world and childhood memories of the Caribbean have
informed the sculptures of Veronica Ryan since the 1970s. In a 2022 interview for the Tate, the artist
explained, "I tend to collect things wherever I am and that's become part of how the work gets made
as well, a bit like a magpie." Ryan's colorful sculptures experiment with different materials to explore
the complex historical and contemporary networks of exchanges between migration, trade, and
commerce. She began experimenting with plaster of Paris as a material during her time as an MA
student at the Slade School of Fine Art, London, in the 1970s and has since expanded to using
materials as diverse as teabags, vegetable trays, hair, seeds, and stones. Bundling and binding materials
are a recurring motif in the artist's work, evinced here in the collection of papers wrapped together
in a bright blue hairnet. The papers appear assembled through a process of sedimentation, their organi-
zation precariously secured by the encircling hairband and twine. The artist's use of familiar materials
suggests the states of stability and vulnerability that must be navigated in the transit of everyday experi-
ences. In 2021 three marble and bronze sculpture installations by Ryan were revealed as the first public
artworks honoring the Windrush generation in Hackney, London.—JD

ALISON SAAR

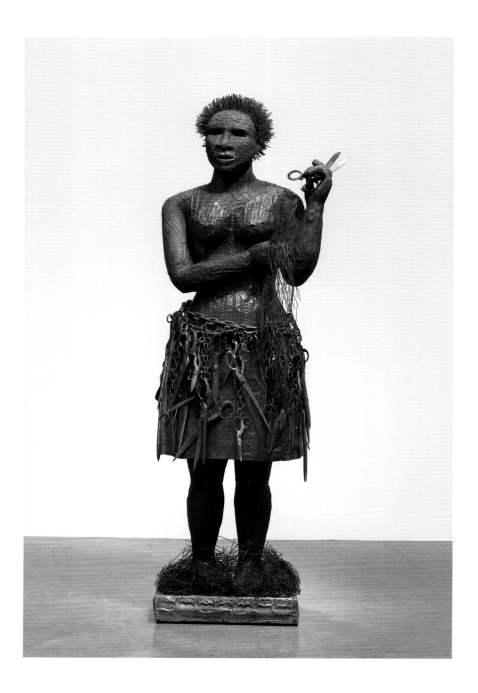

STUBBORN AND KINKY
2023, wood, ceiling tin, wire, and found scissors,
76 × 24 × 20 in. (193 × 61 × 50.8 cm), Hammer
Museum, Los Angeles

Alison Saar, born 1956, Los Angeles,
California, USA.

The sculptures of Alison Saar are concerned with the Black pursuit of autonomy in a white suprema-cist framework. The daughter of artist Betye Saar (p.265)—an artist at the forefront of the Black Arts Movement in the 1960s and 1970s—and a white father, Richard Saar (1924–2004)—a conservationist and ceramicist—Saar grew up "floating between two worlds," as she pronounced in the brochure for her 1993 exhibition *Directions* at the Hirshhorn Museum and Sculpture Garden in Washington, D.C. She is most interested in how materials carry memory—more specifically, the ancestral or genera-tional wisdom one may not have personally experienced but can nonetheless sense. Saar's sculptures, composed of carefully selected found objects like wood, nails, clay and glass fragments, and other detritus, reflect the artist's search for these uncanny moments of finding the familiar in the foreign. The process of making the work responds to the labored history of the Black Diaspora, through an intense and often rhythmic approach that involves carving, cutting, hammering, stitching, and sowing disparate materials into one congruous work. Many of her sculptures—like *Stubborn and Kinky*, which incorporates dozens of found scissors and wafts of wire and nails—are rendered in the female form, addressing the sexual, political, and aesthetic tropes conferred upon Black women.—NM

MTI
1973, wood, palm fronds, acrylic paint, doll, candles,
bone, shell, printed papers, fabric, metal, and other
materials, 42 ½ × 23 ½ × 17 ½ in.
(108 × 59.7 × 44.5 cm), Tate, London

Betye Saar, born 1926, Los Angeles, California,
USA.

Over more than sixty years of art-making, Betye Saar has given found materials new life in works that contemplate spirituality, family, and African American histories. Childhood encounters with Simon Rodia's (1879–1965) monumental mixed-media sculptures the *Watts Towers* (1921–55) "were where I learned how to be an artist," Saar told *frieze* in 2016. A self-professed clairvoyant until around the age of four, she maintains a lifelong interest in mysticism and world religions and credits intuition as her guide for making art. Printmaking studies led to a series of soft-ground etchings for which she pressed stencils, stamps, and objects. She combined these prints with items including disused windows in sculptures inspired by a 1967 visit to a Joseph Cornell (1903–72) exhibition, whose boxed assemblages she found magical. Following the assassination of Martin Luther King, Jr. in 1968, Saar began including racist imagery in her work, juxtaposing it with Black Power symbols and transforming harmful caricatures into revolutionary figures to reclaim her power over them. Titled after the Swahili word for "tree," this is the first of several altarlike works Saar made after studying spiritual traditions including Islam and Hinduism, marking a shift from overt political and social critique to a more reflective consideration of Black history including in ancient Egypt and Oceania.—EDW

NIKI DE SAINT PHALLE

LA TEMPÉRANCE (TEMPERANCE)
1985, polyester resin painted on metal base,
29 ⅞ × 18 ½ × 7 ⅞ in. (76 × 47 × 20 cm)

Niki de Saint Phalle, born 1930, Neuilly-sur-Seine,
Hauts-de-Seine, France. Died 2002, San Diego,
California, USA.

Niki de Saint Phalle's life experiences—including her aristocratic upbringing in France and the
United States, the sexual abuse she suffered from her father, and her time hospitalized after a nervous
breakdown in 1953—directly informed her sculptural practice. She credited art as the therapy that
helped her overcome psychological turmoil. Saint Phalle's work encompassed paintings created by
firing guns at bags filled with paint and found objects attached to canvases, as well as installations,
architecture, public art, and film. She coined the term "Nanas" to describe the sculptures of leaping
women she began making in the 1960s, whose full-bodied forms and kaleidoscopic palettes evoke
a spirit of joyful liberation, in direct counterpoint to the Conceptualist and Minimalist work of an art
world dominated by men. Her *Tarot Garden* (1978–2002) in Tuscany, Italy, created over more than
two decades with local collaborators, brings to life the iconography of the tarot deck as a mosaiced
sculpture garden. *Temperance* reinterprets the card depicting the Angel of Temperance who, through
the act of pouring life-giving water between two cups, demonstrates the virtue of balance. Saint Phalle
placed a version of this sculpture atop a chapel in the *Tarot Garden*, dedicated to her husband, the
sculptor Jean Tinguely (1925–91).—LJ

SPICE CHESS
c. 1977, wood chessboard with 32 wood and cork
pieces containing various spices, overall 2 ¹¹⁄₁₆ ×
12 ½ × 12 ½ in. (6.8 × 31.8 × 31.7 cm), each 1 ⁹⁄₁₆ ×
1 ¼ × 1 ¼ in. (4 × 3.1 × 3.2 cm), Museum of
Modern Art, New York

Takako Saitō, born 1929, Sabae, Fukui, Japan.

Between 1947 and 1950 Takako Saitō studied psychology at Japan Women's University in Tokyo, where
she became a professor and joined the Creative Art Education group, a movement fostering freedom
and play. During her time there, she developed a close friendship with Japanese artist Ay-O (b. 1931),
who introduced her to avant-garde art initiatives in Japan and the United States. In 1963 Saitō briefly
moved to New York and became closely associated with Fluxus, the global avant-garde group of artists,
designers, composers, and poets started by Lithuanian American George Maciunas (1931–78). Over
the course of a career that spans more than seven decades, Saitō has become known for creating
performances and unique objects that propitiate novel social encounters, such as her series of specialty
chess sets that, among others, include *Sound Chess*, *Book Chess*, *Weight Chess*, and *Spice Chess*, seen here.
Made with a series of identical cubes, players can only tell the pieces apart by smelling the spices
the artist has stored inside each one. Saitō participated in the creation of "Fluxus Boxes," collaborative
compositions that included her chess sets, alongside other artworks. —SGU

DORIS SALCEDO

UNTITLED
1995, wood, cement, steel, cloth, and leather,
93 × 41 × 19 in. (236.2 × 104.1 × 48.2 cm)

Doris Salcedo, born 1958, Bogotá, Colombia.

Doris Salcedo's work responds to the painfully silenced tales of specific communities and individuals victimized by conflict in her native Colombia. Responding to political oppression, civil war, paramilitary violence, and their effect on the most vulnerable, her practice engages with uncovering human injustices and finds ways to translate them—through conceptual, material, and formal mechanisms—into unexpected acts and objects. Salcedo's early work from the 1980s is characterized by the use of organic matter such as wood and animal fiber, resulting in distressed-looking surfaces or dysfunctional sculptures, qualities that remain present in her work to this day. In her twenty-year-long *Untitled* series, pieces of wooden domestic furniture are recast as vessels for blocks of cement. In this process, the furniture becomes functionally null, while evoking the void left behind by absent bodies who have suffered forced disappearance or death. In a 2023 interview with Evan Moffitt for *Artforum*, the artist stated, "My whole task in this world is to give back some of the dignity that was taken away from the victims." For Salcedo, art can function as a site in which memory resides or as a temple of mourning, while her juxtaposition of familiar and strange materials makes evident that the domestic and the political—the private and the public—are forever intertwined.—LO

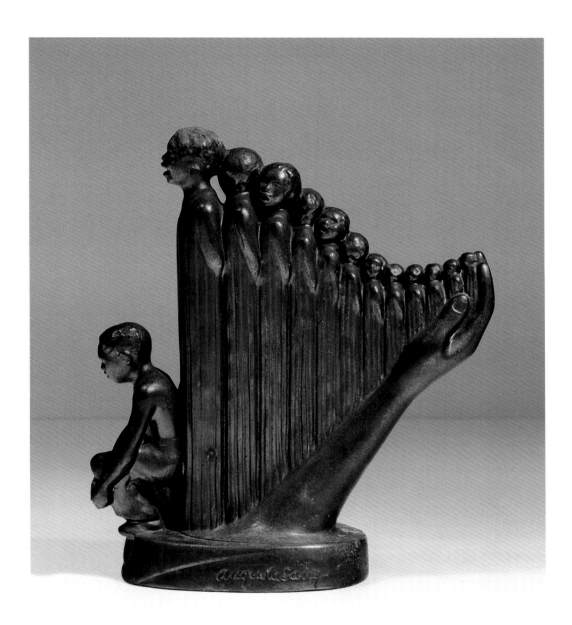

LIFT EVERY VOICE AND SING (THE HARP)
1939, bronze, 10 ¾ × 9 ½ in. (27.3 × 24.1 cm)

Augusta Savage, born 1892, Green Cove Springs,
Florida, USA. Died 1962, New York, USA.

Artist, activist, and educator Augusta Savage's sculptures—of which only twelve survive—champion equality and empowerment for Black people. In 1921 Savage arrived in New York to study art at Cooper Union. When the French government withdrew a scholarship to study abroad in 1923, citing the color of her skin, eminent members of Harlem's artistic community protested on her behalf. Savage had made it to Paris by 1929, studying at the Académie de la Grande Chaumière and exhibiting at the Grand Palais. In 1932 she founded the Savage Studio of Arts and Crafts in Harlem and, as part of the WPA Federal Arts Project, in 1937 she was appointed founding director of the Harlem Community Art Center, offering free art classes to locals. A perennial leader, in 1939 Savage was the first African American to open an art gallery: the Salon of Contemporary Negro Art. This sculpture was titled after a 1900 poem by James Weldon Johnson and the song known as the Black National Anthem. The original 16-foot- (4.9-meter-) tall cast plaster version took two years to complete and was the only work by an African American artist commissioned for the 1939 world's fair, after which it was destroyed with only souvenir replicas surviving.—EDW

MIRA SCHENDEL

After being exiled from Europe after World War II, Mira Schendel moved to Brazil and became one of the most prominent artists in the country. Although her practice existed in dialogue with the Concrete and Neo-Concrete art movements, it nevertheless remained separate, and she developed a vast body of work that differs from that of her contemporaries. The artist's material experimentations were concerned with slight gestures, the ephemeral quality of matter, and the radical rupturing of the constraints of each medium. Schendel's work exists in between abstraction and what is readable—a subtle presence that simultaneously evokes what is present and what is hidden in the shadows. Influenced by Concrete poetry and a radical approach to sculpture as a nonmonumental, transient, and disposable medium, *Untitled (Disks)* presents a hanging piece made of overlapping transparencies that uses differently sized letters and numbers as its main compositional element. Described by the Concrete poet Haroldo de Campos in 1966 as "quasi-words," they are not meant to be read as symbols but rather to highlight the visual qualities of written and spoken language, thus signaling its ambiguous and unknown qualities. Schendel's practice dwells on the vagueness of human endeavors by summoning concrete themes like architecture, philosophy, and poetry through minimal and unusual gestures that act as aesthetic declarations.—LO

UNTITLED
2017, cotton, resin, nylon, feathers, button, wig, and wood, 120 × 99 × 108 in. (304.8 × 251.5 × 274.3 cm)

Lara Schnitger, born 1969, Haarlem, North Holland, Netherlands.

Lara Schnitger grew up in the Netherlands, studying at the Koninklijke Academie van Beeldende Kunsten in The Hague, before spending time in Japan and China, and settling in Los Angeles in the late 1990s. In her youth, Schnitger developed a love of fashion and sewing and an interest in dress as a mode of communication and expression. Her sculptures combine humor with feminist politics to emanate joyful sexuality. Although Schnitger is devoted to investigating form, color, and texture, her use of textiles and accessories such as earrings and sequins, combined with protest slogans, casts her as a feminist artist, an identity she heartily embraced, telling *W* magazine in 2008 that her work addresses "the frustration of being a woman and not liking the way I'm represented." Her public procession-protest *Suffragette City*, a parade of men and women carrying portable sculptures and banners through the streets, performed internationally since 2015, was conceived on the model of SlutWalks, a transnational movement in which women march in protest of rape culture, with many using dress as a form of activism, and suffragist demonstrations at the turn of the twentieth century. Although static, this untitled sculpture suggests dynamic motion, proffering a ludic version of parenthood, with diminutive nudes in party mode attached to a central figure, whose earring proclaims allegiance to feminism.—EDW

CLAUDETTE SCHREUDERS

Claudette Schreuders's figures offer quiet studies in guarded emotion. Carved from wood and colored with paint, their forms cite disparate art historical influences, among them West African colon statues and figurative sculptures of medieval churches. Proximity and distance are recurring formal and affective qualities in Schreuders's enigmatic works, which often explore the complexities of two individuals in relation—be they lovers, siblings, or a caregiver and child. Belying their impassive expressions, her figures appear in turns wary and preoccupied. None make eye contact; all seem discomfited. The watchfulness and sidelong glances of her early work made oblique reference to the uncertain position of the white minority in newly democratic South Africa following the 1994 election and illustrated the ambiguity of trying to find a post-Apartheid "African" identity. Schreuders has since retreated inward to the politics of domestic life, her figures pictured in scenes from untold narratives, some intimate, others prosaic, a few dreamlike. More recent works extend Schreuders's reflections on couplings toward the multiplicity of the self, expressed in the doubling of identical figures. Notwithstanding the inferred accusation of its title, *Accomplice* is a tender image; the twinned women's gestures are reminiscent of *The Visitation* (c. 1310–20), a German sculpture of the Virgin Mary and her cousin Elizabeth, from which Schreuder drew inspiration.—LB

DANA SCHUTZ

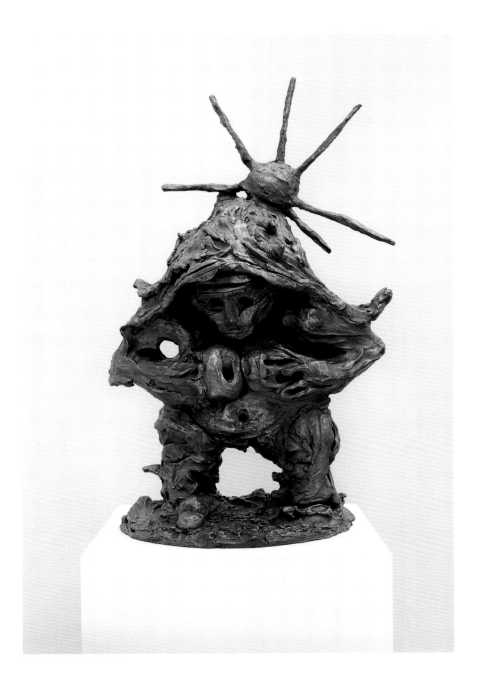

SUN LADY
2018, bronze, 40 × 22 × 18 in.
(101.6 × 55.9 × 45.7 cm)

Dana Schutz, born 1976, Livonia, Michigan, USA.

Having made her name as a gestural figurative painter, Dana Schutz first exhibited her sculptures in a show at Petzel Gallery in New York in 2019. Prior to that, her three-dimensional work went through a period of technical and conceptual gestation, wrestling with the notion that sculpture, unlike painting, takes place in an outbound space, where the perimeter of what is represented is not subjected to a framing edge. Schutz's choice of clay as an initial material, which could be worked with freedom and immediacy, led to a body of sculptural work that, despite the gravitational limitations (floating elements and figures are a staple in Schutz's visual vocabulary), reflected the imaginative and dynamic aesthetic of her paintings. This is particularly evident in the bronze cast *Sun Lady*, where the sunrays seem to burden rather than illuminate the subject. What has remained consistent in Schutz's sculptures, especially in the artist's early attempts in clay, is the idea that the work has a front and a back, and as such asks to be experienced from a determinate perspective. Since then, sculpture has grown to become a regular feature in Schutz's practice, as testified by her 2023 European retrospective *The Visible World.*—MR

IRENA SEDLECKÁ

JOHN GIELGUD (1904–2000), AS HAMLET
1993, bronze, 12 ¼ × 8 ⅝ × 6 ⅝ in.
(32.3 × 22 × 16.8 cm), University of Bristol
Theatre Collection

Irena Sedlecká, born 1928, Pilsen, Czech Republic.
Died 2020, London, UK.

From the age of sixteen, when she was sent to work in a wire factory in German-occupied Czechoslovakia, Irena Sedlecká was a dedicated sculptor, making clay models alongside drawings in her spare time. After World War II, she enrolled at the Academy of Fine Arts in Prague, where she specialized in sculpture, training in the Soviet-endorsed Socialist Realist style of idealized figuration. Sedlecká graduated with the State Prize for Excellence, and soon won commissions for projects such as a memorial to victims of the Nazi regime in Moravia and a series of reliefs depicting communist heroes for the new Lenin Museum in Prague. In 1966 she moved with her family to the United Kingdom, where she initially found work with a company making replicas for the British Museum. Eventually, commissions for her own vividly lifelike portrait busts and figures began to flow in—most famously, in 1996, for a bronze statue 10 feet (3 meters) in height of Freddie Mercury that overlooks Lake Geneva in Montreux. Her private clients included the actor Richard Bebb, who in the 1990s enlisted Sedlecká to produce a limited-edition series of *Great Actors and Singers* cast in resin bronze. Among these was the portrait of English actor John Gielgud performing the role of Hamlet.—GS

HER LATENT POWER LIES DORMANT
2019, grass brooms and wire, 77 ⅛ × 50 × 20 ⅞ in.
(196 × 127 × 53 cm)

Usha Seejarim, born 1974, Bethal, Mpumalanga,
South Africa.

In sculptures composed of commonplace objects, Usha Seejarim extends reflections on domestic labor and its designation as women's work. The artist has long been preoccupied with the rituals of everyday life—brushing one's teeth, commuting to work, washing dishes, drying clothes—and attends to those mundane, dispensable things that recall these gestures, among them toothpaste tubes, ticket stubs, sponges, and clothespins. In reframing found objects marked by use, she offers metonyms of repeated actions; in making sculptures of accumulated parts, she performs the repetition of household chores (to this end, the artist often works in multiples). Most recently, Seejarim's practice has centered on fabricated and ready-made items of domestic utility—primarily irons, mops, and brooms—and their gendered resonances. Yet rather than assume a stated political position, she invites contradictions to inhabit her sculptures, that they might allude at once to domestic drudgery and liberation, the demand (even entrapment) of housekeeping as well as its meditative pleasures. Made from grass broom heads removed from their corresponding sticks, *Her Latent Power Lies Dormant* is suggestive of both organic forms—dried ears of corn, a termite mound—and a figure: the "her" of the title, whose nascent agency will not be constrained by the provenance of her material form.—LB

TSCHABALALA SELF

LIFTED LOUNGE #1
2021, hand-formed and welded steel rods, powder-coat finish, custom fabric, and Dacron,
43 × 22 × 64 in. (109.2 × 55.9 × 162.6 cm)

Tschabalala Self, born 1990, New York, USA.

Sites of domesticity are an anchor of Tschabalala Self's multimedia practice. For the artist, interior spaces relate to interior feelings, those personal anxieties and desires that are too vulnerable to excavate publicly. Just as these are sites of reprieve, domestic spaces are also fraught places of gendered politics and labor, and Self's works explore this juxtaposition. The artist, whose father was an English teacher and writer and whose mother was a gifted sewer, took after-school art classes growing up in Harlem and completed her graduate training in printmaking. Self began incorporating sewn textiles, especially her mother's collected fabrics, into her canvases after feeling limited by their flat surfaces. These painted, sewn, and printed assemblages secured Self's early reputation as a gifted collagist devoted to representing Black women's bodies, a source of political and personal interest for the artist who came of age in and takes inspiration from the era of early 2000s hip-hop music videos, as she noted in a 2022 interview with *The Guardian*. In 2021 Self introduced her functional art objects, furniture made of wrought iron, as part of a live performance. The pieces of furniture, often also rendered in the artist's paintings, at once evoke leisure activities and resemble reclining bodies, their very appendages recalling the physicality of rest. Self focuses on scenes and objects of domesticity, asserting Black women's right to comfort, respite, and interiority.—MS

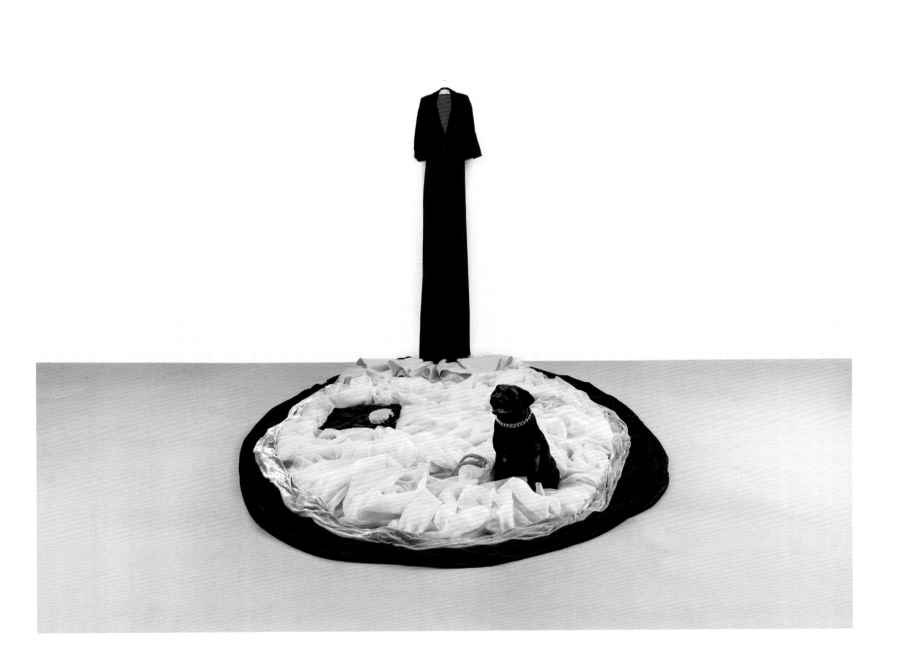

MARIGOLD
2022, velvet, organza, faux fur, silk, Alexander McQueen dress, stuffed and taped AMQ clutch purse and strap, taped AMQ shoes, and painted plastic resin dog with AMQ clutch purse chain, 188 × 188 × 171 in. (477.5 × 477.5 × 434.3 cm)

Beverly Semmes, born 1958, Washington, D.C., USA.

Beverly Semmes gravitated toward working with her hands at an early age, inspired by her grandmother, a tall, stylish woman who would sew matching outfits for herself, Semmes, and her dolls. Later, Semmes adopted other forms of craft such as quilts and ceramics, processes defined by tactility. While some might get hung up on the categories Semmes moves through—painting, sculpture, photography, ceramics, and installation—to her they all bear shared characteristics of color and texture. Throughout each medium, her practice maintains a relationship to the body, a strong feminist current, and a canny sense of humor. *Marigold* was commissioned by the design team at the Alexander McQueen studio for their flagship store in London. The surreally long, purple gown mounted on the wall is a distortion common in Semmes's work, in which she often makes giant garments that engulf entire galleries. Similarly, the pool of wan-colored organza on the floor embodies a tactic often used by Semmes, of revealing and concealing. Here the fabric semi-hides readymades—a handbag and a pair of shoes—modified with a slathering of fluorescent paint. The attentive canine that presides over the scene is a thrift store find symbolic of Semmes's own dog, who napped in and around the artwork while it was being made.—RH

ARLENE SHECHET

EVER HOWEVER
2019, glazed ceramic, wood, steel, paint, and silver
leaf, 31 × 19 × 22 in. (78.7 × 48.3 × 55.9 cm)

Arlene Shechet, born 1951, New York, USA.

Arlene Shechet creates multidimensional sculptures that toy with accepted conventions of form, color, and composition. Graduating with an MFA in ceramics from the Rhode Island School of Design in 1978, Shechet often works with clay—manipulating a traditionally static medium to produce forms that appear to move with the viewer, as if they are undulating, oscillating, or rotating of their own volition. Comprising ceramic and other materials, such as wood and steel, Shechet's sculptures frequently consist of divergent shapes driven together. The shapes—some geometric, some anthropomorphic, and others undefinable—embrace the evident discordance of their combination to create humorous compositions that nonetheless feel like a united whole. "I want the work to look like it's slipping and sliding and has life," Shechet explained in a 2020 interview with the *New York Times*. An endearing amalgam of colored forms, *Ever However* combines a large organically shaped wood piece that wraps around a contrastingly stark blue triangle and bubbly green geometric prisms, all set atop three slim legs supported by dainty rounded feet. As the viewer circumambulates the figure, it begins to morph and change, with each different perspective awarding an entirely new experience.—JS

PAYSAGE
2009, lacquered wood, metal, and wigs,
59 × 118 ⅛ × 334 ⅝ in. (150 × 300 × 850 cm)

Shen Yuan, born 1959, Xianyou, Fujian, China.

Encouraged to pursue Chinese classical painting by her father, Shen Yuan was among the first generation of artists to study fine art in China after the Cultural Revolution. Upon graduating from the Zhejiang Academy of Fine Arts, Hangzhou, in 1982, she embraced experimental and avant-garde practices, emerging as part of the radical '85 New Wave Movement. In 1990 Shen permanently relocated to Paris with her husband, the artist Huang Yong Ping (1954–2019), with whom she sometimes collaborated. Shen's sculptures and installations address themes of migration, language, identity, and her own experience of cultural displacement, subtly drawing attention to the cultural differences that can obstruct true understanding between people. Combinations of the familiar and the fragile typify her works, which incorporate everyday objects and autobiographical references, including furniture, clothing, food, and bodily residues such as her own nail clippings. The juxtaposition of natural and human-made materials is a recurring strategy, as in *Paysage*, a giant hairbrush entwined with real human hair, the different types and colors symbolizing the shared experiences of multiple women immigrants from around the world.—DT

ALYSON SHOTZ

MIRROR FENCE
2003, Starphire glass mirror, aluminum, and
stainless steel hardware, 1,656 × 36 × 4 in.
(4,206.2 × 91.4 × 10.2 cm), Storm King Art Center,
New Windsor, New York

Alyson Shotz, born 1964, Glendale, Arizona, USA.

Before deciding to turn to art, Alyson Shotz studied geology and physics in college, a background that is evident in her abstract sculptural practice. After graduating from the Rhode Island School of Design in 1987 with a degree in painting, Shotz turned to the three-dimensional in the 1990s, developing a dynamic body of work of monumental sculptures that "subvert their own physicality," as stated on her website. Her installations—often comprising synthetic materials like glass, wire, metal, and thread manipulated into naturalistic or recognizable forms—integrate themselves into their surrounding environments, interacting with light, space, movement, and time. For *Mirror Fence*, Shotz reconfigured a traditionally American picket fence out of glass mirrors. Instead of creating an enclosure, the fence stretches in a straight line for 130 feet (nearly 40 meters), reflecting the natural landscape, which grows and changes over the course of the day and through the seasons. The work thus becomes a part of the landscape itself, almost disappearing entirely into the surrounding grass and trees. By virtue of its reflective material, the picket fence—most often a thing that demarcates space by limiting or preventing access—becomes an agent of inclusion, inviting the viewer to see themselves in the work, and become a part of it.—JS

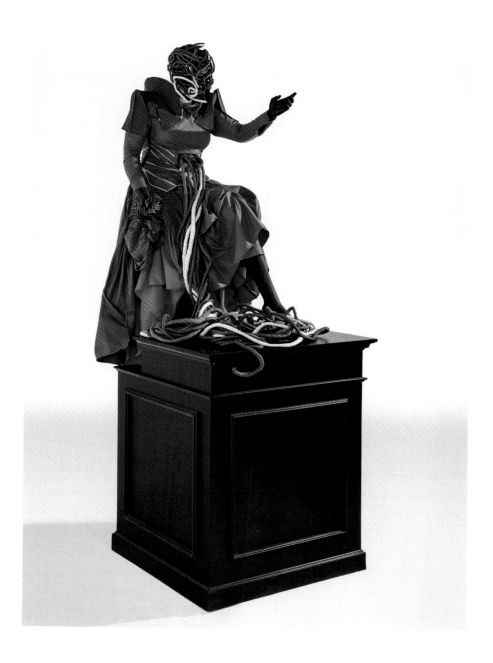

ASCENSION OF THE PURPLE FIGURE
2016, life-size fiberglass mannequin, polyester
fiberfill stuffing, and cotton fabric,
111 ¾ × 39 ¾ × 39 ¾ in. (284 × 101 × 101 cm)

Mary Sibande, born 1982, Barberton, Mpumalanga,
South Africa.

Mary Sibande harnesses the power of color, couture, and figurative sculpture to address her own personal history and contest the official histories of South Africa. Sibande's practice centers on a single figure: Sophie, the artist's alter ego, who stands in, at turns, for various family figures, as well as socially constructed roles for Black women and men in colonial, Apartheid, and contemporary South Africa. Each new body of Sibande's work takes on a different color: blue, referencing the uniform worn by Black women who had few choices other than domestic work; green, for her father's military uniform; purple, for the notorious Purple Rain protest of 1989, representing a rhizomatic maternal figure donning the European color associated with wealth and religion; and red, representing fury at institutions of oppression and embodying the Zulu expression that anger is a red dog. In *Ascension of the Purple Figure*, Sophie is seen mounting a tall plinth, taking the place usually occupied by a white male political or military leader. Fabric tentacles emerge from her belly, poised to eventually consume and transform her into the red character hinted at under her skirts, upon reaching the pedestal's zenith.—MK

AYESHA SINGH

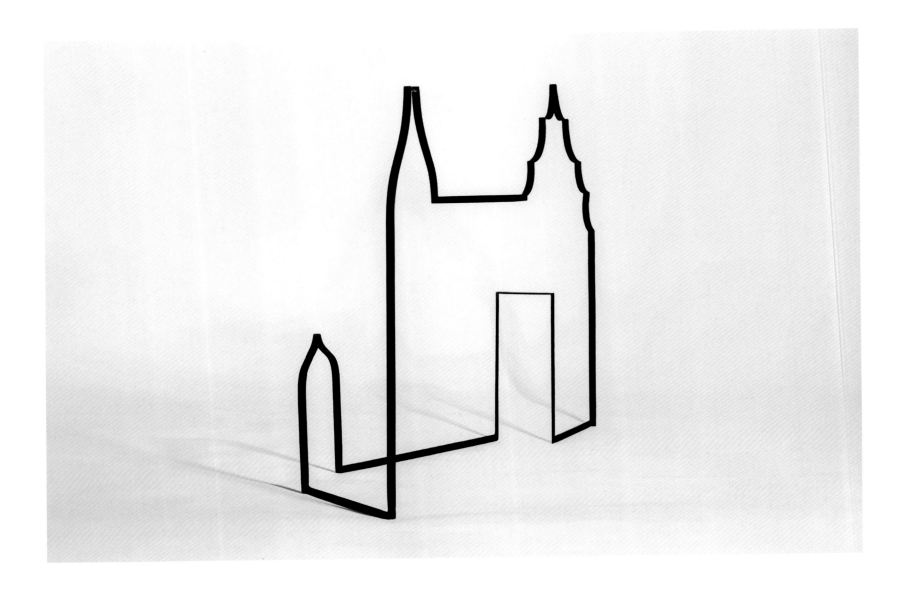

HYBRID PROTOTYPE
2021, stainless steel, 24 ½ × 35 × 9 in.
(62.2 × 88.9 × 22.8 cm)

Ayesha Singh, born 1990, New Delhi, India.

Histories of colonial power, appropriation, migration, and multicultural amalgamation, expressed through shifting architecture, inform Ayesha Singh's artwork. Raised in India, she received a BFA from the Slade School of Fine Art, London, and an MFA from the Art Institute of Chicago. She began creating work about the built environment of her home country during her time in college, in response to a feeling of displacement. Her practice encompasses sculpture, drawing, text, video, and performance, often collaging various architectural styles. As she related in a 2019 interview for *Public Parking*, "In a time of puritan politics it feels important to have works that reinforce the undeniable evidence of the layering of cultures and multiplicity we embody." Singh began her *Hybrid Drawings* series in 2015. Conceived as three-dimensional drawings in space, they consist of metal frames that depict building silhouettes and ornamentation from various architectural movements seen in contemporary postcolonial India—such as Indo-Saracenic, Mughal, Modernist, and Victorian. The scale of *Hybrid Prototype* allows viewers to circumambulate the sculpture from different angles, exploring the schematic forms of two slender, gently tapering domes, a fluted tower, and a rectilinear entryway.—WV

STICKS & STONES
2013–21, 9 flitches, mixed media,
each c. 148 ½ × 28 × 2 ½ in. (c. 376 × 71 × 5 cm)

Lucy Skaer, born 1975, Cambridge,
Cambridgeshire, UK.

The materials Lucy Skaer employs typically hold specific histories. Her parents were scientists, and her childhood home held an abundance of fossils, shells, and insect specimens, as well as her father's cigarette card and coin collections. Influenced by British modernist and Surrealist artists such as Paul Nash (1889–1946) and Leonora Carrington (1917–2011), Skaer's drawing, film, and sculpture scrutinize our sense-making structures and habits of looking. The source matter for *Sticks & Stones* derives from mahogany dredged from riverways in Belize, where logs, sunk during the British-controlled export of the prized wood, have lain preserved for up to a century. Sculpted by the water, these planks or "flitches" are receptacles for stories of colonial exploitation, deforestation, and material culture. Skaer inlaid the wood with prototypes and samples for earlier works, salvaged from her studio before a move. Over a nine-year period, she then crafted or commissioned replicas of the flitches in ceramic, marble, aluminum, and wood veneer. Skaer is interested in what she described in a 2015 lecture at Emily Carr University of Art + Design in Vancouver as "extreme points of subjectivity." Each material, copied directly from its predecessor without digital intervention or the use of images, bears its own symbolism. The result is a series of translations, the value of which is transformed through the art-making process.—AC

KIKI SMITH

Kiki Smith is one of the United States' most influential artists. Pursuing art on her own terms, Smith moved to New York in 1976 after leaving Hartford Art School in Connecticut. Influenced by the second-wave feminist movement, Smith bucked the prevailing trend for abstraction and gained recognition for her provocative figurative sculptures of the female body in materials as diverse as bronze, wax, porcelain, and paper. Themes of mortality, decay, and human vulnerability defined Smith's work in the late 1980s and early 1990s, prompted by the death of her sculptor father, Tony Smith (1912–80), and by the AIDS epidemic, which claimed the lives of friends and family members. Drawing inspiration from mythology and folktales, she has since expanded her visual lexicon to include birds and animals in sculptures, prints, and tapestries exploring themes of transformation, metamorphosis, and the human condition in relationship to the natural world. The sculpture *Born*, depicting a life-size doe giving birth to an adult woman, is one of many works juxtaposing the female form with animals. The surreal image evokes the myth of Diana, the ancient Roman goddess of wild animals and the hunt, and alludes to our symbiotic connection with nature.—DT

BOOT LEG
2019, 20 ⅞ × 15 ¼ × 12 ⅛ in.
(53 × 40 × 30.9 cm)

Renee So, born 1974, Hong Kong, China.

Working primarily in textiles and sculpture, Renee So reframes gendered symbols such as boots, beards, and pipes to explore how tropes of masculine self-presentation have historically been used to signal power. Steeped in representations from and of the ancient world, So frequently reprises aesthetics from Mesopotamia, ancient Egypt, and the Roman Empire, references she redeploys to gesture anew at the provenance debates surrounding many encyclopedic museum collections. Her practice centers on specific stories of looting that have in turn fed such collections, notably the Assyrian objects in the British Museum, London—some of which include male figures whose looped hair So often renders as fully three-dimensional in her ceramic pieces—and the story of the 8th Earl of Elgin pillaging the Qing Dynasty's Summer Palace in Beijing during the Opium Wars of 1860. So consciously works in historically underappreciated craft mediums, drawing a clear throughline between her works and these taken objects, repeatedly displayed less as fine art than as the material culture from colonized land. In *Boot Leg*, a giant black boot peeks below the hem of a blue trouser leg, which stretches floor to ceiling like a stone column. The work plays with the iconography of the military, a shamelessly masculine sphere whose missions for conquest have resulted in the very looting So's practice sits in dialogue with.—MH

VALESKA SOARES

Valeska Soares's work has explored the interconnections between time, individual and collective memory, desire and the fragility of human relationships, and the paradox between proximity and detachment. In a practice that entangles fictional and real narratives, she proposes new ways of interpretation through an intimate and personal look at the world and its objects. With a degree in architecture and visual arts, an important part of her work is made up of discarded everyday artifacts, such as clocks, furniture, dishes, candy boxes, and books, which she has collected since a very early age and into which she breathes new life to evoke a poetic universe. In adherence to the tenets of both Minimalism and Conceptual art, she also juxtaposes these objects with ephemeral experiences, inviting viewers to engage their senses in order to activate the work. In *Finale*, beautifully delicate antique glasses, some partially filled with liquor, are arranged on a vintage mirrored table, evoking the seductive and joyful image of the end of a celebration that can only be imagined by the viewer. At the same time as the work brings to mind feelings of togetherness and happiness, creating an atmosphere laden with nostalgia, it embodies with similar force the impermanence of life and the passage of time.—TP

THE FENCE 1
2011, painted rebar, 66 ⅛ × 165 × 102 ⅜ in.
(168 × 419 × 260 cm)

Monika Sosnowska, born 1972, Ryki,
Lublin, Poland.

Having spent the 1990s studying painting, first at the University of Fine Arts in Poznań, Poland, and then at the Rijksakademie van Beeldende Kunsten in Amsterdam, Monika Sosnowska abandoned brushes and canvas for sculptural investigations of space. Her large-scale installations and works in steel, concrete, and other construction materials question and subvert the rationality of utopian Modernist architecture with particular reference to the Soviet-era buildings of her native Poland and the physical, social, and psychological impact of the hastily erected, poorly maintained housing developments that replaced them after communism fell. Sosnowska's skeletal structures are typically bent, buckled, and twisted, as if ruined by war or natural disaster. Although her visual language quotes from Constructivism and Minimalism, geometric order gives way to chaos and uncertainty as architectural forms are made to appear vulnerable and damaged. For her monumental installation *1:1* (2007), she shoehorned a life-size replica of the steel frame of a two-story, postwar apartment building into the Polish Pavilion at the 52nd Venice Biennale in 2007, crushing, slicing, and reassembling it to fit. Other works have incorporated architectural elements, such as staircases, gates, windows or, as here, fences, to create surprising and sometimes unsettling encounters.—DT

DIAMOND STINGILY

ENTRYWAYS
2019, door with bat and hardware, 80 × 36 × 40 in.
(203.2 × 14.1 × 15.7 cm), Institute of Contemporary
Art, Miami

Diamond Stingily, born 1990, Chicago,
Illinois, USA.

Diamond Stingily is drawn to found objects, ranging from doors and fences to trophies and synthetic hair, which she uses to create multimedia works that reference her family and upbringing in Chicago, as well as larger introspections on Black girlhood and the collective memory of private and public spaces. *Entryways*, one of a series of distressed wooden doors mounted to the wall with a baseball bat leaning against it, alludes to the artist's memory of her grandmother's apartment in Chicago. Missing a knob and lock, the door also includes metal window bars, heightening the notion of surveillance and security. The presence of the bat suggests a threat of violence as a form of protection against intruders. For Stingily, bats represent her native city, where she saw many residents fashion homemade weapons to guard themselves against daily occurrences of violence. As she suggests, a life of nonviolence is a form of privilege not afforded to all. Stingily's doors represent the duality of toughness and affection that she witnessed and experienced from being raised by her two grandmothers, a resilient and powerful line of matriarchy. Although replete with personal histories and reflections, her works point to the universal understanding that childhood experiences have profound, long-lasting effects on each and every one of us.—OZ

JESSICA STOCKHOLDER

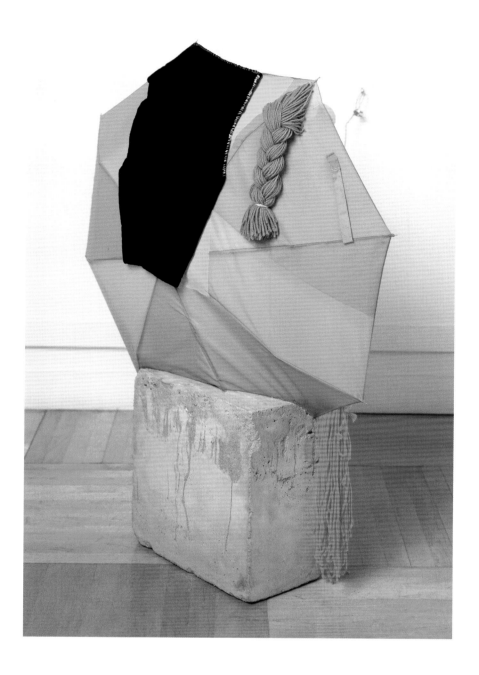

UNTITLED

1995, acrylic paint, cement, green nylon umbrella, aluminum tubing, velvet, green and yellow thread, purple and orange acrylic yarn, 3 eye hooks, cable with clamps, and plastic lemon, 43 × 34 × 12 ½ in. (109.2 × 86.4 × 31.8 cm), cable: 50 in. (127 cm), edition of 15

Jessica Stockholder, born 1959, Seattle, Washington, USA.

Jessica Stockholder synthesizes the practices of painting and sculpture into a singular art form. Although her work defies easy categorization, a common throughline is her raucous use of vibrant color. It emanates from the diverse materials she culls from everyday life and is located in the paint that she splatters, brushes, or sticks to a work's various surfaces. Stockholder's installations exist in an expanded field of painting, combining sculptural forms, found objects (usually cheap household items and industrial supplies), textiles, plastic, and paint into a colorful pictorial plane that interacts with specific spaces or architectures and results in works that can sprawl across floors or move up and down walls. She uses color to arrest viewers' gazes, while deploying many commonplace consumer items to evoke feeling or reveal the way people perceive the nature of ordinary things. Stockholder's mastery of both color and formal composition cuts through the visual clamor of her constructions without relying on obvious symbols or narratives. The cascading orange yarn, lime green nylon umbrella, jutting aluminum tube, and plastic lemon here, for instance, create multiple surfaces for the eye to rest on, engendering strange narratives from quotidian materials and asserting the richness of everyday life through the matter it produces.—OC

MICHELLE STUART

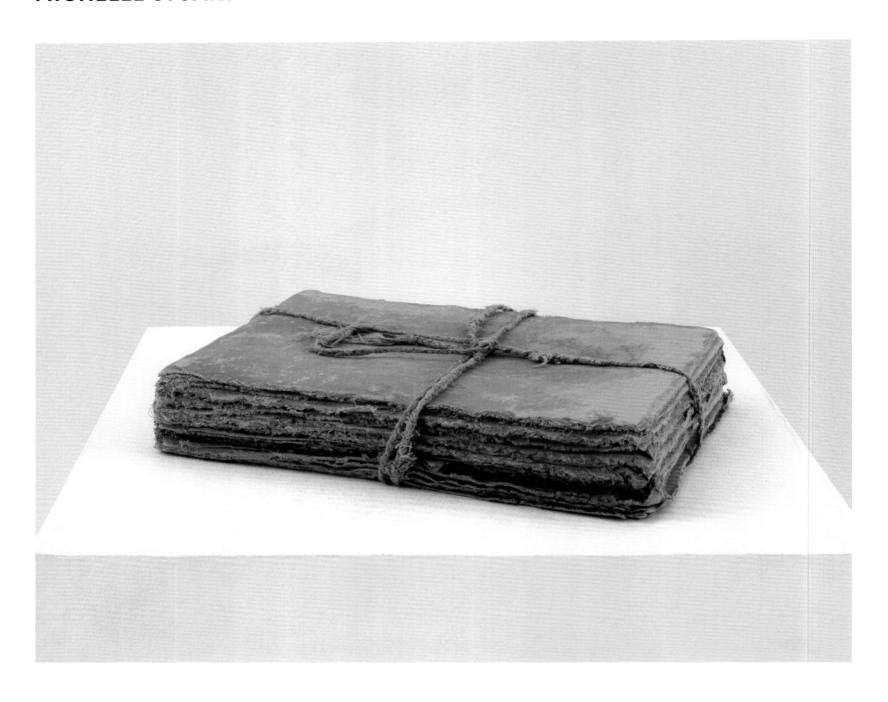

GALESTEO II BOOK
1977, earth on muslin-mounted paper and
handmade woven cord, 13 ½ × 9 ½ × 3 in.
(34.3 × 24.1 × 7.6 cm), Gray Collection

Michelle Stuart, born 1933, Los Angeles,
California, USA.

As a child Michelle Stuart traveled with her father, an engineer, as he mapped water lines in Californian deserts. After studying at the Chouinard Art Institute in Los Angeles, she worked as a topographical draftswoman for the Army Corps of Engineers. In the mid-1950s Stuart studied at Mexico City's Nacional Instituto de Bellas Artes, where she was taught by, and assisted, Diego Rivera (1886–1957). She later studied at the New School for Social Research in New York, where she moved in 1958. A lifelong fascination with nature and sciences including archaeology, astronomy, and ecology led her to use materials sourced directly from the land, including shells, seeds, butterflies, rocks, and soil, which she applied by hand to large sheets of paper in labor-intensive processes to create rubbings and impressions of the texture of the landscape's surfaces. Concerned with making a minimal impact on the environment, Stuart was a pioneer of biodegradable materials, creating ephemeral works for natural surroundings, such as a 460-foot- (140-meter-) long sheet of paper marked by rocks rolled down a bank of the Niagara River. In 2022 Stuart told *The Art Newspaper* that *Galesteo II Book*, made using earth collected in New Mexico, was one of several "books of secrets" influenced by "a small talismanic object—likely Indigenous—that resembled a little package buried in earth."—EDW

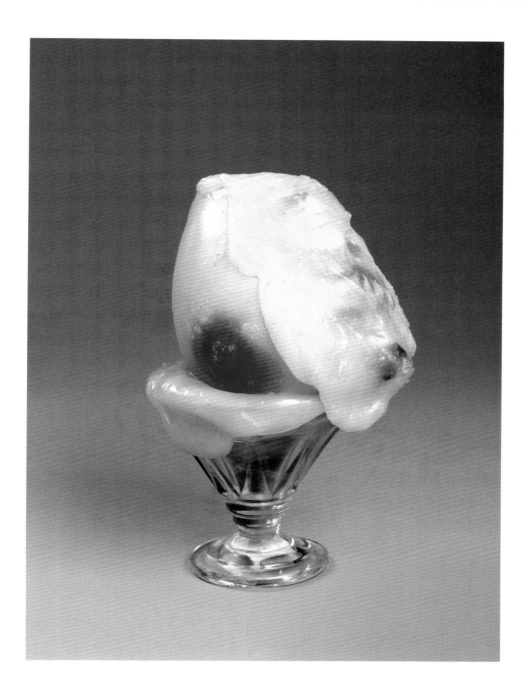

DESER II (DESSERT II)
1970–1, polyester resin, glass, and photographs,
7 ½ × 5 ⅛ × 5 ⅛ in. (19 × 13 × 13 cm), private
collection

Alina Szapocznikow, born 1926, Kalisz, Greater
Poland, Poland. Died 1973, Passy, Haute-Savoie,
France.

The ephemeral, vulnerable human body preoccupied Alina Szapocznikow throughout her life.
A Holocaust survivor, she sought to convey the trauma and suffering—but also sensuality and joy
—of the female bodily experience in visceral sculptures ranging from giant folded bellies and
lip-lamps to rocky forms imprinted with human traits. Following her internment during World War
II, Szapocznikow studied art in Prague, then Paris. In the early 1960s she began casting parts of
her body, moving away from the classical figurative style of her early sculptures in bronze and stone
to innovate with nontraditional materials such as synthetic resin and polyurethane. The artist trans-
formed her corporeal fragments into utilitarian objects such as lamps, vases, and ashtrays, offering wry
comment on consumer culture and the commodification of women's bodies. This provocative sculpture
of a red-nippled breast resembling an ice-cream scoop playfully served up on a dish forms part of
her *Dessert* series, which also includes a work featuring a glistening half-face with suggestively parted
lips—a mold of the artist's own—atop a custard-yellow ooze. Szapocznikow's sculptures took a darker
turn following her breast cancer diagnosis in 1969 with a series titled *Personified Tumours*. Although
she was acclaimed in her homeland early in her career, international recognition only came thirty years
after her death.—EF

SARAH SZE

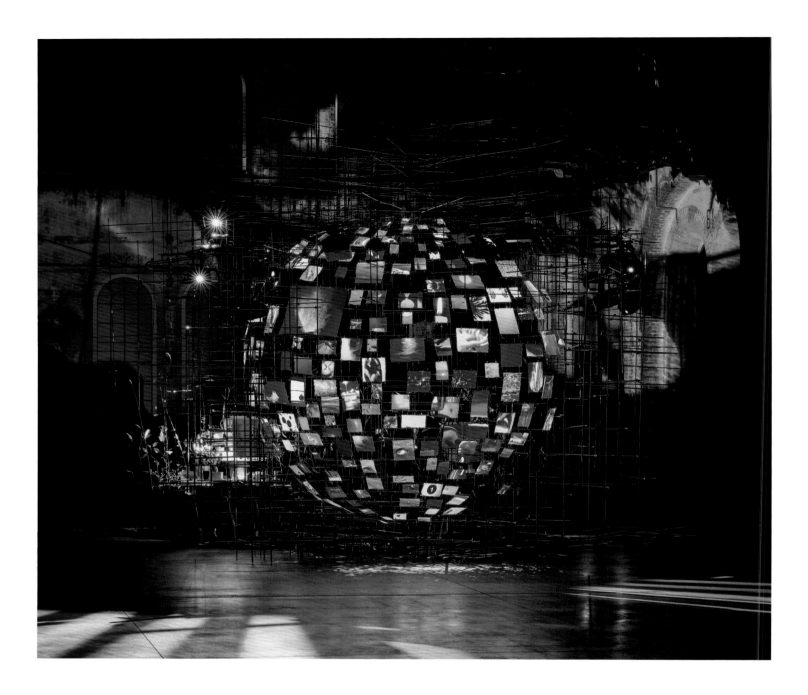

METRONOME
2023, mixed media, dimensions variable, installation view, OGR Torino, Turin, 2023–4

Sarah Sze, born 1969, Boston, Massachusetts, USA.

The experience of viewing an installation by Sarah Sze is a singular one: dynamically vast yet intricately assembled, the artist's meticulous attention to compositional detail involves not just color, but also the exploration of different materials and their relationship with the surrounding architecture and their use of solar or artificial lighting produced by video projectors. Often incorporating utilitarian objects that have been removed from their original function, the artist's works engage the viewer in a continuously physical push-and-pull that invites them to get closer and then take a few steps back. *Metronome* embodies this experiential effect: even though there is an apparent centrality to the work in the cluster of objects that resembles a globe, the viewer's gaze is constantly redirected by the many lights, projected images, and sensory information that dissipate throughout the architectural environment of the installation, here a railway station in southeast London. Concentration and dispersion are central elements to Sze's practice as a sculptor. Both scientifically studied and imbued with mystery—like the eccentricities of human memory—here the complexity of her fragmentary works reminds their audience that human existence, like these pieces, is just a miscellany of varied images in tiny shards. Instead of looking for answers, perhaps it is worth dwelling on the preciousness of these fragments.—RF

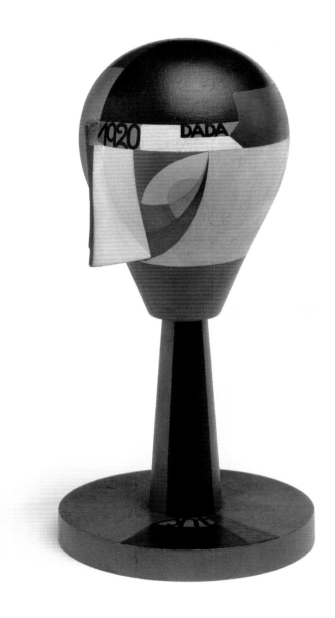

TÊTE DADA (DADA HEAD)
1920, oil and metallic paint on wood, height:
11 ⅝ in. (29.4 cm), diam: 5 ½ in. (14 cm),
Centre Pompidou, Paris

Sophie Taeuber-Arp, born 1889, Davos,
Graubünden, Switzerland. Died 1943,
Zürich, Switzerland.

A pioneer of abstract art in the 1910s, Sophie Taeuber-Arp came to abstraction through experimentation with textile art. After training in applied arts at the Debschitz School in Munich, she returned to Switzerland, where she studied dance with Rudolf von Laban. Early on, she found herself freed from any hierarchy between the arts, and throughout her career she devoted herself to the design of textiles, furniture, and interiors, as well as practicing sculpture, painting, engraving, and dance. In 1915 she met the artist Jean (Hans) Arp (1886–1966), whom she married in 1921, and became a prominent participant in the Zürich Dada movement at the Cabaret Voltaire. She also took part in the Swiss Werkbund from 1916, an association of artists, architects, designers, and industrialists inspired by the model of the German Werkbund, who sought to integrate high-quality craft and design with industrialized production techniques. Between 1918 and 1920 Taeuber-Arp produced a series of *Dada Heads*. Recalling the models used by hatmakers and made of painted wood, in this sculpture the traces of the human figure dissolve into curves and flat areas of color. These heads evoke the geometric nature of masks from the oceanic or northwest Indian regions, which can be found in abstract paintings made by Taeuber-Arp at the same time, such as the 1920 work *Composition dada (Tête au plat)* (*Dada Composition [Flat Head]*).—TP

DOROTHEA TANNING

**PELOTE D'ÉPINGLES POUVANT SERVIR DE
FÉTICHE (PINCUSHION TO SERVE AS FETISH)**
1965, velvet, plastic funnel, metal pins, sawdust, and
wool, 14 ⅜ × 14 ½ × 17 ⅞ in. (37.2 × 37 × 45.5 cm),
Tate, London

Dorothea Tanning, born 1910, Galesburg, Illinois,
USA. Died 2012, New York, USA.

By the time Dorothea Tanning began experimenting with fabric sculpture in the mid-1960s, she
was already a prolific painter, often depicting women in haunting interiors or fantastical landscapes.
The influence of Surrealism, which she first encountered in New York in the 1930s, is unmistakable,
yet the varied preoccupations of her seventy-year career are richer than the label suggests. Living
between Paris and the French countryside in the 1960s and 1970s, Tanning took up scissors and sewing
machine (a portable Singer she had had since leaving Illinois) to fashion stuffed forms from repur-
posed objects and textiles. *Pincushion to Serve as Fetish* prefigures a series of soft sculptures she made
between 1969 and 1974 that are redolent of both rumpled furniture and bulbous creatures. Menacing
and charged with eroticism, they twist and writhe, present ambiguous orifices, and even, in the case
of Tanning's installation *Hôtel du Pavot, Chambre 202* (1970–3), burst from the walls and merge with
the fireplace. Although she later returned to the seminal form of *Pincushion to Serve as Fetish* in
a much larger version from 1979, Tanning's sculptural practice produced relatively few works overall.
Nonetheless, in their eerie corporeality, these sculptures advanced her consistent interest in themes
of metamorphosis, thresholds, and unconscious forces.—AT

UNION OF WATER AND FIRE
1974, linen, 39 ⅜ × 36 ⅝ in. (100 × 93 cm)

Lenore Tawney, born 1907, Lorain, Ohio, USA.
Died 2007, New York, USA.

Lenore Tawney is celebrated for her "woven forms," a weaving technique she innovated in 1955 in which threads could remain loose, assembling in diaphanous and irregular compositions at odds with the tight uniformity of traditional weaving. One of the first fiber artists to hang weavings in space rather than flat against the wall—a proclamation of their three-dimensionality—in her inaugural solo presentation at the Chicago Public Library in 1955, Tawney created works that were described as where "design, drawing, and sculpture can all be put to use." The artist's interdisciplinary approach is often traced to her having taken classes in drawing, weaving, and sculpture in the 1940s at the Institute of Design of Chicago, also known as the New Bauhaus, with Alexander Archipenko, László Moholy-Nagy, Emerson Woelffer, and Marli Ehrman. However, working in Archipenko's studio in the summer of 1947 culminated in her destroying much of her clay sculpture. Aged fifty, Tawney moved to artist-centric Coenties Slip in New York, and her career as an artist began. Despite the denouncement of her early sculptures, the intricate geometric compositions of her sculptural weavings, like *Union of Water and Fire*, speak to her hybridized forms of working. Here, linen threads rest against one another, allowed to drape under their own weight and leave rhythms of unwoven space.—MKM

ALINA TENSER

PARENTHESES, ORANGE PATH
2022, satin ribbon, steel, expanded metal,
and casters, 56 ½ × 33 × 14 in.
(143.5 × 83.8 × 35.6 cm)

Alina Tenser, born 1981, Kyiv, Ukraine.

"When I'm holding my work I feel like the maker, and when I'm performing with my work it's actually very enjoyable because I know so well how to handle it," Alina Tenser explained in a 2016 interview with *The Third Rail*. For Tenser, making, crafting, handling, and playing are all part of the experience of sculpture. Drawing inspiration from Lygia Clark's (p.68) interactive "non-objects" and psychologist James J. Gibson's notion of "affordances"—the cues that indicate whether something should be flipped, twisted, pressed, or zipped—she fashions or assembles objects that call out for tactile engagement. In live performances and surreal videos, Tenser manipulates her sculptures in ways that evoke both absurdist domestic routine and open-ended childhood play. The works in Tenser's *Parentheses* series are all human-scale steel armatures set upon casters sorted into pairs by the brightly colored satin ribbons woven through their perforated surfaces. Even when still, the sculptures' potential for mobility suggests how their curved edges might section a room or enclose a body. The difference between a blockage and an embrace becomes a matter of rotation—or perspective.—CC

TATIANA TROUVÉ

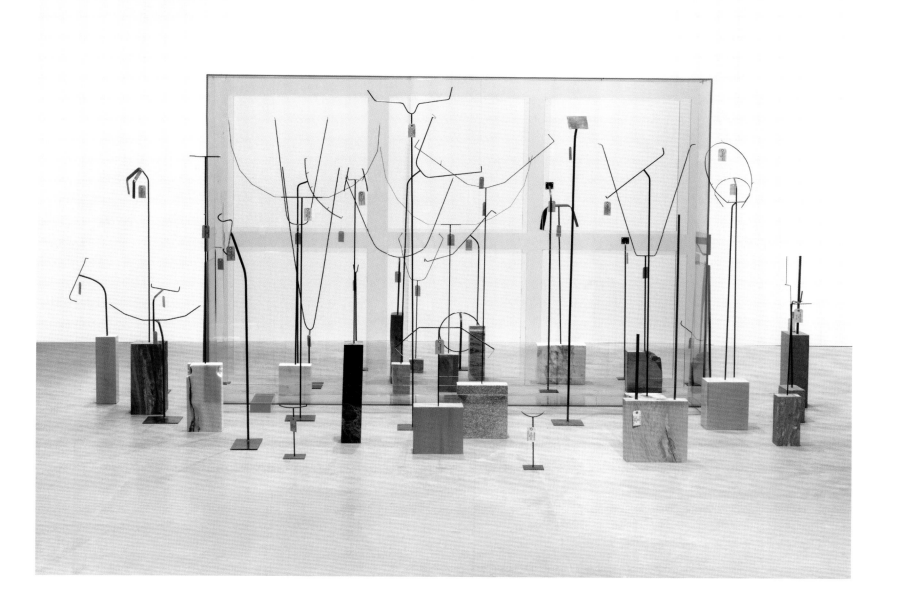

LES INDÉFINIS
2018, Plexiglas, bronze, paint, stone, wood, steel,
and patina, 78 ¾ × 135 ⅞ × 168 ⅞ in.
(200 × 345 × 429 cm), installation view,
One Day for Eternity, König Galerie, Berlin

Tatiana Trouvé, born 1968, Cosenza, Calabria, Italy.

Time and memory are core themes in Tatiana Trouvé's practice, which encompasses drawing, sculpture, and installation. Shifting between two and three dimensions, the artist employs quotidian objects and materials to create poetic architectural environments that evoke a sense of something lost or forgotten. Having been brought up in Senegal and studied in the Netherlands and France, where she currently resides, Trouvé imbues her elegant installations with a certain elusiveness; leaving time and place unspecified, her disorienting ecosystems appear at once familiar and dreamlike. In one installation, *The Shaman* (2018), for instance, an upturned oak erupts through a concrete landscape, its roots weeping with water; in her *Guardian* series of sculptures, vacated chairs with abandoned objects and books take on different personalities, becoming creatures inhabiting space. *Les Indéfinis*, part of an ongoing series, is staged with a nod to museum and ethnographic displays, but the objects are, as their title suggests, undefinable, stripped of their functions. The viewer is presented with enigmatic constellations of items clustered around shipping-container-size Plexiglas vitrines: pedestals, trestles, and lopsided copper loops. Stripped of their function, these items simultaneously suggest a past life and a future purpose or aesthetic that we do not yet understand.—EF

ANNE TRUITT

Anne Truitt began her abstract sculptural practice in the early 1960s, after an early career in medicine and psychology, having graduated from Bryn Mawr College, Pennsylvania, with a degree in the latter subject in 1943. She later studied sculpture at the Institute of Contemporary Art in Washington, D.C. in 1949. In the wake of Abstract Expressionism, Truitt's uninflected, geometric wooden sculptures—painted in a delicate palette of layered and lightly varied colors—anticipated the aesthetic of Minimalism. However, in contrast to Minimalism's nonreferential approach to color and form, Truitt's works are based upon meaning and metaphor: they reflect a "relationship between shape and color which feels to me like my experience. To make what feels . . . like reality," as she wrote in a journal in April 1965. Truitt used pure form, in combination with monochromatic fields, to evoke her own psychological states. *A Wall for Apricots* comprises a tall, plinthlike form painted with three stacked bands of vibrant white, green, and ocher; the colors balance each other and interact at their borders to create vitality and a sense of life.—JS

SHIRLEY TSE

THE VEHICLE SERIES: #6
2016, 3D-printed ABS plastic and glass,
5 ½ × 5 ¼ × 5 ¼ in. (14 × 13.3 × 13.3 cm)

Shirley Tse, born 1968, Hong Kong, China.

Shirley Tse's practice is defined by a rigorous and continuous exploration of materials. For many years she has restricted herself to working only with plastics, or synthetic polymers as she refers to them. From within the wide range of objects made using these chemical compounds, she hones in on products such as Styrofoam for the part they play in helping to move goods around the world, which also evokes migration and the artist's own journey as an American originally from Hong Kong, China. The skull-shaped *#6* is from the artist's *The Vehicle Series*, a collection of nineteen sculptures made of various configurations of wire and plastic and so titled according to the idea that the body is a vehicle. *#6* is a strikingly modern memento mori: the "bone" is made from 3D-printed ABS plastic with embedded glass "eyes." The honeycomb of the skull's structure mimics one of the most space-efficient and strength-creating patterns found in nature, but also one that is often copied to encase fragile items in transit. In bringing these elements together, or as Tse might say in "negotiating" a relationship between them, she invites the viewer to consider questions of old and new technologies, heterogeneity and plasticity, as well as the age-old trope of movement through life toward death.—RH

SARA VANDERBEEK

ROMAN WOMAN XXXVIV
2020, dye sublimation print on Neoprene with
extruded plastic, 72 × 12 × 12 in.
(182.9 × 30.5 × 30.5 cm)

Sara VanDerBeek, born 1976, Baltimore,
Maryland, USA.

Working at the intersection of photography and sculpture, Sara VanDerBeek often makes objects by evocatively interpreting them in space. The works she creates are usually amalgamations of research-driven appropriation, in that she exhaustively studies historical precedents to explore and rejuvenate their relevance in today's world. Deploying a collage aesthetic, VanDerBeek reflects the abundance of imagery with which we are constantly bombarded. By taking pictures of pictures that oscillate between the virtual and real space, she addresses institutional power dynamics often hidden within society's institutions, focusing on women's work. VanDerBeek highlights intergenerational awareness of how women are represented to investigate ideas of reproduction in all its forms. Sculptures of the female form from antiquity are often represented as a supposed ideal in their pure, marble whiteness, but historians have determined that they were vividly polychrome for the ancients. In *Roman Woman XXXVIV*, VanDerBeek transforms photographs of a Roman sculpture of Aphrodite into a column wrapped in Neoprene, a material used to protect both the body and hi-tech devices, such as phones and computers. The column is then submerged in saturated color on the cool blue spectrum—a dominant tone in our tech landscape—to challenge how we experience the world around us, proposing we question conventions of representation and dismantle assumptions about the reality we see.—KM

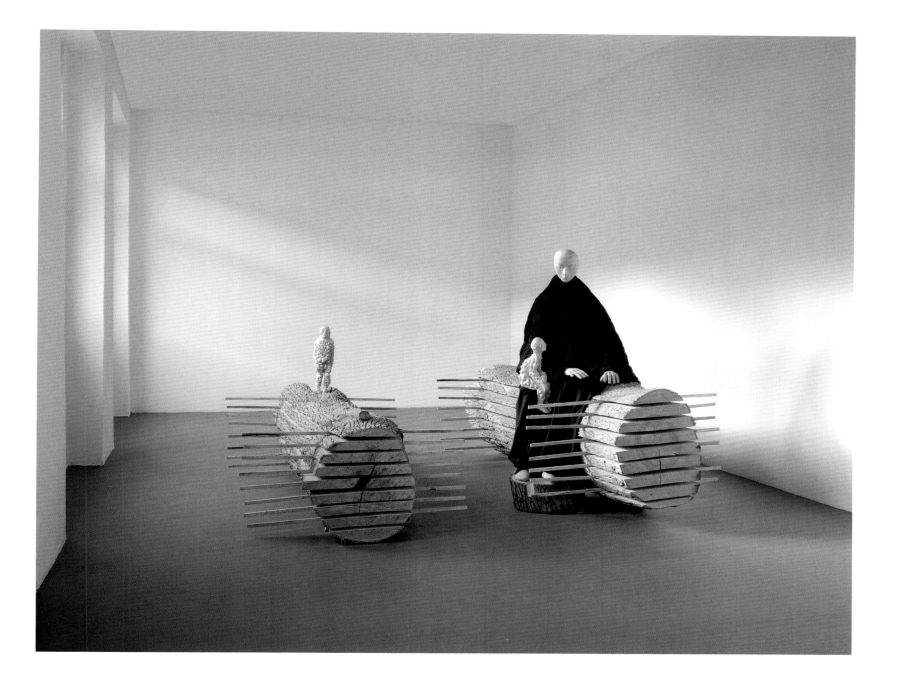

WALDFRAU (WOMAN OF THE FOREST)
2001, limewood, fabric, and tree trunks,
122 × 57 ⅛ × 102 ⅜ in. (310 × 145 × 260 cm)

Paloma Varga Weisz, born 1966, Mannheim,
Baden-Württemberg, Germany.

Principally working figuratively in sculpture and drawing, Paloma Varga Weisz's formative art training took place at a small school in Bavaria where she learned wood carving, casting, and modeling. In these traditional techniques she found her artistic language. She had already been immersed in art from childhood, thanks to her father Ferenc Varga (1906–89), a painter, and subsequently attended the art academy in Düsseldorf. In her drawings and sculptures, Varga Weisz has created a cast of intriguing characters such as the hybrid person-animal "Dogman, Double-headed Woman and Foreign Body," a being pierced through by an enormous bone. Varga Weisz has spoken of her interest in images of holy misfits from the Middle Ages and in the painters of the northern Renaissance. Sometimes scaled up monumentally or down to diminutive size, her inscrutable creatures appear descended from the dark world of the Grimm Brothers. In this tableau, the "Woman of the Forest" casts a mysterious presence, seated on a log with a small "Bump Man" on her lap. Another boil-covered homunculus stands forlorn on the second log. Are they seeking her wisdom or her protection? Her expression appears benign, yet cloaked in black, she might equally be a malevolent force. We seem to have stepped into an age-old folkloric narrative.—EF

JOANA VASCONCELOS

POP GALO
2016, Viúva Lamego hand-painted tiles, LED, fiberglass, iron, power supply units, controllers, and sound system, sound and light composition by Jonas Runa, 354 ⅜ × 146 ½ × 268 ½ in. (900 × 372 × 682 cm), collection of the artist

Joana Vasconcelos, born 1971, Paris, France.

Giant stiletto heels made from saucepans and lids, a large handgun fashioned out of old rotary dial telephones, a huge teapot made with lacy wrought iron more usually seen on a garden gate—Portuguese artist Joana Vasconcelos uses and embellishes existing objects to create spectacular new forms that surprise and beguile. Broken down into their material and conceptual elements, her sculptures offer succinct but often ambiguous commentary on subjects including women's roles, cultural traditions, and national and collective identity. In many pieces, textiles, crochet, and weaving feature strongly, highlighting the artist's relationship to craft, the domestic sphere, and women's labor. Exemplary of her approach in combining old and new to impressive effect is *Pop Galo*. Directly referencing a well-known Portuguese symbol, the rooster of Barcelos—a popular piece of pottery—Vasconcelos renders this colorful bird in handmade ceramic tiles and LED lights. At 29 ½ feet (9 meters) high and covered by 17,000 tiles and 15,000 LED lights, the piece is monumental in size, intricacy, and ambition. As daylight fades, the LED lights illuminate, and the rooster emanates music by the contemporary Portuguese composer Jonas Runa. The rooster of Barcelos is said to bring luck and happiness, and the sculpture, with its promise of good fortune has toured from Lisbon to Beijing, Barcelos itself, and Yorkshire Sculpture Park.—RH

BURNT QUIPU
2018, unspun wool, dimensions variable,
site-specific installation for *Cecilia Vicuña: About to Happen*, University of California, Berkeley Art Museum and Pacific Film Archive

Cecilia Vicuña, born 1948, Santiago, Chile.

Known for her striking paintings and layered assemblage installations involving textiles, Cecilia Vicuña is an artist and a poet deeply connected to the precariousness of the natural world. Exiled after the 1973 military coup that overthrew the government led by Chilean President Salvador Allende, Vicuña eventually settled in New York as her adopted home. Before leaving Chile, Vicuña began making tiny sculptures called *precarios* (precarious) from found materials linked together with thread that she installed outdoors, especially along the ocean where they could be washed away with the tide. Her subsequent paintings, made immediately before and after the coup, reflect the political turmoil at the time in surreal figurative imagery, as well as the subversive images made by Indigenous artists in Chile in the 1500s after Spanish colonization. Vicuña's large *Quipu* installations of colorful unspun wool reference the ancient Andean record-keeping system that relies on a complex series of knots tied in string. Extending from ceiling to floor, the works connect sky and ground, and often serve as a backdrop for the artist's film projections. Installed at the Berkeley Art Museum and Pacific Film Archive at the University of California, *Burnt Quipu* responded to the place and moment of the exhibition, mourning the recent loss of thousands of trees to forest fires across northern California.—MK

CLAUDE VIGNON

DAPHNÉ CHANGÉE EN LAURIER (DAPHNE CHANGED INTO A LAUREL)
1866, marble, height: 82 ⅝ in. (210 cm),
Musée des Beaux-Arts, Marseille

Marie-Noémi Cadiot-Constant Rouvier (known
as Claude Vignon), born 1828, Paris, France. Died
1888, Saint-Jean-Cap-Ferrat, Provence-Alpes-Côte
d'Azur, France.

Marie-Noémi Cadiot-Constant Rouvier was a French sculptor, journalist, and critic, who wrote under the pseudonym Claude Vignon. Although she found great success as an author, Vignon's role as an important sculptor during France's Second Empire and Third Republic is only recently being reexamined. A political feminist who had participated in the 1848 Revolution and was a friend of Victor Hugo and Balzac, she began to train in sculpture under James Pradier (1790–1852) in 1849, debuting her first work at the 1852 Salon. Vignon created monumental figures, bas-relief carvings, and portrait busts in the Neoclassical style, often with themes from Greco-Roman mythology and the feminist criticism espoused in her writings. These ideas are evident in *Daphne Changed into a Laurel*, which depicts the larger-than-life-sized nymph mid-arboreal transformation and was presented at the 1867 world's fair in Paris. Vignon was also the recipient of major public commissions, including the entire series of ornamental carvings representing the spirits of the arts that decorate the Louvre's Lefuel staircase. She became better known for her novels and art criticism, although she never lost her artistic identity: on her death, she had her tomb decorated with a bronze self-portrait, as well as a sculptor's mallet and chisel.—OC

URSULA VON RYDINGSVARD

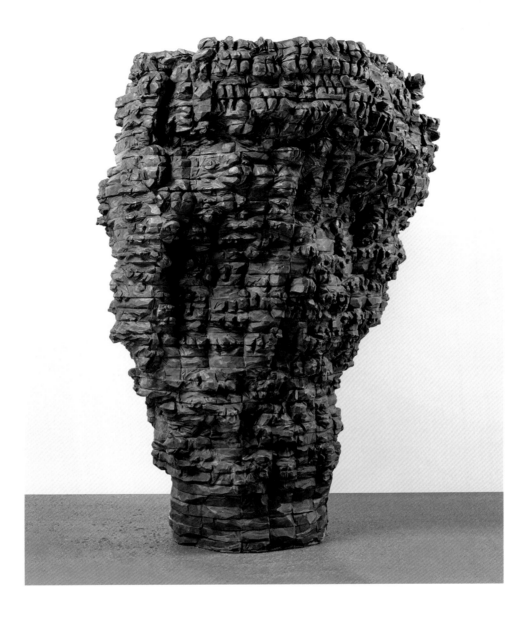

BOWL WITH FINGERS
2022, bronze, 64 ½ × 40 × 37 ½ in.
(164 × 102 × 95 cm)

Ursula von Rydingsvard, born 1942, Deensen,
Lower Saxony, Germany.

Ursula von Rydingsvard's monumental abstract wood sculptures reflect her profound desire to connect to her Polish heritage. The daughter of a woodcutter from a long line of peasant farmers, she spent the first eight years of her childhood in the wooden barracks of forced labor and refugee camps in Germany at the end of World War II, before the family emigrated to the United States in 1950. Working intuitively and painstakingly in a labor-intensive process, she marks, cuts, glues, and stacks 4x4 cedar beams, dusts them with graphite, and assembles them onsite. These sprawling, writhing, looming creations evoke the look and feel of rustic wooden dwellings, humble furniture, and household kitchen utensils. *Bowl with Fingers* is a large sculpture first constructed in cedar wood and then cast in bronze, with shades of green, gold, and copper patina. One of the artist's characteristic vertical forms, it widens as it climbs in height. Resisting biographical readings of her works, von Rydingsvard prefers to preserve their enigmatic nature. This and similar *Bowls* offer the viewer some context, but the execution also provides the artist an excuse to unfurl and explore sculptural ideas of materiality, the pull of gravity, and their spatial relationship to the human body.—OZ

KARA WALKER

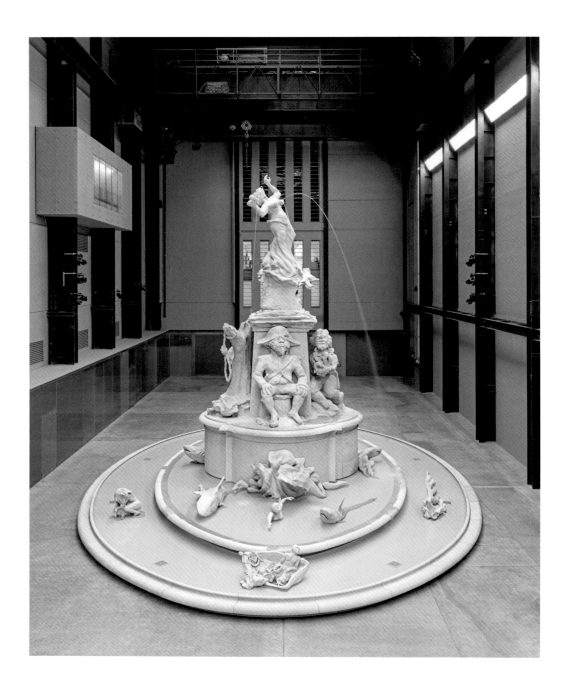

FONS AMERICANUS
2019, nontoxic acrylic and cement composite,
recyclable cork, wood, and metal,
main: 43 × 50 × 73 ½ ft. (13.2 × 15.2 × 22.4 m),
grotto: 10 ¾ × 10 ¼ × 10 ½ ft. (3.3 × 3.1 × 3.2 m),
installation view, *Hyundai Commission: Kara Walker –
Fons Americanus*, Tate Modern, London

Kara Walker, born 1969, Stockton, California, USA.

Over the years, Kara Walker has created prints, paintings, and especially silhouettes, all of which are distinctly defined by a sculptural quality. She has, however, less frequently experimented with conventional sculpture, targeting the Western notion of monuments intended as structures commemorating a particular character or chapter in history. This was the case with her gigantic sugar-crafted sphinx *A Subtlety* (2014), where the Egyptian feline was replaced by a prostrated and rather sexually explicit Aunt Jemima figure; or the equally macroscopic *Fons Americanus* commissioned for the vast Turbine Hall at Tate Modern, London, in 2019. Designed by Walker but loosely based on Sir Thomas Brock's (1847–1922) memorial to Queen Victoria (1911), situated near Buckingham Palace, the piece is a fully operating fountain made of recyclable and reusable materials, with water sprinkling from the breast and slashed throat of the female body dominating the scene. Below her, trademark themes in the artist's practice, such as slavery and European colonialism, are addressed and represented in the form of sinking rafts in shark-infested water or nooses hanging from a tree. Walker's "monument" does not celebrate, but rather questions mechanisms of power and the role of the British Empire during the transatlantic slave trade.—MR

GLEN
1987/2022, earth, vegetation, and steel mesh, dimensions variable, installation view, *Artgenève*, Geneva, 2022

Meg Webster, born 1944, San Francisco, California, USA.

Since the early 1980s New York-based sculptor Meg Webster has worked at the intersection of Land art and post-Minimalism, shaping natural materials such as salt, sand, and soil into spare geometric forms. Two key early mentors were affiliated with these respective movements: fresh from receiving her MFA at Yale University, Webster was an assistant to Michael Heizer (b. 1944) in 1983 and had her first solo exhibition in New York at Donald Judd's (1928–94) Spring Street space in 1984. Circular designs— cones, mounds, and spirals, for example—dominate her output and often, as in the case of *Glen*, are enclosures to be entered by the visitor. These multisensory experiences approach architecture but remain intimate rather than overwhelming. In *Glen*, conceived in 1987 but first installed at the Walker Art Center in Minneapolis in 1988, heavily planted tiers exude scent, both of growth and decay. Hay, a material the artist also used in *Soft Broch* (1984/2022), walls the exterior circumference and blocks sight of the flowering embankments within. Informed by an appreciation for the natural world and concerns over its degradation, Webster acts as a gardener, in a sense, to encourage visitor interaction with living ecosystems in surprising and provocative ways.—AT

NICOLE WERMERS

**ABWASCHSKULPTUR #14 (DISHWASHING
SCULPTURE #14)**
2020, various china, ceramic, kitchen utensils,
modified dishwasher basket, and plinth,
81 ⅞ × 35 ⅜ × 33 ½ in. (208 × 90 × 85 cm)

Nicole Wermers, born 1971, Emsdetten, North
Rhine-Westphalia, Germany.

Combining and reconfiguring everyday objects into her sculptures, collages, and installations, Nicole Wermers explores the visible and invisible structures of daily urban life, specifically the effects that design and material culture have on our perceptions and behaviors. Nominated for the Turner Prize in 2015, Wermers explores social rituals and fleeting moments where public and private space intersect; in *Untitled Chairs* (2014–15), for instance, she arrested the act of draping one's coat over a chair, sewing fur jackets around the furniture to make the gesture permanent in one coherent object. In other works she creates delicate yet architectonic sculptures out of domestic objects. These consider the shapes, materials, and visual cues of differing labor systems, contrasting media often connected to women's household work with grandiose architecture, work usually identified with men. As the artist told curator Maria Abramenko in 2020, "Architectural and material narratives and the hierarchies expressed through them are interesting to me." For her *Dishwashing Sculpture* series, she wedges decorative tableware, silver platters, kitchen utensils, and other domestic items into a dish rack, building up an impermanent sculpture that must be reassembled with each installation. These disarranged and shaky compositions are at once examinations of precarity—both material and spatial—and studies in the contrasting values and power dynamics ascribed to gendered work.—DT

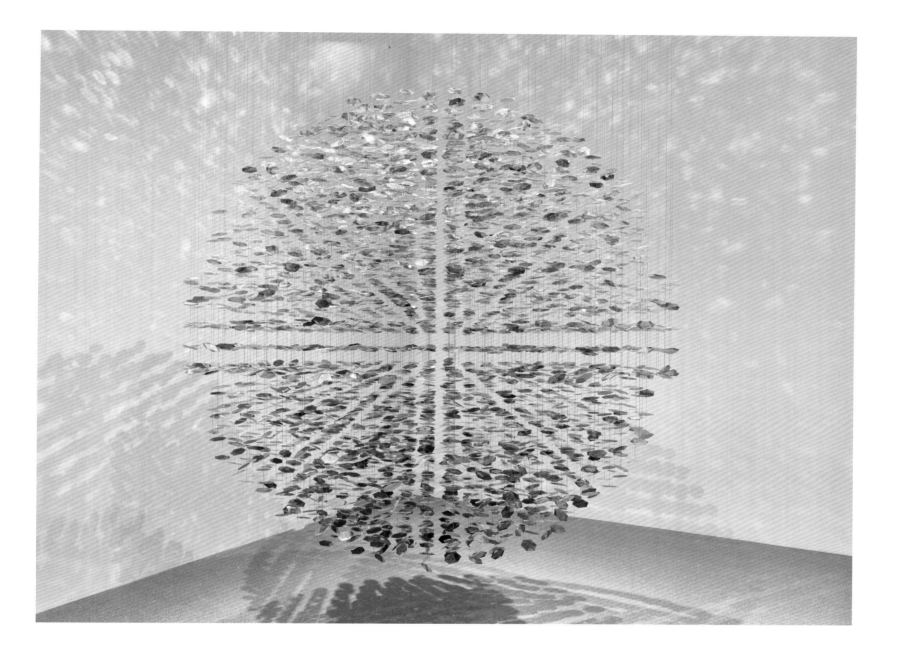

AN ALLEGORY OF AIR: TOO FULL TO SAY TOO
2017, polished stainless steel, cable, and silk-screened elements, diam: 84 ¼ in. (214 cm)

Pae White, born 1963, Pasadena, California, USA.

Seeking to investigate and celebrate the wonders of the mundane, Pae White blurs the lines between art, craft, and design by breathing new life into ordinary materials that range from textiles and mirrors to cardboard, cobwebs, and clay. The multimedia artist is especially known for creating large-scale pieces, including a series of tapestries that depict realistic images of smoke or wrinkled aluminum foil. She has also made vast yet intricate spherical mobiles, of which *An Allegory of Air: Too full to say Too* is one. Designed using custom software, in these works, White plays with light, color, and reflectivity by assembling thousands of hexagonal mirrors hung from a constellation of delicate strings. The ordinary, colorless steel is suspended in gentle movement, playing with refraction and the viewer's gaze to create infinite hues. The elaborate construction of works like these points to White's grasp of not just the fine, but also the applied arts. Speaking about the importance of sustaining a rich art practice during an interview with the San José Museum of Art in 2020, White said, "For me, it's very important to think of everything as having a possibility to be made as an artwork . . . I don't want to be just a painter or just a sculptor, I want to be many things."—SGU

RACHEL WHITEREAD

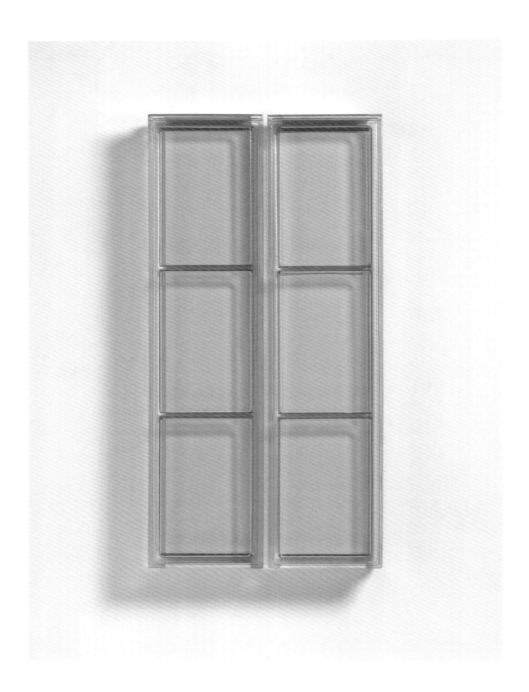

UNTITLED
2013, resin, in 2 parts, overall 38 ⅝ × 18 ⅞ × 3 in.
(98 × 48 × 7.5 cm)

Rachel Whiteread, born 1963, London, UK.

Rachel Whiteread first explored casting as a sculptural process as a student, taking domestic objects and furniture and capturing the negative space within. She initially worked with plaster but soon embraced rubber, resin, and concrete as her regular materials. Thrust into the media spotlight with *House* (1993), a cast of an entire terraced house in East London, Whiteread became the first female artist to win the Tate's prestigious Turner Prize later that year. Major public commissions followed, including *Water Tower* (1998) for the Public Art Fund, New York; *Holocaust Memorial* (2000), which commemorates Austrian victims of the Holocaust in Vienna; and a work for the Fourth Plinth program in London's Trafalgar Square (2001). More recent outdoor works have formed a series Whiteread calls *Shy Sculptures* (2010–), located in remote places, including a fjord in Norway and in rural Norfolk, UK. Throughout her career, Whiteread has also continued to produce smaller, indoor sculptures, including this pink resin cast of windows. The transparent nature of the resin echoes the inherent function of the original object, but in its presentation—hanging on a gallery wall—such use value is redundant. Instead, its formal and aesthetic qualities are brought to the fore.—RM

TITANIC MEMORIAL
1931, granite, height: 13 ft. (4 m), Washington, D.C.

Gertrude Vanderbilt Whitney, born 1875,
New York, USA. Died 1942, New York.

Famous for her legacy as an art patron and founder of New York's Whitney Museum of American Art in 1930, Gertrude Vanderbilt Whitney was also a sculptor who studied at the Arts Students League in New York with James Earle Fraser (1876–1953) and was mentored by Auguste Rodin (1840–1917) in Paris. After her marriage in 1896, Whitney pursued art while also supporting contemporary American artists like Edward Hopper (1882–1967) at a time when United States museums were more concerned with European arts. She opened a studio in downtown Manhattan in 1907, which she also used as an exhibition space for other artists. Until 1910, Whitney, who was a Vanderbilt by birth, worked under an assumed name out of fear that she would be dismissed as a dilettante. Indeed, her wealth allowed her to enlist the highest quality materials and assistance to create her works. Within the next decade she began receiving commissions for major commemorative sculptures, including the *Titanic Memorial* and the *Washington Heights-Inwood War Memorial* (1922) in upper Manhattan. Having volunteered in a French hospital that she established and maintained during World War I, Whitney was moved by those who fought and surrendered their lives. Characterized by idealized forms in realistic scenes, Whitney's symbolic public monuments are prized for their legibility and formal mastery.—MS

ALISON WILDING

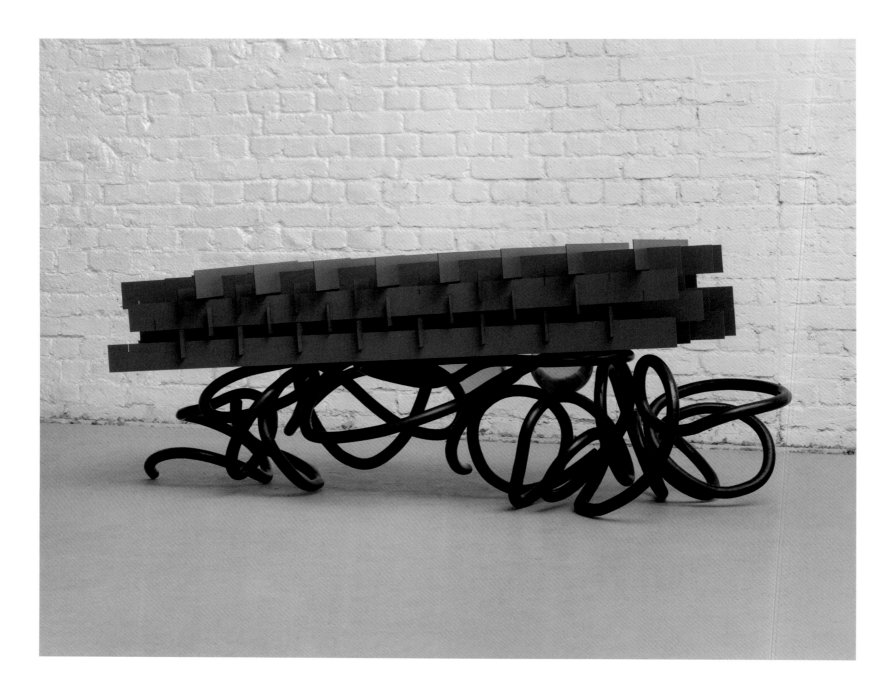

DRAMONIA
2022, patinated bronze, laminate, and acrylic,
37 ⅜ × 70 ⅞ × 33 ½ in. (95 × 180 × 85 cm)

Alison Wilding, born 1948, Blackburn,
Lancashire, UK.

Alison Wilding belongs to a generation of British sculptors who began combining traditional and indus-trial materials in innovative ways from the 1980s onward. Mostly abstract, her pieces juxtapose bronze, stone, marble, or gesso with more unconventional media like neoprene rubber, mirror, or polystyrene. The way they occupy space adds a layer of meaning. This was particularly evident in her 2018 exhibi-tion at the De La Warr Pavilion in Bexhill-on-Sea, East Sussex, where *Riptide* (2018), a wavy sculpture placed on the roof, interacted with the motion of the sea behind it, and *Red Skies* (1992) applied a fierce filter to the horizon line through a slit in a metal column with a red interior. Dialogues—between inside and outside, and among disparate materials, their textures, timeframes, and origins—underpin Wilding's practice. In *Dramonia*, two acrylic spheres appear to be trapped between a confusingly curvy bronze coil and an illogically patterned roof made of laminate. The piece's tilted angle could lead one to believe the whole ensemble will soon be swallowed by the floor or that the knotted bronze will set in motion and become a cart that propels the object forward. Such transformations lie at the core of Wilding's universe.—CI

TWO-FOLD GESTURAL SCULPTURE
1978, glazed ceramic, 3 ½ × 5 ½ × 4 ½ in.
(8.9 × 14 × 11.4 cm)

Hannah Wilke, born 1940, New York, USA.
Died 1993, Houston, Texas, USA.

A pioneer of feminist art, Hannah Wilke was among the first artists to draw on vulvic symbolism
to consider issues related to womanhood, sexuality, and eroticism. Born Arlene Hannah Butter,
she studied at the Tyler School of Art at Temple University in Philadelphia during the late 1950s and
worked across many mediums, including painting, photography, video, performance art, and sculpture.
In the early 1960s Wilke began to create her now iconic series of biomorphic ceramic sculptures resem-
bling vulvas. She continuously turned to folding to construct these gestural pieces in various materials,
including porcelain, terracotta, bronze, gum, and dough. One of her most notable projects, *S.O.S.
Starification Object Series* (1974–82), consists of multiple monochrome self-portrait photographs for
which Wilke posed like a supermodel while covered in small pieces of chewing gum shaped like vulvas.
In 1977, during an interview with art historian Ruth Iskin for *Visual Dialog*, Wilke spoke about her
choice to make art centered on female genitals: "I wanted to put us on the pedestal that we deserve,
to make emotional and physical contact, to make real blossoms out of us, like books or Toras opening
up—real objects of worship. We deserve it."—SGU

JACKIE WINSOR

PINK AND BLUE PIECE
1985, mirror, wood, paint, and cheesecloth,
31 × 31 × 31 in. (78.7 × 78.7 × 78.7 cm)

Jackie Winsor, born 1941, St. John's, Newfoundland
and Labrador, Canada.

Born and raised next to the coastal vastness of the great North Atlantic Ocean, Jackie Winsor found the same sense of scale among the skyscrapers of her adopted home New York as she once did with the cold, rocky cliffs of the Canadian landscape. Working in a resolutely human dimension, Winsor wraps, burns, carves, nails, and stacks unassuming materials such as bricks, sticks, twine, rope, and concrete to harness the same sense of immense scale as the energy involved in the hundreds of hours of repetitive process bound up in her works. Studying drawing and painting in college, Winsor turned to sculpture in graduate school. Her later wrapped sculptures remain drawings at their core: long pieces of twine form graphic lines that, after thousands of turns around a piece of plywood or grid of branches, swell into new bulbous forms. Often cited as an artist raised within—and in reaction to—Minimalism, Winsor emphasizes her sculptures as self-contained units of potential energy built on a tension between interior and exterior, force and form. In *Pink and Blue Piece* a mirrored cube framed with pink-painted wood almost disappears into its exhibition context. A viewer looking for their reflection finds a hole at the center of the mirror, and inside, the inner dimensions of the deep blue twilight sky.—MK

AZTEC VASE AND CARPET #8
2015, glazed earthenware, epoxy resin, lacquer, acrylic paint, and canvas, 36 ¼ × 54 ¼ × 43 in. (92 × 139 × 109.2 cm)

Betty Woodman, born 1930, Norwalk, Connecticut, USA. Died 2018, New York, USA.

Multidisciplinary artist Betty Woodman is known for a bold and inventive reinterpretation of the vase form, which she accomplished by drawing from a wide range of visual influences. Woodman started her career as a functional potter in the 1950s and, from the 1960s, the subject of the vessel became central to her creative output. Over more than half a century she steadily produced drawings, sculptures, and prints that reconfigured the concept and form of the vase, making reference to modernist craft, as well as the functional and domestic elements of design. Woodman traveled extensively throughout her life and resided in Italy for part of each year starting in 1968 after several earlier visits. Inspired by her cultural surroundings and fascination with art history, she developed a distinct formal lexicon, in which Classical Greek and Roman pottery, Korean folk art and modern painting met to embody a cohesive jubilant practice. Toward the end of her career, Woodman's vessels expanded onto the wall and floor, often incorporating painted canvases into large-scale installations, as seen here. Baroque architecture and Italian theatrics were fundamental for these later works, as was the notion of play. As she said in a 2010 statement on the Woodman Family Foundation website, "Character, *mise-en-scène*, costume, plot, and denouement are all important here. I am playing with play."—JM

YAMAZAKI TSURUKO

TIN CANS
1955/86, dye, lacquer, and thinner on tin cans, dimensions variable, M+, Hong Kong

Yamazaki Tsuruko, born 1925, Ashiya, Hyogō, Japan. Died 2019, Hyogō, Japan.

Yamazaki Tsuruko was a founding member of the Gutai Art Association, a seminal Japanese collective of avant-garde artists whose radical and multidisciplinary approaches to making art anticipated global developments in Conceptual and performance art in the decades to come. Yamazaki was the sole woman artist to remain active within the group, which was founded in 1954, until it dissolved in 1972. Her practice is characterized by the inclusion of industrial materials, such as mirror, tin, acrylic, and vinyl, much of it reflective. She would treat these with aniline dyes to produce bold colors, as seen in *Tin Cans*. Inspired by the cans distributed to American soldiers stationed in postwar Japan, Yamazaki created this work for the First Gutai Art Exhibition in Tokyo in 1955. Metal sheets were dyed before being cut, shaped, and stacked into the familiar tin can forms. A similarly vibrant red appears in the artist's wood and vinyl sculptural piece *Work (Red Cube)* (1956). The Guggenheim's *Gutai: Splendid Playground* (2013) audio guide for this work states, "Postwar Japan was a scene of rubble, a scene of no color. The radicality of these bright primary colors . . . had not been seen in Japan for decades. And color is a very vital part of Gutai's understanding of material. Material and color were inseparable."—MKM

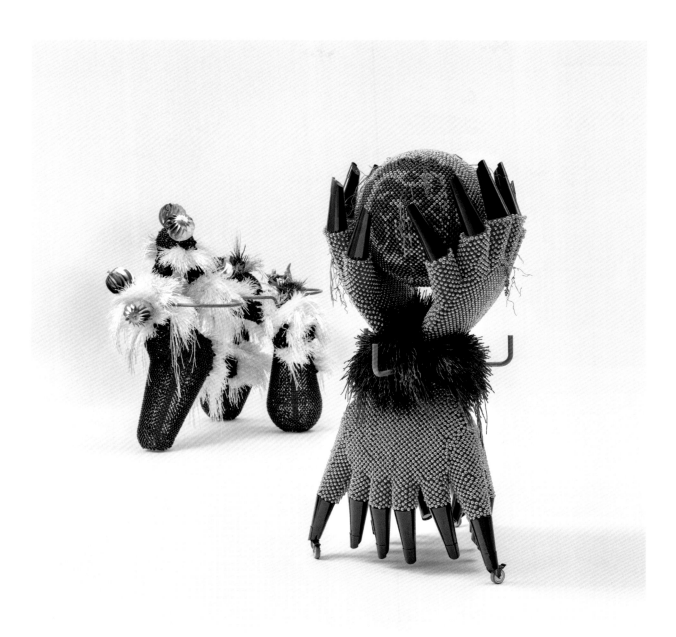

**SONIC INTERMEDIATES – DOUBLE SOUL
(SONIC INTERMEDIATE – TRIPODAL
SHAPESHIFTER AFTER FERLOV MANCOBA
AND SONIC INTERMEDIATE – SIX-FINGERED
WAYFARER AFTER ARKE)**
2021, powder-coated steel frame, mesh and handles,
ball bearings, casters, stainless steel bells, PVD-
coated stainless steel bells, powder-coated stainless
steel bells, black brass-plated bells, split rings,
plastic twine, artificial plants, and turbine vents,
75 ¼ × 58 ⅞ × 83 ½ in. (191 × 147 × 212 cm) and
82 ⅝ × 39 ⅜ × 41 in. (210 × 100 × 104 cm)

Haegue Yang, born 1971, Seoul, South Korea.

There is a fine line separating anthropomorphism and animism in Haegue Yang's sculptures. In an enticing balancing act, her pieces make use of industrial materials such as venetian blinds, drying racks, and turbine vents, or manipulate media to appear as figurative, almost friendly characters, usually staged in pairs or collectives. In the booklet for her 2022 exhibition *Double Soul* at Copenhagen's Statens Museum for Kunst, the artist described her work as dealing with "the possible projection of oneself onto another being, life, thing, or phenomenon, whether through supernatural power, human imagination, telepathy, and empathy." Such amplitude is present in the sculptural duo *Sonic Intermediates – Double Soul,* the title and form of which make reference to Sonja Ferlov Mancoba (p.101) and Pia Arke (1958–2007). The three artists share stories of transculturalism—Yang's engagements with Seoul and Berlin, and Ferlov Mancoba's and Arke's in relation to South Africa and Greenland respectively. The artificial plants in the sculpture bearing Ferlov Mancoba's name replicate South African species and reveal Yang's interest in juxtaposing the synthetic with the natural. The globe alludes to a map featured in Arke's works that explores colonial relations between Greenland and Denmark. The bells adorning this duo, which Yang has mobilized recurrently, address a similar transcultural language: they resonate with various belief systems, encompassing Korean shamanism and European pagan rituals.—CI

KENNEDY YANKO

ANCHOR I
2019, paint skin and metal, 14 × 12 ½ × 12 in.
(35.6 × 31.8 × 30.5 cm)

Kennedy Yanko, born 1988, St. Louis,
Missouri, USA.

Painting and sculpture come together unexpectedly in the hybrid works of Kennedy Yanko.
An autodidact, Yanko disrupts formal art historical categorizations through her combination of paint skins and scrap metals, including steel, copper, aluminum, and zinc, which she salvages from junkyards. Yanko developed a technique of pouring latex paint in thick layers, which she allows to dry before folding, twisting, and bending them around found metal to create abstract sculptures that may rest on the floor or hang from the ceiling or wall. To some, the suspension of flowing paint calls to mind the work of Lynda Benglis (p.42), while the metal's mangled monumentality recalls the U.S. artist John Chamberlain (1927–2011). Many of Yanko's works are the result of considerable physical exertion, although *Anchor I* is a much smaller maquette, envisioning the potential of a larger work before it is so strenuously created. Here, the juxtaposition of the roughly aged metal balanced with the velvety smooth paint speaks to her interest in what emerges when contrasting materials are placed in conversation.
In a 2020 interview with curator Kimberly Drew for *Cultured*, Yanko noted, "After I pull metal and other materials from salvage yards, I sit with them in a formal dialogue. I have to understand their physical stance before I can comprehend their presence conceptually. In time, the objects' stories reveal themselves to me."—JD

CAMP DOG
2002–3, pandanus, ocher and paperbark,
29 ⅛ × 13 × 51 ⅝ in. (74 × 33 × 131 cm),
Museum of Contemporary Art, Sydney, and
Maningrida Arts and Culture, Maningrida

Lena Yarinkura, born 1961, Maningrida, west
Arnhem Land, Northern Territory, Australia.

Lena Yarinkura was raised in a bustling hub of artistic practice, instructed in the art of string-making and pandanus-weaving by the matriarchs of her family, as well as making conical fish-traps with her father and, later, bark paintings with her husband and collaborator, Kamarrang "Bob" Burruwal (1952–2021). Yarinkura mastered a diverse creative skillset that became a foundation for experimentation. Innovating from within Aboriginal tradition, deeply rooted in the Kune and Rembarrnga cultural context of Australia's Northern Territory, Yarinkura transformed the art of twined basketry into contemporary sculptural forms. Her metamorphic approach to weaving during the late 1980s and 1990s set in motion a whole new idiom of figurative fiber practice in central Arnhem Land and beyond. The transformative nature of her practice is embodied in works such as *Camp Dog*. Yarinkura began by weaving a *kunmadj* (dilly bag) from twined *kundayarr* (*Pandanus spiralis*) but then gradually reworked its shape, stuffing the emerging figure with paperbark to hold its form before using ocher to define its playful features. Continually diverse in their subject matter, her life-size works are inspired by animals on her Rembarrnga homelands and beings from ancestral stories. The form of the dog has particular significance in her practice, as it represents her *Djang*—dog dreaming—while bringing to life the hybrid individuality of *jamu* or "camp dogs."—SS

ANICKA YI

LIVING AND DYING IN THE BACTERIACENE
2019, powder-coated steel with inset acrylic vitrine,
water, 3D-printed epoxy plastic, and filamentous
algae, 33 × 25 × 5 ½ in. (83.8 × 63.5 × 14 cm)

Anicka Yi, born 1971, Seoul, South Korea.

Born in South Korea and brought up in the United States from the age of two, Anicka Yi began making art in her mid-thirties. Her oeuvre addresses the big questions facing humankind, asking what art can be and how we define the limits of life. In 2019 she told *MoMA Magazine*, "I think that the role of the artist is really, quite frankly, as much as a scientist, to define what life is and what life can be." Yi adopts a cross-disciplinary approach, collaborating with chemists, biologists, and engineers, and her works often demonstrate the interdependence of living species, although she is equally concerned with the symbiotic relationships between humans and nonliving forms including artificial intelligence. Smell is a recurring component of Yi's work, offering a different way to encounter art from the usual visual sense, and highlighting the way air connects everything and everyone. In 2015 she created the smell of forgetting for an exhibition in Switzerland. Works using perishable materials including tempura-fried flowers and kombucha, or living organisms such as bacteria and ants, evolve and decay over time. *Living and Dying In The Bacteriacene* features an algae type, sometimes classified as a plague, and a 3D-printed honeycomb structure encased in an aquascape, which the algae may colonize over time, positioning living and nonliving elements in a tenuous relationship.—EDW

PORTABLE CITY: HANGZHOU
2011, suitcase, clothes, magnifying glass, and map,
31 ½ × 11 × 34 ⅝ in. (80 × 28 × 88 cm)

Yin Xiuzhen, born 1963, Beijing, China.

Often incorporating used clothing, personal effects, and cement, Yin Xiuzhen's sculptures memorialize places undergoing the effects of rapid development and globalization. Yin earned a degree in oil painting from Beijing's Capital Normal University in 1989. She turned to experimental installations and performances in 1994, using discarded materials to comment on Beijing's modernization efforts that demolished older structures and displaced city dwellers. In an interview with curator Hou Hanru, published in her Phaidon monograph in 2015, she reflected on her use of recycled materials: "When you take the rubble directly into the works, these materials, with their experiences and histories, can 'speak' for themselves. They have individual and collective memories, as well as many traces of life." Yin draws a direct link between clothes and architecture, explaining, "Clothing is like a soft building that attaches to the human body as a second skin." In 2001 Yin began her *Portable Cities* series—a group of sculptures that repurpose suitcases and clothing worn by people living in the given city. These microcosmic urban "portraits" include a soundscape composed from local field recordings. In *Portable City: Hangzhou*, Yin uses stitched textiles to recreate the metropolis's aquatic landscape, traditional buildings, and modern architecture.—WV

DAISY YOUNGBLOOD

ANUBIS AND THE FIRST CHAKRA
2012, clay, wood, and stone, 32 × 22 × 17 ½ in.
(81.3 × 55.9 × 44.5 cm), San Francisco Museum
of Modern Art

Daisy Youngblood, born 1945, Asheville, North
Carolina, USA.

Since the late 1970s Daisy Youngblood has tapped into the timeless act of creating art from the earth, converging visual traditions from the prehistoric to the contemporary in her figurative sculptures of clay and bronze. Mostly using low-fired clay and traditional hand-modeling techniques, Youngblood shapes the fragile medium into smooth forms with human or animal qualities. These ordinary figures, such as gorillas, donkeys, dogs, or hawks, are made surreal or elevated to the spiritual, as in her depiction of the Egyptian god of the afterlife in *Anubis and the First Chakra*, although they never lose their connection to the physical world. As in *Anubis*, which was inspired both by the environment of Youngblood's home in Pérez Zeledón, Costa Rica, and a dream she had about it, these beings surpass simple reinterpretations of myth or the unconscious thanks to both the earthen material with which they are made and the negative spaces left by gaping eye sockets or absent limbs. Her creatures emphasize mortality through their twisted and fragmented poses, which are often exaggerated with other natural elements, including sticks, rocks, teeth, and hair. Youngblood portrays the natural world's power and vulnerability through these melancholic archetypes, fashioning a loop in which the creation and destruction of life plays out through clay, wood, and stone.—OC

**A-Z ESCAPE VEHICLE: CUSTOMIZED
BY ANDREA ZITTEL**

1996, exterior: steel, insulation, wood, and glass,
interior: colored lights, water, fiberglass, wood,
papier-mâché, pebbles, and paint,
62 × 84 × 40 in. (157.5 × 213.3 × 101.6 cm),
Museum of Modern Art, New York

Andrea Zittel, born 1965, Escondido,
California, USA.

Andrea Zittel reconceives the built environment under the aegis of A-Z Enterprises to create new
approaches to living and navigating life in the Anthropocene. Zittel explores utopian ideas surrounding
design and aesthetics, such as those espoused by the Bauhaus and the Russian Constructivists. Using
innovative and experimental methodologies, she reinvents things we see every day, to find order,
transform space, and enhance notions of social exchange. Her *A-Z Escape Vehicle: Customized by Andrea
Zittel* is from a series of ten units, all externally anonymous with interiors customized to reflect the
intended owner's idealized environment of escape. As Zittel explains on her website, "*The A-Z Escape
Vehicles* can be used to escape to an inner world, rather than traveling to a destination in the external
world. As mass production creates increasingly standardized external conditions, we cater to our
craving for creativity and personal control by turning inward to our hidden private worlds." In this
work, constructed by the artist for her own use, she created a fantastic memory-projection of a grotto,
which Ludwig II, the King of Bavaria, had constructed in the garden of his Linderhof Palace in 1876–7
so he could float in his swan rowboat. The ecstasy of such an experience is represented here by
an interior space fashioned from papier-mâché and other materials to reflect on and subtly critique
the sociocultural ecosystem of leisure and escape.—KM

GLOSSARY

'85 NEW WAVE MOVEMENT
Term applied to Chinese artists from 1985 to 1989 making work that was **Conceptual** and experimental, and therefore more connected with an international **avant-garde** than those working in the country's dominant **Socialist Realist** style. The movement reached its peak with the 1989 *China/Avant-Garde Exhibition* at the National Art Gallery in Beijing.
Shen Yuan (b. 1959)

3D MODELING / PRINTING
A form of computer-aided design with origins in the 1970s aerospace and automotive industries. 3D modeling creates a digital image that can be rotated to be viewed from all angles by plotting points in three dimensions. 3D printing is a means of outputting such designs into a physical format created in layers, with the capacity for precision and complexity that would be hard to reproduce by other means. As with many **industrial materials** and processes, contemporary sculptors have been keen to explore the creative potential of this technology both as a means of creating artwork and as a subject matter.
Auriea Harvey (b. 1971)
Shirley Tse (b. 1968)
Anicka Yi (b. 1971)

A

ABJECT ART / ABJECTION
Art that explores transgressive themes and challenges notions of propriety, cleanliness, and idealization, especially in relation to the human body and its functions. Used widely from the early 1990s onward, it has particular currency for **feminist artists** as female bodily forms and functions are seen to have been "abjected" by **patriarchal values**.
Jodie Carey (b. 1981)
Nicola Costantino (b. 1964)
Berlinde De Bruyckere (b. 1964)
Sarah Lucas (b. 1962)
Annette Messager (b. 1943)

ABSTRACT ART / ABSTRACTION
A composition that is not concerned with representing the world or presenting a narrative through **figurative** forms. Abstraction in its widest sense includes the kind of mark-making that is also described as pattern or ornament, as can be seen across many cultures and periods. The term "abstract art" strictly applied relates to styles of **modernist** painting and sculpture from the turn of the twentieth century onward, which were developed as a deliberate rejection of realistic art in the aftermath of photography's invention. See also **Concrete art**, **Minimalism,** and **hard-edged**.
Nairy Baghramian (b. 1971)
Chakaia Booker (b. 1953)
Saloua Raouda Choucair (1916–2017)
Gisela Colón (b. 1966)
Monir Shahroudy Farmanfarmaian (1922–2019)
Gego (1912–94)
Rachel Harrison (b. 1966)
Kim Lim (1936–97)
Ana Navas (b. 1984)
Eva Rothschild (b. 1971)
Alison Wilding (b. 1948)

ABSTRACT EXPRESSIONISM
Art movement primarily associated with painting that began in New York and flourished in the 1940s and 1950s in parallel with other similar trends internationally. Although their styles and techniques varied, these artists used **abstraction** to externalize emotions, allowing the subconscious to express itself on the canvas. Hugely influential on the course of art history, its dominance led some subsequent artists to react against it aesthetically and conceptually in a broad variety of ways, including rejecting painting in favor of other art

forms (such as sculpture), working with **nontraditional materials**, and rejecting subjective emotion in favor of objective form. The movement has also impacted how gestural abstraction is discussed across art forms, especially in relation to a looseness of color and freedom of form that may as equally apply to sculpture and **installation** as the painted canvas.
Claire Falkenstein (1908–97)

AFROFUTURISM
Coined by American writer Mark Dery in 1993, this approach visualizes a future where Black protagonists have achieved liberation with the aid of technology. Part sci-fi, part utopic, and part self-affirmation, Afrofuturism is also represented in the creative fields beyond the visual arts, including music, literature, and film.
Lauren Halsey (b. 1987)
Wangechi Mutu (b. 1972)
Mary Sibande (b. 1982)

AGGREGATION
The process of collecting and combining units into a single group, or the name for such grouping. In relation to sculpture and **installation**, the term is often applied to forms of **assemblage** where the constituent units are uniform objects or material, including mass-produced, **found objects**.
Tara Donovan (b. 1969)
Liza Lou (b. 1969)
Usha Seejarim (b. 1974)
Yamazaki Tsuruko (1925–2019)

ANTHROPOMORPHIC
The attribution of human characteristics to something nonhuman. Anthropomorphism in art may be deliberately intended by an artist or perceived by a viewer. Many of the oldest objects found by archaeologists and defined as sculpture, typically being either **stone** that has been modified by **carving**, or **found objects** that have been purposefully relocated (called manuports), are anthropomorphic and suggest a universal tendency to see human characteristics in the world around us.
Holly Hendry (b. 1990)
Camille Henrot (b. 1978)
Liao Wen (b. 1994)
Nandipha Mntambo (b. 1982)
Haegue Yang (b. 1971)

APPROPRIATION
The artistic practice of intentionally recycling or borrowing imagery from another context—from high art to popular culture—for inclusion in new work. With roots in the **readymade**, and a major element in **Pop art**, the term gained currency in 1980s North America when artists used the strategy to address questions around originality, authenticity, and authorship in art. It continues to be an approach used by artists today.
Anthea Hamilton (b. 1978)
Sherrie Levine (b. 1947)

ARMATURE
A structural framework made from rigid materials such as metal or **wood** that shapes or supports a sculpture's overall form. An armature functions in the same way that a skeleton supports the form of a body beneath its flesh and is particularly useful when a work is molded from soft materials (such as **clay**, **plaster**, or wax). Armatures are also used in large, hollow sculptures, to hold in place materials prone to distort at a scale. Historically, an armature would be entirely hidden beneath surface layers, but some contemporary artists have chosen to make it partially or fully visible, either for aesthetic reasons or to emphasize the **materiality** of the work.
Ghazaleh Avarzamani (b. 1980)
Alina Tenser (b. 1981)

ART ACADEMY
Established in Europe during the **Renaissance** and becoming more widespread by the seventeenth century, art academies were artist-run organizations that sought to professionalize and promote art through formal training and public **Salon** exhibitions. In **Western art**, the French

Académie Royale de Peinture et de Sculpture (founded in Paris in 1648, and renamed Académie des Beaux-Arts after the French Revolution) and the Royal Academy of Arts (founded in London in 1768) were particularly central to the way in which art was taught, produced, exhibited, and critically endorsed. Women artists were initially entirely excluded from becoming full members (and barred access to life drawing classes; see **the nude**), and even after they were admitted remained small in numbers, with gender parity still not yet achieved.

ART DECO
A style from the 1920s and 1930s primarily used in furniture, **decorative arts**, and architecture. Noted for its geometric character, it was a reaction against the organic forms of **Art Nouveau** and connected instead with the fragmented shapes of **Cubism**.
Elza Köveshází-Kalmár (1876–1956)

ARTE POVERA
A twentieth-century artistic movement that became particularly prevalent in Italy in the late 1960s, whose name literally means "poor art." These artists celebrated simple and cheap materials, such as mud, twigs, paper, cloth, and cement, fusing nature and culture in a reflection of contemporary life. The movement was influential beyond Italy and can be seen as a precursor to what became prevalent practices of employing **nontraditional** or **industrial materials** in sculpture.
Marisa Merz (1926–2019)

ART NOUVEAU
A primarily architectural and **decorative art** style of late-nineteenth- and early-twentieth-century Europe and North America, which influenced fine art. Rejecting austere **Classical** aesthetics, the movement sought an approach based on traditional crafts and the imitation of nature, characterized by asymmetry and flowing organic forms.
Sarah Bernhardt (1844–1923)
Dora Gordine (1895–1991)

ASSEMBLAGE
Form of sculpture produced by arranging often disparate **found objects** and everyday materials. With roots in **Dada**, assemblage became more widely used in the 1950s and is now a common process for making sculpture and **installation**.
Cosima von Bonin (b. 1962)
Isa Genzken (b. 1948)
vanessa german (b. 1976)
Guan Xiao (b. 1983)
Siobhán Hapaska (b. 1963)
Portia Munson (b. 1961)
Louise Nevelson (1899–1988)
Virginia Overton (b. 1971)
Nancy Rubins (b. 1952)
Betye Saar (b. 1926)

AVANT-GARDE
Term used to describe a movement or work that is experimental, innovative, and challenges the current predominant style. It comes from the French phrase meaning "advance guard" and was first used in relation to art in 1825. While originally connected with **modernism**, the term continues to be applicable today.
Lygia Clark (1920–88)
Katarzyna Kobro (1898–1951)
Shigeko Kubota (1937–2015)
Chana Orloff (1888–1968)
Germaine Richier (1902–59)
Shen Yuan (b. 1959)

B

BAROQUE
Principal European art style of the seventeenth and early eighteenth centuries. Beginning in Italy,

it has been suggested that the Baroque style was born out of the Counter-Reformation, and was at first a form of propaganda for the Catholic Church. Baroque art was intended to address the senses directly and to influence the intellect through emotion rather than through reason. Decorative excess, dramatic movement, and spectacle characterize the style, which is now also applied to describe contemporary art that fits these criteria.

Anna Morandi Manzolini (1714–74)

BAS-RELIEF

A form of sculptural **relief** meaning "low to the surface" (from the Italian *bassorilievo*) in which the three-dimensional projection from the surrounding surface is shallow, and no part of the **modeled** form is undercut; for example, images on coins and medals are typically bas-relief. Bas-relief contrasts with high relief, where projection is more substantial and requires more time and great sculptural skill, although definitions of what constitutes high versus bas-relief are subjective, and the two are often combined in a single work.

Marcelle Renée Lancelot-Croce (1854–c. 1938)
Blanche-Adèle Moria (1859–1926)

BAUHAUS

School of art, design, and architecture established in Weimar Germany in 1919 by the architect Walter Gropius. Its roots lay in nineteenth- and early-twentieth-century attempts to re-establish the connection between design and manufacture, and it reinstated the idea of workshop training in preference to the **art academy**. Its disciplined, functional style widely influenced European and American architecture and design.

Sue Fuller (1914–2006)
Lenore Tawney (1907–2007)

BIENNIAL

A large-scale exhibition held every two years, usually linked to a specific city or location. The oldest and most revered is the **Venice Biennale** (since 1895) but other influential biennials occur around the world, including São Paulo (since 1951), Istanbul (since 1987), Sydney (since 1973), Sharjah (since 1993), and at the Whitney Museum of American Art, New York (annual from 1932, then biennial since 1973), among others.

BIOMORPHIC

Images or forms that are wholly or semi-abstract yet evocative of natural, living things, including the human body or plants. The word came into art usage in the 1930s in relation to certain **Surrealist** artworks, and continues to be applied where appropriate to art today.

Marta Colvin (1907–95)
Lily Garafulic (1914–2012)
Lee Bul (b. 1964)
Rita Longa (1912–2000)
Mrinalini Mukherjee (1949–2015)
Julia Phillips (b. 1985)

BLACK ARTS MOVEMENT

An African American-led ideological movement beginning in the 1960s in which artists, writers, and intellectuals united to create a distinctly Black aesthetic that centralized Black life and culture in literature and visual art. It was described by theorist Larry Neal in 1968 as the "aesthetic and spiritual sister of the Black Power Movement." The movement expanded upon the work of the earlier **Harlem Renaissance** while introducing new, more radically political stances. Its legacy can be seen in the work of contemporary North American artists where Black experiences and representation are at the fore. See also **identity politics**.

Abigail DeVille (b. 1981)
Tau Lewis (b. 1993)
Senga Nengudi (b. 1943)
Alison Saar (b. 1956)
Betye Saar (b. 1926)
Tschabalala Self (b. 1990)
Kara Walker (b. 1969)

BRONZE

Metal alloy primarily made of copper and tin used by humankind since the mid-fourth millennium BCE and valued for its strength and durability in comparison to other metals. As a **traditional sculptural material**, it dates back to at least 2,500 BCE and has remained one of the primary materials for **casting** sculpture up to the present day. When molten, bronze expands slightly prior to setting thus capturing the finest details inside a mold, and shrinks when cooling, facilitating ease of removal. Bronze is often used in preference to other metals for outdoor sculpture because it does not rust, but rather forms a natural **patina** gradually through oxidation. Artificial patinas and paints may be used to seal the surface of bronze sculpture, and control the visual appearance.

Fiona Connor (b. 1981)
Tracey Emin (b. 1963)
Elisabeth Frink (1930–93)
Barbara Hepworth (1903–75)
Gertrude Hermes (1901–83)
Anna Hyatt Huntington (1876–1973)
Blanche-Adèle Moria (1859–1926)
Meera Mukherjee (1923–98)
Wangechi Mutu (b. 1972)
Germaine Richier (1902–59)
Augusta Savage (1892–1962)
Dana Schutz (b. 1976)

CANON OF ART HISTORY

Artists and artworks featured in **Western art** histories and museum collections are deemed to be "canonical" because of their innovative approach or enduring influence. While the mainstream art historical canon has been heavily critiqued since the late twentieth century for propagating wider power relations, in particular for its lack of racial and gender diversity, the canon of art history is still a valid starting point for learning about art of the past, and understanding work in which contemporary artists are critiquing the canon. See also **patriarchal values**.

CARVING

A **traditional sculptural process** described as "reductive" as it involves removing material, usually with a chisel, in order to create a finished form. **Wood** and **stone** (including **marble**) are the most common materials for carved sculpture. "Direct carving" is the term used for artists who do not create preparatory studies prior to starting to carve but rather work instinctually, in response to the material and its physical properties. See also **materiality**.

Elizabeth Catlett (1915–2012)
Maria Faydherbe (1587–1643)
Gu Erniang (flourished 1700–c. 1727)
Han Sai Por (b. 1943)
Barbara Hepworth (1903–75)
Andrea de Mena (1654–1734)
Properzia de' Rossi (c. 1490–1530)
Alison Saar (b. 1956)
Claudette Schreuders (b. 1973)

CASTING

A **traditional sculptural process** that can be used to make unique works, editioned series, or cheaper reproductions of valuable works—depending on the materials involved. To cast an object, a hollow mold is made of an original **modeled** form, into which material in a liquid state (such as **bronze**, **glass**, **plaster**, **resin**, or wax) is poured. When set or cured, the mold is removed to reveal the cast object. Some molds are reusable for multiple use, including sectioned "piece molds," while others, called "waste molds," are destroyed to remove the cast, so can only be used once. See also **lost-wax casting**.

Helen Chadwick (1953–96)
Katharina Fritsch (b. 1956)
Anna Hyatt Huntington (1876–1973)
Rachel Whiteread (b. 1963)

CERAMIC

When exposed to a high enough temperature, **clay** becomes ceramic, which is stronger and more durable than air-dried clay. Up to 2,190°F (1,200°C), fired clay becomes earthenware (often called terracotta), which is permeable to water unless coated in a glaze. At higher temperatures, non-permeable stoneware, bone china, or porcelain can be created. The process of kiln-firing developed during the Neolithic period (around 10,000 BCE) and ceramic has been employed as a versatile and **traditional sculptural material** across the globe as well as having a rich artistic history of surface decoration, such as on vessels and tiles. In various parts of the world, such as East and Southeast Asia, there are long traditions of valuing ceramics as "fine art," differing from traditional **Western art** histories where ceramic-making was often categorized as a form of **craft**. Since the twentieth century, as definitions of sculpture broadened, ceramic has gained more acceptance as a viable art material.

Seyni Awa Camara (b. 1945)
Emma Hart (b. 1974)
Clementine Keith-Roach (b. 1984)
Shio Kusaka (b. 1972)
Simone Leigh (b. 1967)
Savia Mahajan (b. 1980)
Anna Maria Maiolino (b. 1942)
Anina Major (b. 1981)
Lindsey Mendick (b. 1987)
Luisa Roldán (1652–1706)
Annabeth Rosen (b. 1957)
Arlene Shechet (b. 1951)
Hannah Wilke (1940–93)
Betty Woodman (1930–2018)

CLASSICAL

Term used to suggest a continuation of style or subject matter that can be traced directly to the civilizations of ancient Greece and Rome (also called Greco-Roman). Classical mythology has remained an enduring subject for artists across the ages, for which Classical sculpture can be defined by a strict adherence to idealized proportions for representations of the human body, including deities in human form. See also **Neoclassical**.

Janine Antoni (b. 1964)
Shio Kusaka (b. 1972)
Cathie Pilkington (b. 1968)
Sara VanDerBeek (b. 1976)

CLAY

A type of fine-grained soil that, due to its mineral composition, becomes elastic when wet, solidifies when dry, and can be hardened with heat to form **ceramic**. As a raw material, clay was used in functional and symbolic objects as early as the Paleolithic era (which began around 2.6 million years ago and lasted until around 10,000 BCE). Clay was baked in the sun to harden, or open/pit-firing techniques were used prior to the invention of closed, controlled temperature kilns. In Western art history, clay was long used in sculpture as a means of **modeling** a form to be cast or carved in another higher-status material, such as **bronze** or **marble**, but is now a viable fine art material in its own right as it has long been in other parts of the world.

Nicole Eisenman (b. 1965)
Adebunmi Gbadebo (b. 1992)
Savia Mahajan (b. 1980)
Delcy Morelos (b. 1967)
Daisy Youngblood (b. 1945)

CONCEPTUAL ART / CONCEPTUALISM

Broad term applied to art produced from the mid-1960s onward in which artists eliminate or radically reduce emphasis on aesthetic and material concerns in favor of the idea behind the work, thus elevating conception above execution.

Helen Chadwick (1953–96)
Ceal Floyer (b. 1968)
Shilpa Gupta (b. 1976)
Kimsooja (b. 1957)
Teresa Margolles (b. 1963)
Rivane Neuenschwander (b. 1967)
Cornelia Parker (b. 1956)
Katie Paterson (b. 1981)
Liliana Porter (b. 1941)
Doris Salcedo (b. 1958)

CONCRETE ART

Not to be confused with art made of the **industrial material** comprising cement and aggregate, the term was coined in Paris by artist Theo van Doesburg (1883–1931) in the sole issue of *Art Concret* magazine (1930) to describe **abstract** works with no basis in observable reality or any symbolic meaning. It was developed by Swiss artist Max Bill (1908–94), who integrated geometry and mathematics into his works. His contact with Tomás Maldonado (1922–2018) in the 1940s helped introduce Concrete art to Latin America where it became a highly influential style. See also **Neo-Concretism** and **Constructivism**.

 María Freire (1917–2015)
 Mira Schendel (1919–88)

CONSTRUCTIVISM

Modernist movement that began in Russia and spread to other parts of the world, remaining important throughout the mid-twentieth century and still influential, particularly stylistically, on art today. Inspired by the 1917 Bolshevik Revolution and its socialist aspirations, the "Constructivist Manifesto," was published in 1923. It revealed a desire for art to be central to the building of a new kind of society through a radical aesthetic that broke free from artistic conventions, turned toward **abstraction** and experimented with new forms of sculpture and modern technology, including **kinetic art** and practical design.

 Katarzyna Kobro (1898–1951)

CONTEMPORARY ART

Loose term that at its most literal refers to art of the present day yet is also applied to art of the recent past that is considered innovative or **avant-garde**. The starting date for contemporary art is widely debated; however, many art historians consider the late 1960s to mark the end of **modernism** and the start of the contemporary. See also **postmodernism**.

CRAFT

A verb that is applied as a noun in the **Western art** tradition to handmade material culture that does not fit within the definition of fine art—created primarily for visual or symbolic reasons and prioritizing innovation—but rather for functional or domestic purposes. Within this tradition, many techniques and media associated with craft, such as weaving, sewing, knitting, and pottery, were considered to be "feminine" pursuits. As such, objects produced by these means were excluded from the **canon of art history** so that some artists have deliberately employed them to draw attention to this marginalization and elevate craft practices to the status of fine art. Outside of the **Western art** history, there are countless cultures worldwide in which "craft" is not separated from "fine art" or lesser in status. Here the continuation rather than disruption of traditions is highly valued as a means of sustaining the artisanal skills of a particular people or society. See also **ceramic**, **decorative arts,** and **textile art**.

 Patricia Belli (b. 1964)
 Claire Falkenstein (1908–97)
 Maren Hassinger (b. 1947)
 Liza Lou (b. 1969)
 Beverly Semmes (b. 1958)
 Renee So (b. 1974)
 Pae White (b. 1963)

CUBISM

Hugely important **modernist** art movement based in France from the late 1900s to the early 1920s, which spread internationally in Europe and beyond. It was especially influential to the development of modern art in the United States after Cubist and Proto-Cubist artworks from Europe were shown in the 1913 Armory Show in New York, Chicago, and Boston, gaining substantial media coverage (including many satirical responses in the popular press that brought it to wider public attention). The style is characterized by the fracturing of images, the simplification of form to its essential elements, and the use of unnatural and multiple perspectives.

DADA

Founded in Zürich in 1916, Dada was an anti-rational **modernist** art movement formed in response to the horrors of World War I. Rejecting artistic conventions, the Dadaists used performance, irony, and humor to subvert societal norms and shock the establishment. Many independent Dada groups were later set up in other European and American cities, and the movement was a strong force throughout the 1920s, as well as influencing later generations, including those referred to as neo-Dada artists—a term that has been applied from the 1960s onward to artists employing collage, **assemblage**, and **found objects**, and an anti-aesthetic agenda.

 Sophie Taeuber-Arp (1889–1943)

DECORATIVE ARTS

Term in **Western art** history for overtly decorated objects that are typically functional (furniture, clocks, tableware, etc.) but also including some nonutilitarian objects such as figurines. As with **craft**, the decorative arts have been considered of lesser status than fine art, although in some stylistic art movements such as **Art Deco**, **Art Nouveau**, **Bauhaus**, and **Rococo**, decorative arts (and also architecture) have been as, or even more, central than painting and sculpture.

 Félicie de Fauveau (1801–86)
 Rachel Feinstein (b. 1971)
 Elza Kövesházi-Kalmár (1876–1956)

DIASPORA

In relation to art, this term is used for artists who (or whose forebears) have migrated from one part of the world to another, including forcibly or under duress. Through their art they may express diverse experiences of multiple cultures and identities, often challenging the ideas and structures of dominant ideologies and expressing alternative perspectives and narratives. See also **identity politics**.

 Leilah Babirye (b. 1985)
 Rina Banerjee (b. 1963)
 Sokari Douglas Camp (b. 1958)
 Adebunmi Gbadebo (b. 1992)
 Tau Lewis (b. 1993)
 Precious Okoyomon (b. 1993)
 Alison Saar (b. 1956)

ENVIRONMENTAL / ECOLOGICAL ART

Term applied to art that is concerned with issues relating to the natural world, its ecologies, and all that humankind has done to threaten the Earth's ecosystem, particularly through industrialization, globalization, and consumerism. First becoming prominent in the 1960s, the following decades have seen a sharp increase in work that highlights and addresses climate change in particular, with both artistic and activist strategies being employed to communicate concerns, ideas, and alternative models of living. See also **Land art**.

 Lauren Berkowitz (b. 1965)
 Monica Bonvicini (b. 1965)
 Dora Budor (b. 1984)
 Alia Farid (b. 1985)
 Maya Lin (b. 1959)
 Mary Miss (b. 1944)
 Otobong Nkanga (b. 1974)
 Michelle Stuart (b. 1933)

Anicka Yi (b. 1971)
Andrea Zittel (b. 1965)

EPHEMERAL

Term for artworks that are deliberately intended to be temporary and made of materials that will degrade either naturally (such as flowers, food stuffs, or other organic matter) or due to environmental conditions (such as ice, smoke, and other evaporating and dispersing substances). Artists may make ephemeral art due to an interest in **nontraditional materials** and the creative potential of their physical properties, or may be driven by a desire to remove their work from the commercial market, or to push against the notion that artworks should be conserved in perpetuity.

 Lara Favaretto (b. 1973)
 Anya Gallaccio (b. 1963)
 Ann Veronica Janssens (b. 1956)
 Kitty Kraus (b. 1976)
 Rei Naito (b. 1961)
 Michelle Stuart (b. 1933)

EXPRESSIONISM

International art movement that flourished from 1905 through the 1920s, particularly in Germany and Scandinavia. Its practitioners sought to move away from pure representation in an attempt to externalize the human condition. Expressionist artists used distortion, bold colors, and abstract lines to convey spiritual and emotional messages. See also **Abstract Expressionism**.

 Käthe Kollwitz (1867–1945)

FEMINIST ART

Feminism rejects the notion that a heterosexual, white, male view of the world is a universal one, and seeks equality. The term "feminist art" emerged in the 1960s as part of second-wave feminism, but has roots in women artists' fight for increased visibility since the early twentieth century. Artists today continue to make feminist work. In a move away from male-dominated practices of painting and **traditional sculptural materials** and **processes** (**carving** and **casting**), feminist artists often utilized the materials and processes of **craft**, as well as film, video, body art, performance, **installation**, and **Conceptual art**. By changing the rules of how art is made and perceived, feminism questions the way in which women are represented by male artists. Feminist theorists and art historians have also challenged the orthodoxies of the mainstream **canon of art history** and initiated research into overlooked women artists. See also **identity politics**.

 Judy Chicago (b. 1939)
 Nancy Fried (b. 1945)
 Nancy Grossman (b. 1940)
 Madeleine Jouvray (1862–1935)
 Portia Munson (b. 1961)
 Lara Schnitger (b. 1969)
 Hannah Wilke (1940–93)

FIBER ART MOVEMENT

Art movement from the 1950s onward, particularly active in America and Europe, that sought to redefine work in materials such as fabric, silk, thread, wool, and yarn, and processes such as embroidery, knitting, knotting, sewing, and weaving as having the potential to be categorized as fine art rather than always being considered as **craft**. Many of these artists also sought to defy conventions regarding scale, producing **monumental** works and **installations** not typically associated with these materials. See also **textile art**.

 Magdalena Abakanowicz (1930–2017)
 Maren Hassinger (b. 1947)
 Sheila Hicks (b. 1934)
 Lenore Tawney (1907–2007)

FIGURATIVE ART

Art that depicts the world around us, whether with truthful accuracy or deliberate distortion. Figurative sculpture is typically associated with human or animal forms, although it can be used in a more general sense where art is derived from real object sources. The term "representational art" is often used synonymously, and **abstract art** is its opposite. See also **the nude** and **portraiture**.

 Camille Claudel (1864–1943)
 Paula Dawson (b. 1954)
 Nicole Eisenman (b. 1965)
 Elisabeth Frink (1930–93)
 Dora Gordine (1895–1991)
 Bharti Kher (b. 1969)
 Greer Lankton (1958–96)
 Ethel Myers (1881–1960)
 Jane Poupelet (1874–1932)
 Kiki Smith (b. 1954)
 Daisy Youngblood (b. 1945)

FLUXUS

An international collective, named in 1961, whose participants reacted against traditional art forms. The term described a condition of perpetual activity and change, and often the works made by Fluxus artists were inexpensive, low-tech, or **ephemeral**. Many **avant-garde** artists took part in Fluxus, and it paved the way for performance art and **Conceptual art**.

 Shigeko Kubota (1937–2015)
 Takako Saitō (b. 1929)

FOLK ART

A broad term used to define art produced outside the professionally sanctioned sphere of artistic production (such as the **art academy**), often created using materials and techniques that are traditional within a particular community or culture but historically considered as **nontraditional materials** within the institutions of fine art. The aesthetics and authenticity of folk art from different cultures have also been the source of inspiration for some contemporary artists.

FOUND OBJECT

Originating from the French *objet trouvé*, the term describes undisguised, but often modified, objects or images that are not normally considered art because they already have a nonart identity or function and are often everyday and mass-produced. A "found" object may form part of a larger **assemblage**, be displayed on its own as a **readymade**, or provide source material for an artwork. Featuring widely in **Dada**, **Surrealism**, and **Pop art**, found objects and images are also commonly used in contemporary art.

 Nina Beier (b. 1975)
 Alexandra Bircken (b. 1967)
 Karla Dickens (b. 1967)
 Fiona Hall (b. 1953)
 Mona Hatoum (b. 1952)
 Rebecca Horn (b. 1944)
 Jac Leirner (b. 1961)
 Tayeba Begum Lipi (b. 1969)
 Portia Munson (b. 1961)
 Cornelia Parker (b. 1956)
 Veronica Ryan (b. 1956)
 Doris Salcedo (b. 1958)
 Usha Seejarim (b. 1974)
 Valeska Soares (b. 1957)
 Diamond Stingily (b. 1990)
 Jessica Stockholder (b. 1959)

FOUNDRY

A **casting** facility for creating metal objects. Many sculptors who conceive cast-metal artworks will outsource the process to a specialist foundry to produce the final sculpture to the artist's specifications.

GANDHĀRAN SCULPTURE

A style of Buddhist visual art that developed and flourished in what is now northwestern Pakistan and eastern Afghanistan between the first century BCE and the fourth century CE. Its **figurative** style suggests the influence of both **Classical** Greek art and Indian art from the Gangetic Valley and it still provides inspiration to sculpture made today.

GLASS

Less common as a **traditional sculptural material** on account of its fragility, the nonporous and translucent qualities of glass have dictated its primary cultural functions (i.e., in windows and drinking vessels). Artistic mastery in glass can be seen in manufactured objects, particularly after the process of glassblowing was spread across the Roman Empire and became a means by which elaborate three-dimensional forms could be created beyond purely functional purposes. As a material that is liquid when heated and solidifies when cooled, glass objects can also be produced by **casting**. Technically speaking, glass is an amorphous solid, meaning it lacks the long-range order and repeating crystalline structure that is characteristic of true solids, such as metal or **stone**.

 Claire Falkenstein (1908–97)
 Monir Shahroudy Farmanfarmaian (1922–2019)
 Simone Fattal (b. 1942)
 Hannah Levy (b. 1991)

GLOBAL SOUTH

Broad grouping of Latin America, Africa, and some parts of Asia and Oceania, the term's roots lie in the division of the world into "North" and "South" by the United Nations in the 1960s. This was done along economic lines rather than strictly geographical hemispheres, although most of the Global South countries are located in or south of the equator. "Global" was added as a means of reinforcing worldwide interconnectedness, and to assist cross-regional and multilateral alliances. See also **Western art**.

GUTAI

Radical art group in Japan, founded in 1954 in response to the reactionary context of the post World War II period. This influential group, also known as *Gutai Bijutsu Kyokai* (Gutai Art Association), was involved in large-scale multimedia environments, performances, and theatrical events. A precursor to the "happenings" of the late 1950s in New York, and later body art and **Conceptual art**, many of the group's activities involved physical acts of exertion.

 Yamazaki Tsuruko (1925–2019)

HARD-EDGED

Term coined in 1959 by Californian critic Jules Langster to describe the work of **abstract** painters (especially on the West Coast of the United States) whose art was in contrast with the more gestural forms of **Abstract Expressionism**. The term was also applied to sculpture characterized by sharply defined, geometric shapes and clean, precise lines and it became particularly associated with **Minimalism**.

 Tauba Auerbach (b. 1981)
 Mikala Dwyer (b. 1959)
 Helen Escobedo (1934–2010)
 Iman Issa (b. 1979)

 Kim Lim (1936–97)
 Anne Truitt (1921–2004)

HARLEM RENAISSANCE

Black intellectual and artistic movement of the 1920s and 1930s, centered in the Harlem neighborhood of New York and considered one of the most significant cultural eras in American history. Across literature and the visual and performing arts, the figures associated with the movement explored Black identity and celebrated Black culture and history. See also **Black Arts Movement**.

 Meta Vaux Warrick Fuller (1887–1968)
 Augusta Savage (1892–1962)

HYPERREALISM

Term coined in the early 1970s to describe highly realistic, **figurative art** that is founded on the principles of photorealism yet takes it further. Hyperrealist sculptors often use materials that look lifelike, yet play with scale or use other unexpected elements or distortions that create an unsettling and uncanny effect, often evoking narrative elements, political values, or emotive aspects.

 Patricia Piccinini (b. 1965)

IDENTITY POLITICS

Emerging from the 1960s Black civil rights movement, second-wave feminism, and LGBTQ+ liberation, the term describes a cultural movement that gained prominence in Europe and the United States in the mid-1980s. Identity politics raises questions about repression, inequality, and injustice, often focusing on the experiences of marginalized groups, past and present. In more recent years, "intersectionality"—the idea that gender, race, sexual orientation, age, religion, etc. do not exist separately, but form an interwoven complex that defines an individual's lived experience—has expanded how identity politics are understood and represented in art. See also **feminist art**, **Indigenous art**, **political art**, **postcolonial art**, and **Queer art**.

INDIGENOUS ART

Broad term for art that addresses ethnic identity in relation to the native peoples of a given place, prior to its colonization. While some Indigenous artists make work that continues long-standing cultural traditions (40,000 years in the case of some Australian Aboriginal art practices), others make work that directly references the historic or contemporary plight of Indigenous peoples. See also **postcolonial art**.

 Margarita Azurdia (1931–98)
 Natalie Ball (b. 1980)
 Karla Dickens (b. 1967)
 Delcy Morelos (b. 1967)
 Cecilia Vicuña (b. 1948)
 Lena Yarinkura (b. 1961)

INDUSTRIAL MATERIALS

Any physical material that was developed for, and is more commonly used in, industrial purposes, particularly manufacturing and construction. This includes both natural and artificial raw materials that are **nontraditional sculptural materials** because of quality, durability, or economic or cultural value. The term includes aluminum, concrete, rubber, tin, and many different forms of plastic—including acrylic (Lucite, Perspex, and Plexiglas), fiberglass, **resin**, synthetic latex, and vinyl. **Readymade** and **found objects** from an industrial context (such as beams, bricks, wheels, and vehicle parts) also fall into this category. As well as the creative potential offered by the physical properties of such materials, artists have also engaged them to draw on the poignant meanings they evoke in relation to their usual everyday function, outside of an art context.

Shaikha Al Mazrou (b. 1988)
Alice Aycock (b. 1946)
Fiona Banner (b. 1966)
Phyllida Barlow (1944–2023)
Lynda Benglis (b. 1941)
Monica Bonvicini (b. 1965)
Chakaia Booker (b. 1953)
Gisela Colón (b. 1966)
Alia Farid (b. 1985)
Sheela Gowda (b. 1957)
Nadia Kaabi-Linke (b. 1978)
Reena Saini Kallat (b. 1973)
Marjetica Potrč (b. 1953)

INSTALLATION

Also used to describe the process of positioning works in the gallery setting, installation has come to denote a distinct kind of art. Installation art describes works comprising individual elements within a defined space that is viewed as a single work. It can be made from one or several materials, including nontangible media such as sound and light. Some Installation art is **ephemeral** and exists only temporarily. Some is created for a particular location, with those that cannot be relocated elsewhere being referred to as **site-specific**. See also **Light art**.
Yto Barrada (b. 1971)
Tara Donovan (b. 1969)
Ayşe Erkmen (b. 1949)
Lara Favaretto (b. 1973)
Cristina Iglesias (b. 1956)
Rita McBride (b. 1960)
Füsun Onur (b. 1938)
Cornelia Parker (b. 1956)
Katie Paterson (b. 1981)
Sarah Sze (b. 1969)
Tatiana Trouvé (b. 1968)

KINETIC ART

Any artwork that involves movement—either real or illusory—of all or part of an artwork, including the movement of light, water, or smoke. Starting in the early twentieth century, when modern technology introduced new **nontraditional materials** and motors to art, kinetic art played an important part in **Constructivism** and has continued to be used by artists ever since.
Rosa Barba (b. 1972)
Jenny Holzer (b. 1950)
Rebecca Horn (b. 1944)
Liliane Lijn (b. 1939)
Laura Lima (b. 1971)
Annette Messager (b. 1943)
Michal Rovner (b. 1957)

KOUROI

Plural of *kouros*, a type of **Classical** Greek **figurative** statue of a young standing male whose initial appearance coincides with the reopening of Greek trade with Egypt (c. 672 BCE). The earliest *kouroi* followed the Egyptian geometric norms: a broad-shouldered and narrow-waisted nude with arms held close to the sides, clenched fists, and both feet on the ground, with the left foot slightly advanced, while later *kouroi* became increasingly naturalistic.

LAND ART

Art movement that began in the late 1960s as a reaction to the insularity of gallery-contained art,

the commodification of art in the market, and as a response to growing environmental concerns. Land artists produce monumental works, often in remote locations, inspired by such ancient structures as Stonehenge in Britain, Nazca Lines in Latin America, and Native American burial mounds, as well as using natural materials, including earth, vegetation, and **stone**. See also **environmental / ecological art**.
Agnes Denes (b. 1931)
Nancy Holt (1938–2014)
Mary Miss (b. 1944)
Meg Webster (b. 1944)

LIGHT AND SPACE MOVEMENT

Style that developed in the 1960s on the West Coast of the United States in parallel with **Minimalism** in New York. While both were characterized by **industrial materials** and a **hard-edged**, geometric aesthetic, Light and Space artists experimented with newer technologies and industrial materials including polyester resins, cast acrylic, and neon and argon lights. Their works also embraced the concept of the **sublime** as an all-encompassing, timeless, and transcendental, aesthetic experience.
Brigitte Kowanz (1957–2022)
Helen Pashgian (b. 1934)

LIGHT ART

Term for any art that uses light as a medium either predominantly or entirely, particularly electric light, whether neon, fluorescent, or incandescent bulbs, or LEDs (light-emitting diodes). Artificial light was first introduced into art in the **Constructivist** and **Bauhaus** movements, but gained momentum in the second half of the twentieth century in **Pop** and **Minimalist** sculptures, and through movements such as **Light and Space** where **installations** formed of only light were conceived. Such immersive, experiential works have had a resurgence in the twenty-first century, driven in part by new technologies that enable light sequences to be programmed and choreographed.
Angela Bulloch (b. 1966)
Elaine Cameron-Weir (b. 1985)
Chryssa (1933–2013)
Laura Grisi (1939–2017)
Brigitte Kowanz (1957–2022)
Liliane Lijn (b. 1939)
Won Ju Lim (b. 1968)

LOST-WAX CASTING

Process developed for **casting** metal that dates back over six thousand years, enabling hollow or intricate objects to be produced. The intended final form is captured in a thin layer of wax coating the inside of a mold. The hollow wax model is then packed with foundry sand (that can withstand high heat). When baked, the wax layer melts and is lost through draining holes. Molten metal is then poured in to take the form in the space vacated by the wax. After cooling, the mold is removed and sand shaken out of the metal cast. The process has also been adapted for casting **glass**.
Kelly Akashi (b. 1983)
Meera Mukherjee (1923–98)

MARBLE

Type of **stone** that became highly prized as a **traditional sculptural material** from Classical times onward. As marble is a relatively soft rock that is also resistant to shattering, it can be carved into detailed forms. The way in which light penetrates its surface also appealed to artists who identified that this brought a more lifelike quality to **figurative** sculptures. White marble in particular is associated with **Western art** history, in part due to its availability across

the Mediterranean region. While a white marble statue may be considered the archetypal form of **Classical** sculpture—hence its revival by **Neoclassical** artists—in fact, many such ancient works were once **polychrome**.
Han Sai Por (b. 1943)
Harriet Hosmer (1830–1908)
Edmonia Lewis (c. 1844–1907)
Rita Longa (1912–2000)
Rebeca Matte (1875–1929)
Claude Vignon (1828–88)

MATERIALITY

A concern with the essential physical qualities of materials and their potential for transformation through creative intervention and processes. Artists interested in materiality foreground the material from which a sculpture is formed, rather than their work representing something else (as in **portraiture**). As the range of materials used in sculpture has expanded and diversified, to include **nontraditional** and **industrial materials**, so more artists have embraced materiality as their primary concern.
Ruth Asawa (1926–2013)
Nina Canell (b. 1979)
Roni Horn (b. 1955)
Liz Larner (b. 1960)
Laura Lima (b. 1971)
Kennedy Yanko (b. 1988)

MEMENTO MORI

Western art historical term that is applied to still life paintings in which particular objects are included to represent the passing of time and mortality, to remind the viewer of the fleeting nature of life. The Latin phrase literally translates as "remember you must die," and was particularly popular in seventeenth-century European painting traditions. While it does not have the same history in relation to sculpture, where **still life** was not a common subject until the twentieth century, the same symbolic objects from earlier painting can now be found in sculpture to signify the same meanings.
Anya Gallaccio (b. 1963)
Shirley Tse (b. 1968)

MINIMALISM

Art movement beginning in the 1960s that can be seen as an extreme form of **abstract art**. Works are made of simple geometric configurations with serial, repeating elements and sculptural pieces that often incorporate **nontraditional** or **industrial materials**. Minimalist art is concerned mainly with purity and perfection of form rather than representing the external world. See also **post-Minimalism** and **aggregation**.
Kazuko Miyamoto (b. 1942)
Jackie Winsor (b. 1941)

MIXED MEDIA

Shorthand term for an artwork comprising multiple materials (and not to be confused with multimedia, which relates to art involving electronics). The term was especially embraced by some **feminist artists** who deliberately rejected the **traditional sculptural materials** connected to **patriarchal values** yet sought to avoid the categorization of their work as **craft** when using associated materials. As the art world has developed a broader attitude toward **nontraditional sculptural materials**, many artists have returned to more specific and precise descriptions of materials, sometimes resulting in substantially expanded captions in books and museum labels listing all of the many materials and objects used in any one work.
Abigail DeVille (b. 1981)
vanessa german (b. 1976)
Lauren Halsey (b. 1987)
Edith Karlson (b. 1983)
Zsófia Keresztes (b. 1985)
Lucy Skaer (b. 1975)

MODELING

The working of a malleable material, such as **clay** or wax, to create a desired sculptural form. The resulting form may be a finished sculpture in itself, or used to create a mold for **casting** a sculpture in another material.

Abastenia St. Leger Eberle (1878–1942)
Caterina de Julianis (1670–1743)
Daisy Youngblood (b. 1945)

MODERNISM

More of a paradigm than a style, modernism is
a celebration of the new and a rejection of the
continuity of tradition. The term encompasses an
array of **avant-garde** movements in art, design,
and architecture from the mid-nineteenth to the
mid-twentieth century (including **Concrete art**,
Constructivism, **Cubism**, and **Dada**), with
artists seeking to visually represent modern life.
By the late 1960s modernism was displaced as the
dominant cultural ideology by **postmodernism**,
which deliberately sought to react against the
principles and aesthetics of modernism. More
recently, modernism has been revived as a stylistic
motif resonant of a utopian ideology.

Saloua Raouda Choucair (1916–2017)
Sonja Ferlov Mancoba (1911–84)
Lily Garafulic (1914–2012)
Barbara Hepworth (1903–75)
Elza Kövesházi-Kalmár (1876–1956)
Chana Orloff (1888–1968)
Germaine Richier (1902–59)

MONUMENTAL

A word applied to sculpture that resembles
a monument in terms of size or importance.
Monuments have typically been created to
commemorate a notable person(s), place, or
event. In art writing, the term "monumental" is
often used more loosely to describe works that
are large, solid, or imposing, especially in relation
to human scale, even when exhibited without a
plinth to elevate them above eye level.

Phyllida Barlow (1944–2023)
Heidi Bucher (1926–93)
Tracey Emin (b. 1963)
Sheila Hicks (b. 1934)
Katarzyna Józefowicz (b. 1959)
Yayoi Kusama (b. 1929)
Vera Mukhina (1889–1953)
Virginia Overton (b. 1971)
Marjetica Potrč (b. 1953)
Ursula von Rydingsvard (b. 1942)

NEGATIVE SPACE

In relation to sculpture, the term used to describe
the empty space created in relation to a three-
dimensional object (including its interior space
and gaps between elements of a complete work)
or between an object and its near surrounding.
For some artists, the consideration of the shape
of negative space that their work creates is
as fundamental as the physical aspects of the
object itself. Contemporary art has also seen
artists draw attention to negative space where it
might typically be overlooked in **found objects**,
and create sculptures whose entire forms are
representations of normally empty volume.

Rachel Whiteread (b. 1963)

NEOCLASSICAL

Predominant artistic style in Europe and North
America between 1750 and 1830. The revival of
Classical (Greek and Roman) styles was based
on a new and unprecedented understanding of the
art and architecture of these ancient civilizations
as a result of the discovery of Pompeii and
Herculaneum in southern Italy. Neoclassical art
emphasized calm simplicity and noble grandeur,
in reaction to the preceding **Rococo** movement.

Anne Seymour Damer (1748–1828)
Harriet Hosmer (1830–1908)
Edmonia Lewis (c. 1844–1907)
Claude Vignon (1828–88)

NEO-CONCRETISM

Brazilian art movement that launched with a
manifesto in 1959, proposing a more sensual,
colorful, and poetic version of **Concrete art**—the
European high-modernist style of **abstraction**
that used pure, geometric forms with no symbolic
meaning or elements of representation.

Lygia Clark (1920–88)
Lygia Pape (1927–2004)

NKISI

Objects invested with sacred energy and used for
spiritual protection according to traditions rooted
in west-central Africa and transmitted to the
Americas during the transatlantic slave trade.
A wooden sculpture, often **anthropomorphic**
or zoomorphic, is passed to a ritual specialist,
a nganga, to activate the figure by filling cavities
with materials that are considered to have
medicinal and magical properties. Over time,
as clients approach the nganga for help, various
objects are added to the Nkisi's exterior, such
as cloth, shells, beads, rope, and nails.

NONTRADITIONAL SCULPTURAL MATERIALS

Materials not historically used in **Western art**
became more prevalent from the early twentieth
century onward, in part due to the expanded
practices of artists considered key to the
development of **modernism**. Movements such
as **Dada**, in which the use of **readymades** and
found objects and the process of **assemblage**
were elevated in status, were a catalyst for a
shift toward an art world in which any material
became viable, even those that may not be
durable or stable—qualities that would once have
excluded their use. Such materials may be labeled
unconventional or unexpected if they seem
especially out of place in an art context. See also
ephemeral and **industrial materials**.

NOUVEAU RÉALISME

A European movement that emerged in the
late 1950s and focused on everyday items and
found objects for aesthetic ends. The term was
coined in 1960 and translates as "New Realism."
Primarily based in France, the Nouveau Réalistes
reacted against the gestural paintings of **Abstract
Expressionism**, producing works that were
more rooted in contemporary life. Superficially
resembling **Pop art**, the work is in fact closer
to **assemblage** in its emphasis on the use of
discarded materials.

Nicòla L. (1932–2018)
Niki de Saint Phalle (1930–2002)

THE NUDE

In literal terms, the nude is the unclothed human
figure as a subject in art. However, the nude is
differentiated from the naked body in terms of
the artist's intention, meaning, and symbolism,
which are usually rooted in the dominant cultural
ideology in which an artist is operating. The nude
in art has often represented the idealized human
form (as perceived by a particular culture), or is
used as a means of reflecting societal attitudes
regarding sexuality, social structure, or gender.
The female nude has had a particular place in
certain strands of art history—from its role as
a symbol of fertility from the Upper Paleolithic
period onward to the trope of the "reclining
nude" in **Western art** since the **Renaissance**. A
consideration of the nude, especially the female
nude, has been a central focus in feminist art
history and for many **feminist artists** who have
sought to make works that both critiqued and
overturned traditional representations of the nude.

Nina Beier (b. 1975)
Camille Claudel (1864–1943)
Vaska Emanuilova (1905–85)
Nancy Fried (b. 1945)
Madeleine Jouvray (1862–1935)
Jane Poupelet (1874–1932)

PARTICIPATORY

A form of art in which the audience/viewer is
directly involved in the activation of the artwork
in order to complete it, or to impact its meaning
(possibly including the introduction of meanings
not fixed or predetermined by the artist). One of
several art forms that challenge the notion that
an artwork, by definition, must always be created
by an individual, professional artist.

Ghazaleh Avarzamani (b. 1980)
Shilpa Gupta (b. 1976)
Mariko Mori (b. 1967)
Senga Nengudi (b. 1943)
Rivane Neuenschwander (b. 1967)
Lygia Pape (1927–2004)

PATINA

A thin layer on the surface of an object that may
occur naturally (acquired) as a result of chemical
reactions between a material and an aspect of the
surrounding environment such as air and water,
or artificially (applied) where the maker adds a
layer in order to change the material's durability or
appearance. For some materials, such as weathered
steel, the development of a natural patina provides
a protective layer that prevents the material from
further degradation, which is particularly important
for **public art** that is permanently sited outdoors
or in a **sculpture park**.

Sonja Ferlov Mancoba (1911–84)
Alicja Kwade (b. 1979)
Beverly Pepper (1922–2020)
Jane Poupelet (1874–1932)
Ursula von Rydingsvard (b. 1942)
Alison Wilding (b. 1948)

PATRIARCHY / PATRIARCHAL VALUES

A patriarchy is a social system of male domination
that can exist in both public and private spheres.
Patriarchies are sustained with a set of ideas—a
patriarchal ideology—that act to explain and
justify this dominance by attributing it to inherent
natural differences between men and women.
Feminist theorists have written extensively about
patriarchy as a primary cause of gender inequality.

PERFORMATIVE SCULPTURE

Term used for sculpture that is activated or
finished by an artist's own—or someone else's—
body. In contrast with performance art, which
may or may not involve props, performative
sculpture features objects that have been made
or assembled by the artist, and which are a
central aspect of the work. Such objects are often
displayed as discrete art objects in themselves.

Maren Hassinger (b. 1947)
Senga Nengudi (b. 1943)

PLASTER

While in terms of wider art history, plaster can
also refer to a material used to cover walls on
which frescoes are painted, in sculpture, plaster
usually refers to plaster of Paris. A fine white
powder made of pulverized gypsum stone is
roasted to alter its chemistry so that, when mixed
with water and cast or molded into a form, it then
doesn't crack or shrink and lose volume when
it dries and sets. While plaster is known to have
been used as far back as ancient Egypt, "of Paris"
was used from the eighteenth century, when high-
quality gypsum deposits, found in the Montmartre
area of the French capital, became favored
for plaster used by sculptors. Plaster was not
considered a **traditional sculptural material**
in that it tended to be used in the service of
other more durable and valuable materials,
either to create copies of highly prized sculptures
(particularly for use in **art academies**); for
making molds for **casting**; or to make maquettes
and models using cloth, such as gauze, dipped in
wet plaster and shaped over an **armature**.

Mária Bartuszová (1936–96)
Jodie Carey (b. 1981)
Dora Gordine (1895–1991)
Clara Rilke-Westhoff (1878–1954)

PLINTH / PEDESTAL

A block or platform on which a sculpture is placed so that its base is not in direct contact with the ground, it is often simple and utilitarian in form, in contrast with a pedestal, which is usually narrower, decorative, and/or designed with the intention of enhancing the presentation of the artwork it elevates. A high plinth or pedestal serves practical and symbolic functions, relating to preservation (raising it out of reach of the viewer or other ground-level threats) and to increase its perceived size and impact in relation to the human scale of a viewer. This is particularly impactful for statues of figures (both human and divine) considered important to the society from which they were commissioned. In **modernism** and contemporary art, sculptors have often deliberately avoided using plinths to separate their work from statuary. This is achieved by placing work directly on the floor, or by suspending work by hanging it from a ceiling or wall. See also **monumental**.

Janine Antoni (b. 1964)
Camille Claudel (1864–1943)
Mary Sibande (b. 1982)

POLITICAL ART

Broad term to describe art where the maker's intention is to highlight or critique political, social, or ideological systems in the wider world, particularly in relation to issues of power, economics, inequality, and injustice. See also **feminist art**, **identity politics**, and **postcolonial art**.

POLYCHROME

Term used to describe the decoration of a sculpture's surface with multiple colors using glazes, paints, or pigments. Polychrome is primarily applied for aesthetic and symbolic purposes, although in some cases it was also used to provide a protective surface to prevent material degradation due to exposure to air or water, and sometimes even as a means of disguising the underlying material to elevate its value.

Beverly Buchanan (1940–2015)
Vanessa da Silva (b. 1976)
Helen Escobedo (1934–2010)
Félicie de Fauveau (1801–86)
Caterina de Julianis (1670–1743)
Yayoi Kusama (b. 1929)
Andrea de Mena (1654–1734)
Annie Morris (b. 1978)
Luisa Roldán (1652–1706)

POP ART

Abbreviation for "popular art," the term is used to describe a movement that began in the late 1950s and flourished until the 1970s, independently but simultaneously in Europe, the United States, and Latin America. It included artists working in a variety of different styles whose subject matter embraced and celebrated popular commercial culture, including advertising, photography, comics, and the entertainment industry. Pop art sculptures–including those made today by artists who continue Pop's legacy–often used **nontraditional** or **industrial materials** and employed strategies such as **appropriation** to connect the art object more directly to the everyday life of the viewer.

Teresa Burga (1935–2021)
Sylvie Fleury (b. 1961)
Marisol (1930–2016)
Paola Pivi (b. 1971)
Joana Vasconcelos (b. 1971)

PORTRAITURE

One of the oldest genres of art, going back to ancient Egypt, portraiture was one of art's primary functions before photography. Portraits are a means of documenting a person's physical appearance, but they are often also intended to represent nonphysical aspects of the sitter, such as their values, wealth, taste, power, status, and intellect. In contrast to **figurative art**, in which a human subject may be anonymous or generic in order to represent an idea, in portraiture the sitter is a specific individual who is usually named—many portraits are created on commission. As well as capturing others, artists often create self-portraits, taking themselves as the subject, sometimes repeatedly throughout their artistic careers.

Marie-Anne Collot (1748–1821)
Gertrude Hermes (1901–83)
Artis Lane (b. 1927)
Chana Orloff (1888–1968)
Clara Rilke-Westhoff (1878–1954)
Irena Sedlecká (1928–2020)

POSTCOLONIAL ART

Art that analyzes and exposes the legacies of colonial rule and the many consequences—short- and long-term—for those colonized and exploited. Issues relating to race, ethnicity, and cultural and national identity are central themes. See also **Diaspora**, **identity politics**, and **Indigenous art**.

Claudia Casarino (b. 1974)
Abigail DeVille (b. 1981)
Bronwyn Katz (b. 1993)
Ayesha Singh (b. 1990)
Kara Walker (b. 1969)

POST-MINIMALISM

Term used since the early 1970s to describe art that is influenced by, and develops further, the aesthetics and ideas of **Minimalism**. Often using **nontraditional materials**, artists employ themes found in Minimalism, such as the grid and seriality, but with a human element that contrasts the **hard-edged** forms and lack of external references of pure Minimalism.

Alice Adams (b. 1930)
Ruth Asawa (1926–2013)
Rana Begum (b. 1977)
Rosemarie Castoro (1939–2015)
Mikala Dwyer (b. 1959)
Eva Hesse (1936–70)
Meg Webster (b. 1944)

POSTMODERNISM

As well as pushing some aspects of **modernism** to the extreme, postmodernism saw the return of elements of **Classical** styles. Characteristics of postmodernism include a refusal to recognize any single definition of art, a blurring of the boundaries between fine art and popular culture, and frequent use of **appropriation**.

Rachel Feinstein (b. 1971)
Rachel Harrison (b. 1966)
Sherrie Levine (b. 1947)
Judy Pfaff (b. 1946)
Ayesha Singh (b. 1990)

PRE-COLUMBIAN / PRE-HISPANIC

Terms used to describe the period of time in the Americas before Christopher Columbus arrived from Spain with the first wave of European colonists in the late fifteenth century. In Latin America, it broadly refers to the history, art, and archaeology of a multitude of Indigenous cultures. A number of artists across Latin America (and beyond, in terms of the wider **Diaspora**) have made conscious reference to pre-Columbian motifs, forms, and methods in their work, combining these with modern and contemporary approaches to art-marking as a way of synthesizing their cultural histories with a wider global movement. See also **Indigenous art**.

PRIMITIVISM

Art movement that developed in the early twentieth century, where European artists—most famously Pablo Picasso (1881–1973)—drew inspiration and, at times, appropriated art forms, styles, and compositions from ethnic groups in Africa, Oceania, and Latin America whose visual culture was mislabeled as "primitive" (in other words, underdeveloped and lacking sophistication in relation to notions of artistic progress and the aesthetic values of Western cultures, which to the artists involved represented a kind of purity and freedom). Today, the term carries derogatory connotations due to the ethnocentrism and fetishization of the cultures implied by it.

Sonja Ferlov Mancoba (1911–84)

PROCESS ART

Type of art made from the late 1960s onward whereby the process of the production is foregrounded in the finished piece, which can emphasize different aspects of making including the time involved, the physical act, **materiality**, and how the artist interacts with mediums used.

Lynda Benglis (b. 1941)
Heidi Bucher (1926–93)
Tara Donovan (b. 1969)

PUBLIC ART

Art that is exhibited in a place where it can be freely viewed by the public. It is often in an outdoor setting, which requires particular considerations about materials to ensure they can withstand the elements. Public sculptures are typically designed specifically for their location, making them **site-specific**, and serve a variety of purposes from commemoration to aesthetic or economic enhancement of the surrounding area. Public art may be paid for privately or by public bodies, and while many such works are in situ permanently, others are installed temporarily, including those commissioned as part of rolling programs such as the Public Art Fund and the High Line, New York, or Fourth Plinth, London.

Ghazaleh Avarzamani (b. 1980)
Alice Aycock (b. 1946)
Tracey Emin (b. 1963)
Marie-Louise Lefèvre-Deumier (1812–77)
Rita Longa (1912–2000)
Vera Mukhina (1889–1953)
Tomie Ohtake (1913–2015)
Katrina Palmer (b. 1967)
Beverly Pepper (1922–2020)
Nancy Rubins (b. 1952)
Alyson Shotz (b. 1964)
Gertrude Vanderbilt Whitney (1875–1942)

QUEER ART

Term used for art that represents issues relating to Queer (lesbian, gay, bisexual, trans-, and other nonbinary or gender nonconforming) identities. The term evolved out of the gender and **identity politics** of the 1980s and refers to art that takes alternative sexuality as its subject, including historic works made at a time when sexual fluidity was considered deviant.

Leilah Babirye (b. 1985)
Greer Lankton (1958–96)
Precious Okoyomon (b. 1993)

READYMADE

A term used since 1916 to describe an everyday object selected by an artist and placed in an art context without significant alteration. Such an action implies that it is not the object itself that carries artistic value but rather the context in which the object is displayed. This idea drastically changed the course of art, shifting art production from a technical to a **conceptual** concern and opening up the possibility for many **nontraditional materials** to be brought into the artist's realm. See also **found object** and **assemblage**.

Fiona Connor (b. 1981)
Ceal Floyer (b. 1968)
Meret Oppenheim (1913–85)

RELIEF

Wall-hung works in which sculpted elements appear raised from a flat plane so elements project into the space in front of the picture plane so that, seen from an oblique angle, they are revealed as three-dimensional. See also **bas-relief**.

Fiona Hall (b. 1953)
Caterina de Julianis (1670–1743)
Ana Navas (b. 1984)

RENAISSANCE

Word used generally to describe periods in which there is renewed artistic or cultural vigor, often inspired by the past. Specifically, it also refers to the period between the fourteenth and seventeenth centuries, starting in Italy and spreading across Europe, during which there was a revival of learning based on Classical literary sources. The use of perspective and other techniques was developed in painting, and increasing realism was expressed in sculpture; **Classical** art served as inspiration. The Early Renaissance spans the fifteenth century, the High Renaissance dates to the first quarter of the sixteenth century and was confined mainly to Italy, and the Late Renaissance followed after c. 1525. See also **Harlem Renaissance**.

Properzia de' Rossi (c. 1490–1530)

RESIN

While natural-occurring plant resins have long been used by humankind for a variety of purposes, the invention in the 1930s of synthetic polymer resins—viscous substances that become rigid by a process of curing—has impacted modern sculpture with artists exploring both the aesthetic and material potential that **casting** resin can offer: the translucency of glass with the durability of metal. Resin can also be tinted with pigment or painted. See also **industrial materials**.

Jane Alexander (b. 1959)
Helen Pashgian (b. 1934)
Alina Szapocznikow (1926–73)
Rachel Whiteread (b. 1963)

ROCOCO

Ostentatious decorative style that became very popular in France, southern Germany, and Austria in the eighteenth century. Rococo architecture, interiors, furniture, and objects were characterized by asymmetry and the playful use of organic forms. Motifs such as shells, leaves, and cherubs were particularly prominent. Rococo was lighter in tone than both the more monumental **Baroque** style from which it stemmed and the more formal **Neoclassicism** that succeeded it.

S

SALON

Originally the name of the official art exhibitions organized by the French **art academy** from 1725 onward. Inclusion in Salons was at the discretion of academies. In the late nineteenth century there was a rise of alternative, unofficial Salons to accommodate more experimental work than the conservative establishment would allow. "Salon" became adopted as a more generic term for mixed art exhibitions.

SCULPTURE GARDEN / PARK

An outdoor area that has been allocated specifically for the presentation of sculptures, which may or may not include cultivated vegetation typically associated with gardens. Often created by collectors, they can equally feature monographic displays or present works by multiple artists, sometimes united by a theme such as an art movement, historic period, or subject matter. Some individual artists, such as Niki de Saint Phalle (p.266), have created sculpture gardens entirely of their own works, which become a form of **installation** and are preserved in their entirety as a

complete work. Larger sculpture gardens, especially those that are accessible to the public, may be called sculpture parks.

SITE-SPECIFIC

Term used for art that was made for a particular location that has some connection to its surrounding environment, so that its meaning would be changed or lost if it were sited elsewhere. Site-specific art can be permanent, temporary, or **ephemeral**. See also **Land art**.

Tara Donovan (b. 1969)
Nancy Holt (1938–2014)
Teresa Margolles (b. 1963)
Mary Miss (b. 1944)
Cecilia Vicuña (b. 1948)

SOCIALIST REALISM

Term used to describe a style of painting and sculpture in which the rule of the proletariat is idealized and celebrated. It was made the official style of the USSR from 1934—artists who worked in other styles risked imprisonment—until the death of Joseph Stalin. It later became the officially sanctioned style in China.

Vaska Emanuilova (1905–85)
Vera Mukhina (1889–1953)
Irena Sedlecká (1928–2020)

SOFT SCULPTURE

Loose term used for three-dimensional art made from nonrigid and therefore **nontraditional sculptural materials**, including those used in **textile art** and some papers and plastics (e.g., foam rubber and synthetic latex). It also includes works employing **found objects** with these qualities. With roots in the work of **Surrealist** sculptors such as Meret Oppenheim (p.236) and **Pop artists** such as Claes Oldenburg (1929–2022), soft sculpture is particularly prevalent in **post-Minimalism**.

Sylvie Fleury (b. 1961)
Laura Ford (b. 1961)
Lee Bul (b. 1964)
Sarah Lucas (b. 1962)
Marta Minujin (b. 1943)
Dorothea Tanning (1910–2012)

STEEL

Alloy of iron and carbon that is stronger and less prone to fracture than iron, and can be cast, welded, or beaten into shape. The addition of chromium creates stainless steel, which is non-reactive to the elements and maintains its silvery shine, making it a popular material for **public art**. Some artists, however, prefer the matt surface and red-brown hues created by a **patina** of rust; Cor-ten (or weathering) steel, which develops a stable and consistent surface layer of rust through oxidization and is also harder and stronger than other alloys, became particularly associated with **Minimalism** and **monumental** sculpture, with Beverly Pepper (p.245) credited as the first artist to use the material in 1964.

Carol Bove (b. 1971)
Sokari Douglas Camp (b. 1958)
Monika Sosnowska (b. 1972)

STILL LIFE

A composition that depicts (mostly) inanimate subject matter, typically everyday objects. Arrangements of flowers and/or fruits and other foods are particularly popular subjects. Still life emerged as a distinct genre in **Western art** history in the Dutch painting of the late sixteenth to seventeenth century, and while less common as a genre of sculpture prior to **modernism**, the term has come to be applied particularly to sculptures employing **found objects** and **readymades**. See also **memento mori**.

Petah Coyne (b. 1953)
Kathleen Ryan (b. 1984)
Nicole Wermers (b. 1971)

STONE

The durability of stone has enabled carved objects to survive for millennia. The earliest discovered objects with artificially incised grooves date back over a quarter of a million years. Stone sculpture is traditionally created by hand-carving and requires skill and expertise in the material

properties of each type of stone. Technological developments in machine-carving and the creation of castable composite stone, such as concrete and Jesmonite, have also impacted how stone is used in contemporary sculptural practices. See also **industrial materials**.

Gu Erniang (flourished 1700–c. 1727)
Holly Hendry (b. 1990)
Bronwyn Katz (b. 1993)
Alicja Kwade (b. 1979)
Tosia Malamud (1923–2008)
Gertrude Vanderbilt Whitney (1875–1942)

SUBLIME

In art, the sublime refers to a quality of greatness or grandeur that inspires awe and wonder. From the mid-eighteenth century it became a deliberate artistic effect, in which the artist aimed to evoke the strongest emotion possible in the mind of the viewer, particularly in relation to depictions of landscapes and nature.

Petah Coyne (b. 1953)
Teresita Fernández (b. 1968)

SURREALISM

Artistic and literary movement prominent from the 1920s onward—with continued influence today—which sought to explore the unconscious mind. Surrealists produced fantastical, disturbing, and sometimes humorous works of art, using many styles and media, including **found objects**, **hyperrealism**, and manipulated photography. It was especially influential in France, Britain, Mexico, and across Latin America.

Louise Bourgeois (1911–2010)
Maria Martins (1894–1973)
Meret Oppenheim (1913–85)
Dorothea Tanning (1910–2012)

SYMBOLISM

Literary and artistic movement of the 1880s and 1890s that aimed to explore the psyche, using objects symbolically to express underlying ideas and emotions. Reacting against the growing dominance of Impressionism and Realism, Symbolists aimed to reconcile matter and spirit through a language of signs and hidden meanings.

Sarah Bernhardt (1844–1923)
Madeleine Jouvray (1862–1935)

T

TEXTILE ART

The term can be applied to any work made of fabric or yarn, including weaving, tapestry, embroidery, and quilting. "Textile" may also be used to describe nonwoven or thread-based materials, such as leather, hair, or raw wool and for works comprising **found objects** of any of these materials, including clothing and soft furnishings. See also **craft**, **Fiber Art Movement**, and **soft sculpture**.

Olga de Amaral (b. 1932)
Tamar Ettun (b. 1982)
Sue Fuller (1914–2006)
Sonia Gomes (b. 1948)
Nancy Grossman (b. 1940)
Klára Hosnedlová (b. 1990)
Lin Tianmiao (b. 1961)
Mrinalini Mukherjee (1949–2015)
Yin Xiuzhen (b. 1963)

TOTEM

In its original sense, the word "totem" refers to a symbolic object, often carved or otherwise formed by human hands, that represents a specific group of people, such as a tribe, family, or clan. Found in various cultures around the world and throughout history, totems serve a range of cultural, spiritual, or symbolic purposes. More recently, the word is used in contemporary art to describe work that either superficially resembles a totem (in its verticality, its surface carving, or its

figurative form) or is deliberately drawing on the aesthetics of traditional totems from a particular culture in relation to the artist's **identity politics**.

Huma Bhabha (b. 1962)
Seyni Awa Camara (b. 1945)
Marguerite Humeau (b. 1986)
Annie Morris (b. 1978)
Betye Saar (b. 1926)

TRADITIONAL SCULPTURAL MATERIALS

Certain raw materials—such as **clay**, ivory, metal, **stone**, and **wood**—have proved particularly suitable for sculpture across the globe and throughout human history, on account of their availability, inherent physical properties, and durability, so that even in **avant-garde** art practices such materials have continued to be used by sculptors alongside **nontraditional** and **industrial materials**.

TRADITIONAL SCULPTURAL PROCESSES

The techniques traditionally employed in creating sculpture are **carving** (for ivory, **stone**, and **wood**), which is described as "subtractive" in that material is removed to create the desired finished form; and **modeling** (**clay**, **plaster**, and wax) and **casting** (metal, wax, rubber, and synthetic materials), which are called "additive" processes, where material is added and forms are built outward.

TROMPE L'OEIL

French term meaning to "deceive the eye," used to describe an artwork designed to create the illusion that depicted objects exist in three dimensions, rather than being merely two-dimensional representations. The term is most commonly applied to painting, but some sculptors also employ the effect to distort perceptions of depth and space.

Clementine Keith-Roach (b. 1984)
Rebecca Manson (b. 1989)

THE UNCANNY

Art evoking strange or anxious feelings, especially when created using familiar, **found objects** that are placed in unusual contexts or altered to make them psychologically unsettling. The term was introduced into art via psychoanalyst Sigmund Freud in a 1919 essay of that name, which was of particular interest to **Dada** and then **Surrealist** artists who were engaged with exploring the subconscious in their work.

Katharina Fritsch (b. 1956)
Rachel Khedoori (b. 1964)
Jennifer Pastor (b. 1966)

VENICE BIENNALE

Each edition of this biennial exhibition has two main elements: National Pavilions and the International Exhibition. Artists featured in National Pavilions are selected from within the nation they are representing, and this may be a solo presentation (living or dead) or a group exhibition. Historically, these were all in permanent pavilion buildings situated in the Giardini della Biennale in Venice, but as the exhibition has expanded to challenge its inherent biases and exclusions, National Pavilions are now presented across the city. The International Exhibition, in contrast, is presented in and around the Arsenale and in the Central Pavilion of the Giardini. Conceived by a different, invited guest curator for each edition, it is loosely organized around a title and theme, and involves a global range of artists. See also **Biennials**.

WESTERN ART

Originally describing art from Europe (and later the United States and parts of Australasia) in connection with artificial divisions of the world into "West" and "East" that go back to the Classical world and continued into the late twentieth century before being critiqued for the colonialist values and inequalities they reinforce. As the academic discipline of art history was formulated in the West, the term has continued to be widely used, and while not unproblematic, can be a useful shorthand for understanding art's context.

WOOD

Due to the ease with which most types of wood can be carved and the detail that can be obtained using fine, sharp tools, wood has been one of the most **traditional sculptural materials** throughout much of the world. While its tendency to degrade has meant that many ancient wooden artifacts have not survived, the few that have been conserved (usually in a peat-rich environment) reveal wood being decoratively carved as far back as the Mesolithic (Middle Stone Age) period. The material qualities of the wood from different tree species varies substantially in terms of hardness, density, and color, all of which impact how wood has been used by artists through time. As well as pure wood, some sculptors also work with wood-based **industrial materials**, such as MDF, particleboard and plywood that offer different material properties to wholly natural planks.

Margarita Azurdia (1931–98)
Elizabeth Catlett (1915–2012)
Helen Escobedo (1934–2010)
Andrea de Mena (1654–1734)
Louise Nevelson (1899–1988)
Alison Saar (b. 1956)
Takako Saitō (b. 1929)
Claudette Schreuders (b. 1973)
Paloma Varga Weisz (b. 1966)

INDEX

Page numbers in *italics* refer to the illustrations

3D modeling/printing 25, 133, 320, 324
'85 New Wave movement 279, 324
2001: A Space Odyssey (film) 55

A

Abakanowicz, Magdalena 18, 327
 Four Seated 18, *18*
abject art/abjection 211, 324
Aboriginal Australians 82, 319, 327
Abramenko, Maria 308
abstract art/abstraction 19, 23, 31, 62, 233, 293,
 324, 326, 327, 328, 329
Abstract Expressionism 93, 131, 170, 196, 298,
 324, 327, 329
Académie Colarossi, Paris 153
Académie de la Grande Chaumière, Paris 236,
 245, 269
Académie des Beaux-Arts, Paris 324
Académie Julian, Paris 219, 253
Académie Russe, Paris 237
Academy of Fine Arts, Prague 274
Academy of Plastic Arts, Warsaw 18
Accademia di Belli Arti di Brera, Milan 250
Accademia di San Luca 175
ACME Gallery, Los Angeles 202
Adams, Alice 19, 330
 Volume 19, *19*
Adelaide 126
Adnan, Etel 96
Afghanistan 45, 327
Africa 21, 30, 45, 84, 106, 181, 215, 225, 327,
 329, 330
 see also individual countries
African Americans 110, 114, 127, 176, 265, 269
Afrofuturism 127, 324
aggregation 83, 324
AIDS epidemic 145, 284
A.I.R. Gallery, New York 214
Akademie der Bildenden Künste München 221
Akashi, Kelly 20, 328
 Cultivator (Hanami) 20, *20*
Alaska 250
Albers, Josef 111
The Aldrich Contemporary Art Museum,
 Ridgefield, Connecticut 15
Alexander, Jane 21, 331
 Bom Boys 21, *21*
Algeria 37
Allende, Salvador 303
Al Mazrou, Shaikha 22, 328
 Red Stack 22, *22*
Amaral, Olga de 23, 331
 *Bruma G (The Mist G), Bruma D (The Mist D),
 and Bruma F (The Mist F)* 23, *23*
Amazon 205, 217
American Craft Council 257
Andes 72, 141, 217, 303
Andre, Carl 15, 62
Angkor Wat, Cambodia 188, 245
Anthropocene 323
Anthropological Survey of India 221
anthropomorphic 72, 106, 140, 158, 174, 187, 278,
 317, 324, 329
Antoni, Janine 24, 325, 330
 Lick and Lather 24, *24*
Antony, Paris 50
Aphrodite 300
appropriation 324, 330
"a.r." 165
Arabian Gulf 94
Archipenko, Alexander 295
Archives of American Art 231
Arctic 48
Ardini, Giovanni 138
Argentina 212
Ariyoshi, Sawako 75
Arke, Pia 317
armatures 60, 324, 330
Armory Show, New York (1913) 226
Army Corps of Engineers (US) 290
Arneson, Robert 261
Arnhem Land, Australia 319
Arp, Jean (Hans) 293
Art21: Art in the 21st Century 164
art academies 324, 325, 327, 329, 331
Art Deco 167, 195, 324, 326
Art Education 25
Arte Madi 106
Arte Nuevo 56
Arte Povera 45, 121, 210, 324
Artforum 98, 140, 162, 268

Art Gallery of New South Wales, Sydney 85
ARThouse 117
Art in America 45
Art Institute of Chicago 282
Artist Profile Archive 28
Artists' Union, Czechoslovakia 38
Artnet 83
The Art Newspaper 290
Art Nouveau 44, 119, 161, 167, 324, 326
ArtReview 100, 128
Arts and Decoration 226
Art Students League, New York 52, 86, 214, 311
Artsy 196
Art Workers' Coalition, New York 62
Asawa, Ruth 25, 328, 330
 Untitled 25, *25*
Asia 327
 see also individual countries
assemblage 32, 46, 47, 116, 135, 190, 204, 211, 231,
 236, 276, 324, 326, 327, 329
Association of Independent Artists (Bulgaria) 88
Assy, France 254
Asunción, Paraguay 61
Atelier 17, New York 111, 113
Athens 45
Atlantica 74
Auerbach, Tauba 26, 327
 Fold series 26
 Gnomon/Wave Fulgurite 1.11 26, *26*
Australia 78, 82, 126, 319, 327
Austria 310, 331
avant-garde 165, 324, 326, 327, 329, 332
Avarzamani, Ghazaleh 27, 324, 329, 330
 Strange Temporalities 27, *27*
Aycock, Alice 28, 328, 330
 Twister Again 28, *28*
Ay-O 267
Azurdia, Margarita 29, 327, 332
 The Coming of the Goddess 29, *29*

B

Babel, Tower of 151
Babirye, Leilah 30, 326, 330
 Senga Nanseera (Kindhearted Kuchu Auntie) 30,
 30
Bad Girls, New York (1994) 224
Baghramian, Nairy 31, 324
 Dösender (Drowsy) 31, *31*
The Bahamas 200
Bailey, Spencer 117
Ball, Natalie 32, 327
 ~~You usually bury the head in the woods.~~ *Trophy
 Head* 32, *32*
Balzac, Honoré de 304
Banerjee, Rina 33, 326
 Lady of Commerce 33, *33*
Banff, Canada 64
Bangladesh 194
Banner, Fiona aka The Vanity Press 34, 328
 Poker Face 34, *34*
Barba, Rosa 35, 328
 Off Splintered Time 35, *35*
Barbizon school 255
Barcelos 302
Barlow, Phyllida 10, 36, 328, 329
 untitled: upturnedhouse2, 2012 36, *36*
Baroque 190, 216, 256, 315, 324–5, 331
Barrada, Yto 37, 328
 Lyautey Unit Blocks (Play) 37, *37*
Bartuszová, Mária 12, 38, 330
 Untitled (1985) 38, *38*
Basilica de Lourdes, Santiago 113
bas-relief 175, 304, 325
Batammaliba architecture 181
Bauhaus 111, 323, 325, 326, 328
Bavaria 301, 323
Bay Area Funk art movement 261
Bebb, Richard 274
Begum, Rana 39, 330
 No. 1048 Mesh 39, *39*
Behari, Benode 222
Beier, Nina 12–13, 40, 327, 329
 Women & Children 40, *40*
Beijing 193, 285, 302, 321
Beirut 66, 96, 135
Belgium 81
Belize 283
Belli, Patricia 41, 326
 Muda 2 (Moult 2) 41, *41*
Benedict XIV, Pope 216
Bengal 221

Benglis, Lynda 42, 85, 202, 318, 328, 330
 Eat Meat 42, *42*
Benito, Saint 208
Berkeley Art Museum and Pacific Film Archive,
 University of California 303
Berkowitz, Lauren 43, 326
 Plastic Topographies 43, *43*
Berlin 35, 156, 166, 317
Berlin Art Link 169
Bernardo, Saint 208
Bernhardt, Sarah 44, 324, 331
 Self-portrait as a Chimera 44, *44*
Bertaux, Hélène 180
Bhabha, Huma 45, 332
 Receiver 45, *45*
Bible 130
Bienal de São Paulo (1953) 106
biennial 325
Bignona, Senegal 57
Bill, Max 326
biomorphic 118, 161, 179, 313, 325
Bircken, Alexandra 46, 327
 Aprilia 46, *46*
Birkenstock sandals 73
Bjørvika, Oslo 48
Black Arts movement 229, 264, 325
Black civil rights movement 81, 176, 192, 327
Black Mountain College, North Carolina 25
Black Power 82, 265, 325
Blok 165
Bogotá, Colombia 23
Bologna, Italy 216, 258
Bomb magazine 59
Bom Jesus do Monte sanctuary, Portugal 40
Bonheur, Rosa 97
Bonin, Cosima von 47, 324
 Hermit Crab 47, *47*
Bonvicini, Monica 48, 326, 328
 She Lies 48, *48*
Booker, Chakaia 49, 324, 328
 It's So Hard to Be Green 49, *49*
Border Crossings 35
Bosphorus 90, 235
Boston 149, 185
Boucher, Alfred 153
Bourbon Restoration 97
Bourdelle, Antoine 254
Bourgeois, Louise 50, 331
 Spider (Cell) 50, *50*
Bove, Carol 51, 331
 Polka Dots 51, *51*
Brancusi, Constantin 38, 138
Brazil 68, 77, 182, 191, 199, 205, 230, 233, 270,
 329
Breton, André 205
British Antarctic Survey 244
British Empire 306
British Museum, London 274, 285
British Sculpture in the Twentieth Century, London
 (1981–2) 129
Brock, Sir Thomas 306
Bronx Zoo, New York 149
bronze 11, 12–13, 42, 45, 88, 108, 325
Brookgreen Gardens, South Carolina 149
Brook Green School of Painting and Sculpture,
 London 139
Brooklyn, New York 102, 193, 225
The Brooklyn Rail 47, 193
Brown, John 185
Browning, Elizabeth Barrett 146
Browning, Robert 146
Brussels 81, 205, 238
Brutalism 147
Bryn Mawr College, Pennsylvania 298
Buchanan, Beverly 9, 52, 330
 Miz Hurston's Neighbourhood Series – Church
 52, *52*
Bucher, Heidi 53, 329, 330
 *Hautraum (Ricks Kinderzimmer, Lindgut
 Wintherthur) (Skin Room (Rick's Nursery,
 Lindgut Wintherthur))* 53, *53*
Budapest 167
Buddhism 45, 327
Budor, Dora 54, 326
 Origin II (Burning of the Houses) 54, *54*
Buenos Aires 106, 212
Bulgaria 88
Bulloch, Angela 55, 328
 Horizontal Technicolour 55, *55*
Bungey, Squadron Leader Robert Wilton 126
Burga, Teresa 56, 330

Untitled/Prismas (B) 56, *56*
Burruwal, Kamarrang "Bob" 319

C
Cabaret Voltaire, Zürich 293
California 303
California Institute of Arts 178
California State University, Los Angeles 229
Camara, Seyni Awa 57, 325, 332
 Sans Titre (Untitled) 57, *57*
Cambodia 119, 157, 188, 189, 245
Cameron-Weir, Elaine 58, 328
 Right Hand Left Hand, Grinds a Fantasizer's Dust 58, *58*
Camnitzer, Luis 251
Campos, Haroldo de 270
Canada 27, 64, 139, 176, 186, 314
Canell, Nina 59, 328
 Brief Syllable (Tripled) 59, *59*
canon of art history 255, 325, 326
Cape Town 21
Caracas, Venezuela 115, 252
Carey, Jodie 60, 324, 330
 Untitled (Slabs) 60, *60*
Caribbean 200, 263
Carmelite Monastery, Frankfurt 227
Caro, Anthony 51, 189
Caroline, Princess of Wales 76
Carrington, Leonora 283
Carvão, Alusio 240
carving 30, 138, 324, 325, 326, 331, 332
Casablanca, Morocco 37
Casamance region, Senegal 57
Casarino, Claudia 61, 330
 Corollas 61, *61*
"Case Study Houses", Los Angeles 190
Castillo, José Guillermo 251
casting 20, 60, 160, 310, 325, 326, 327, 328, 329, 331, 332
Castoro, Rosemarie 62, 330
 Land of Lashes 62, *62*
Catalan Art Nouveau 161
Catherine, Saint 256
Catherine the Great, Empress of Russia 70
Catholic Church 29, 325
Catlett, Elizabeth 63, 325, 332
 Maternity 63, *63*
Cenci, Beatrice 146
Central Academy of Fine Arts, Beijing 187
Central America 41
 see also individual countries
Central Saint Martins School of Art, London 46, 189
ceramics 132, 171, 202, 209, 257, 325
 see also clay
Chadwick, Helen 64, 325
 Piss Flowers 64, *64*
Chamberlain, John 51, 318
Changi region, Japan 129
Chaplain, Jules-Clément 219
Charles X, King of France 97
Charlesworth, J. J. 128
Chelsea College of Art, London 36, 64, 108
Chelsea Hotel, New York 174
Chhattisgarh, India 221
Chicago 56, 288
Chicago, Judy 65, 326
 Rainbow Pickett 65, *65*
Chicago Public Library 295
Chile 72, 113, 141, 206, 303
China 123, 124, 189, 193, 271, 279, 321, 331
Choucair, Saloua Raouda 66, 324, 329
 Poem 66, *66*
Chouinard Art Institute, Los Angeles 290
Christ 99, 155, 166, 254, 256
Christianity 186, 208
Christo 212
Chryssa 67, 328
 Cents Sign Travelling from Broadway to Africa via Guadeloupe 67, *67*
Circulo de Bellas Artes, Montevideo 106
City as Living Laboratory 213
City College of New York 49
Clark, Lygia 10, 68, 77, 296, 324, 329
 Estruturas de Caixa de Fósforos Vermelho (Red Matchbox Structures) 68, *68*
Classical 24, 42, 324, 325, 327, 328, 329, 330, 331
Claudel, Camille 69, 327, 329, 330
 L'Homme penché (Man Leaning) 69, *69*
clay 57, 86, 132, 198, 200, 257, 261, 273, 322, 325, 328, 332

Cobra 101
Coenties Slip, New York 295
Collings-James, Phoebe 200
Collot, Marie-Anne 70, 330
 Bust of Catherine the Great 70, *70*
Cologne 35, 46, 47
Colombia 217, 268
Colón, Gisela 71, 324, 328
 Untitled (12 Foot Circular Monolith Titanium) 71, *71*
Colorado 192, 213
Color Field painting 43
Columbia University, New York 80
Colvin, Marta 72, 325
 Vigías (Sentries) 72, *72*
conceptual art/conceptualism 36, 56, 62, 102, 131, 266, 286, 316, 324, 325–6, 327
The Condition Report 248
concrete art 62, 68, 106, 182, 240, 270, 326, 329
Congo 81
Connor, Fiona 73, 325, 330
 Untitled (Shoes) 73, *73*
constructivism 39, 106, 165, 287, 323, 326, 328, 329
contemporary art 326
Cooke Latham Gallery, London 209
Cooper Union, New York 224, 269
Copenhagen 101, 317
Cornell, Joseph 265
Cornell University, New York 123, 184
Cornwall 138
Corse, Mary 71
Costantino, Nicola 74, 324
 Human Furriery, Male Nipples Corset 74, *74*
Costa Rica 322
Costigliolo, José Pedro 106
Coyne, Petah 75, 331
 Untitled #1408 (The Lost Landscape) 75, *75*
craft 41, 93, 141, 164, 196, 209, 277, 325, 326, 328
Cranbrook Academy of Art, Michigan 23
Creative Art Education group 267
Crumb, R. 128
Cuba 102, 195
Cubism 45, 106, 204, 324, 326, 329
Culiacán, Mexico 203
Cultural Revolution, China 279
Cultured Magazine 54, 318
Cunningham, Merce 78
Cycladic art 189
Czechoslovakia 38, 274

D
Dada 204, 293, 324, 326, 327, 329, 332
Damer, Anne Seymour 76, 329
 Shock Dog (Nickname for a Dog of the Maltese Breed) 76, *76*
Danish Geologic Survey 244
Darz magazine 61
da Silva, Vanessa 77, 330
 Muamba Grove #4 77, *77*
Dawson, Paula 78, 327
 Mirror Mirror: Graeme Murphy 78, *78*
De Bruyckere, Berlinde 32, 79
 J.L., 2005–2006 79, *79*
Debschitz School, Munich 293
decorative arts 19, 97, 324, 326
Delaplanche, Eugène 175
De La Warr Pavilion, Bexhill-on-Sea, East Sussex 312
Delhi Polytechnic 221
Denes, Agnes 80, 328
 The Living Pyramid 80, *80*
Denmark 101, 317
Dery, Mark 324
DeVille, Abigail 81, 325, 328, 330
 Day 1 81, *81*
Dhokra sculptors 221
Dia Art Foundation 207
Diana 284
Diaspora 30, 33, 114, 264, 326, 330
Dickens, Karla 82, 327
 Pound-for-Pound #5 82, *82*
Diderot, Denis 70
Didion, Joan 75
Disney World 100
Doesburg, Theo van 326
Donovan, Tara 83, 324, 328, 330, 331
 Untitled (Mylar) 83, *83*
Douglas Camp, Sokari 84, 326, 331
 Jesus Loves Me 2/2 84, *84*
Drew, Kimberly 318

Driekopseiland, South Africa 159
Duarte Sequeira Gallery, Portugal 77
Dubai 156
Dubois, Paul 206
Du Bois, W.E.B. 110
Duchamp, Marcel 170, 205
Duncan, Isadora 167
Düsseldorf 207, 301
Dwyer, Mikala 43, 85, 327, 330
 The Guards 85, *85*

E
Easter Island 72
East Sydney Technical College 126
East Village, New York 49, 177
Eberle, Abastenia St. Léger 86, 329
 Girl Skating 86, *86*
Eccentric Abstraction, New York (1966) 19
Echo 206
Ecole des Beaux-Arts, Montpellier 254
Ecole des Beaux-Arts, Paris 66, 119
Ecole Nationale des Arts Décoratifs, Paris 237
Ecole Nationale Supérieure des Beaux-Arts, Paris 220
Eesti Kunstiakadeemia, Tallinn 157
Egypt 66, 189
Egypt, ancient 78, 171, 265, 285, 322, 328, 329, 330
Ehrman, Marli 295
Eisenman, Nicole 11, 13, 87, 325, 327
 Maker's Muck 87, *87*
Elephant magazine 37, 187
Elgin, 8th Earl of 285
Elizabeth, Saint 272
Elle India 39
Emanuilova, Vaska 88, 329, 331
 Seated Female Figure 88, *88*
Emily Carr University of Art + Design, Vancouver 283
Emin, Tracey 89, 325, 329, 330
 The Mother 89, *89*
England's Creative Coast's Waterfronts project 239
Enlightenment 70, 216
environmental/ecological art 49, 80, 213, 326
ephemeral 60, 98, 152, 168, 190, 227, 290, 326, 327, 328, 331
Erkmen, Ayşe 90, 328
 Plan B 90, *90*
Escobedo, Helen 91, 201, 327, 330, 332
 Eclipse 91, *91*
Escuela de Bellas Artes, Rosario 74
Escuela Nacional de Artes Plásticas, Mexico City 201
Estonia 119, 157
Eswatini 215
Ettun, Tamar 92, 331
 Doreen 92, *92*
Eugénie, Empress 180
European Space Agency 244
Expressionism 166, 326
 see also Abstract Expressionism

F
Faenza, Italy 132
Falconet, Etienne-Maurice 70
Falkenstein, Claire 93, 324, 326, 327
 Untitled 93, *93*
Faou Foundation 218
Farid, Alia 94, 326, 328
 Palm Orchard 94, *94*
Farmanfarmaian, Monir Shahroudy 95, 324, 327
 Fourth Family Hexagon 95, *95*
Farren, Elizabeth 76
Farroukh, Moustafa 66
Fattal, Simone 96, 327
 Pearls 96, *96*
Fauveau, Félicie de 97, 326, 330
 Lampe de l'Archange Saint Michel 97, *97*
Fauvism 113
Favaretto, Lara 98, 326, 328
 The Man Who Fell on Earth 98, *98*
Faydherbe, Maria 99, 325
 The Virgin and Child 99, *99*
Feinstein, Rachel 100, 326, 330
 The Shack 100, *100*
feminist artists 107, 271, 284, 324, 326, 328, 329
Feminist Studies 107
Ferlov Mancoba, Sonja 101, 317, 329, 330
 Maske (Krigens Udbrud) (Mask (Outbreak of War) 101, *101*

Fernández, Teresita 102, 331
 Fire 102, *102*
Festival of Two Worlds, Spoleto (1962) 245
Feuillet, Octave 44
Fez, Morocco 37
Fiber Art Movement 18, 19, 23, 141, 295, 319,
 326–7
 see also textile art
figurative art 11, 13, 21, 69, 79, 87, 88, 99, 110,
 119, 139, 146, 185, 284, 304, 311, 324, 327, 328,
 330, 332
film 35, 94, 124
First Gutai Art Exhibition, Tokyo (1955) 316
Fischerhude, Germany 255
Flash Art 26
Fleury, Sylvie 103, 330, 331
 Untitled (Soft Rocket) 103, *103*
Florence 96, 97, 185
Floyer, Ceal 104, 325, 330
 Mirror Globe 104, *104*
Fluxus 9, 170, 267, 327
folk art 117, 204, 315, 327
Fondazione Memmo, Rome 137
Ford, Laura 105, 331
 Blue Girl with Demons 105, *105*
found objects 51, 82, 186, 232, 235, 264, 288, 324,
 326, 327, 329, 331, 332
foundry 11, 176, 245, 327
Fourth Plinth, London 310, 330
France 66, 69, 70, 78, 97, 101, 110, 153, 175, 180,
 219, 253, 254, 294, 297, 304, 311, 331
Frankfurt 227
Fraser, James Earle 311
Freire, Mária 106, 326
 Forma Amarilla (Yellow Form) 106, *106*
French Revolution 70
Freud, Sigmund 332
Fridman Gallery, New York 92
Fried, Nancy 107, 326, 329
 Exposed Anger 107, *107*
Friedrich, Caspar David 48
frieze 130, 234, 259, 265
Frink, Elisabeth 36, 108, 189, 325, 327
 Riace I 108, *108*
Fritsch, Katharina 109, 325, 332
 Oktopus (Octopus) 109, *109*
Fulbright scholarships 141, 235
Fuller, Meta Vaux Warrick 110, 327
 Bust of a Young Boy (Solomon Fuller, Jr.) 110,
 110
Fuller, Sue 111, 325, 331
 String Composition #530 111, *111*

G
Galerie Rivolta, Lausanne 103
Gallaccio, Anya 112, 326, 328
 Double Doors 112, *112*
Gandhāran sculpture 45, 327
Gangetic Valley 327
Garafulic, Lily 113, 325, 329
 Cópula Cósmica (Cosmic Copulation) 113, *113*
Gbadebo, Adebunmi 114, 200, 325, 326
 Jane/Mother of J. H. Lee… 114, *114*
Gee's Bend Quilting Collective 186
Gego 9, 115, 324
 Sphere 115, *115*
Generación del 40 (Chile) 113
Genesis 130
Geneva, Lake 274
Genzken, Isa 116, 324
 Schauspieler (Actors) 116, *116*
Geometry of Fear 108
Georgia, USA 52
German, Sandra 117
german, vanessa 117, 324, 328
 *SKINNER AND THE WASHERWOMAN IN
 THE GARDEN OF EDEN* 117, *117*
Germany 31, 35, 47, 115, 140, 207, 221, 255, 293,
 305, 331
Gibson, James J. 296
Gibson, John 146
Gielgud, John 274, *274*
glass 20, 26, 35, 96, 325, 327
Global South 232, 327
Glycera 180
Goldsmiths College, London 34, 64, 104, 112, 259
Gomes, Sonia 118, 331
 Untitled (Torção series) | Sem título (série Torção)
 118, *118*
Gongbi style 193
Gonzalez-Torres, Felix 145

Gordine, Dora 119, 324, 327, 330
 Carmen 119, *119*
Gowda, Sheela 120, 328
 What Yet Remains 120, *120*
Graf, Jody 58
Graham, Martha 78
Grand Palais, Paris 269
Greece 189
Greece, ancient 11, 45, 78, 108, 142, 143, 160,
 171, 180, 186, 188, 206, 249, 304, 315, 325, 327,
 328, 329
Greenberg, Clement 65
Greenland 317
Grimm Brothers 301
Grisi, Laura 121, 328
 Sunset Light 121, *121*
Gritz, Laura 147
Gropius, Walter 325
Grossman, Nancy 122, 326, 331
 Untitled (1968) 122, *122*
Ground Zero, New York 213
Grupo de Arte No Figurativo 106
Grupo Frente 240
Grupo Seibi 233
Gu Erniang 123, 325, 331
 Inkstone with Phoenix Design 123, *123*
Guan Xiao 124, 324
 Mushroom 124, *124*
The Guardian 89, 259, 276
Guatemala 29
Guggenheim Fellowships 113
Guggenheim Museum, New York 181, 316
Guigues, Louis-Jacques 254
Guild of Saint Luke, Mechelen 99
Gulf News 22
Gulf War (1990–1) 34
Gupta, Shilpa 125, 325, 329
 Threat 125, *125*
Gutai 229, 316, 327

H
Haacke, Hans 224
Hackney, London 263
Hagenbund group 167
The Hague 206
Haifa 135
Hall, Fiona 126, 327, 331
 Holdfast (Macrocystis Angustifolia; Giant Kelp)
 126, *126*
Halsey, Lauren 127, 324, 328
 My Hope 127, *127*
Hamilton, Anthea 128, 324
 Wrestler Sedan Chair 128, *128*
Hammons, David 229
Han Sai Por 129, 325, 328
 Microorganisms 2 129, *129*
Han sculpture 189
Hapaska, Siobhán 130, 324
 Snake & Apple 130, *130*
Hard and Soft, Los Angeles (2015) 202
hard-edged 140, 327, 328, 330
Harlem, New York 63, 269
Harlem Community Art Center 269
Harlem Renaissance 110, 325, 327
Harrison, Rachel 131, 324, 330
 Sculpture with Boots 131, *131*
Hart, Emma 132, 325
 Red and Green Should Never Be Seen 132, *132*
Hartford School of Art, Connecticut 284
Harvey, Auriea 133, 324
 Ox Vi 133, *133*
Hassinger, Maren 134, 229, 326, 327, 329
 Leaning 134, *134*
Hatoum, Mona 135, 327
 Electrified (variable II) 135, *135*
Hauser & Wirth 36
Havana 195
Hawthorne, Nathaniel 146
*Hear Me Now: The Black Potters of Old Edgefield,
 South Carolina*, New York (2022) 114
Height, Dorothy 176
Heizer, Michael 307
Held, Al 246
Hendry, Holly 136, 324, 331
 Body Language 136, *136*
Henrot, Camille 137, 324
 Contrology 137, *137*
Hepworth, Barbara 129, 138, 259, 325, 329
 Spring 138, *138*
The Hepworth Wakefield 259
Herculaneum 329

Hermes, Gertrude 139, 325, 330
 Kathleen Raine 139, *139*
Hesse, Eva 140, 330
 Repetition Nineteen III 140, *140*
Hestia 188
Hicks, Sheila 18, 141, 327, 329
 Nowhere to Go 141, *141*
High Line, New York 330
The Hindu 198
Hinduism 265
Hirshhorn Museum and Sculpture Garden,
 Washington, D.C. 264
Hohlenstein 14
Holdfast Bay, Adelaide 126
Holley, Lonnie 186
Hollywood 100
Holocaust 291, 310
Holography Lab, Sydney 78
Holt, Nancy 14, 15, 16, 142, 328, 331
 Hydra's Head 142, *142*
Holzer, Jenny 143, 328
 Heap 143, *143*
Homewood, Pittsburgh 117
Hong Kong 299
Hoover Dam, Nevada 243
Hopper, Edward 311
Hoptman, Laura 51
Horn, Rebecca 144, 327
 Untitled (Records on the Floor) 144, *144*
Horn, Roni 145, 328
 Gold Mats, Paired – For Ross and Felix 145, *145*
Hosmer, Harriet 11–12, 13, 14, 146, 185, 328, 329
 Beatrice Cenci 146, *146*
Hosnedlová, Klára 147, 331
 Untitled from the series *To Infinity* 147, *147*
Hou Hanru 321
Huang Yong Ping 279
Hugo, Victor 304
Humeau, Marguerite 148, 332
 The Guardian of Termitomyces 148, *148*
Hume, David 76
Hungary 161
Huntington, Anna Hyatt 86, 149, 325
 Reaching Jaguar 149, *149*
Huntington, Arthur 149
Hurston, Zora Neale 75
hyperrealism 248, 327, 331

I
Icard, Honoré 153
identity politics 327, 330, 332
Iglesias, Cristina 150, 328
 Phreatic Zone I 150, *150*
Impressionism 113, 246, 331
The Independent 105
India 33, 120, 125, 157, 198, 221, 222, 282, 293, 327
Indian Ocean 47
Indigenous art 29, 32, 217, 220, 221, 303, 319,
 327, 330
Indonesia 189
industrial materials 39, 42, 83, 312, 317, 324, 326,
 327–8, 330, 332
Ingleby Gallery, Edinburgh 244
inkstones 123
installation 14, 27, 39, 43, 48, 58, 64, 98, 116, 121,
 127, 130, 173, 217, 224, 227, 232, 235, 239, 243,
 280, 289, 292, 297, 324, 328, 331
Institute of Contemporary Art, Washington, D.C.
 298
Institute of Design, Chicago 295
Instituto Torcuato Di Tella (Argentina) 212
Iowa 86
Iran 31, 95
Iran-Iraq War (1980–8) 94
Iraq 94
Ireland 75
Isamu Noguchi Award 171
Iskin, Ruth 313
Islam 265
Islamic art 39, 66, 95
Issa, Iman 151, 327
 Heritage Studies #22 151, *151*
İstanbul Kültur Sanat Vakfi 235
Istanbul State Academy of Fine Arts 235
Italy 86, 97, 121, 132, 138, 175, 185, 210, 266, 315,
 329, 331
It's So Hard To Be Green, New York (2000) 49

J
Jackson, Roy 82
Jamaica 186

James, Henry 146
Janssens, Ann Veronica 13–14, 152, 326
 Untitled (Blue Glitter), Open Sculpture #3 152, *152*
Japan 20, 25, 67, 129, 170, 171, 172, 199, 229, 231, 233, 271, 316, 327
Japan Women's University, Tokyo 267
Jespers, Oscar 205
Jewish art 237
Jewish Museum, New York 65
Johannesburg 21
Johnson, James Weldon 269
John Weber Gallery, New York 15
Jones, Jonathan 89
Jouvray, Madeleine 153, 326, 329, 331
 La Douleur (Pain) 153, *153*
Józefowicz, Katarzyna 154, 329
 "cities" 154, *154*
Judd, Donald 190, 307
Julianis, Caterina de 155, 329, 330, 331
 Penitent Magdalene 155, *155*

K

Kaabi-Linke, Nadia 156, 328
 "The Bank is Safe" (In Memory of Wilhelm Voigt) 156, *156*
Kalabari people 84
Kallat, Reena Saini 157, 328
 Siamese Trees (Ratchyra-Palm) 157, *157*
Kangxi Emperor 123
Karachi, Pakistan 45
Karlson, Edith 158, 328
 Family 158, *158*
Katrib, Ruba 56
Katz, Bronwyn 159, 330, 331
 /Xabi (Spurt of Water from the Mouth) 159, *159*
Keith-Roach, Clementine 160, 325, 332
 Knot 160, *160*
Kennedy, Jacqueline 177
Kennedy, John F. 177
Kenya 47
Keresztes, Zsófia 161, 328
 Under Armour II 161, *161*
Kestner Gesellschaft, Hanover 147
Kéve group 167
Khedoori, Rachel 162, 332
 Butter Cave 162, *162*
Kher, Bharti 163, 327
 Strange Attractor 163, *163*
Kimsooja 164, 325
 Bottari 164, *164*
kinetic art 115, 144, 326, 328
King, Martin Luther, Jr. 81, 265
 Where Do We Go from Here: Chaos or Community? 81
Kingston University, London 112, 132
Klamath people 32
Ko, Dorothy 123
Kobro, Katarzyna 165, 324, 326
 Spatial Composition No. 6 165, *165*
Kolkata, India 33, 221
Kollwitz, Käthe 88, 166, 326
 Pietà (Mother with Dead Son) 166, *166*
Koninklijke Academie van Beeldende Kunsten, The Hague 271
Koolhaas, Rem 54
Korea 315
kouroi 45, 328
Köveszházi-Kalmár, Elza 167, 324, 326, 329
 Breathing Dance 167, *167*
Kowanz, Brigitte 168, 328
 Matter of Time 168, *168*
Krasner, Lee 131
Krasner Gallery, New York 122
Kraus, Kitty 169, 326
 Untitled (2006) 169, *169*
Krauss, Rosalind 9, 11
Kruger, Barbara 224
Kubota, Shigeko 9, 170, 324, 327
 Berlin Diary: Thanks to My Ancestors 170, *170*
Kubrick, Stanley 55
Kune culture 319
Kunstakademie, Düsseldorf 207
Kunstgewerbeschule Zürich 53
Kusaka, Shio 171, 325
 (dinosaur 37) 171, *171*
Kusama, Yayoi 172, 329, 330
 Flowers That Bloom Tomorrow 172, *172*
Kuwait 94
Kwade, Alicja 9–10, 173, 329, 331
 Duodecuple Be-Hide 173, *173*

KwaZulu-Natal, South Africa 196
Kyiv 156
Kyoto, Japan 172

L

L., Nicola 174, 329
 Orange Femme Commode 174, *174*
Laban, Rudolf van 293
Laboratory of General Physics and Optics, Besançon 78
Ladd, Anna 253
Lancelot-Croce, Marcelle Renée 175, 325
 Infirmières Soignant un Blessé (Nurses Treating an Injured Person) 175, *175*
Lancelot, Dieudonné 175
Land art 9, 14, 80, 91, 102, 112, 142, 213, 307, 328
Lane, Artis 176, 329
 First Man, New Man and Spiritual Man 176, *176*
Langster, Jules 327
Lang Syne Plantation, South Carolina 114
Lankton, Greer 177, 327, 330
 Jacqueline Kennedy Doll 177, *177*
Larner, Liz 178, 328
 Meerschaum Drift (Blue) 178, *178*
Latin America 23, 29, 56, 72, 199, 240, 327, 328, 330, 331
 see also individual countries
Latvia 119
Laycock, Ross 145
Lebanese Civil War (1975–90) 96, 135
Lebanon 66, 96
Lee Bul 179, 325, 331
 Monster: Black 179, *179*
Lefèvre-Deumier, Marie-Louise 180, 330
 Couronne de Fleurs (Crown of Flowers) 180, *180*
Léger, Fernand 245
Leigh, Simone 181, 325
 Titi (Cobalt) 181, *181*
Leirner, Jac 182, 327
 Prisms 182, *182*
Le Maistre, Yvanna 237
Lenin Museum, Prague 274
Leopold II, King of the Belgians 81
Levine, Sherrie 183, 324, 330
 "La Fortune" (After Man Ray): 4 183, *183*
Levy, Hannah 184, 327
 Untitled (2022) 184, *184*
Lewis, Edmonia 11–12, 13, 146, 185, 328, 329
 Forever Free 185, *185*
Lewis, Norman 52
Lewis, Samella 63
Lewis, Tau 186, 325, 326
 Resurrector 186, *186*
Lewiston, New York 142
LeWitt, Sol 214
LGBTQ+ people 30, 327
Liao Wen 187, 324
 Headwind 187, *187*
Light and Space movement 67, 71, 168, 242, 328
light art 168, 169, 188, 292, 302, 328
Lijn, Liliane 188, 328
 Mars Koan 188, *188*
Lim, Kim 189, 324, 327
 Pegasus 189, *189*
Lim, Won Ju 190, 328
 Kiss T3 190, *190*
Lima, Laura 191, 328
 Levianas #5 191, *191*
Lin, Maya 192, 326
 Blue Lake Pass 192, *192*
Linderhof Palace, Bavaria 323
Lin Tianmiao 193, 331
 More or less the same (small) 2 193, *193*
Lipchitz, Jacques 205
Lipi, Tayeba Begum 194, 327
 The Rack I Remember 194, *194*
Lippard, Lucy 15, 19, 62
Lisbon 302
Loft New Media Art Space, Beijing 193
London 33, 36, 46, 64, 119, 136, 185
Longa, Rita 195, 325, 328, 330
 Forma, Espacio y Luz (Form, Space and Light) 195, *195*
Long Street, Cape Town 21
Los Angeles 53, 71, 127, 134, 190, 229, 242, 271
lost-wax casting 221, 328
Lou, Liza 196, 324, 326
 Aggregate: Primary 196, *196*
Louis Philippe I, King of France 97
Louvre, Paris 180, 304
Love Front Porch 117

Löwenmensch figurine 14
L.S. Raheja School of Art, Mumbai 198
Lucas, Sarah 13, 197, 324, 331
 Suffolk Bunny 197, *197*
Ludwig II, King of Bavaria 323
Luipaard, Jelle 79
Lyautey, Louis-Hubert-Gonzalve 37
Lycée Molière, Paris 219

M

Maciunas, George 170, 267
Mackensen, Fritz 255
Madrid 256
Mahajan, Savia 198, 325
 Lithified Lives 7 198, *198*
Maiolino, Anna Maria 199, 325
 Na Horizontal (On the Horizontal) 199, *199*
Les Maîtres de l'art independent, Paris (1937) 237
Major, Anina 200, 325
 Sunburst 200, *200*
Malamud, Tosia 201, 331
 Mujer Reclinada o Recostada (Reclining Woman) 201, *201*
Malaysia 119, 189
Maldonado, Tomás 326
Malevich, Kazimir 165
Malines (Mechelen), Belgium 99
Manchester 33
Mancoba, Ernest 101
Mandela, Nelson 21
Manson, Rebecca 202, 332
 Gale 202, *202*
Manzolini, Giovanni 216
marble 11, 69, 70, 74, 146, 206, 325, 328
Margolles, Teresa 203, 325, 331
 La Promesa (The Promise) 203, *203*
Marianne Boesky Gallery, New York 100
Marisol 204, 330
 Dinner Date 204, *204*
Martin, Agnes 39
Martins, Maria 77, 205, 331
 The Impossible 205, *205*
Maryland Institute College of Art, Baltimore 235, 261
Mary Magdalene 155
Massey University, New Zealand 32
materiality 42, 59, 116, 178, 324, 328, 330
Matte, Rebeca 206, 328
 Eco, Encantamiento o Ensoñación (Echo, Enchantment; or Dream) 206, *206*
Mattress Factory, Pittsburgh 177
Max Mara Art Prize for Women 132
McBride, Rita 207, 328
 Arena 207, *207*
McQueen, Alexander 277
McShine, Kynaston 65
Mechelen (Malines), Belgium 99
Mediterranean 96, 250
memento mori 112, 299, 328
Mena, Andrea de 13, 208, 325, 330, 332
 Mater Dolorosa 208, *208*
Mena, Claudia de 208
Mena, Pedro de 208
Mendick, Lindsey 209, 325
 Crawling In My Skin 209, *209*
Mercury, Freddie 274
Merz, Marisa 210, 324
 Untitled (1968) 210, *210*
Mesopotamia 285
Messager, Annette 211, 324, 328
 Sacs Plastiques Échevéles 211, *211*
Metropolitan Museum of Art, New York 114, 225, 231
Mexico 25, 63, 141, 201, 203, 331
Mexico City 91, 201, 290
Miami 102
Michelangelo 166
Micheline Szwajcer Gallery, Antwerp 152
Middle Ages 301
Minimalism 19, 22, 36, 39, 55, 56, 62, 65, 95, 98, 112, 121, 134, 142, 182, 213, 298, 314, 327, 328, 331
Minujin, Marta 212, 331
 Colchón (Mattress) 212, *212*
Miss, Mary 213, 326, 328, 331
 Perimeters/Pavilions/Decoys 213, *213*
Missouri Medical College, St. Louis 146
MIT Media Lab, Massachusetts 78
mixed media 40, 190, 209, 288, 309, 328
Miyamoto, Kazuko 214, 328
 Untitled (1977) 214, *214*

Mntambo, Nandipha 215, 324
 Enchantment 215, *215*
modeling 11, 322, 324, 325, 328–9, 332
Modern Institute, Glasgow 259
Modernism 28, 51, 287, 324, 326, 329, 330
Modern Painters 79
Modersohn-Becker, Paula 255
Modoc people 32
Moffitt, Evan 268
Moholy-Nagy, László 295
MoMA Magazine 320
Monet, Claude 246
Monolith 223
Monteverde, Giulio 206
Montevideo 106
Montreux 274
monumental 206, 223, 306, 311, 326, 329, 331
Moore, Henry 129
Morandi Manzolini, Anna 216, 325
 *Anatomical Model of the Eye and Its Extrinsic
 Muscles* 216, *216*
Moravia 274
Morelos, Delcy 10, 217, 325, 327
 Mother's Surface 217, *217*
Mori, Mariko 218, 329
 Oneness 218, *218*
Moria, Blanche-Adèle 219, 325
 In the Village 219, *219*
Morocco 37
Morris, Annie 220, 330, 332
 Stack 9, Ultramarine Blue 220, *220*
Morris, Robert 85
Moscoso, Manuela 228
Moscow 223
Moscow School of Painting 165
Mousse 207, 247
The Moving Company 92
Mukherjee, Leela 222
Mukherjee, Meera 221, 325, 328
 Untitled (The Storm) 221, *221*
Mukherjee, Mrinalini 18, 222, 325, 331
 Jauba (Hibiscus) 222, *222*
Mukhina, Vera 223, 329, 330, 331
 Mir (Peace) 223, *223*
Mumbai 125, 198
Munch, Edvard 89
Munch Museum, Oslo 89
Munich 100
Munson, Portia 224, 324, 326, 327
 today will be AWESOME 224, *224*
Murphy, Graeme 78
Museo de Arte Moderno, Mexico City 91
Museo de Bellas Artes, Caracas 115
Museo Nacional de Bellas Artes, Havana 195
Museo Nacional de Bellas Artes, Santiago 113
Museo Universitario de Arte Contemporáneo,
 Mexico City 203
Museo Universitario de Ciencias y Arte (MUCA),
 Mexico City 91
Museu d'Art Contemporani de Barcelona
 (MACBA) 91
Museum Boijmans Van Beuningen, Rotterdam 46
Museum of Contemporary Art Australia, Sydney
 43
Museum Łódz 165
Muséum national d'Histoire naturelle, Paris 219
Museum of Modern Art, New York (MoMA) 115,
 134, 179
Mutu, Wangechi 225, 324, 325
 She Walks 225, *225*
Myers, Ethel 226, 327
 A Lady 226, *226*
Myers, Jerome 226

N

Nacional Instituto de Bellas Artes, Mexico City
 290
Nairobi 225
Naito, Rei 227, 326
 Pillow for the Dead 227, *227*
Naples 86, 155
Napoleon III, Emperor 180
Nash, Paul 283
Nasher Sculpture Center, Dallas 87
National Art Prize (Chile) 72, 113
National Art School, Sydney 82
National Gallery of Art, Washington, D.C. 102
Native Americans 213, 328
Navas, Ana 228, 324, 331
 Pecera (Fishbowl) 228, *228*
Nazca Lines, Peru 328

Nazis 18, 101, 115, 237, 274
Neal, Larry 325
negative space 111, 165, 310, 322, 329
Nelson, Lord 76
Nengudi, Senga 134, 229, 325, 329
 Water Composition III 229, *229*
Neoclassical 12, 76, 97, 146, 185, 223, 304, 328,
 329, 331
Neo-Concretism 68, 191, 240, 270, 329
neo-Dada 131
Netherlands 271, 297
Neue Nationalgalerie, Berlin 35
Neuenschwander, Rivane 230, 325, 329
 Bala-bala 230, *230*
Nevelson, Louise 51, 231, 324, 332
 Royal Tide II 231, *231*
New Bauhaus 295
New Brazilian Objectivity movement 199
New Figuration movement 199
New Mexico 290
New Museum, New York 224
New School, New York 80
New School for Social Research, New York 290
New South Wales 82
New York 19, 33, 49, 52, 62, 67, 80, 86, 95, 113,
 149, 170, 172, 174, 177, 183, 226
New Yorker 131
New York Graphic Workshop 251
New York School of Art 226
New York Times 31, 51, 109, 171, 177, 212, 278
New Zealand 32
Niagara River 142, 290
Nicaragua 41
Nigeria 84, 234
Nkanga, Otobong 232, 326
 In Pursuit of Bling 232, *232*
Nkisi 117, 329
Nochlin, Linda, "Why Have There Been No Great
 Women Artists?" 16–17
Noguchi, Isamu 38
nontraditional sculptural materials 41, 64, 83, 291,
 324, 326, 327, 328, 329, 330, 331, 332
Noor Eesti (Young Estonia) group 119
Norfolk 310
North Africa 37
northern Renaissance 301
Northern Territory, Australia 319
Norway 48, 310
Notarius, David 64
Nouveau Réalisme 174, 329
The nude 12, 13, 40, 69, 76, 88, 107, 253, 324, 329

O

Oates, Joyce Carol 75
Oberlin College, Ohio 185
Obrist, Hans Ulrich 95
occult 44
Oceania 265, 327, 330
Ohtake, Tomie 233, 330
 *Untitled (Monument to Eighty Years of Japanese
 Immigration)* 233, *233*
Oiticica, Hélio 77, 240
Okoyomon, Precious 234, 326, 330
 Not Yet Titled (Blood Memory) 234, *234*
Oldenburg, Claes 331
Oliver, Guy 209
Olympic Games, Rio de Janeiro (2016) 218
Onsi, Omar 66
Onur, Füsun 235, 328
 Icons of Time 235, *235*
Op art 56, 115, 121
Opium Wars (1860s) 285
Oppenheim, Meret 236, 331
 *Ma Gouvernante – My Nurse – Mein
 Kindermädchen* 236, *236*
Orloff, Chana 237, 324, 329, 330
 *Woman with a Fan (Portrait of Yvanna Le
 Maistre)* 237, *237*
Oslo 48, 89
Otero, Alejandro 115
Overton, Virginia 238, 324, 329
 Untitled (HILUX) 238, *238*

P

Pakistan 45, 327
Palaeolithic 13, 329
Palestine 237
Palmer, Katrina 239, 330
 Hello 239, *239*
Pape, Lygia 191, 240, 329
 Roda Dos Prazeres (Wheel of Pleasures) 240, *240*

Paraguay 61
Parcours, Brussels (2016) 238
Paris 50, 67, 70, 96, 101, 110, 119, 141, 153, 180,
 185, 206, 237, 329
Paris+ Art Basel 20
Park Chung-Hee 179
Parker, Cornelia 241, 326, 327, 328
 Perpetual Canon 241, *241*
Parks, Rosa 176
Parsons School of Design, New York 133
Participant Inc., New York 177
participatory art 68, 125, 229, 240, 329
Pashgian, Helen 71, 242, 331
 Untitled (1968–9) 242, *242*
Pastor, Jennifer 243, 332
 The Perfect Ride (dam) 243, *243*
Paterson, Katie 244, 326, 328
 Requiem 244, *244*
patina 40, 73, 119, 325, 329, 331
patriarchy/patriarchal values 324, 328, 329
Pausias 180
Pearl Harbor 25
pedestal *see* plinth
Penguin Books 139
Penone, Giuseppe 220
Pepper, Beverly 245, 329, 330, 331
 Double Palimpsest 245, *245*
Pérez Zeledón, Costa Rica 322
performative sculpture 35, 134, 156, 203, 229,
 329
Peru 56
Pesce, Gaetano 128
Peter the Great, Tsar 70
Petzel Gallery, New York 273
Pfaff, Judy 246, 330
 Blue Vase with Nasturtiums 246, *246*
Philadelphia 110, 313
Phillips, Julia 247, 325
 Nourisher 247, *247*
Picasso, Pablo 330
Piccinini, Patricia 248, 327
 The Naturalist 248, *248*
Pictures Generation 183
Pilates, Joseph 137
Pilkington, Cathie 249, 325
 On the Table 249, *249*
Pittsburgh 117
Pivi, Paola 250, 330
 Are You the Manager? 250, *250*
plaster 11, 38, 60, 325, 329–30, 332
plinth/pedestal 281, 329, 330
Pliny the Elder 180
Poland 18, 165, 287, 305
political art 125, 185, 330
Pollock, Jackson 170
polychrome 208, 256, 328, 330
Pompeii 329
Ponscarme, Hubert 175
Pop Art 56, 67, 121, 182, 204, 251, 324, 327, 328,
 329, 330, 331
Porter, Liliana 251, 326
 Nail 251, *251*
portraiture 24, 70, 88, 139, 176, 255, 328, 330
Portugal 40, 77, 302
Post-Apollo Press 96
postcolonial art 282, 330
Post-Impressionism 110
Post-Minimalism 62, 83, 85, 140, 307, 330, 331
Postmodernism 28, 329, 330
Potrč, Marjetica 252, 328, 329
 Caracas: Growing Houses 252, *252*
Poupelet, Jane 253, 327, 329
 Imploration 253, *253*
Pradier, James 304
Praesens 165
Prague 12, 187, 274, 291
Pratt Institute, New York 62, 122
pre-Columbian/pre-Hispanic art 63, 72, 106, 141,
 330
*Primary Structures: Younger American and British
 Sculptures*, New York (1966) 65
primitivism 101, 330
process art 42, 83, 330
Prost, Henri 37
Proust, Marcel 190
Prussian Academy of Arts, Berlin 166
public art 27, 28, 213, 233, 245, 311, 329, 330, 331
Public Art Fund, New York 310, 330
Public Parking 282
Puerto Rico 71
Purple Rain protest (1989) 281

Q

Qing dynasty 123, 285
Queer art 30, 234, 330
Quench Gallery, Margate 209
Quilici, Folco 121

R

Rabat, Morocco 37
Raine, Kathleen 139
Rainer, Yvonne 62
Ray, Man 183, 236
readymades 116, 277, 324, 327, 329, 330–1
Realism 63, 248, 331
Regionalism 63
relief 38, 95, 126, 141, 175, 274, 325, 331
Rembarrnga language 319
Renaissance 14, 258, 324, 329, 331
resin 325, 327, 331
The Responsive Eye, New York (1965) 115
Reynolds, Joshua 76
Rhode Island School of Design, Providence 87, 200, 202, 278, 280
Richier, Germaine 254, 324, 325, 329
 La Chauve-Souris (The Bat) 254, *254*
Right Click Save 133
Rijksakademie van Beeldende Kunsten, Amsterdam 287
Rilke, Rainer Maria 255
Rilke-Westhoff, Clara 255, 330
 Portrait of Paula Modersohn-Becker 255, *255*
Rio de Janeiro 218
Rivera, Diego 290
Rivière, Thérèse 37
Rococo 100, 326, 329, 331
Rodia, Simon 265
Rodin, Auguste 69, 110, 153, 253, 311
Roldán, Luisa 256, 325, 330
 The Mystical Marriage of Saint Catherine 256, *256*
Roldán, Pedro 256
Romans 11, 206, 249, 284, 285, 300, 304, 315, 325, 327, 329
Romanticism 48, 97
Rome 11–12, 78, 121, 133, 138, 146, 185, 206
Rosa Barba: In a Perpetual Now, Berlin (2021) 35
Rosario, Argentina 74
Rosen, Annabeth 257, 325
 Droove 257, *257*
Rosler, Martha 224
Rossi, Properzia de' 14, 258, 325, 331
 Jewel with Carved Cherry Stone 258, *258*
Rothschild, Eva 259, 324
 Alpine 259, *259*
Rotterdam 46
Rovner, Michal 260, 328
 Data Zone, Cultures Table #3 260, *260*
Royal Academy of Arts, London 76, 139, 324
Royal College of Art, London 64, 91, 120, 138
Rubins, Nancy 261, 324, 330
 Agrifolia Majoris 261, *261*
Runa, Jonas 302
Russia 70, 165, 223, 323
Russia Revolution (1917) 223, 326
Ryan, Kathleen 262, 331
 Bad Lemon (Thirsty) 262, *262*
Ryan, Veronica 263, 327
 Collective Moments XV 263, *263*

S

Saar, Alison 264, 325, 326, 332
 Stubborn and Kinky 264, *264*
Saar, Betye 264, 265, 324, 325, 332
 MTI 265, *265*
Saar, Richard 264
St. Ives, Cornwall 138
St. Louis 146
St. Peter's Basilica, Rome 133, 166
St. Petersburg 70
St. Peter's Church, New York 231
Saint Phalle, Niki de 161, 212, 266, 329, 331
 La Tempérance (Temperance) 266, *266*
Saitō, Takako 267, 327, 332
 Spice Chess 267, *267*
Salcedo, Doris 268, 326, 327
 Untitled (1995) 268, *268*
Salon 44, 175, 180, 219, 304, 324, 331
Salon des Artistes Français 175
Salon of Contemporary Negro Art, New York 269
Samyn, Michaël 133
San Francisco 67, 93, 96, 261
San Francisco Museum of Modern Art 24

San José Museum of Art 309
San Juan, Puerto Rico 71
San Petronio, Bologna 258
Santa Ana de Recoletas Bernardas, Málaga 208
Santiago, Chile 72, 113, 206
São Paulo, Brazil 77, 106, 233
Saul, Sally 202
Savage, Augusta 269, 325, 327
 Lift Every Voice and Sing (The Harp) 269, *269*
Savage Studio of Arts and Crafts, Harlem, New York 269
Scharrer, Eva 162
Schechet, Arlene 202
Schendel, Mira 270, 326
 Sem Titulo (Discos) (Untitled (Disks)) 270, *270*
Schjeldahl, Peter 131
Schnegg, Lucien 253
Schnitger, Lara 271, 326
 Untitled (2017) 271, *271*
School of the Art Institute of Chicago 56
School of Paris 237
Schreuders, Claudette 272, 325, 332
 Accomplice 272, *272*
Schutz, Dana 273, 325
 Sun Lady 273, *273*
sculpture garden/park 22, 77, 266, 329, 331
Sculpture magazine 34, 141, 218
Secession 167
Sedlecká, Irena 274, 330, 331
 John Gielgud (1904–2000), as Hamlet 274, *274*
Seejarim, Usha 275, 324, 327
 Her Latent Power Lies Dormant 275, *275*
Self, Tschabalala 276, 325
 Lifted Lounge #1 276, *276*
Semmes, Beverly 277, 326
 Marigold 277, *277*
Senegal 57, 297
Seoul 317
Shang bronzes 189
Shaw, Robert Gould 185
Shechet, Arlene 278, 325
 Ever However 278, *278*
Shen Yuan 279, 324
 Paysage 279, *279*
Shoeburyness, Essex 239
Shotz, Alyson 280, 330
 Mirror Fence 280, *280*
Sibande, Mary 281, 324, 330
 Ascension of the Purple Figures 281, *281*
Singapore 119, 129, 189
Singh, Ayesha 282, 330
 Hybrid Prototype 282, *282*
Sir J. J. School of Fine Arts, Mumbai 125
site-specific sculpture 142, 203, 231, 328, 330, 331
Skaer, Lucy 283, 328
 Sticks & Stones 283, *283*
Slade School of Fine Art, London 36, 189, 220, 263, 282
slavery/slave trade 81, 114, 185, 306, 329
SlutWalks 271
Smith, David 122
Smith, Kiki 16, 284, 327
 Born 284, *284*
Smith, Roberta 171
Smithson, Robert 142
Smith, Tony 284
So, Renee 285, 326
 Boot Leg 285, *285*
Soares, Valeska 286, 327
 Finale 286, *286*
Socialist Realism 88, 223, 274, 324, 331
Society of New Artists (Bulgaria) 88
soft sculpture 211, 212, 294, 331
Sontag, Susan 75
Sosnowska, Monika 287, 331
 The Fence I 287, *287*
Soto, Jesús Rafael 115
South Africa 21, 159, 196, 215, 272, 281, 317
South America 61, 141
 see also individual countries
Southeast Asia 119
 see also individual countries
South Korea 179, 320
Spain 208, 256, 303, 330
Spoleto, Italy 245
Stadelhole, Hohlenstein 14
Städelschule, Frankfurt am Main 184
Stalin, Joseph 331
State Academy of Arts, Sofia 88
State of the Arts (TV program) 49
Statens Museum for Kunst, Copenhagen 317

steel 22, 51, 84, 134, 245, 329, 331
still life 40, 246, 328, 331
Stingily, Diamond 288, 327
 Entryways 288, *288*
STIRworld magazine 168
Stockholder, Jessica 289, 327
 Untitled (1995) 289, *289*
stone 88, 325, 328, 331, 332
Stonehenge, Britain 328
Strawberry Hill House, Twickenham, London 76
Strengell, Marianne 23
Strzemiński, Władysław 165
Stuart, Michelle 290, 326
 Galesteo II Book 290, *290*
Studio for Portrait Masks 253
Studio Z, Los Angeles 229
sublime 75, 102, 328, 331
Subramanyan, K. G. 222
Suffragists 271
Sufi poetry 66
Sugano, Keisuke 233
Surrealism 101, 144, 161, 183, 188, 205, 236, 283, 294, 325, 327, 331, 332
Suzhou, China 123
Swiss Werkbund 293
Switzerland 53, 293, 320
Symbolism 44, 153, 331
Szapocznikow, Alina 291, 331
 Deser II (Dessert II) 291, *291*
Sze, Sarah 43, 292, 328
 Metronome 292, *292*

T

Taeuber-Arp, Sophie 293, 326
 Tête Dada (Dada Head) 293, *293*
Taller de Gráfica Popular 63
Tallinn, Estonia 119
Tannenbaum, Judith 42
Tanning, Dorothea 294, 331
 Pelote d'Épingles pouvant servir de fétiche (Pincushion to Serve as Fetish) 294, *294*
Tate, London 66, 108, 112, 119, 259, 263, 306, 310
Tawney, Lenore 295, 325, 327
 Union of Water and Fire 295, *295*
Tel Aviv Museum of Art 237
Temple University, Philadelphia 313
TENbyTen 224
Tenser, Alina 296, 324
 Parentheses, Orange Path 296, *296*
textile art 46, 60, 61, 111, 118, 122, 164, 222, 294, 295, 321, 331
 see also Fiber Art Movement
Thailand 119, 157
Thames, River 239
The Third Rail 296
TIME magazine 67
Times Square, New York 67
Tinguely, Jean 266
Tokyo 170, 179
totem 45, 57, 71, 106, 148, 220, 259, 331–2
traditional sculptural materials 325, 326, 327, 328, 329, 332
 see also bronze, marble *etc*
traditional sculptural processes 325, 326, 332
Trafalgar Square, London 310
trompe l'oeil 160, 202, 332
Trouvé, Tatiana 297, 328
 Les Indéfinis 297, *297*
True Blue Plantation, South Carolina 114
Truitt, Anne 298, 327
 A Wall for Apricots 298, *298*
Truth, Sojourner 176
Tse, Shirley 299, 324, 328
 The Vehicle Series: #6 299, *299*
Tunis 156
Turkey 90, 160, 189, 235
Turnbull, William 189
Turner, J.M.W. 54
Turner Prize 64, 128, 308, 310
Tuscany, Italy 266
Twenty-Six Contemporary Women Artists, Ridgefield, Connecticut (1971) 15
Tyler School of Art, Temple University, Philadelphia 313

U

Uganda 30
Ukraine 201
The uncanny 105, 109, 116, 162, 170, 238, 243, 249, 332
Underground Railroad 176

Underwood, Leon 139
Union Square Subway station, New York 213
Union of Women Painters and Sculptors 219
United Nations 327
Universidad Colegio Mayor de Cundinamarca, Bogotá 23
Universidad de Chile, Santiago 72
Universidad Nacional de Asunción 61
Universidad Nacional de México 63
Universidad Nacional de Rosario 74
Universität der Kunste, Berlin 169
Universität für angewandte Kunst, Vienna 167
University of Applied Arts, Prague 12
University of Bologna 216
University of California 261, 303
University of Fine Arts, Poznań 287
University of Iowa 63
University of Oregon 32
University of Southern California 71
University of Stuttgart 115
Uruguay 106
USSR 223, 331

V

VanDerBeek, Sara 300, 325
 Roman Woman XXXVIV 300, *300*
Vanderbilt family 311
vanitas tradition 262
Vanity Fair 237
The Vanity Press (Fiona Banner) 34, *34*
Varga, Ferenc 301
Varga Weisz, Paloma 301, 332
 Waldfrau (Woman of the Forest) 301, *301*
Vasari, Giorgio 258
Vasconcelos, Joana 302, 330
 Pop Galo 302, *302*
Vatican City 133
Venezuela 115, 199, 204, 252
Venice Biennale 325, 332
Venice Biennale, 50th (2003) 243
Venice Biennale, 52nd (2007) 287
Venice Biennale, 54th (2011) 90, 156
Venice Biennale, 57th (2017) 141, 173
Venice Biennale, 58th (2019) 259
Venice Biennale, 59th (2022) 161, 181, 184
Vermeer, Johannes 242
Victoria, Queen of England 306
Victorian College of the Arts, Melbourne 248
Vicuña, Cecilia 303, 327, 331
 Burnt Quipu 303, *303*
video 9, 61, 124, 170, 292
Vienna 100, 167, 310
Vietnam War (1954–75) 122, 192
Vignon, Claude 180, 304, 328, 329
 Daphné changée en laurier (Daphne Changed Into a Laurel) 304, *304*
Virginia Commonwealth University, Richmond 102
Virgin Mary 13, 99, 166, 208, 272
Visual Dialog 313
Vogue 23
Vogue India 163
Voigt, Friedrich Wilhelm 156
Volgograd Planetarium 223
von Rydingsvard, Ursula 305, 329
 Bowl with Fingers 305, *305*

W

Walker, Kara 306, 325, 330
 Fons Americanus 306, *306*
Walker Art Center, Minneapolis 307
Walpole, Horace 76
Wang Gongxin 193
Warashina, Patti 202
Warhol, Andy 212
Warsaw 18
Washington, D.C. 192, 205, 235, 244
wax 75, 79, 155, 216, 332
Webster, Meg 307, 328, 330
 Glen 307, *307*
Werkbund 293
Wermers, Nicole 308, 331
 Abwaschskulptur #14 (Dishwashing Sculpture #14) 308, *308*
Wesleyan University, Middletown, Connecticut 131
West Africa 181, 272
Western art 324, 325, 326, 328, 329, 332
White, Pae 309, 326
 An Allegory of Air: Too full to say Too 309, *309*
Whitechapel Gallery, London 129

White Cube, London 89, 148
Whiteread, Rachel 310, 325, 329, 331
 Untitled (2013) 310, *310*
Whitney, Gertrude Vanderbilt 311, 330, 331
 Titanic Memorial 311, *311*
Whitney Biennial 49, 94, 225
Whitney Museum of American Art, New York 196, 311
Wilding, Alison 312, 324, 329
 Dramonia 312, *312*
Wilke, Hannah 313, 325, 326
 Two-Fold Gestural Sculpture 313, *313*
Winsor, Jackie 314, 328
 Pink and Blue Piece 314, *314*
Wiradjuri people 82
W magazine 271
Woelfffer, Emerson 295
Wolverhampton Polytechnic 129
wood 11, 30, 305, 325, 332
Woodman, Betty 315, 325
 Aztec Vase and Carpet #8 315, *315*
world's fairs 223, 269, 304
World War I 166, 175, 253, 311, 326
World War II 18, 25, 108, 139, 140, 165, 242, 291, 305
Worpswede, Germany 255
WPA Federal Arts Project 269
Wumen, China 123

Y

Yale School of Art 141
Yale University 32, 192, 246, 307
Yamazaki Tsuruko 316, 324, 327
 Tin Cans 316, *316*
Yang, Haegue 317, 324
 Sonic Intermediates 317, *317*
Yanko, Kennedy 318, 328
 Anchor I 318, *318*
Yarinkura, Lena 319, 327
 Camp Dog 319, *319*
Yayoi period, Japan 171
Yi, Anicka 320, 324, 326
 Living and Dying In The Bacteriacene 320, *320*
Yin Xiuzhen 321, 331
 Portable City: Hangzhou 321, *321*
Yorkshire Sculpture Park, Wakefield 77, 302
Yoruba people 186
Youngblood, Daisy 322, 325, 327, 329
 Anubis and the First Chakra 322, *322*
Young British Artists 64, 104, 112, 197

Z

Zen Buddhism 188, 233
Zhejiang Academy of Fine Arts, Hangzhou 279
Zittel, Andrea 323, 326
 A–Z Escape Vehicle: Customized by Andrea Zittel 323, *323*
Zsikla, Mónika 161
Zulu people 196, 281
Zumbo, Gaetano Giulio 155
Zürich 53, 293

PICTURE CREDITS

All images © the artists. p.18 © The Estate of Magdalena Abakanowicz. Courtesy GRAY, Chicago/New York and Marlborough Gallery, New York. p.19 Courtesy the artist and Zürcher Gallery, New York/Paris. Photo: Adam Reich. p. 20 © Kelly Akashi. Courtesy the artist. Photo: Paul Salveson. p.21 © Jane Alexander. All rights reserved, DALRO/DACS 2024. Photo: Paul Hester. p.22 Courtesy the artist and Lawrie Shabibi. Photo: Thierry Bal. p.23 © Olga de Amaral. Courtesy Lisson Gallery. Photo: Diego Amaral. p.24 Gift of Carla Emil and Rich Silverstein and John Caldwell Fund for Contemporary Art purchase (Curator of Painting and Sculpture, 1989–93). © Janine Antoni. Courtesy the artist and Luhring Augustine, New York. Photo: Ben Blackwell. p.25 © 2024 Ruth Asawa Lanier, Inc./© ARS, NY and DACS, London 2024. Courtesy David Zwirner. Photo: Laurence Cuneo. p.26 © Tauba Auerbach. Courtesy Paula Cooper Gallery, New York. p.27 Courtesy the artist. Photo: Stephen White. p.28 Courtesy the artist and Marlborough Gallery, New York. Photo: Sarah Lyon. p.29 Gift of Margarita Azurdia, Smith College Museum of Art, Northampton, Massachusetts, SC 1995.8.2. Courtesy Milagro de Amor, S.A. p.30 Collection of Glori Cohen, New York. © Leilah Babirye. Courtesy the artist, Stephen Friedman Gallery, and Gordon Robichaux. Photo: Gregory Carideo. p.31 Courtesy the artist, Marian Goodman Gallery and kurimanzutto. p.32 © Natalie Ball. Courtesy the artist. Photo: Robert Glowacki. p.33 Courtesy the artist and Perrotin. Photo: Guillaume Ziccarelli. p.34 Courtesy the artist and Frith Street Gallery. Photo: Peter Cox. p.35 © Rosa Barba. Courtesy the artist and Esther Schipper, Berlin/Paris/Seoul. All rights reserved, DACS, 2024. Photo: Andrea Rossetti. p.36 © Phyllida Barlow. Courtesy Hauser & Wirth. Photo: Alex Delfanne. p.37 Gift of The Pierre and Tana Matisse Foundation, 2011 (2011.602), The Metropolitan Museum of Art. © Yto Barrada. Courtesy Pace Gallery; Sfeir-Semler Gallery, Hamburg, Beirut; and Galerie Polaris, Paris. Photo: Art Resource/Scala, Florence. p.38 © The Archive of Maria Bartuszová, Košice. Courtesy The Estate of Maria Bartuszová, Košice, and Alison Jacques, London. Photo: Michael Brzezinski. p.39 Courtesy Begum Studio and Kate MacGarry Gallery. Photo: Angus Mill. p.40 Courtesy the artist; Croy Nielsen, Vienna and Standard (Oslo), Oslo; and the High Line. Photo: Timothy Schenck. p.41 Courtesy the artist. Photo: Aurélien Mole. p.42 © Lynda Benglis. Courtesy the artist, VAGA at ARS, NY and DACS, London 2024. Photo: Brian Buckley. p.43 © Lauren Berkowitz. Courtesy the artist and Museum of Contemporary Art Australia. Photo: Anna Kučera. p.44 Purchased with funds provided by Constance T. and Donald W. Patterson and Pamela Kelley Hull/Art Institute of Chicago. p.45 © Huma Bhabha. Courtesy the artist and David Zwirner. p.46 © Alexandra Bircken. Courtesy Maureen Paley, London, Herald St, London and BQ Berlin. p.47 © Cosima von Bonin. Courtesy the artist and Petzel Gallery, New York. p.48 © Tatiana Silva. Courtesy Dreamstime.com. All rights reserved, DACS, 2024. p.49 © Chakaia Booker Studio. Courtesy Chakaia Booker and the David Nolan Gallery. Photo: Chakaia Booker Studio. p.50 © The Easton Foundation. VAGA at ARS, NY and DACS, London 2024. Photo: Maximilian Geuter. p.51 © Carol Bove. Courtesy the artist and Gagosian. Photo: Dan Bradica. p.52 Courtesy the Estate of Beverly Buchanan and Andrew Edlin Gallery, New York. p.53 © The Estate of Heidi Bucher. Photo: Stefan Altenburger Photography, Zürich. p.54 Courtesy the artist and Kunsthalle Basel. Photo: Gina Folly. p.55 Courtesy the artist and Esther Schipper, Berlin/Paris/Seoul. Photo © Eberle & Eisfeld. p.56 © 2024 Estate of Teresa Burga. Courtesy Alexander Gray Associates, New York, and Galerie Barbara Thumm, Berlin. p.57 Courtesy Galerie Magnin-A, Paris. p.58 Courtesy Henry Art Gallery. Courtesy the artist, Lisson Gallery, New York, and Hannah Hoffman, Los Angeles. Photo: Jonathan Vanderweit. p.59 Courtesy Mendes Wood DM, Galerie Barbara Wien, Kaufmann Repetto and 303 Gallery. Photo: Nick Ash. p.60 Courtesy the artist and The New Art Gallery, Walsall. Photo: Jonathan Shaw. p.61 Courtesy the artist. p.62 © The Estate of Rosemarie Castoro. Photo: Roberto Ruiz. p.63 © Catlett Mora Family Trust. Courtesy the Estate of Samella Lewis. VAGA at ARS, NY and DACS, London 2024. p.64 © Estate of Helen Chadwick. Courtesy Richard Saltoun Gallery, London and Rome. Photo: Peter White. p.65 © Judy Chicago. ARS, NY and DACS, London 2024. Photo: Donald Woodman/ARS, NY. p.66 © Saloua Raouda Choucair Foundation. Photo: Tate. p.67 Brooklyn Museum, Gift of Sidney Singer, 85.290. © Estate of Chryssa Vardea-Mavromichali. All rights reserved, 2024. p.68 Courtesy The World of Lygia Clark Cultural Association. Photo: Amaro Aloysio Bello Neto. p.69 Courtesy RMN-Grand Palais/SCALA, Florence. Photo: Alain Leprince. p.70 © Hermitage Museum, St. Petersburg, Russia/Heritage Images/Photo Scala Florence. p.71 Courtesy the artist and Marlborough Gallery, New York. Photo: Marten Elder. p.72 Collection Museo Nacional de Bellas Artes, Santiago de Chile. © Estate of Marta Colvin Andrade. p.73 © Fiona Connor, Maureen Paley, London, and Château Shatto, Los Angeles. Photo: Rob Harris. p.74 Courtesy the artist. p.75 © Petah Coyne. Courtesy Galerie Lelong & Co., New York. p.76 Purchase, Barbara Walters Gift, in honor of Cha Cha, 2014, The Metropolitan Museum of Art. p.77 Courtesy Duarte Sequeira Gallery. p.78 National Portrait Gallery of Australia. Purchased with the assistance of funds provided by Ann Lewis AM and the Basil Bressler Bequest 2004. © Paula Dawson/Copyright Agency. All rights reserved, DACS, 2024. p.79 © Berlinde De Bruyckere. Courtesy the artist and Hauser & Wirth. Photo: Mirjam Devriendt. p.80 © Agnes Denes. Courtesy Leslie Tonkonow Artworks + Projects. Photo: courtesy Socrates Sculpture Park. p.81 Courtesy the artist and Michel Rein, Paris/Brussels. Photo: Vincent Everarts. p.82 Art Gallery of New South Wales © Karla Dickens/Copyright Agency. All rights reserved, DACS, 2024. Photo: Art Gallery of New South Wales/Bridgeman Images. p.83 © Tara Donovan, courtesy Pace Gallery. Photo: G.R. Christmas. p.84 © Sokari Douglas Camp. Courtesy the artist and October Gallery, London. Photo: © Jonathan Greet. p.85 Courtesy the artist and 1301SW, Melbourne. Photo: Jack Willet. p.86 Smithsonian American Art Museum, Museum purchase through the C.K. Williams Foundation. p.87 Complete work caption: Maker's Muck, 2022, Coney Island Boardwalk (Brazilian Ipe), plaster, bronze, silicone, unfired clay, fired clay, expanding foam, burlap, wire, raw wool, sneakers, magic smooth, magic sculpt, resin, bamboo skewers, tin foil, plaster bandages, plywood, bass wood, Aqua-Resin, fiberglass, seashell, Styrofoam, oil paint, wax, carpet fringe, cardboard, cement, steel pipe, steel rod, aluminum paint tubes, vinyl stickers, granite, telescopic extension pole, sand, fabric, crocheted rug, marbles, miniature rocking chair, grass, woven rush stool, Formica, Le Beau Touché plasteline, canola oil, corn, Valvoline motor oil, sponge, reflective fabric, nylon cord, charcoal, Shimpo Whisper pottery wheel, Saran wrap, coated wire, recording device, AM/FM Radio, assorted clamps, heat lamp bulb, clip light, glass bottles, Plexiglas, dried flowers, SLS plastic, dried plastics, milk crate, canvas, twine, copper tube, elastic cord, steel I-beam, MDF, iron object, Thixotropic polyurethane plastic, 103 1/4 × 120 × 155 1/4 in. (262.3 × 304.8 × 394.3 cm) © Nicole Eisenman. Courtesy the artist and Anton Kern Gallery, New York. Photo: Thomas Barratt. p.88 Collection of the National Gallery, Bulgaria. p.89 © Tracey Emin. All rights reserved, DACS, 2024. Photo: Istvan Virag. p.90 Courtesy the artist and Galerie Barbara Weiss, Berlin. Photo: Roman Mensing/artdoc.de. p.91 Courtesy Proyectos Monclova. Photo: Ramiro Chaves. p.92 Courtesy Fridman Gallery and Dreamsong. Photo: Chase Pellerin. p.93 © The Falkenstein Foundation. Courtesy Michael Rosenfeld Gallery LLC, New York. p.94 Courtesy the artist. Photo: Ron Amstutz. p.95 © The Estate of Monir Shahroudy Farmanfarmaian. Courtesy The Estate of Monir Shahroudy Farmanfarmaian and James Cohan, New York. Photo: Phoebe d'Heurle. p.96 TBA21, Thyssen-Bornemisza Art Contemporary Collection. Commissioned by TBA21–Academy. p.97 RMN-Grand Palais/Dist. Photo SCALA, Florence. Photo: Martine Beck-Coppola. p.98 © Castello di Rivoli Museo d'Arte Contemporanea, Rivoli-Torino. Courtesy the artist. Photo: Renato Ghiazza. p.99 Victoria and Albert Museum, London. p.100 © Rachel Feinstein. Courtesy Gagosian. p.101 Courtesy Estate Ferlov Mancoba and Galerie Mikael Andersen, Copenhagen. p.102 In collaboration with The Fabric Workshop and Museum, Philadelphia. © Teresita Fernández. Courtesy the artist and Lehmann Maupin, New York, Hong Kong, Seoul, and London. p.103 © Sylvie Fleury. Courtesy the artist and Sprüth Magers. Photo: Ingo Kniest. p.104 © Ceal Floyer. Courtesy Lisson Gallery. Photo: Ken Adlard. p.105 Courtesy Bo Lee and Workman. p.106 MACA Collection Uruguay. Courtesy Sammer Gallery Miami & Galeria de las Misiones. Photo: Nicolas Vidal. p.107 © the artist. Photo: Bridgeman Images. p.108 © The Elisabeth Frink Estate and Archive. All rights reserved, DACS 2024. Photo: © Tate. p.109 © Katharina Fritsch. VG Bild-Kunst Bonn/All rights reserved, DACS 2024. Photo: Ivo Faber. p.110 Courtesy the Danforth Art Museum at Framingham State University. Gift of the Meta V. W. Fuller Trust. Photo: Will Howcroft. p.111 Whitney Museum of American Art/Gift of Mrs. Edgar Davy, Mrs. Michael Heron and Miss Berta Walker. Photo © Whitney Museum of American Art/Licensed by Scala. p.112 © Anya Gallaccio. Courtesy the artist and Thomas Dane Gallery. p.113 Museo de Artes Visuales MAVI UC. Photo: Juan Pablo Calderón. p.114 Courtesy the artist. Photo: Eileen Travell. p.115 © Fundación Gego. Photo: The Museum of Modern Art, New York/Scala, Florence. p.116 Courtesy Galerie Buchholz and Hauser & Wirth. All rights reserved, DACS, 2024. Photo: Brian Forres. p.117 Mount Holyoke College Art Museum, South Hadley, Massachusetts, MH 2023.9.1. Purchased with the Belle and Hy Baier Art Acquisition Fund. © vanessa german. Photo: Laura Shea. p.118 Collection Pérez Art Museum Miami, museum purchase with funds provided by Jorge M. Pérez. Courtesy the artist and Mendes Wood DM. p.119 © Dorich House Museum. p.120 Courtesy the artist and Ikon. Photo: Stuart Whipps. p.121 © Laura Grisi Estate, Rome, and P420, Bologna. Photo: Carlo Favero. p.122 © Nancy Grossman. Courtesy of Michael Rosenfeld Gallery LLC, New York. p.123 The Metropolitan Museum of Art, New York. Gift of Lily and Baird Hastings, 1989. p.124 Courtesy the artist; Kraupa-Tuskany Zeidler, Berlin; and David Kordansky Gallery. Photo: def image. p.125 Courtesy the artist and Frith Street Gallery. Photo: Didier Bamoso. p.126 Courtesy the artist and Roslyn Oxley9 Gallery, Sydney. p.127 © Lauren Halsey. Courtesy David Kordansky Gallery. Photo: Allen Chen. p.128 © Anthea Hamilton. Courtesy the artist, kaufmann repetto, Milan/New York, and Thomas Dane Gallery. Photo: Andy Keate. p.129 © Han Sai Por. Courtesy the artist and STPI – Creative Workshop & Gallery, Singapore. p.130 Courtesy the artist and Kerlin Gallery. p.131 Courtesy the artist and Greene Naftali, New York. Photo: Jason Mandella. p.132 Courtesy the artist and Brooke Benington. Photo: Corey Bartle-Sanderson. p.133 Whitney Museum of American Art, New York; purchase, with funds from the Digital Art Committee. Courtesy the artist. p.134 Courtesy the artist and Susan Inglett Gallery. Photo: © The Museum of Modern Art, New York/Scala, Florence. p.135 © Mona Hatoum. Photo © White Cube (George Darrell). p.136 © Holly Hendry. Courtesy the artist and Stephen Friedman Gallery. Photo: Todd-White Art Photography. p.137 © ADAGP Camille Henrot. Courtesy the artist, Mennour (Paris), and Hauser & Wirth. Photo: Aurélien Mole. p.138 Arts Council Collection, Southbank Centre, London. © Bowness, Hepworth Estate.

WRITERS

(A–Z by initials)

AMIE CORRY (AC) is a writer and editor based in London, UK. pp.18, 34, 45, 87, 129, 193, 214, 235, 283

ANNE REEVE (AR) is Curator at the Hirshhorn Museum and Sculpture Garden in Washington, D.C., USA, where she oversees the museum's collection of modern and contemporary sculpture. pp.118, 135

ADAM M. THOMAS (AT) is Curator of American Art at the Palmer Museum of Art and Affiliate Assistant Professor of Art History at Pennsylvania State University, State College, USA. pp.71, 93, 108, 202, 226, 261, 294, 307

COLBY CHAMBERLAIN (CC) is a writer, critic, and assistant professor at the Cleveland Institute of Art's College of Art + Design, Ohio, USA. He is the author of *Fluxus Administration: George Maciunas and the Art of Paperwork* (2024). pp.54, 296

CARRIE DEDON (CD) is Associate Curator of Modern and Contemporary Art at the Seattle Art Museum in Washington, USA. pp.25, 32, 186, 229

CHARLOTTE FLINT (CF) is Senior Editor, Art Surveys, at Phaidon Press, based in London, UK. pp.24, 89

CATALINA IMIZCOZ (CI) is a researcher and editor based in London, UK. An exhibition studies specialist, she is associate lecturer for the Exhibition Studies Research Masters at Central Saint Martins. pp.59, 151, 177, 191, 239, 312, 317

CHARLOTTE JANSEN (CJ) is a British Sri Lankan arts and culture journalist and author. pp.57, 136, 145, 190, 219

DR. CLEO ROBERTS-KOMIREDDI (CRK) speaks and writes on contemporary art, often with a focus on art from South and Southeast Asia. She is currently working on a book for Yale University Press. pp.33, 39, 104, 120, 156, 157, 163, 198, 221

DAVID TRIGG (DT) is a writer, critic, and art historian based in Bristol, UK. He is the author of *Reading Art* (2018). pp.49, 62, 80, 82, 112, 139, 158, 178, 189, 220, 245, 250, 279, 284, 287, 308

ELLEN MARA DE WACHTER (EDW) is a writer based in London, UK, and author of *Co-Art: Artists on Creative Collaboration* (2017) and *More Than The Eyes: Art, Food and The Senses* (2024). pp.26, 78, 113, 207, 213, 236, 247, 265, 269, 271, 290, 320

ELIZABETH FULLERTON (EF) is a critic and writer for publications including the *New York Times*, *The Guardian*, and *Art in America*, and author of *Artrage! The Story of the BritArt Revolution* (2016, 2021). pp.114, 144, 170, 175, 179, 184, 225, 291, 297, 301

EVE STRAUSSMAN-PFLANZER (ESP) is an art historian and curator who specializes in women artists and patrons. pp.28, 70, 99, 146, 149, 155, 208, 216, 256, 257, 258

GORDON HALL (GH) is a sculptor and Assistant Professor of Art at Vassar College based in New York, USA. p.231

GABRIELLE SCHWARZ (GS) is a writer and editor living in London, UK. She has contributed to publications including *Another Gaze*, *Apollo*, *Artforum*, *The Guardian*, and *Outland*. pp.46, 121, 127, 132, 133, 173, 274

IAN BOURLAND (IB) is an art historian at Georgetown University, Washington, D.C., USA, and cultural critic for a range of leading publications. pp.21, 110, 215

JO BARING (JB) is the Frankland Visitor to Brasenose College, Oxford University, UK, and Director of the Ingram Collection. A former Director of Christie's UK, she is the co-writer and co-presenter of the podcast *Sculpting Lives*. p.249

JAREH DAS (JD) is a curator, writer, and researcher based between West Africa and the UK. With a PhD in curation, Das specializes in global modern and contemporary art, and performance art. pp.27, 84, 159, 200, 263, 318

JULIANA MASCOLO (JM) works for ANOTHER SPACE, a nonprofit program dedicated to broadening international awareness of art from Latin America and its Diaspora. She is based in New York, USA, and London, UK. pp.20, 48, 77, 106, 122, 147, 165, 195, 199, 203, 217, 315

JULES SPECTOR (JS) is Editorial Assistant at Phaidon Press, based in New York, USA. pp.50, 131, 152, 168, 169, 187, 278, 280, 298

KATHLEEN MADDEN (KM) is an independent writer and adjunct faculty at Christie's education, Sotheby's Institute of Art, and Barnard College, New York, USA. pp.30, 51, 58, 211, 244, 300, 323

LUCIENNE BESTALL (LB) is an arts writer and curatorial researcher based in Cape Town, South Africa. pp.19, 31, 66, 73, 101, 138, 183, 196, 197, 248, 272, 275

LOTTE JOHNSON (LJ) is a curator at Barbican Art Gallery, London, UK, with an interest in interdisciplinary artistic expressions, feminist practices, and transcultural dialogues. pp.105, 140, 148, 174, 209, 266

LISA LE FEUVRE (LLF) is a curator, writer, and editor. She is inaugural Executive Director of Holt/Smithson Foundation, the artist-endowed foundation dedicated to the creative legacies of Nancy Holt and Robert Smithson. Between 2010 and 2017 Le Feuvre was Head of Sculpture Studies at the Henry Moore Institute, directing the research component of the largest artist-endowed foundation in Europe, leading programs of education, research, publications, and exhibitions focused on sculptural thinking. Introductory essay, pp.9–17

LAURA OROZCO (LO) is a Mexican curator and writer. Since 2013, she has been Director of ESPAC, Mexico City. pp.55, 72, 116, 150, 153, 228, 251, 268

MADDIE HAMPTON (MH) is a writer based in New York, USA. An alum of the Whitney Independent Study Program, her writing has appeared in *The Brooklyn Rail*, *Art Review*, and *frieze*. pp.37, 38, 96, 124, 137, 142, 160, 227, 232, 243, 285

MELANIE KRESS (MK) is Senior Curator for Public Art Fund in New York and Critic at Yale School of Art, New Haven, Connecticut, USA. pp.102, 181, 281, 303, 314

MAIA MURPHY (MKM) is Senior Editor at Phaidon Press, based in New York, USA. pp.117, 295, 316

MIA MATTHIAS (MM) is a curator and writer based in Washington, D.C., USA. pp.109, 111, 119, 204

MARINA MOLARSKY-BECK (MMB) is an art historian, writer, curator, and PhD candidate at Yale University, New Haven, Connecticut, USA, where she studies Queer subjectivity in European modernism. pp.69, 166, 180, 192, 210, 254, 255

MICHELE ROBECCHI (MR) is Commissioning Editor, Contemporary Art, at Phaidon Press, based in London, UK. pp.35, 65, 238, 273, 306

MOLLY SUPERFINE (MS), PhD, is an art historian and postdoctoral research associate at the Center for Advanced Study in the Visual Arts at the National Gallery of Art, Washington, D.C., USA. pp.52, 53, 86, 134, 172, 176, 185, 222, 260, 276, 311

NICOLE MARTINEZ (NM) is a writer and editor based in Miami, Florida, USA, focused on uplifting artistic voices. Her writing has appeared in *ARTnews*, *Hyperallergic*, *Cultured*, and *The Art Newspaper*, among others. pp.68, 206, 212, 230, 262, 264

OLIVIA CLARK (OC) is Project Editor at Phaidon Press, based in New York, USA. pp.42, 63, 76, 88, 97, 167, 201, 218, 223, 237, 253, 289, 304, 322

ORIN ZAHRA (OZ) is Associate Curator at the National Museum of Women in the Arts, Washington, D.C., USA. pp.22, 40, 44, 81, 95, 125, 162, 194, 234, 288, 305

PHILOMENA EPPS (PE) is a writer and researcher living in London, UK. She is a doctoral candidate in the History of Art department at University College London. pp.64, 75, 103, 123

RAPHAEL FONSECA (RF) is Associate Curator of Modern and Contemporary Latin American Art at the Denver Art Museum in Colorado, USA. pp.29, 41, 143, 240, 292

REBECCA HEALD (RH) is a commissioner and curator based in London, UK, committed to making our public spaces materially sustainable and welcoming to all. pp.60, 90, 94, 130, 154, 164, 246, 252, 277, 299, 302

REBECCA MORRILL (RM) is a writer and editor based in Gateshead, UK. As Phaidon's former Commissioning Editor (Art Surveys), she conceived and produced *Great ~~Women~~ Artists* (2019) and *Great ~~Women~~ Painters* (2022). pp.83, 141, 188, 241, 259, 310

SALOMÉ GÓMEZ-UPEGUI (SGU) is a writer and the founder of Solar Consulting Studio, based in Miami, Florida, USA. pp.23, 56, 61, 67, 74, 91, 182, 267, 309, 313

SIMON HUNEGS (SH) is Senior Editor, Art, at Monacelli Press, based in New York, USA. p.242

SAMANTHA LITTLEY (SL) has enjoyed a varied career as a curator, writer, and educator. She is Curator of Australian Art at the Queensland Art Gallery | Gallery of Modern Art, Brisbane, Australia. pp.43, 85, 126

SOPHIA NAMPITJIMPA SAMBONO (SS) is a descendant of the Jingili people from Elliot/Newcastle Waters with kin connections across the top end, including Darwin, Daly River, and the Tiwi Islands. She is Associate Curator, Indigenous Australia Art at the Queensland Art Gallery | Gallery of Modern Art, Brisbane, Australia. p.319

TAISA PALHARES (TP) is a curator, critic, and Professor of Aesthetics in the Department of Philosophy and Human Sciences at UNICAMP Universidade Estadual de Campinas, Brazil. pp.47, 98, 107, 115, 171, 205, 233, 286, 293

WENDY VOGEL (WV) is a writer based in New York, USA, and is a faculty member at Parsons School of Design. She has received an Andy Warhol Foundation Arts Writers Grant in Short-Form Writing. pp.92, 128, 161, 224, 282, 321

YATES NORTON (YN) is a writer and curator, working at the Roberts Institute of Art in London, UK. pp.36, 79, 100

ACKNOWLEDGMENTS

The editors are most grateful to Rebecca Morrill for her role in conceiving this book.

Thank you to all the artists and their studios, artists' families and estates, representative galleries, museums, private collections, auction houses, and other arts organizations who assisted this publication by providing images and arranging permissions.

We would especially like to acknowledge the following individuals who provided generous assistance, shared knowledge and expertise, and made helpful introductions and connections: Rosa Abbott, Vidisha Aggarwal, Dilara Altuğ, Angel Alvarado, Eve Arballo, Chiara Arenella, Domitilla Argentieri-Federzoni, Paige Auerbach, Rosa Bacile, Cristina Balão, Helen Barr, Alberto Baruffato, Julia Bassiri, Jana Baumann, Joy Beckett, Megan Bedford, Sam Begun, Catherine Belloy, Lerato Bereng, Frederico Bertani, Mayane Bessac, Cali Blackwell, Phoebe Boatwright, Sophie Bowness, Bea Bradley, Tyler Brandon, Leslie Brown, Adrianna Brusie, Brea Buchanan, Caroline Burghardt, Brian Butler, Vera Castillo, Tess Charnley, Hannah Chinn, Kathy Cho, Edwige Cochois, Joseph Conder, Cortney Connolly, Olympia Contopidis, Martin Coppel, Bella Coxon, Xavier Danto, William Davie, Clarice De Veyra, Isabelle Demin, Robert Diament, Claire Dilworth, Kieran Doherty, Sky Edenfield, Ian Edquist, Rita Edwards, Sebastian Eising, Niki Fanjul, Gabrielle Farina, Fiona E. Fisher, Joana Fortes, Gizem Gedik, Gaja Golija, Lauren Graber, Christin Graham, Clara Greenfield, Hillary Halter, Heleriin Hein, Julia Hernandez, Thamara Hidalgo, Cate Higgins, Amelia Hinojosa, Jerson Hondall, Monique Howse, Tamsin Huxford, Kyoungeun Hwang, Alison Jacques, Alice Joubert-Nikolaev, Timo Kaabi-Linke, Laura Katzauer, Anna Kim, Adrian Kowanz, Isla Macer Law, Cara Lerchl, Siobhan Maguire, Kathleen N. Mangan, CeCe Manganaro, Valentina Marinai, Rie Marsden, Maddy Martin, Nicole Martin, Jarek Miller, Paul Monroe, Fabiane Morales, Lebo Motsoeneng, Lucy Mounfield, Marissa Moxley, Nick Naber, Peter Nagy, Sophie Netchaef, Kaytlin Nodine, Eve O'Brien, Cathy O'Sullivan, Natsuka Okamoto, Bhooma Padmanabhan, Ludovica Parenti, Ashley Park, Lotte Parmley, Rachel Passannante, Ignacio Pedronzo, Philip Pihl, Davide Pirovano, Margarita Poroshina, Alana Pryce Tojcic, Chris Rawson, Samantha Rees, Hannah Robinson, Agata Rutkowska, Leah Saltoun, Aixa Sánchez, Timothy Schenck, Lieselotte Schinzing, Hala Schoukair, Hannes Schroeder-Finckh, Jelena Seng, Jose Silva, Jess Smith, Lada Sorokopud, Joel Spiegelberg, Edward Stapley-Brown, Clara Sophie Stratmann, Valentina Suma, David Suyasa, Louise Talintyre, Leslie Tonkonow, Monica Truong, Stefka Tsaneva, Ana Varella, Jennifer Voiglio, Aleksandra Volkova, Jorien de Vries, Calvin Wang, Tiffany Wang, Robin Watkins, Alexandra Wells, Adam Whitford, Vincent Wilke, Jack Willet, Nicolette Wong, Alice Workman, Pete Woronkowicz, Pawel Wysocki, Stefan Zebrowski-Rubin, Jake Zellweger, Zhiyi Zhou, and Gwenolee Zürcher.

Additional thanks go to Deborah Aaronson, Caitlin Arnell Argles, Samuel Bennett, Hilary Bird, Clive Burroughs, Zuzana Cimalova, Ellen Mara De Wachter, Keith Fox, Hélène Gallois-Montbrun, Julia Hasting, Simon Hunegs, Tom Keyes, Lisa Le Feuvre, Violeta Mitrova, João Mota, Frankie Moutafis, Joanne Murray, Ma'ayan Noy, Michela Parkin, Michele Robecchi, Baptiste Roque-Genest, Léa Sangaré, Tracey Smith, Jules Spector, Hans Stofregen, Elaine Ward, and Jonathan Whale.

Phaidon Press Limited
2 Cooperage Yard
London E15 2QR

Phaidon Press Inc.
111 Broadway
New York, NY 10006

phaidon.com

First published 2024
© 2024 Phaidon Press Limited

ISBN 978 1 83866 777 1

PROJECT EDITORS: Olivia Clark, Charlotte Flint,
and Maia Murphy
PRODUCTION CONTROLLER: Rebecca Price
PICTURE RESEARCHER: Jen Veall
DESIGNER: Astrid Stavro

Printed in China

All measurements are given height × width ×
depth unless otherwise specified.

Current place names are used throughout unless
otherwise specified.

If this book contains inaccurate information or
language that you feel we should improve or
change, we would like to hear from you. Please
email texts@phaidon.com.